FIVE HUNDRED BUILDINGSOF LONDON

FIVE HUNDRED BUILDINGSOF LONDON

Photography by John Reynolds Text by Gill Davies

Copyright © 2006 Black Dog & Leventhal Publishers, Inc. Original photography © 2006 by John Reynolds

All rights reserved. No part of this book may be reproduced in any form or by any electronic or mechanical means, including information storage and retrieval systems, without written permission from the publisher.

ISBN-13: 978-1-57912-857-9

Library of Congress Cataloging-in-Publication Data on file at the offices of the publisher.

Book cover design and maps Sheila Hart Design Inc.

Building selection, interior design, and production Playne Design Limited, London Designers Kieran Fairnington Clare Playne Research and technical Simon Hack The Tin Limited Playne Books Limited, Pembrokeshire UK Designers Richard Cotton Geraint Jones David Playne Research and editorial assistants Aureole Communications Sheila Jones Chris Kilvington Rupert Matthews Christine Skinner

Published by Black Dog & Leventhal Publishers, Inc. 151 West 19th Street New York, New York 10011

Distributed by Workman Publishing Company 225 Varick Street New York, New York 10014

hgfedcba

Manufactured in China

CONTENTS

6	Introduction	
7	Author's Note	
8	Photog	grapher's Note
10	West	London (W)
12	WI	West End
64	W2	Paddington
73	W4	Chiswick
80	W5	Ealing
82	W6	Hammersmith
84	W8	Kensington
91	W10	North Kensington
92	WII	Notting Hill
94	WI4	West Kensington
98	West Central London (WC)	
100	WCI	Bloomsbury
117	WC2	Covent Garden
157	East Central London (EC)	
		ng City of London
159	ECI	Clerkenwell
181	EC2	Moorgate
181 207	EC2 EC3	Moorgate Fenchurch Street
		0
207	EC3 EC4	Fenchurch Street
207 229	EC3 EC4	Fenchurch Street Queen Victoria Street
207 229 261	EC3 EC4 East I	Fenchurch Street Queen Victoria Street London (E)
207 229 261 263	EC3 EC4 East I EI	Fenchurch Street Queen Victoria Street London (E) Aldgate
207 229 261 263 273	EC3 EC4 East L E1 E2	Fenchurch Street Queen Victoria Street London (E) Aldgate Bethnal Green
207 229 261 263 273 279	EC3 EC4 E1 E2 E4	Fenchurch Street Queen Victoria Street London (E) Aldgate Bethnal Green Chingford
207 229 261 263 273 279 280	EC3 EC4 E1 E1 E2 E4 E8	Fenchurch Street Queen Victoria Street London (E) Aldgate Bethnal Green Chingford Hackney
207 229 261 263 273 279 280 281	EC3 EC4 E1 E2 E4 E8 E9	Fenchurch Street Queen Victoria Street Aldgate Bethnal Green Chingford Hackney Homerton
207 229 261 263 273 279 280 281 282	EC3 EC4 E1 E2 E4 E8 E9 E14	Fenchurch Street Queen Victoria Street Aldgate Bethnal Green Chingford Hackney Homerton Poplar

294 North London (N)

296 NI Islington

- 306 N6 Highgate
- N7 313 Holloway
- 315 N16 Stoke Newington
- Tottenham NI7
- N19 Upper Holloway

323 North West London (NW)

- 325 NWI Camden Town
- 347 NW3 Hampstead
- 365 NW5 Kentish Town
- 366 NW6 Kilburn
- 368 NW8 St. John's Wood
- NWI0 Willesden 371
- 372 NWII Golders Green

376 South West London (SW)

- Victoria Including City of Westminster 378 SWI
- 443 SW2 Brixton
- 445 SW3 Chelsea
- 458 SW7 South Kensington
- 472 SWII Battersea
- 474 SWI5 Putney
- 477 SW16 Streatham

478 South East London (SE)

- 480 SEL Southwark and Bermondsey
- 498 SF3 Blackheath
- 500 SE5 Camberwell
- 501 SF7 Charlton 502 SF9 Eltham
- 504 SE10
- Greenwich 508 SEII Kennington
- 509 SE14 New Cross
- SE16 Rotherhithe
- SE18 Woolwich
- 517 SE21 Dulwich
- 519 Forest Hill SE23
- SE26 Sydenham

521 Close to London

- TW9 Kew, Richmond
- 526 DA6 Bexleyheath
- DA18 Thamesmead

529 **Building Descriptions**

631 Index

INTRODUCTION

Sir, if you wish to have a just notion of the magnitude of this city, you must not be satisfied with seeing its great streets and squares, but must survey the innumerable little lanes and courts. It is not in the showy evolutions of buildings, but in the multiplicity of human habitations which are crowded together, that the wonderful immensity of London consists.

-Samuel Johnson, 1709-84

Arriving in London is always an unforgettable experience. Arriving there for the very first time, raw from school, to take up an editorial role in a publishing house was particularly exciting. Each evening, I left my desk in High Holborn and set out to explore—walking, staring, gazing all around, wildly enthusiastic about being in such an exhilarating city—and stepping out alone, all the better to absorb the architecture and history that presented itself around every corner.

With the passage of time, some streets and sights are rather more familiar to me now but the city remains just as exciting. I no longer live there. I have become a visitor, with my palate refreshed and ready for new experiences. Researching and writing this book has been a hugely satisfying undertaking. I have learned so much and discovered many, many more of the city's secrets. London is a veritable kaleidoscope of images and stories, many of which are encapsulated in the buildings—the Tower of London, the Houses of Parliament, the busy streets and shops, the splendor of Royal London, Georgian terraces, neat little semi-detached houses, inns where Charles Dickens and Doctor Johnson rested a while before taking up their pens again. . . .

I must thank so many people involved in this exploration: the photographer, John, whose enthusiasm and energy was so infectious; J.P. Leventhal for believing we could achieve his dream; editors Laura Ross and Iris Bass for keeping our feet on the ground and making sure we did so; the diligent teams at both Playne Design and Playne Books for tremendous support, input, organization—and patience when my scatter-brained intoxication with this wonderful city needed to be channeled.

Thank you all . . . and may I propose a toast to London, to the thousand faces encapsulated here and the many more besides . . . to quote from the venerable Doctor Johnson once again: "Sir, when a man is tired of London, he is tired of life; for there is in London all that life can afford."

Gill Davies

6

AUTHOR'S NOTE

London is a huge city with many areas and divisions—geographical and political. The decision was made to use the postal codes as the 'boundaries' for each chapter as these encompass well-known, established zones such as Kensington. Moreover, no numbered postcode crosses the natural boundary of the river Thames (which also helped the photographer's schedule!). Eight new postcodes were created in the 1960s based on a system first introduced under Sir Rowland Hill in 1858. The postal codes in Central London—West Central (WC) and East Central (EC)—are numbered according to their centrality; the other sectors are numbered by assigning Number I to the district closest to the centre and allowing the rest of the numbers to follow alphabetically, according to the name of the location. (There are no London postal districts labeled NE or S and the television soap opera East Enders is set in the fictional postal district of E20.) Please note that EC includes the City of London, and SWI the City of Westminster.

While the buildings that have been photographed do cover a wide area of London, there are just a few postcode areas that have escaped the privilege of inclusion in this book, and the contents list reflects this.

All the photographs are new, taken specifically for this book, and so certain notable buildings have, unfortunately, had to be omitted because they were under scaffolding—such as Unilever House and the Royal Festival Hall. The titles used for the buildings may be the actual house names, but often they are of my own devising, in particular to avoid duplication when the address appears above. There are many mentions of ghosts. While the veracity of such apparitions may or may not be accepted, for reasons of space this has not been questioned or prefaced by doubts or explanations.

The Great Fire of 1666 impacted on so many buildings that, again for reasons of space, the date is often omitted, and sometimes it is referred to simply as 'the Fire.'

London has many ancient buildings and it has been quite a challenge to discover all the relevant information but it is amazing just how much is known and recorded. Nonetheless, certain dates and architects have proved elusive, despite vigorous research. I apologise for any such omissions and would welcome this information so that it may be included in future editions.

PHOTOGRAPHER'S NOTE

I remember my first visit to London very clearly. It was 1994; I'd just finished college and had come down to a studio in Soho to shoot some still lifes for a design agency. I went for a walk along Regent Street and I remember thinking, as I looked up at the buildings, that they must have been, by and large, the same buildings that my parents (both originally Londoners, who had died several years earlier) used to look up at, too. In that moment, it was as though the fiber of the buildings had drawn up all of the history and life that had unfolded in and around them, and the buildings themselves were gently resonating with it.

I made it a goal, whenever I took photographs here, to try and capture some of this energy, along with some of the spirit in which the buildings were originally designed and built. Just like people, some buildings have been loved and looked after whilst others have been the victims of neglect. Some will stand to a ripe old age and others will be torn down after only a few years, to be replaced by another cycle of change.

Within months of my first trip to this amazing capital I'd become a Londoner myself, and it has been my home ever since. London is great for that—no matter what your ethnic background or religious persuasion, if you decide to take up residence, you can call yourself a Londoner and nobody will question you about it; you're a member of the club.

I have really enjoyed working on this project—it has been the most satisfying and fulfilling job I have ever done. It has taken me to places in London that, in my twelve years of residency, I had never visited, and some that I'd never even heard of, but now I shall remember all of them, and if ever I need a change of career, I'm sure that I'll be able to find a job as a London cabbie!

During the course of this project, I traveled over two-and-a-half thousand miles on a borrowed I25cc Vespa (thanks Clare!) draped in all kinds of exotic photographic equipment. During this time I wore out three scooter tyres, one pair of boots, and the shutter in my wide-angle lens. I broke shutter release cables too numerous to mention. I picked up only two parking tickets. I lost a stone in weight. I was stopped and searched by the police under the Prevention of Terrorism Act three times. I plotted the position of every building to be shot on a nine-sheet London map. I wore the scooter's brake shoes down to the metal. I made countless lists of important things to do.

I should like to dedicate this book to my wife Katie, for without her constant support, love, and enthusiasm, I simply could not have taken on such a mammoth project. Whilst holding down her own very successful career, she still found the time and the energy to look after me and make me her priority.

I'd also like to thank Mark and Olpha Gibbon and Bob and Margaret O'Donnell for all their support and love. I'd like to thank Alan Simpson for firing my enthusiasm for photography in the first place, and providing answers to all my questions with a wry smile and a rare wit. Thanks must also go to Theo Cohen for well-timed and well-chosen words of encouragement and wisdom; Jenny, Lawrence, and Steve at Teamwork; and Paula Pell-Johnson at Linhof and Studio, for guiding me around the equipment needed for such a very technically challenging and demanding project. Thanks, too, to Clare Playne, Simon Hack, and Kieran Farnington of Playne Design and to David Playne of Playne Books for giving me the opportunity to work on such a fine project, and thanks to Gill Davies for such a superb piece of research and writing. Finally, a big thank-you to all the people who kindly provided access and gave the permission that enabled this book to be. It is greatly appreciated.

John Reynolds

TECHNICAL NOTE

The images were shot using a Phase One P25 digital back on an Alpa 12 SWA, with Schneider and Rodenstock digital lenses. The images were processed on an Apple G5 2.0ghz Dual processor using C1 Pro and Adobe Photoshop. It was all viewed on a Lacie electron blue IV CRT monitor with Gretag Macbeth calibration.

WEST LONDON (W)

London's 'west side story' begins in Mayfair and Soho and then runs along to Kensington, Paddington, Notting Hill, and Shepherds Bush; and thence to Chiswick, Hammersmith, and Ealing. Its central zone includes theatres, cinemas, and night clubs—plus the busiest shopping district.

Today, Mayfair is a most prestigious address. The area was originally developed in the early 1700s by wealthy landowners (the Grosvenors and the Berkeleys) but was, in fact, named after a notorious bawdy fair held here until the early 1700s, when it was finally banned because it invited, 'drunkenness, fornication, gaming and lewdness.'

Famous architect John Nash designed Regent Street in 1812 and, in doing so, divided the upmarket areas of Mayfair and St James's from rather sleazier Soho. The street's lovely arcades were designed to protect shoppers from the muddy, dung-filled roads.

Oxford Street was originally the main Roman route to Oxford, hence its name. By the I700s, it was part of the route along which prisoners were taken to Tyburn Gallows at Marble Arch.

Meanwhile, Soho grew apace on open fields through which many hunts rode, and acquired its name from the hunting call of 'Soe Hoe.' Charles Gerrard, Sir Francis Compton, and Richard Frith helped to develop the area in the late 1600s and have streets named after them.

Further west are the lush, green acres of Hyde Park, Kensington Gardens (with the Palace), Holland Park, and, beyond, the riverside village of Chiswick where Hogarth once lived.

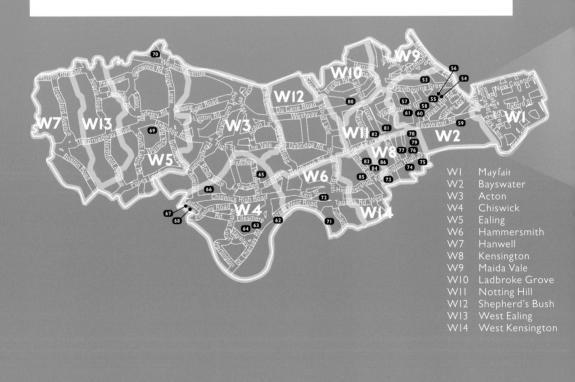

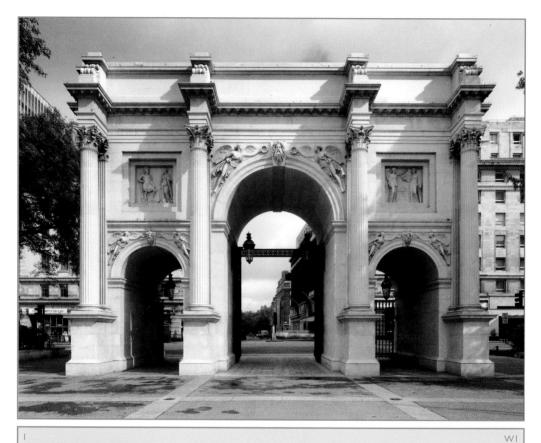

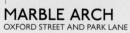

1828 JOHN NASH

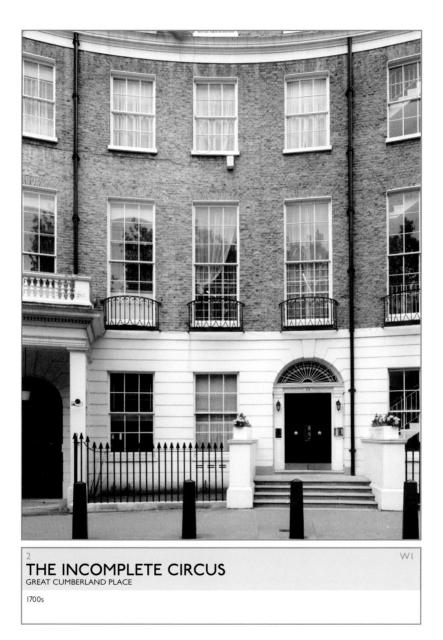

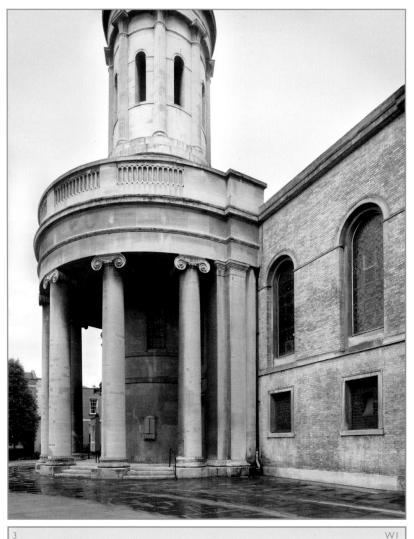

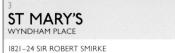

HOME TO THE BEATLES MONTAGU SQUARE

811 DAVID PORTE

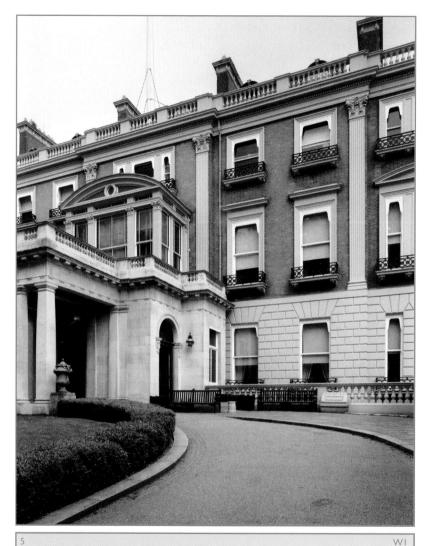

THE WALLACE COLLECTION HERTFORD HOUSE, MANCHESTER SQUARE

1776 DUKE OF MANCHESTER AND 1882 SIR RICHARD WALLACE

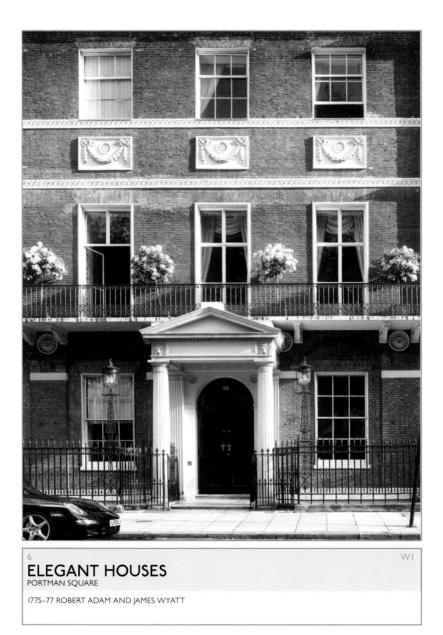

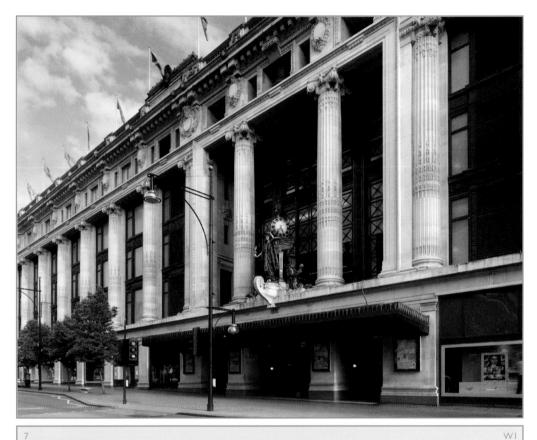

7 SELFRIDGES OXFORD STREET

1907–28 R. F. ATINSON (WITH DANIEL BURNHAM UNDER SIR JOHN BURNET)

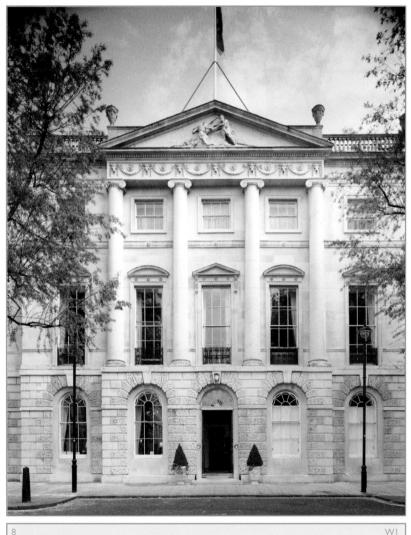

WI

STRATFORD HOUSE STRATFORD PLACE, OFF OXFORD STREET, FORMERLY DERBY HOUSE

C. 1773 RICHARD EDWIN 1909 G. H. JENKINS AND SIR CHARLES ALLOM

WI

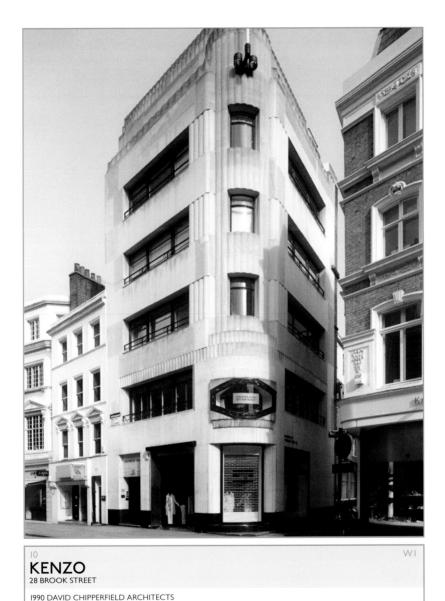

WEST LONDON (W)

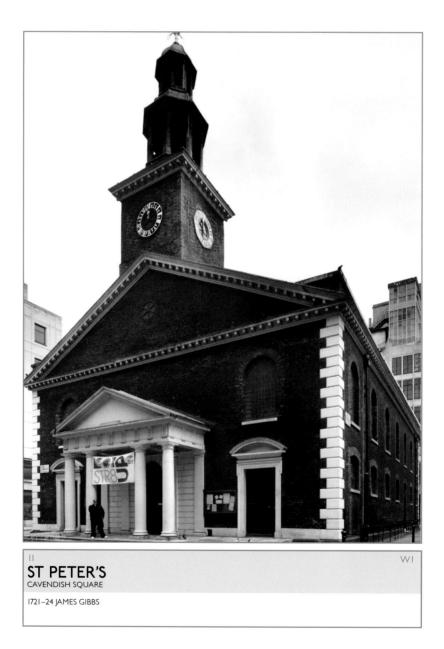

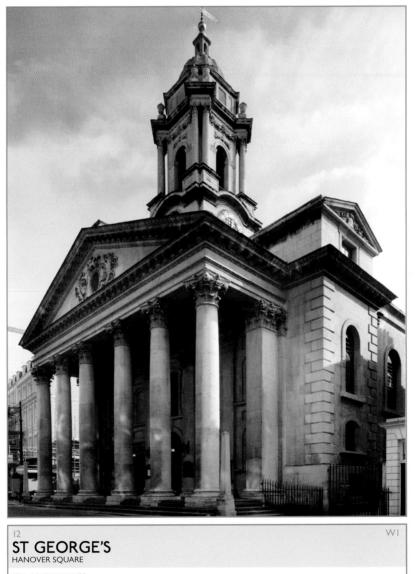

1721–24 JOHN JAMES

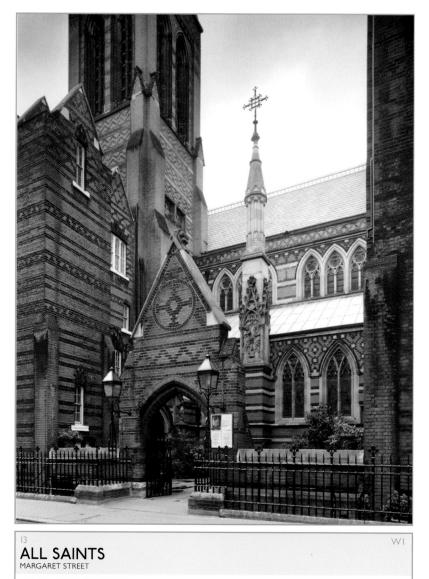

1849-59 WILLIAM BUTTERFIELD

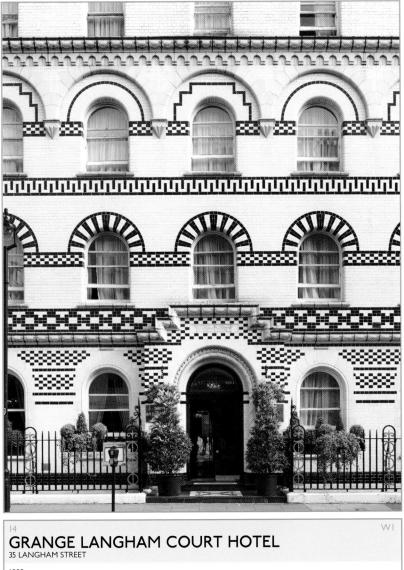

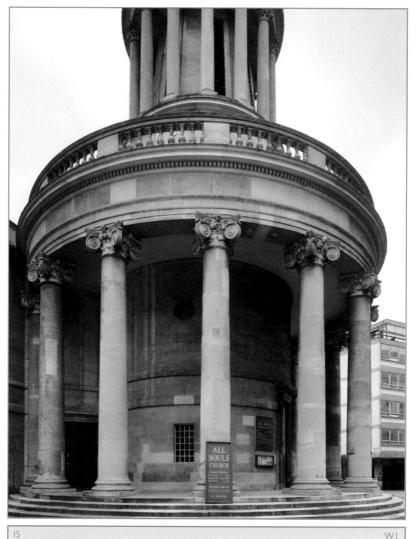

15 V ALL SOULS LANGHAM PLACE 1822–24 JOHN NASH, RESTORED AFTER WORLD WAR II

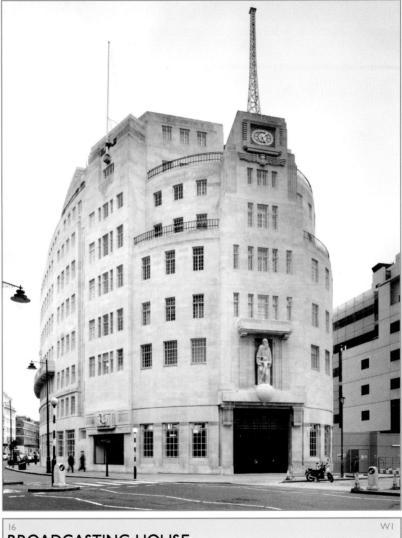

BROADCASTING HOUSE

1931 VAL MYERS AND WATSON-HART

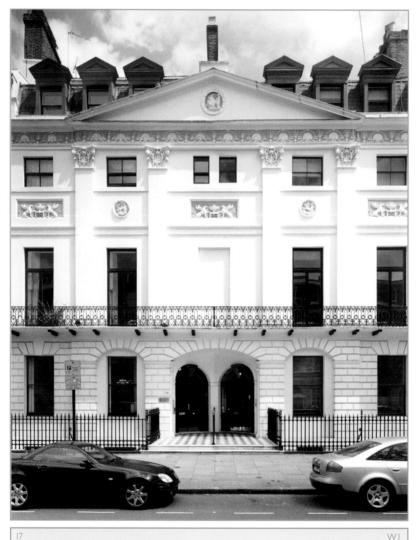

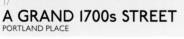

1776-80 JAMES ADAM

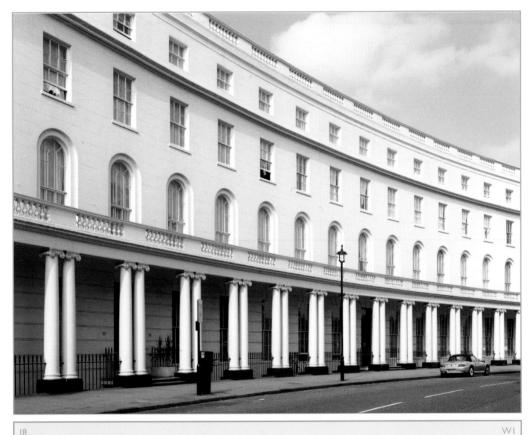

18 PARK CRESCENT REGENT'S PARK

1812 JOHN NASH

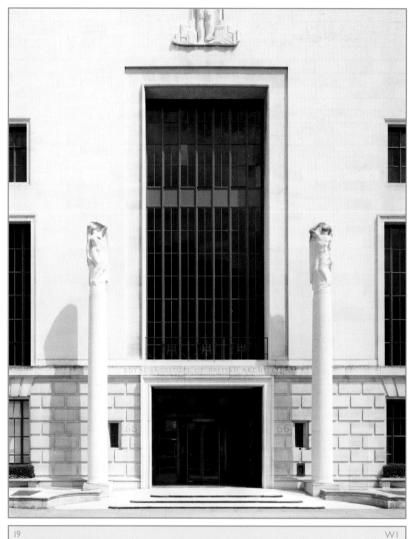

ROYAL INSTITUTE OF BRITISH ARCHITECTS 66 PORTLAND PLACE

1932–34 GREY WORNUM

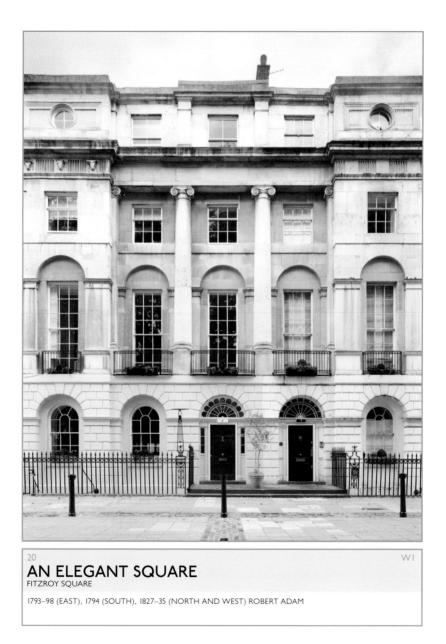

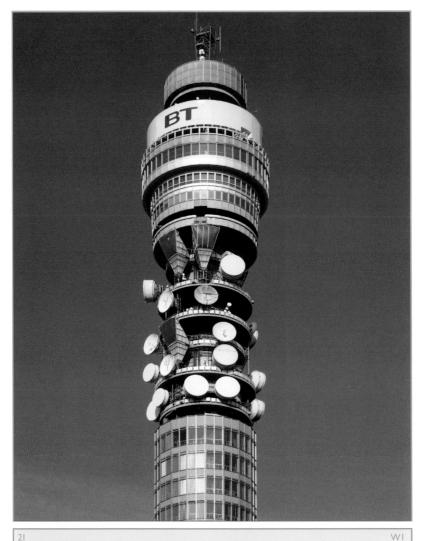

THE BRITISH TELECOM TOWER

1963-66 ARCHITECTS' SECTION OF THE MINISTRY OF WORKS: MAIN ARCHITECT ERIC BEDFORD

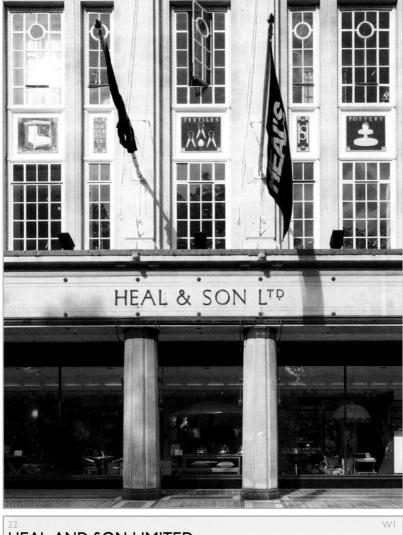

HEAL AND SON LIMITED 196 TOTTENHAM COURT ROAD

1916 SMITH AND BREWER

23 COLVILLE PLACE OFF CHARLOTTE STREET

 $\vee \mid$

1766

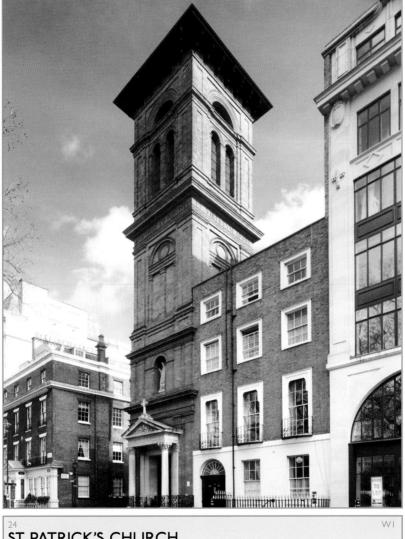

ST PATRICK'S CHURCH

1891–1903 JOHN KELLY AND BIRCHALL

25 WI SOHO THEATRE 21 DEAN STREET 1996-2000 PAXTON LOCHER ARCHITECTS

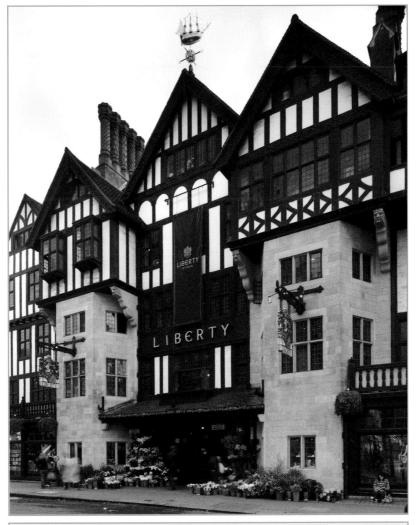

 \mathbb{V}

LIBERTY'S GREAT MARLBOROUGH STREET AND REGENT STREET

1924 AND 1926 E. T. AND S. E. HALL

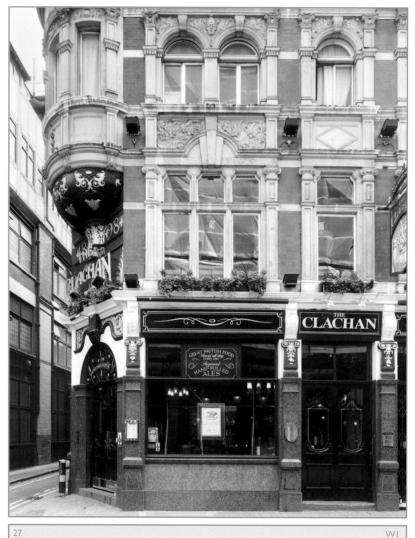

27 **THE CLACHAN** 34 KINGLY STREET; FORMERLY THE BRICKLAYERS ARMS 1898

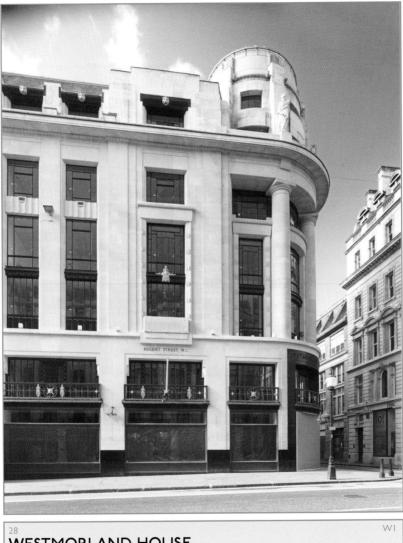

WESTMORLAND HOUSE

1920–25 SIR JOHN BURNET FRIAS, RSA, RA, THOMAS TAIT

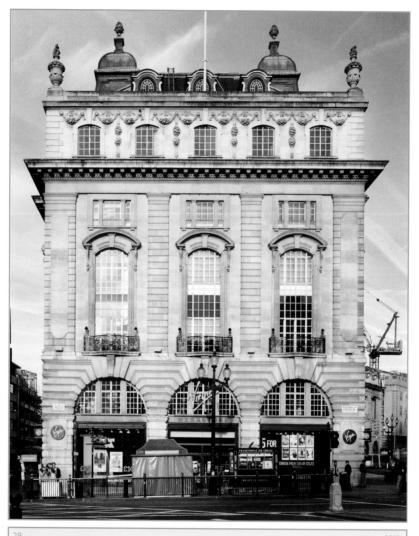

VIRGIN MEGASTORE PICCADILLY CIRCUS; FORMERLY SWAN AND EDGAR

V V I

1910-20 EXTERIORS SIR REGINALD BLOMFIELD; 2003 COLLET & BURGER

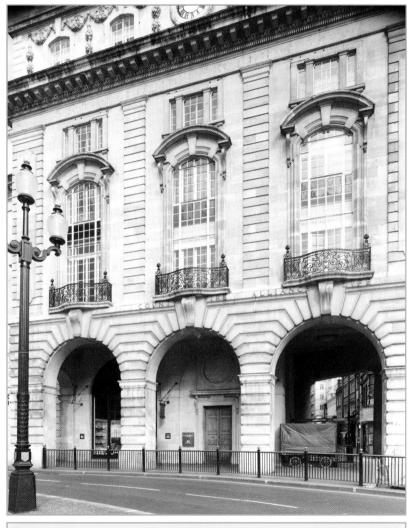

30 RUSTICATED GRANDEUR 50-52 PICCADILLY CIRCUS

1906 R. NORMAN SHAW

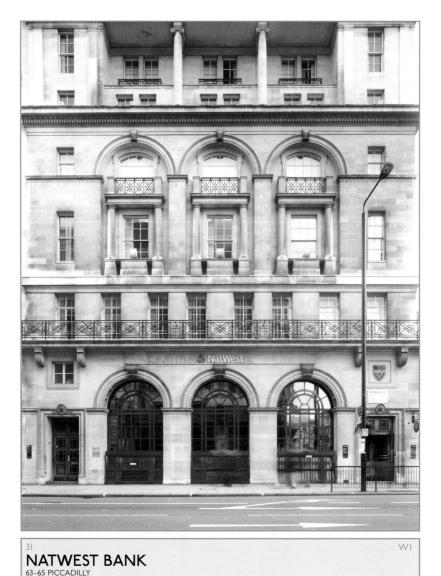

1922–23 WILLIAM CURTIS GREEN

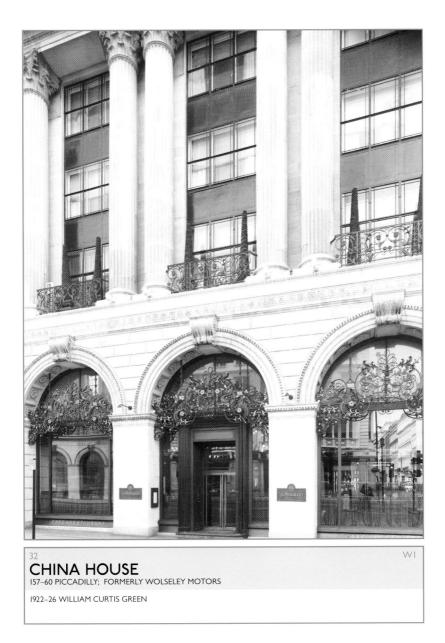

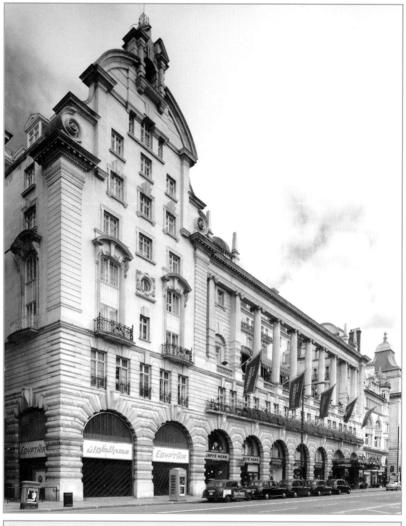

 \mathbb{V}

LE MERIDIEN PICCADILLY; FORMERLY PICCADILLY HOTEL

1905–08 R. NORMAN SHAW

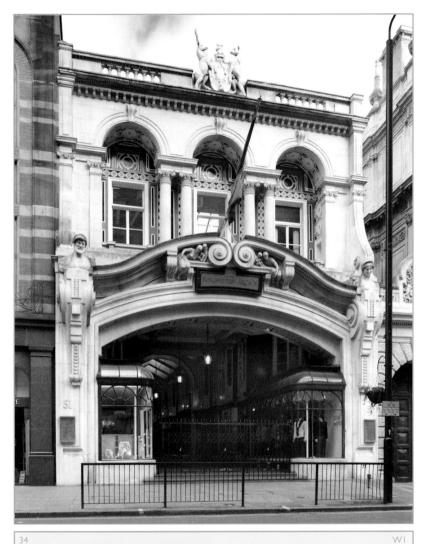

BURLINGTON ARCADE

1815-19 SAMUEL WARE; 1911 AND 1931 (END FAÇADES AND ENTRANCE) E. BERESFORD PITE

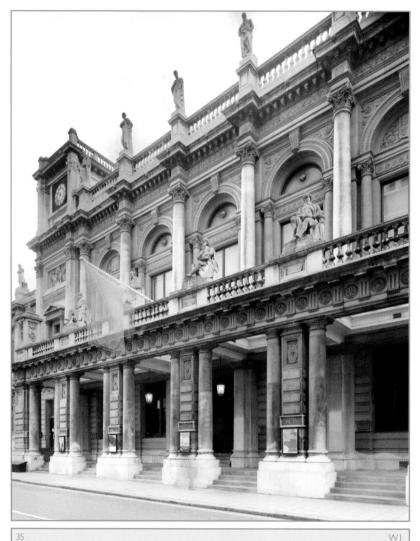

35 THE ROYAL ACADEMY OF ARTS 6 BURLINGTON GARDENS; FORMERLY BURLINGTON HOUSE AND MUSEUM OF MANKIND

1866-69 SIR JAMES PENNETHORNE; 2004-7 MICHAEL HOPKINS AND PARTNERS

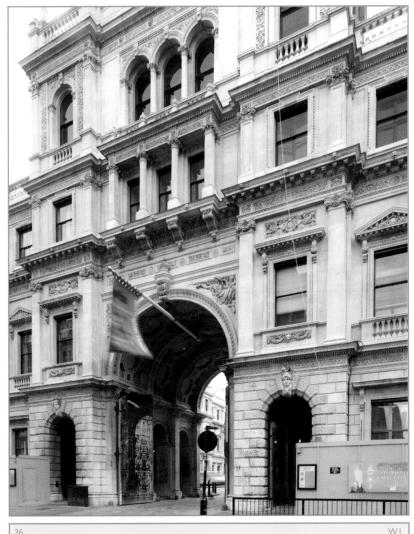

BURLINGTON HOUSE

1664–65 SIR JOHN DENHAM, 17005–1800S EXTENDED AND REMODELLED COLEN CAMPBELL, BANKS AND BARRY, AND OTHERS, 1991 FOSTER ASSOCIATES

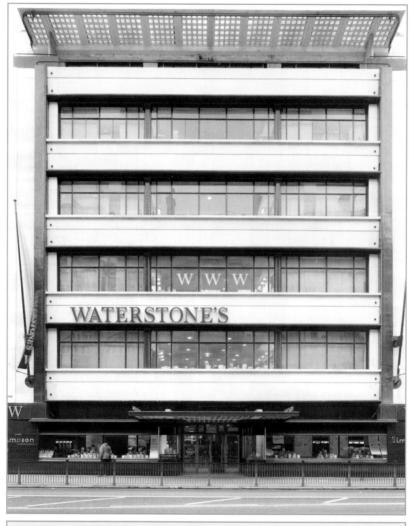

WI

203 PICCADILLY; FORMERLY SIMPSON'S OF PICCADILLY

1935-36 JOSEPH EMBERTON; 1960S ARCHITECTS CO-PARTNERSHIP

WATERSTONE'S

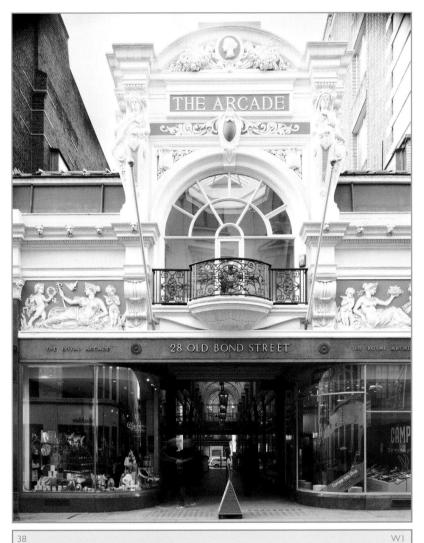

THE ROYAL ARCADE CONNECTING 28 OLD BOND STREET TO 12 ALBEMARLE STREET

1879

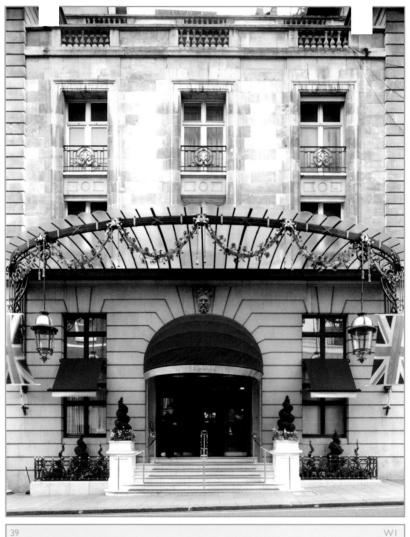

1906 MEWÈS AND DAVIS (INTERIORS EXECUTED BY WARING AND GILLOW)

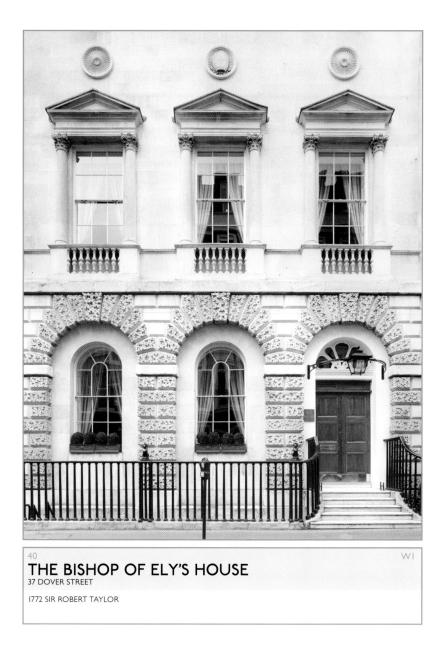

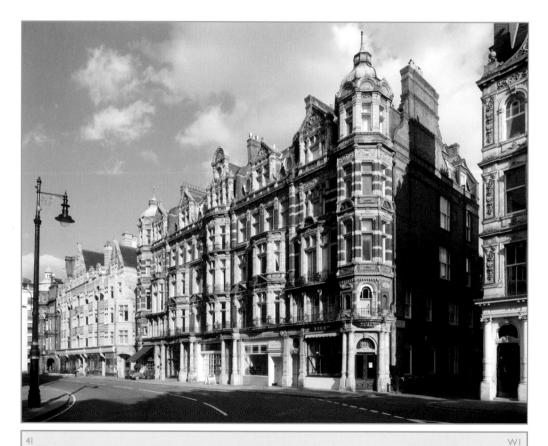

HOUSES WITH ORNATE TILING

1886 J. T. SMITH

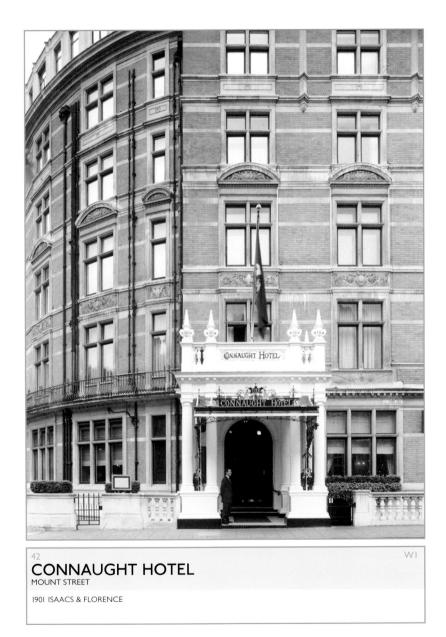

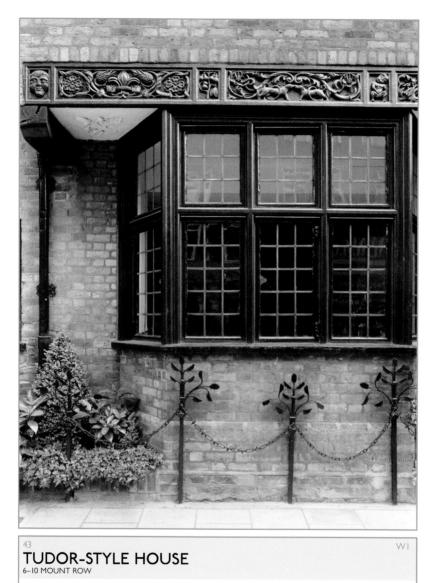

1929-31 FREDERICK ETCHELLS

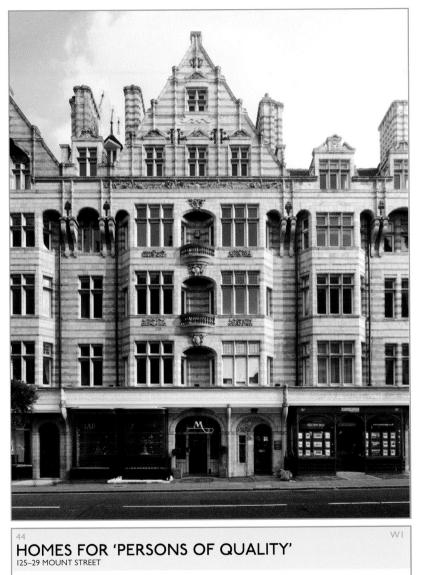

1889 W. H. POWELL

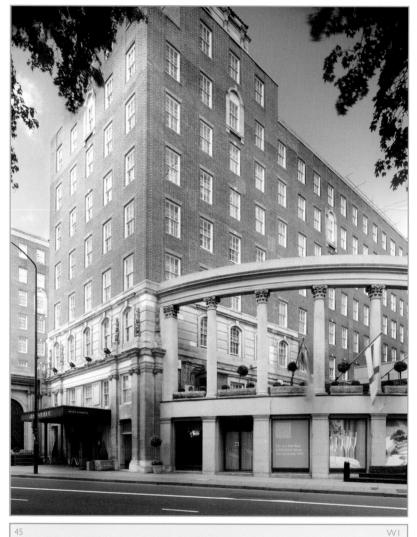

1926-28 WIMPERIS, SIMPSON & GUTHRIE, CONSULTANT SIR EDWARD LUTYENS

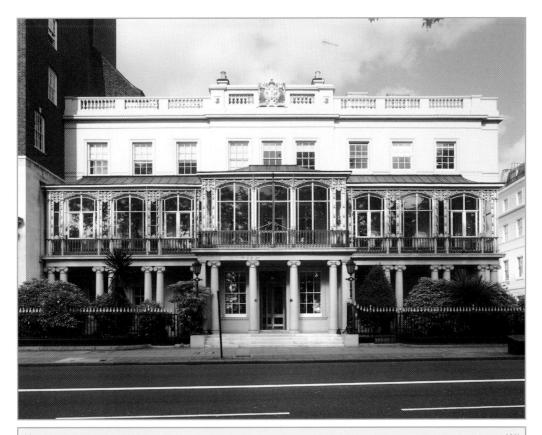

DUDLEY HOUSE

1824-28 WILLIAM ATKINSON

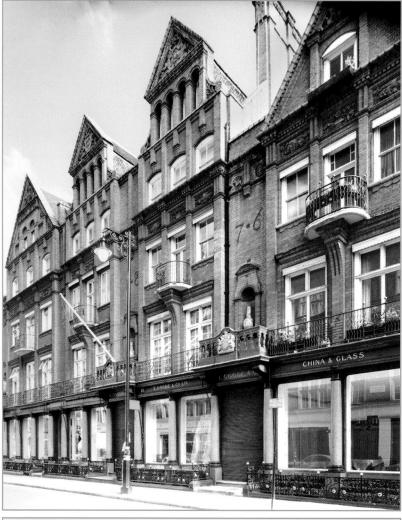

47 **ROYAL HOMES** SOUTH AUDLEY STREET

1845 MANY INCLUDING EDWARD SHEPHERD

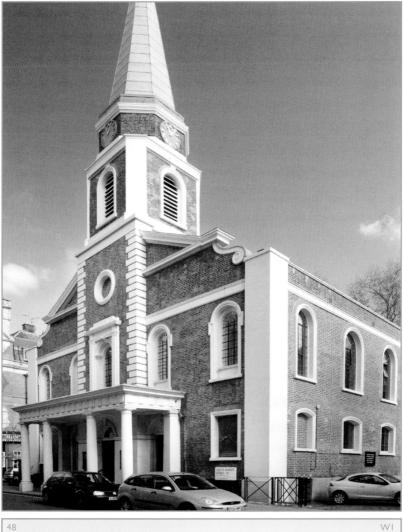

1739 BENJAMIN TIMBRELL

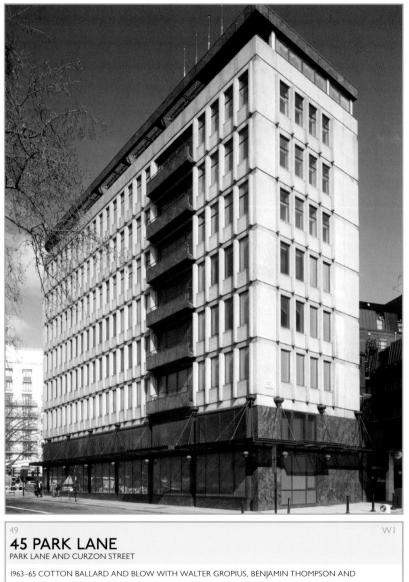

LLEWELYN DAVIES AND WEEKS

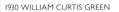

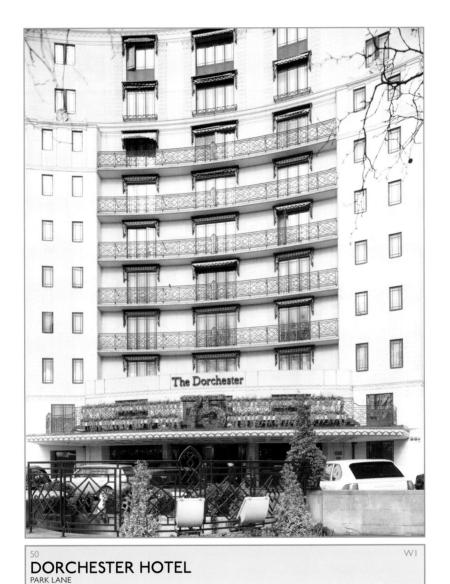

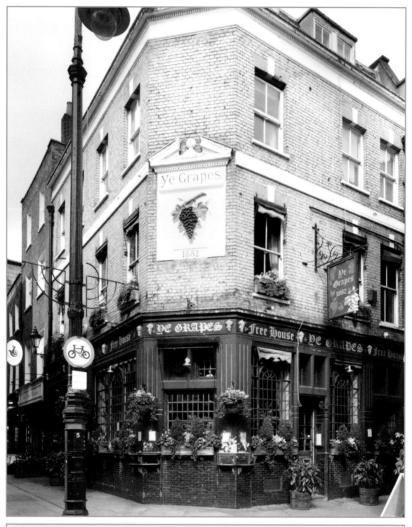

WI

SHEPHERD MARKET CURZON STREET, MAYFAIR

1735 EDWARD SHEPHERD

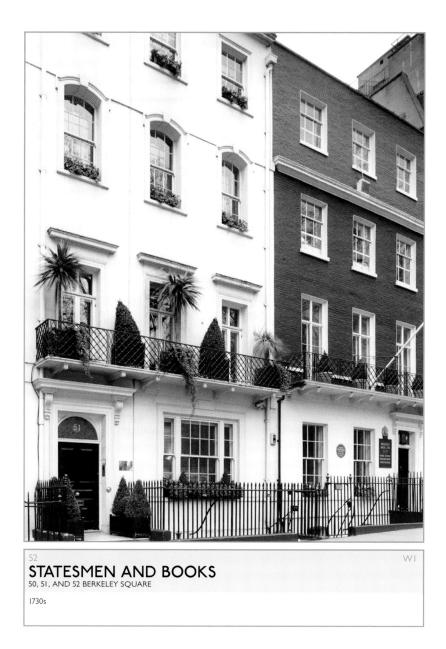

W2

53 **ST MARY** PADDINGTON GREEN

1788–91 JOHN PLAW; 1970s RESTORED BY ERITH AND TERRY

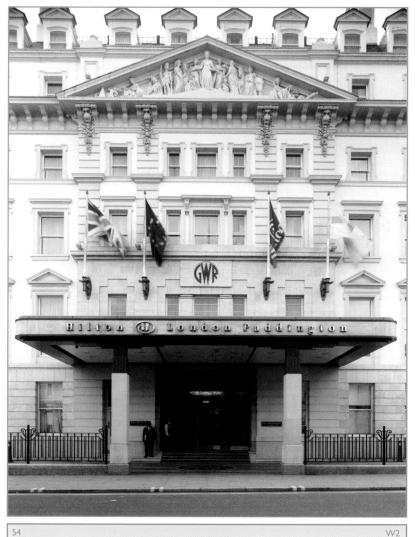

HILTON LONDON METROPOLE 146 PRAED STREET; FORMERLY GREAT WESTERN ROYAL HOTEL

1854 PHILIP CHARLES HARDWICK; 2001-02 RESTORED MUIRGOLD LIMITED

55 **TYBURNIA** INCLUDING CONNAUGHT SQUARE, CONNAUGHT STREET, HYDE PARK SQUARE, WESTBOURNE TERRACE

1828–35 S. P. COCKERELL AND GEORGE GUTCH

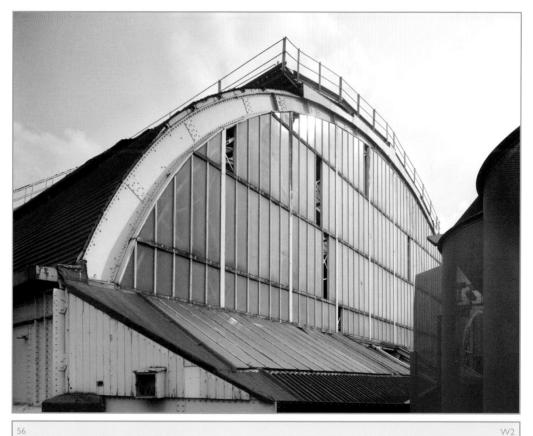

56 PADDINGTON STATION EASTBOURNE TERRACE AND PRAED STREET

1850-54 ISAMBARD KINGDOM BRUNEL, MATTHEW DIGBY WYATT, OWEN JONES

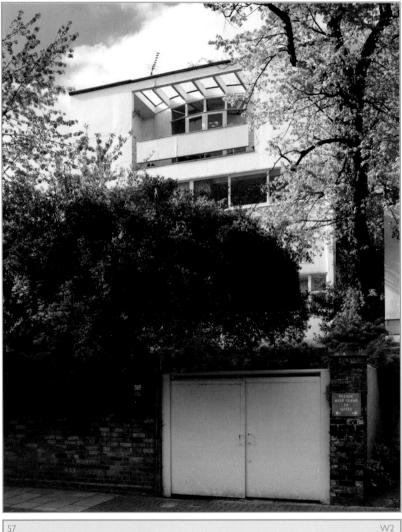

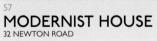

1938 SIR DENYS LASDUN

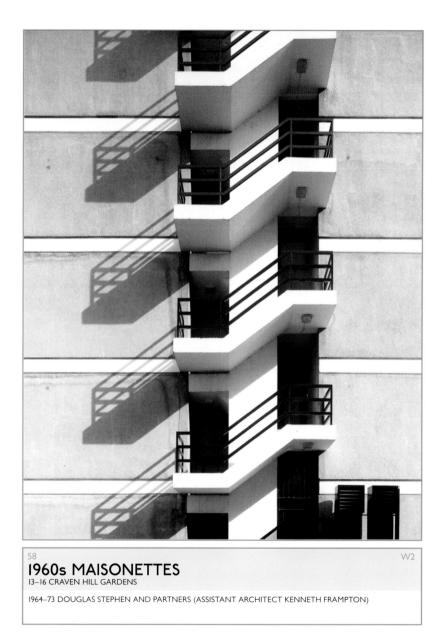

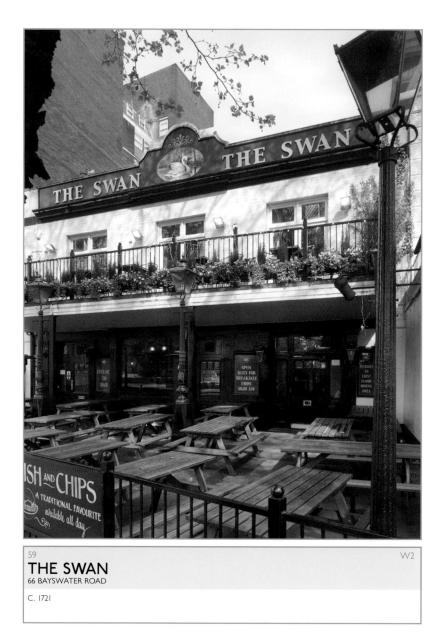

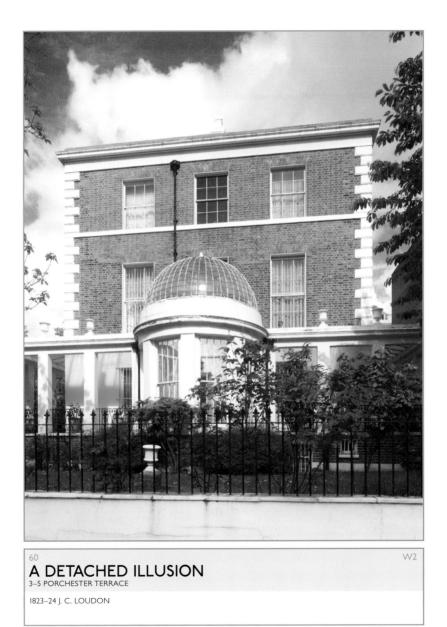

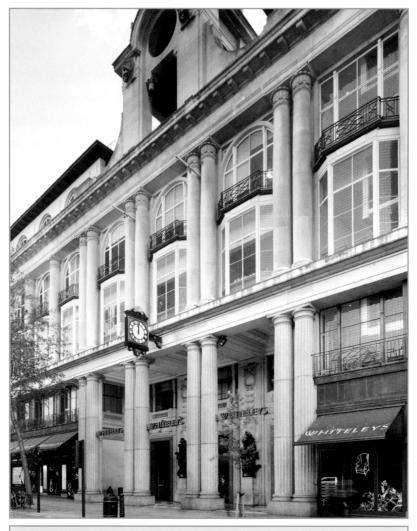

61 WHITELEYS DEPARTMENT STORE, QUEENSWAY

1908-12, 1989 BELCHER AND JOASS BUILDING DESIGN PARTNERSHIP

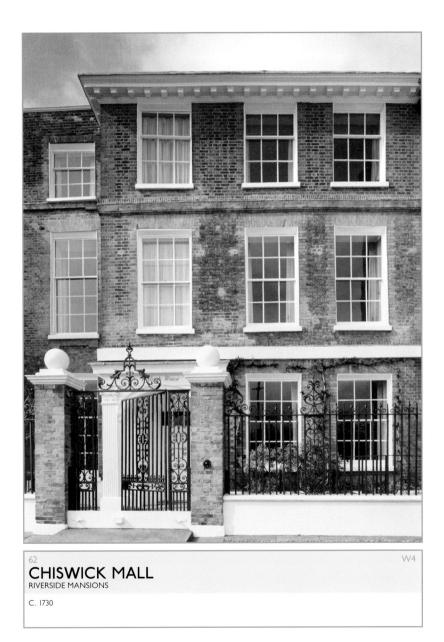

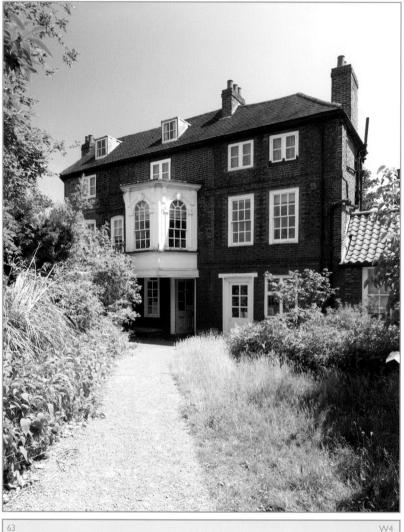

HOGARTH'S HOUSE HOGARTH LANE, GREAT WEST ROAD, CHISWICK

C. EARLY 1700s

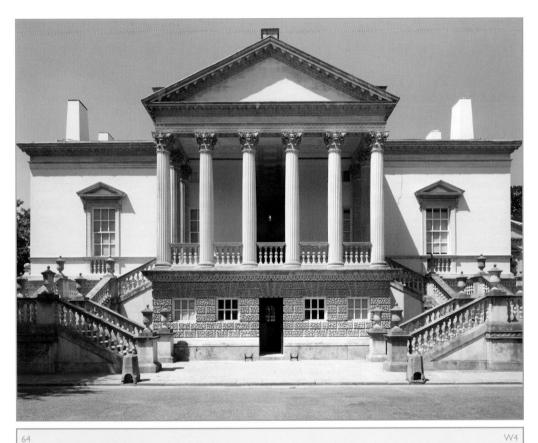

CHISWICK HOUSE HOGARTH LANE AND BURLINGTON LANE

1725-29 LORD BURLINGTON

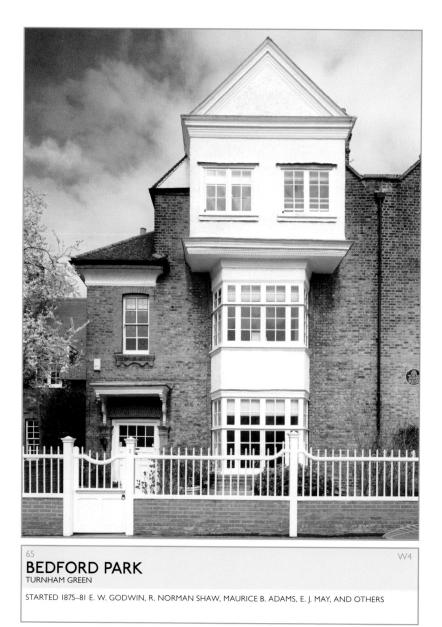

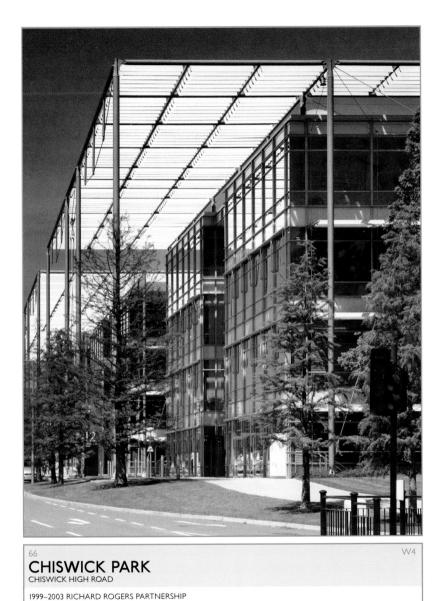

WEST LONDON (W) 77

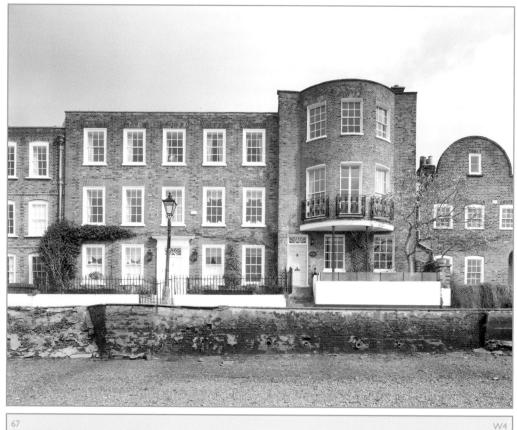

67 **RIVERSIDE HOUSES** STRAND ON THE GREEN, CHISWICK

1700s

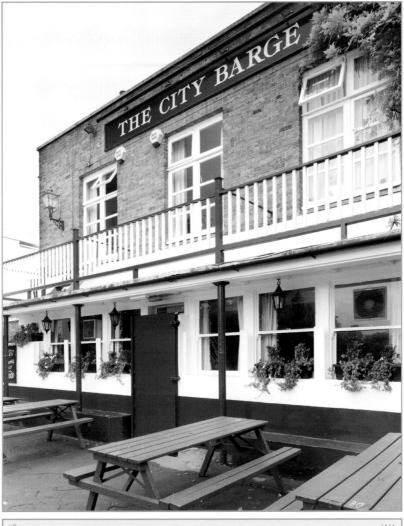

68 THE CITY BARGE 27 STRAND ON THE GREEN, CHISWICK

FROM 1484; REBUILT 1940

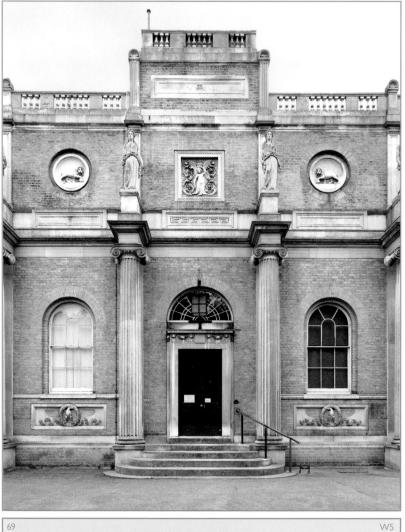

PITSHANGER MANOR MUSEUM

1801–03 SIR JOHN SOANE; 1986 RESTORED JOHN WIBBERLY AND IAN BRISTOW

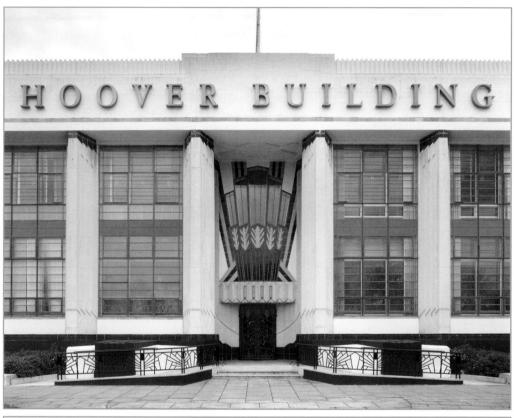

70 HOOVER BUILDING WESTERN AVENUE (NOW TESCO)

1932–35 WALLIS GILBERT AND PARTNERS

W5

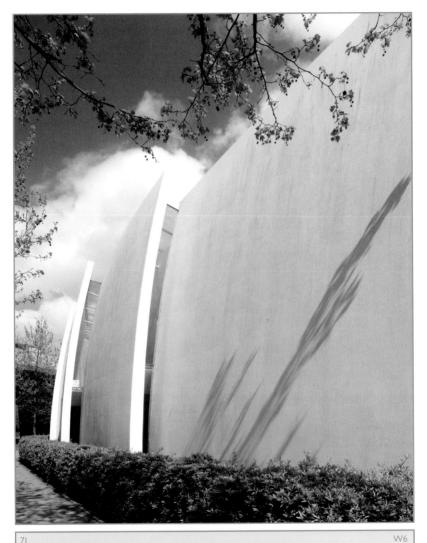

HAMMERSMITH SURGERY

1996–2000 GUY GREENFIELD ARCHITECTS

72 THE ARK HAMMERSMITH FLYOVER

1988–92 RALPH ERSKINE

W6

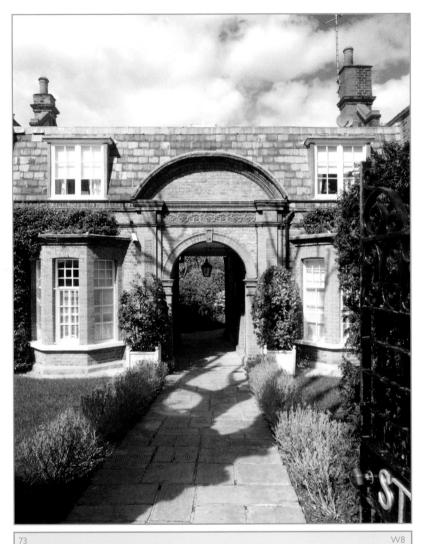

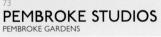

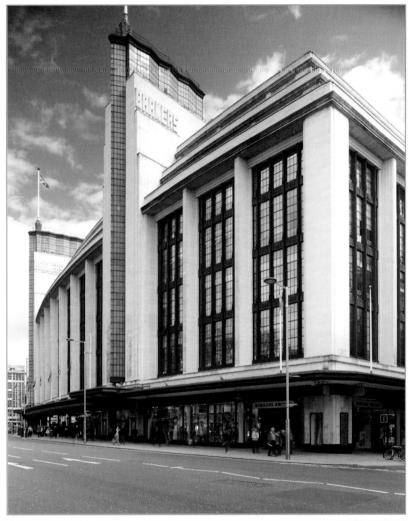

74 W8
BENETTON
KENSINGTON HIGH STREET, FORMERLY BARKERS DEPARTMENT STORE
1933-35 P. E. CULVERHOUSE

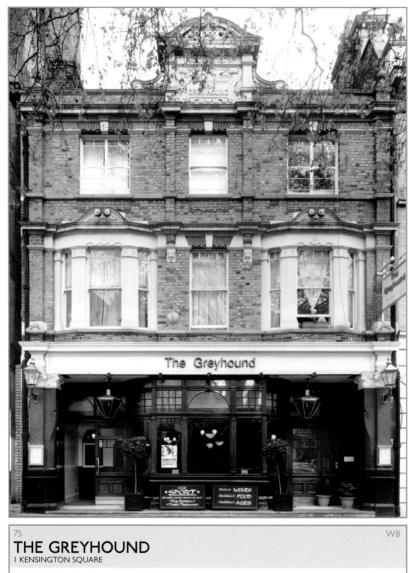

1890s; 1979

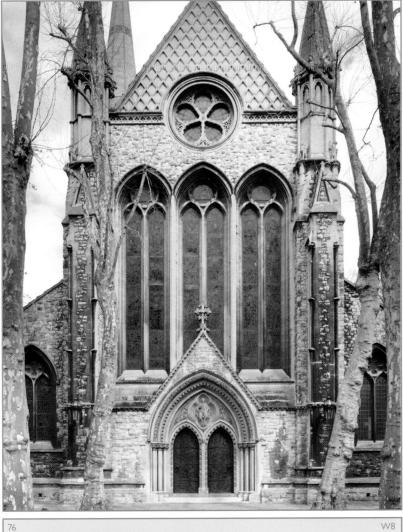

1869–72 SIR GEORGE GILBERT SCOTT

ST MARY ABBOTS

KENSINGTON HIGH STREET; KENSINGTON CHURCH STREET

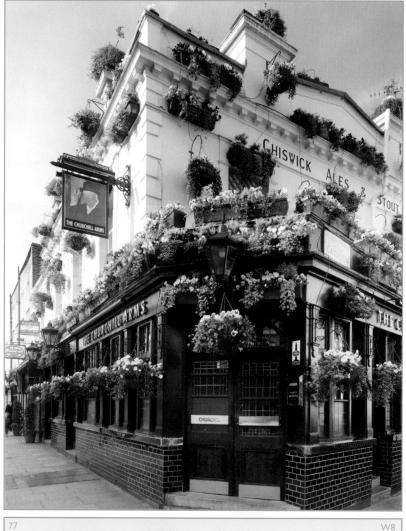

THE CHURCHILL ARMS

C. 1870

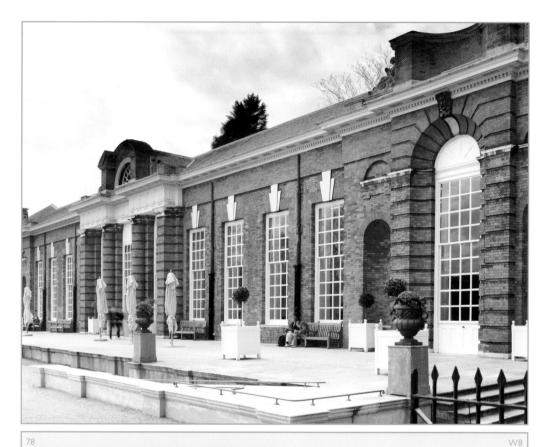

KENSINGTON PALACE ORANGERY THE BROAD WALK, KENSINGTON GARDENS

1695–1704 NICHOLAS HAWKSMOOR, SIR CHRISTOPHER WREN AND JOHN VANBURGH

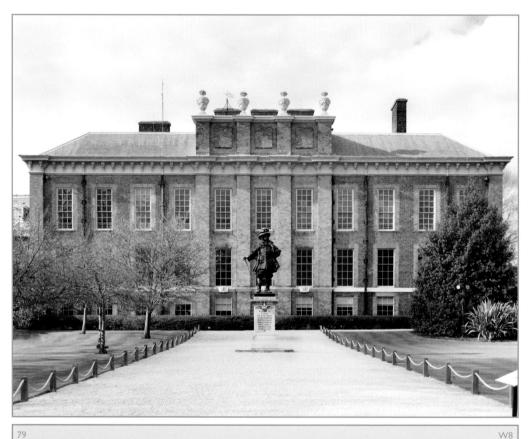

79 KENSINGTON PALACE THE BROAD WALK, KENSINGTON GARDENS

1661–1702 SIR CHRISTOPHER WREN, NICHOLAS HAWKSMOOR, WILLIAM KENT, AND (POSSIBLY) THOMAS RIPLEY

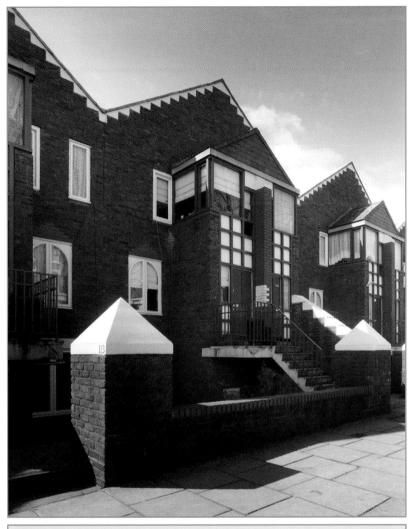

W10

80 HOUSES AND FLATS KENSINGTON HOUSE TRUST, 103–123 ST. MARK'S ROAD

1975-80 JEREMY DIXON

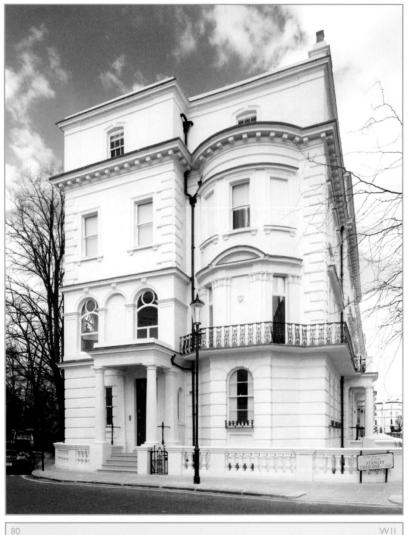

WII

LADBROKE ESTATE BOUNDED BY KENSINGTON PARK ROAD, CLARENDON ROAD, CORNWALL CRESCENT, AND HOLLAND PARK AVENUE

1850 THOMAS ALLOM

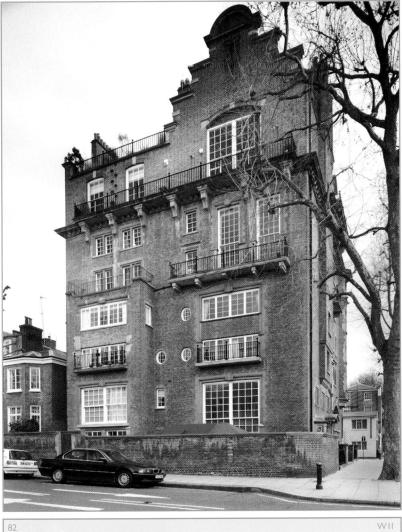

LANSDOWNE HOUSE

1904 H. FLOCKHART

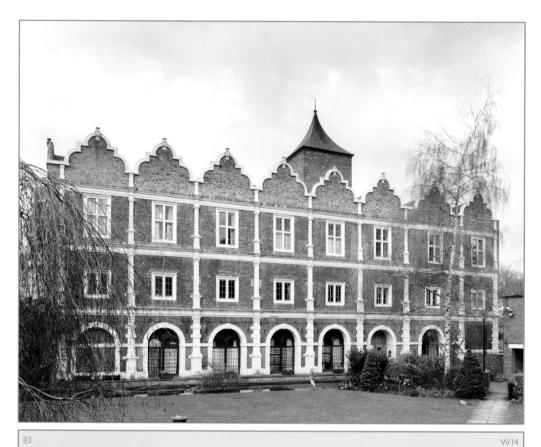

HOLLAND HOUSE

1606-07 JOHN THORPE (PROBABLY); STONE GATEWAY INIGO JONES

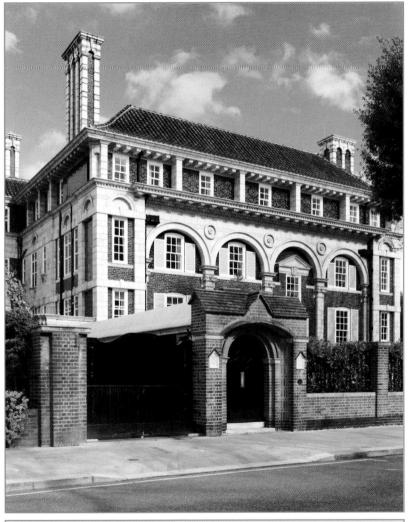

W14

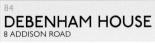

1905–07 HALSEY RICARDO

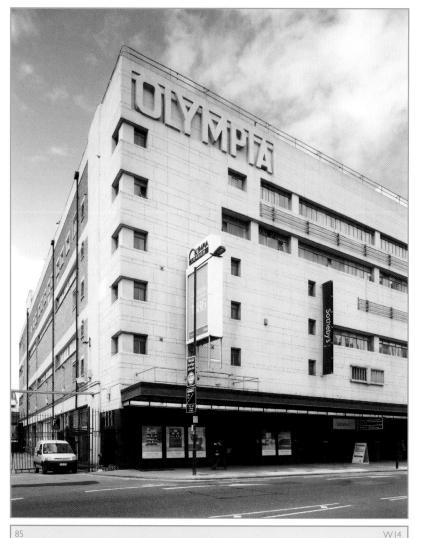

OLYMPIA EXHIBITION HALL

1930 FAÇADE JOSEPH EMBERTON

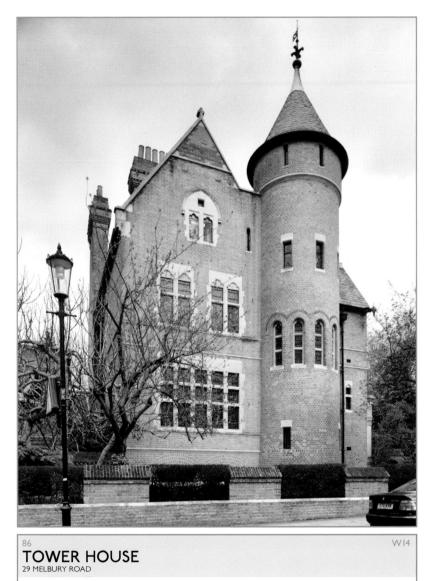

1876-81 WILLIAM BURGES

WEST CENTRAL LONDON (WC)

Here are long straight roads, dotted with many neat green squares and tangled alleys and lanes that weave an intricate pattern of contrasts on the map.

This section travels from the fringes of Tottenham Court Road south to Trafalgar Square, with its pigeons and Nelson's Column, and continues to the Victoria Embankment—built for 'trains and drains' but which created new land and gardens beside the Thames when London's sewage systems arrived in 1870.

Beginning immediately south of St Pancras and Kings Cross stations, one threads through Bloomsbury, rich with literary associations, including the Bloomsbury Group—writers, philosophers, and artists who gathered here in the early 1900s.

The university quarter includes University College in Gower Street, where dead philosopher Jeremy Ben-

tham still sits in the college lobby: his clothed skeleton is on display here, as requested in his will.

Next comes the massive grandeur of the British Museum, the Elgin Marbles and Egyptian mummies among its many treasures.

In Lincoln's Inn Fields, lawyers learn their skills, while the Inns of Court at Gray's Inn bustle with barristers. Meanwhile, the curving sweep of High Holborn, once a publishing domain, runs close to the division of WCI and WC2.

Drury Lane leads off from here, its historic eponymous theatre the place where pretty Nell Gwynn caught the eye of Charles II and, in St Martin's Theatre, Agatha Christie's *The Mousetrap* is still being performed in a run of over fifty years. A little further west is Covent Garden—with its famous market and opera house.

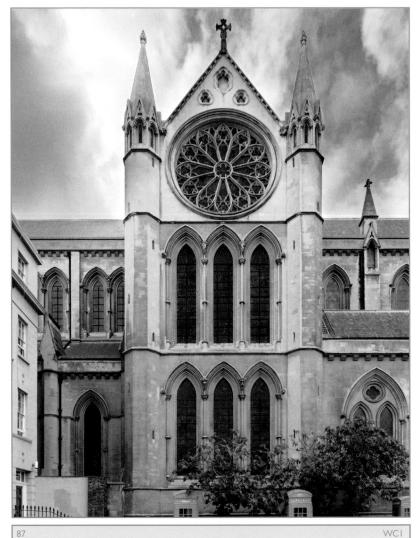

UNIVERSITY CHURCH OF CHRIST THE KING

1853 RAPHAEL BRANDON

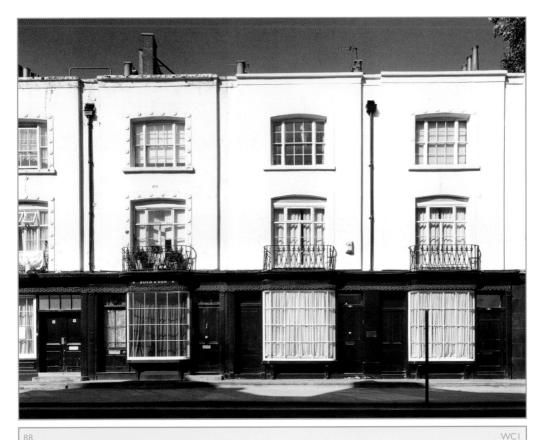

88 BOW-FRONTED SHOPS WOBURN WALK (OFF DUKE'S ROAD)

1822 THOMAS CUBITT

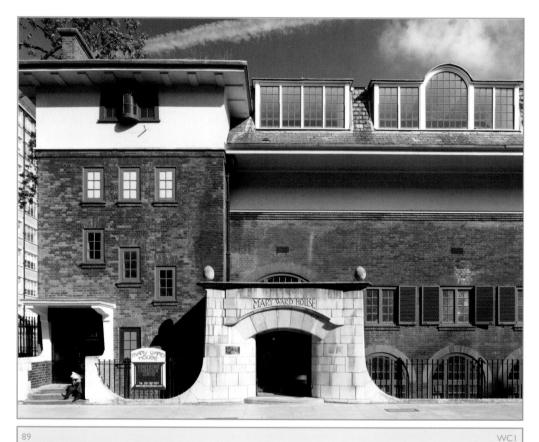

89 MARY WARD HOUSE TAVISTOCK PLACE

1895-98 SMITH AND BREWER

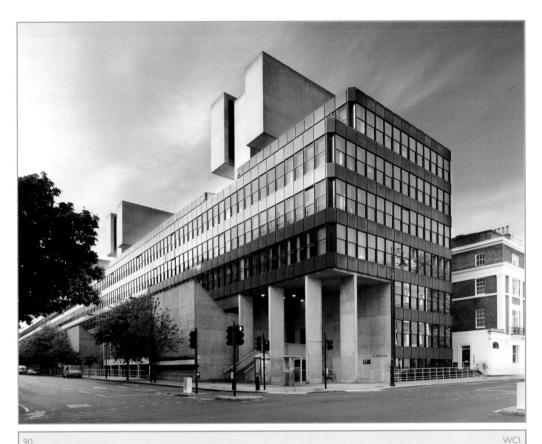

90 INSTITUTE OF EDUCATION UNIVERSITY OF LONDON, BEDFORD WAY

1975-79 SIR DENYS LASDUN AND PARTNERS

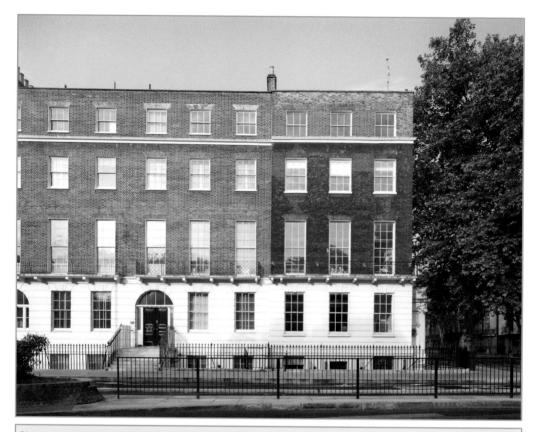

91 LONDON'S LARGEST SQUARE RUSSELL SQUARE

1800 JAMES BURTON, HUMPHREY REPTON

WCI

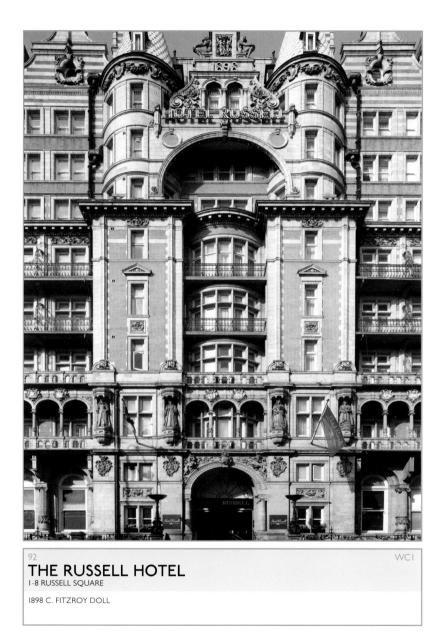

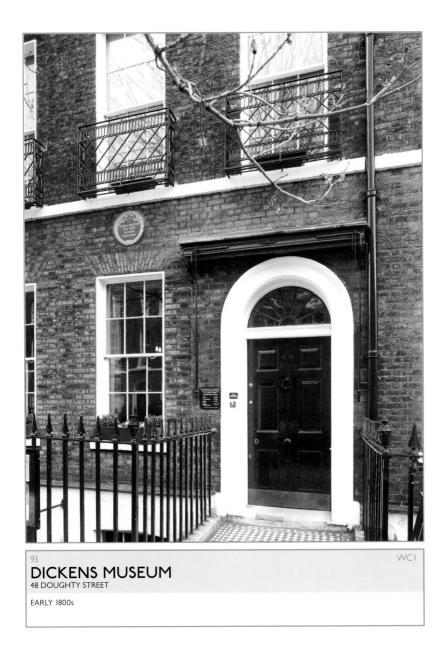

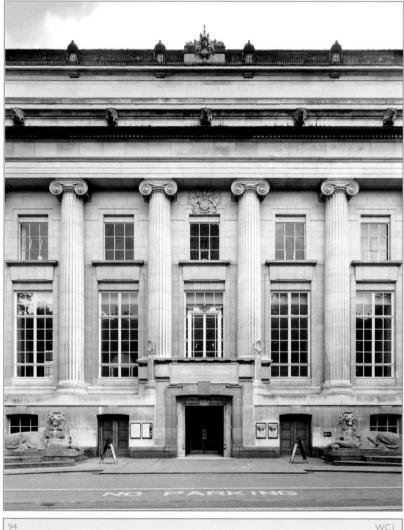

WCI

EDWARD VII GALLERIES MONTAGUE PLACE

1904-11 SIR JOHN BURNET

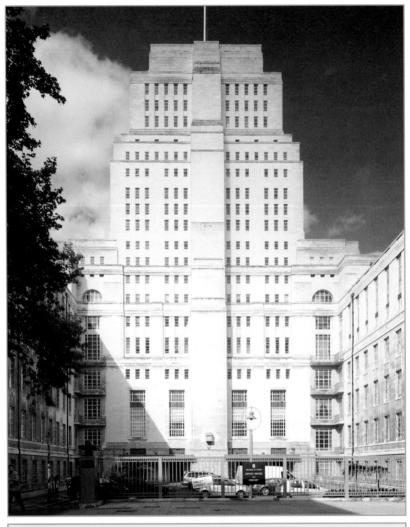

WCI

95 SENATE HOUSE MALET STREET AND MONTAGUE PLACE

1932-37 CHARLES HOLDEN

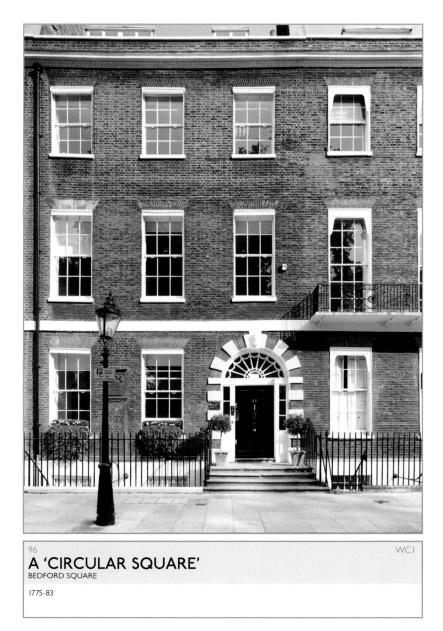

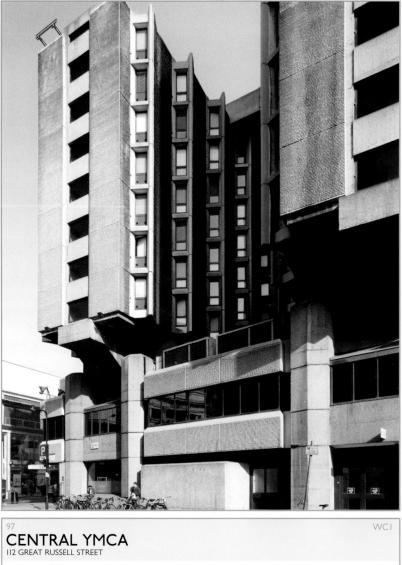

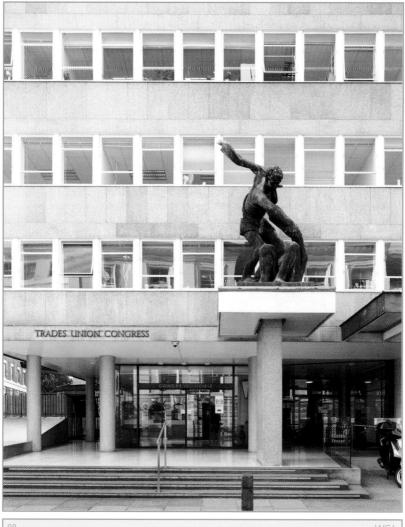

98 CONGRESS HOUSE GREAT RUSSELL STREET

1953-60 DAVID DU ROI ABERDEEN

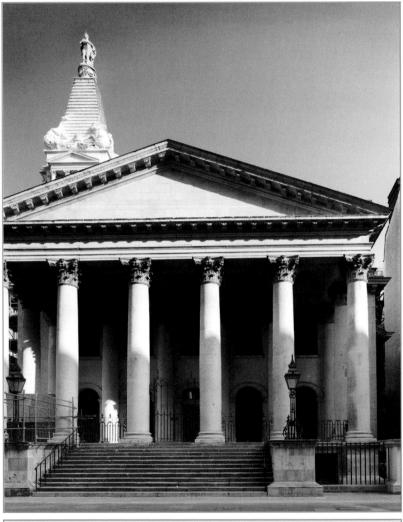

WCI

99 ST GEORGE BLOOMSBURY WAY

1716-31 NICHOLAS HAWKSMOOR

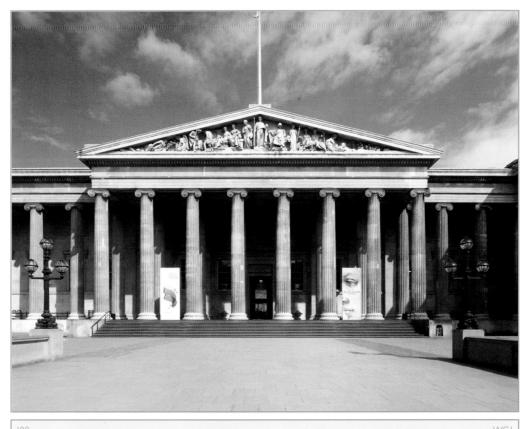

BRITISH MUSEUM

1823-47 SIR ROBERT SMIRKE

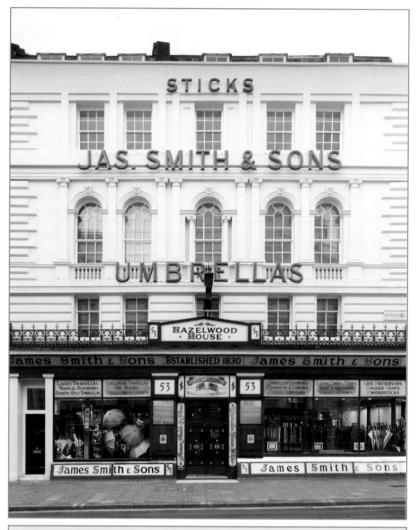

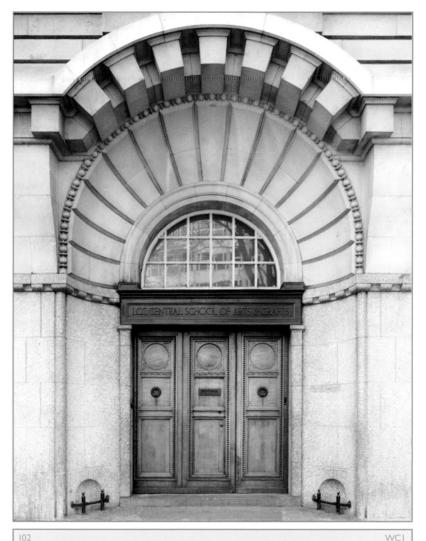

CENTRAL SCHOOL OF ARTS AND CRAFTS SOUTHAMPTON ROW

1906 L. C. ARCHITECTS DEPARTMENT

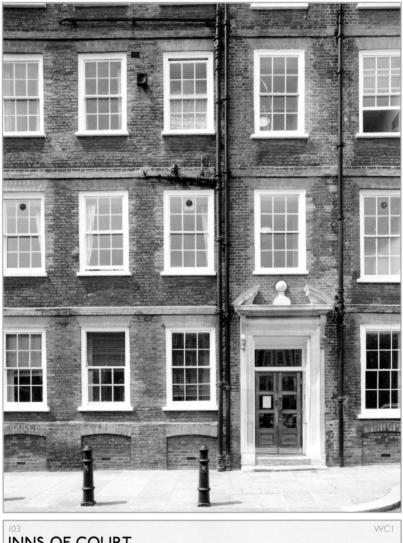

INNS OF COURT

1678-88

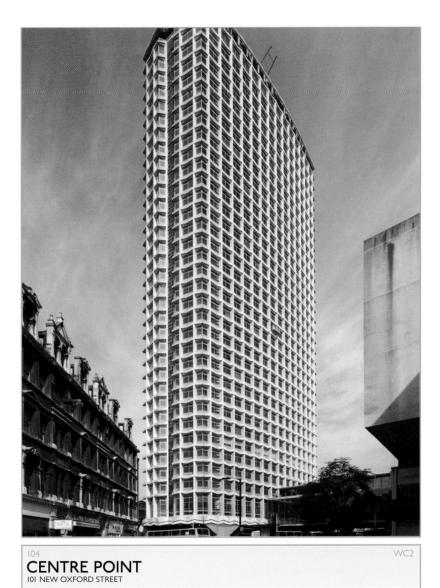

1963-67 RICHARD SEIFERT AND PARTNERS

WEST CENTRAL LONDON (WC) II7

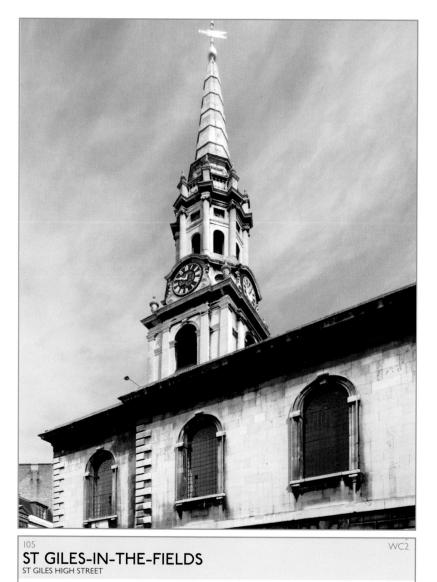

1731-33 HENRY FLITCROFT

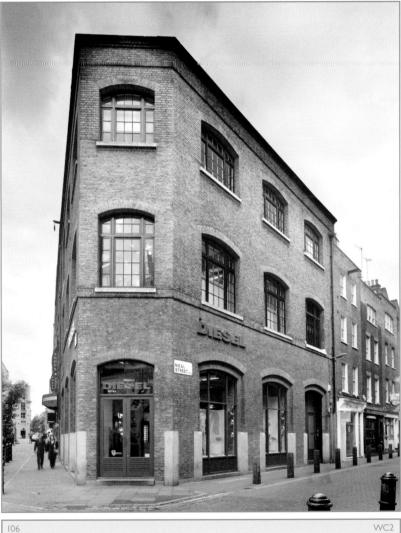

WAREHOUSES NEAL STREET, EARLHAM STREET, SHELTON STREET

C. 1850

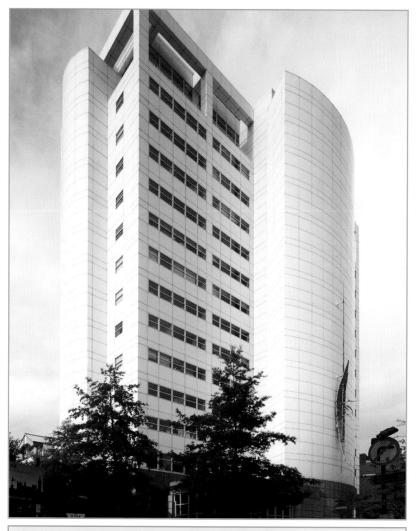

ORION HOUSE UPPER ST MARTIN'S LANE; FORMERLY THORN HOUSE WC2

1957-59 SIR BASIL SPENCE AND PARTNERS; 1990 RHWL PARTNERSHIP ARCHITECTS

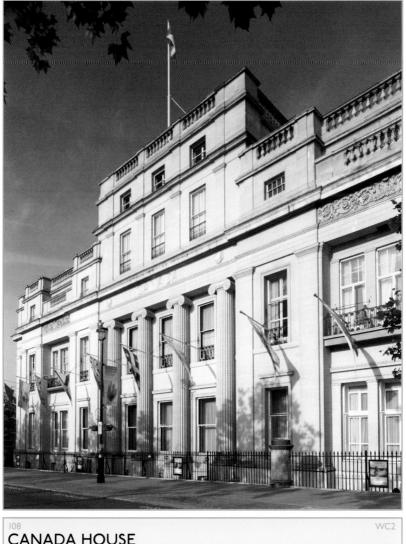

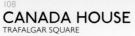

1824–27 SIR ROBERT SMIRKE

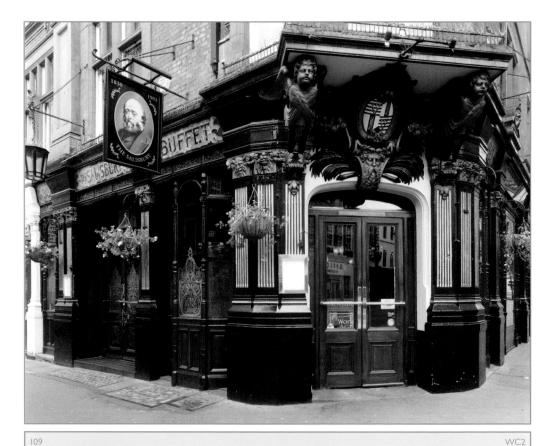

THE SALISBURY ST MARTIN'S LANE; PREVIOUSLY THE COACH AND HORSES AND BEN CAUNT'S HEAD

1840s; 1892

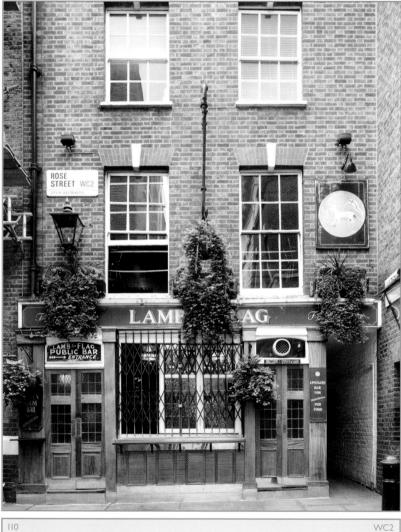

LAMB AND FLAG

1500s; 1623

WEST CENTRAL LONDON (WC) 123

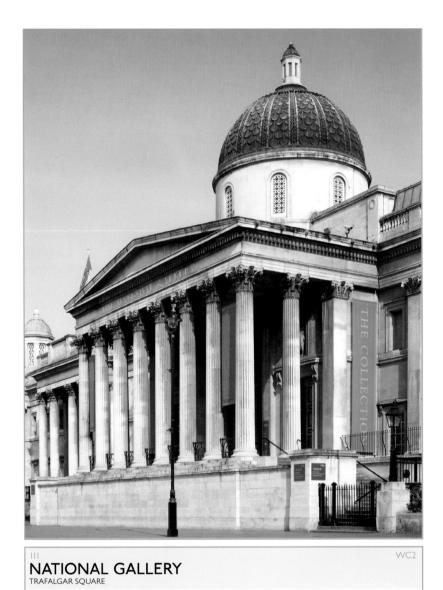

1832–38 WILLIAM WILKINS; 1867–76 INTERIORS, EDWARD MIDDLETON BARRY; 1885 CENTRAL HALL, SIR JOHN TAYLOR

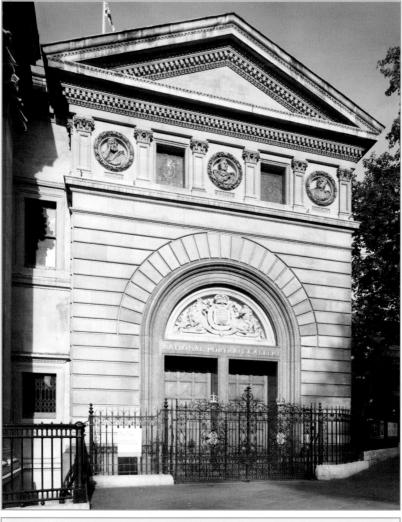

II2 NATIONAL PORTRAIT GALLERY CHARING CROSS ROAD 1890–95 EWAN CHRISTIAN

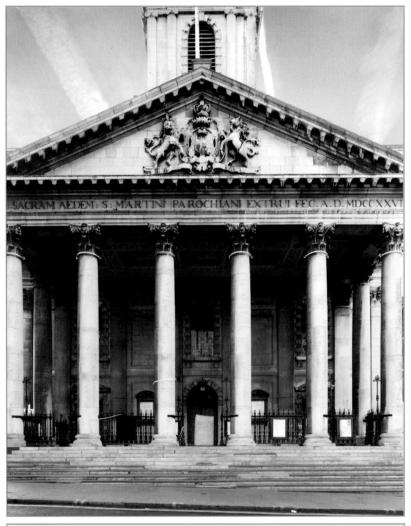

WC2

ST MARTIN-IN-THE-FIELDS

1721-26 JAMES GIBBS

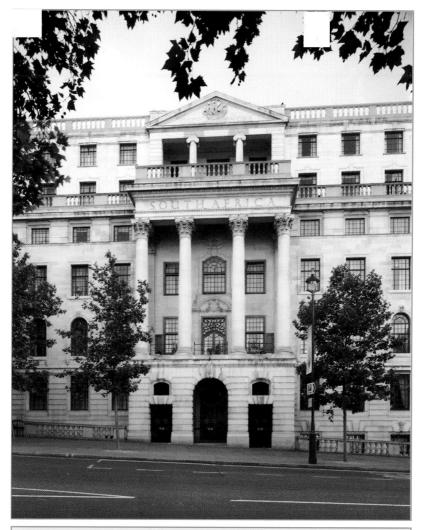

WC2

SOUTH AFRICA HOUSE

1933-35 SIR HERBERT BAKER

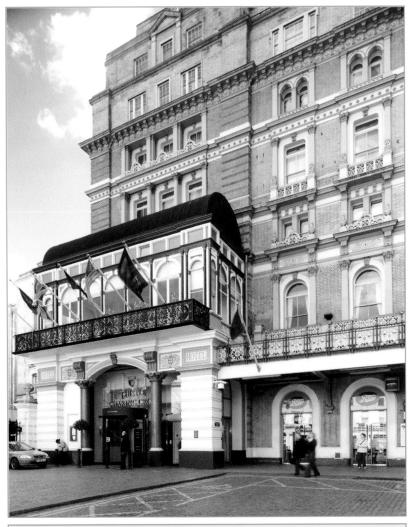

WC2 CHARING CROSS STATION HOTEL THE STRAND 1863-64 EDWARD MIDDLETON BARRY

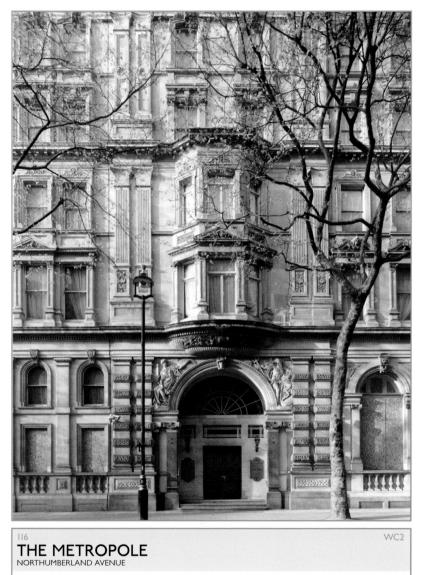

CHARING CROSS STATION

1863–64 JOHN HAWKSHORE; 1990 TERRY FARRELL AND PARTNERS

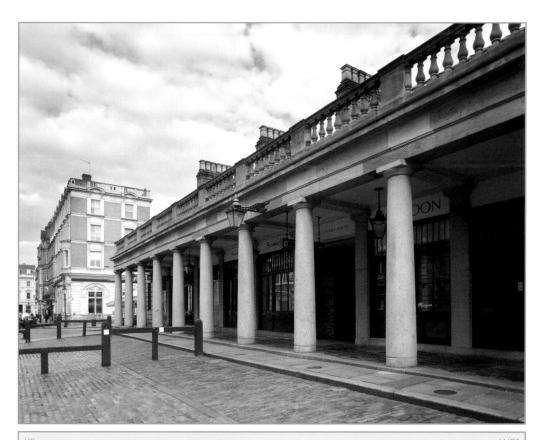

COVENT GARDEN PIAZZA

1631 INIGO JONES AND 1830 CHARLES FOWLER

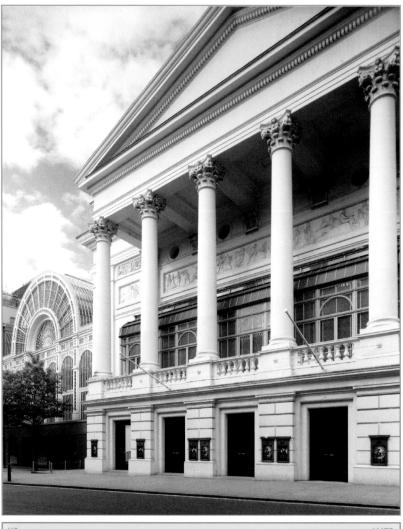

119 WC2 THE ROYAL OPERA HOUSE BOW STREET I857–58 EDWARD MIDDLETON BARRY, 1982 GOLLINS MELVIN WARD PARTNERSHIP, 2000 SIR JEREMY DIXON

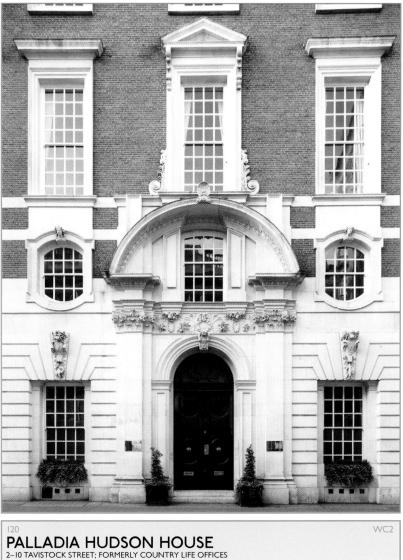

1904 SIR EDWIN LUTYENS

1973-79 SIR FREDERICK GIBBERD

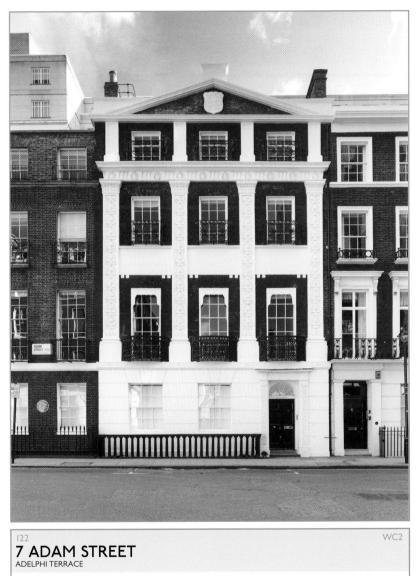

1768-74 JOHN ADAM

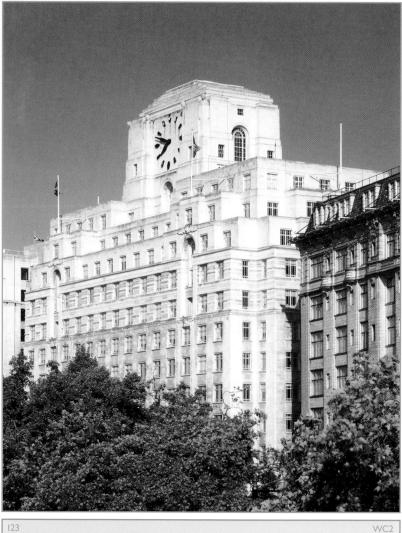

SHELL-MEX HOUSE

1931 ERNEST JOSEPH

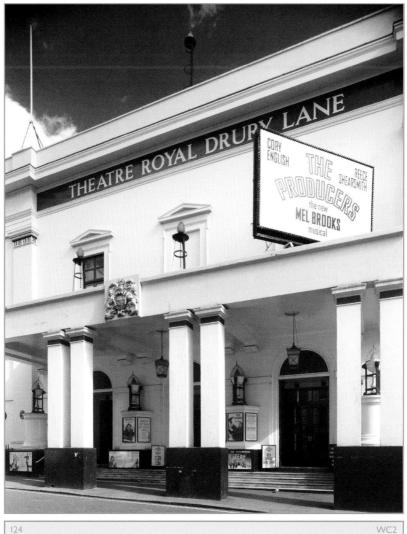

THEATRE ROYAL

1810-12 BENJAMIN WYATT

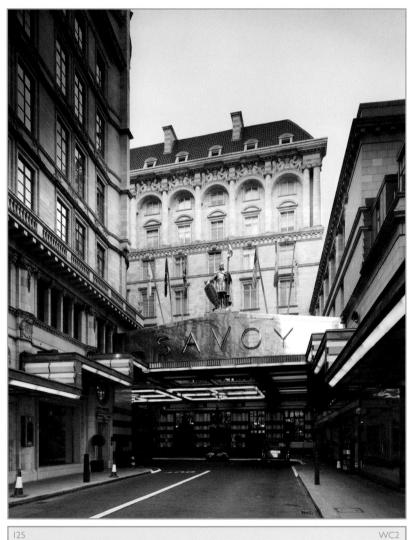

SAVOY HOTEL THE STRAND, VICTORIA EMBANKMENT

1889 AND 1903-04 ARTHUR MACKMURDO, THOMAS COLLCUTT

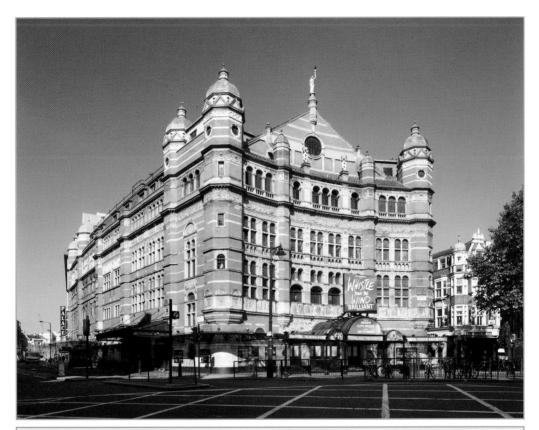

126 PALACE THEATRE CAMBRIDGE CIRCUS

1890 THOMAS COLLCUTT

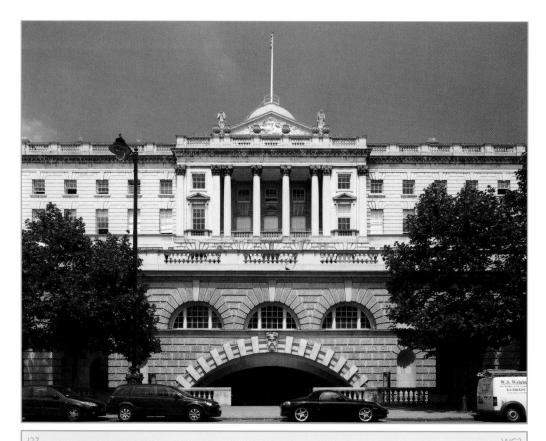

SOMERSET HOUSE THE STRAND, LANCASTER PLACE, AND EMBANKMENT

1776-86, 1830-35, AND 1856 SIR WILLIAM CHAMBERS, SIR ROBERT SMIRKE, SIR JAMES PENNETHORNE

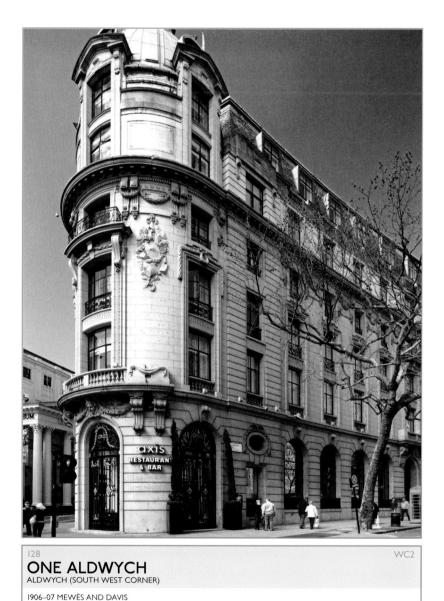

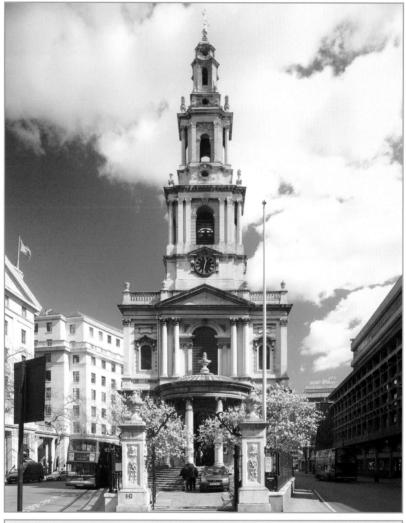

1714-17 JAMES GIBBS

WC2

KING'S COLLEGE

1829–35 SIR ROBERT SMIRKE

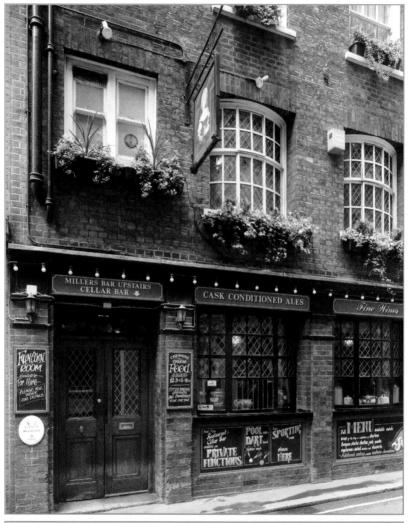

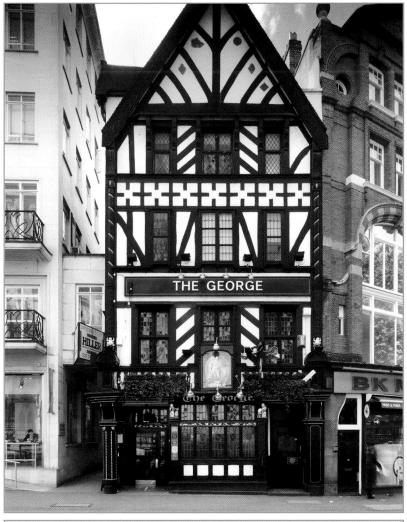

132 WC2 **THE GEORGE** 213 STRAND 1723; 1890s

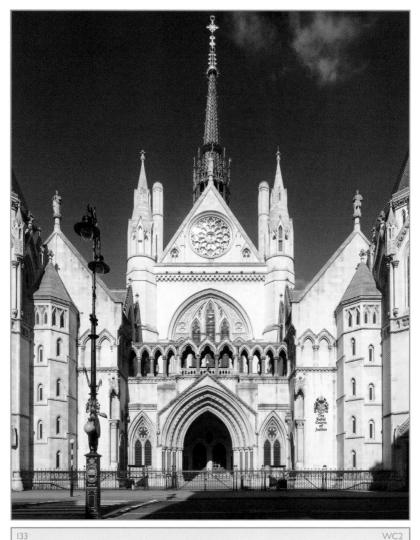

ROYAL COURTS OF JUSTICE

1874-82 GEORGE EDMOND STREET

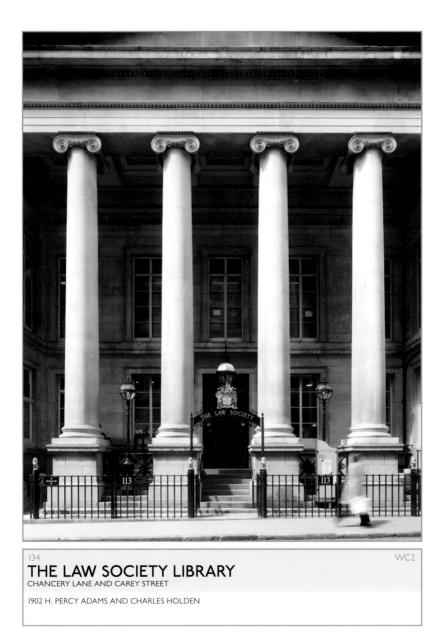

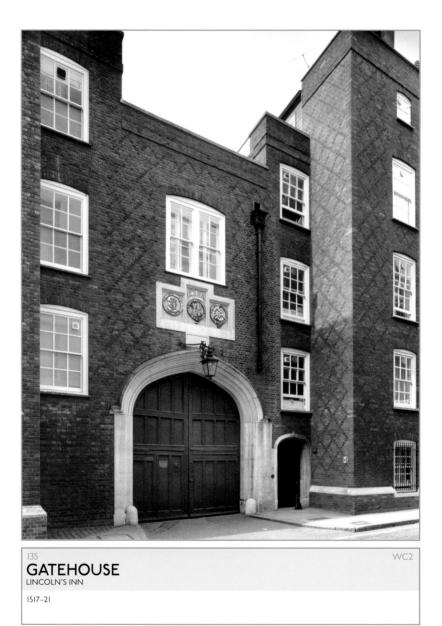

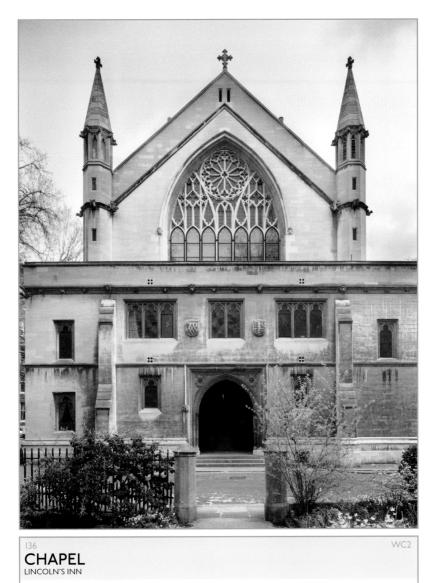

1619–23 PROBABLY INIGO JONES

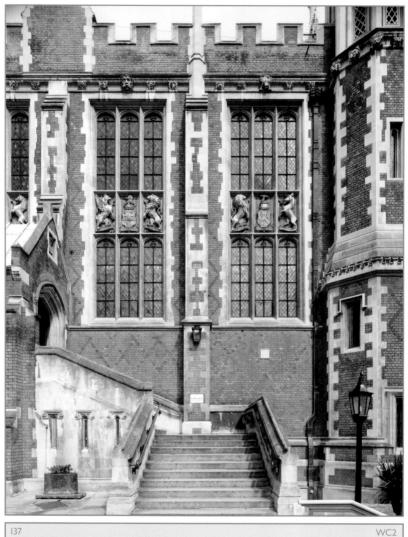

LINCOLN'S INN NEW HALL

1845 PHILIP HARDWICK

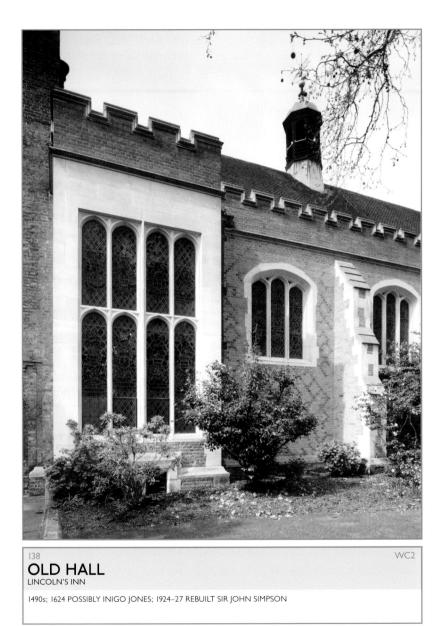

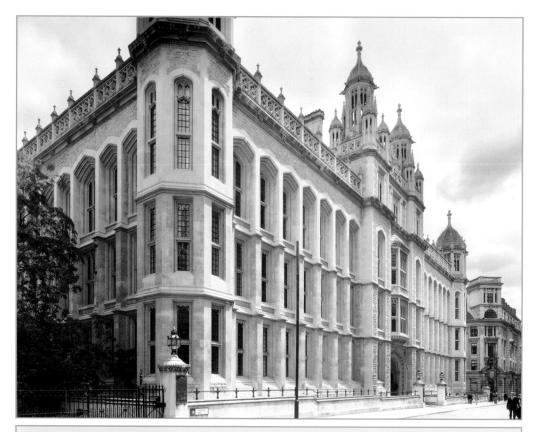

FORMER PUBLIC RECORD OFFICE

1851–96 JAMES PENNETHORNE, SIR JOHN TAYLOR

WC2

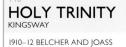

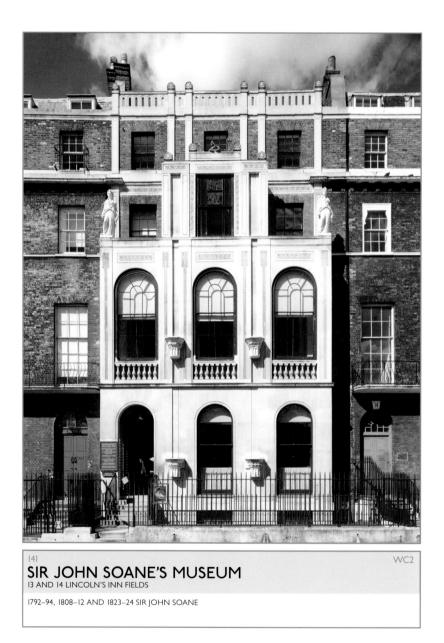

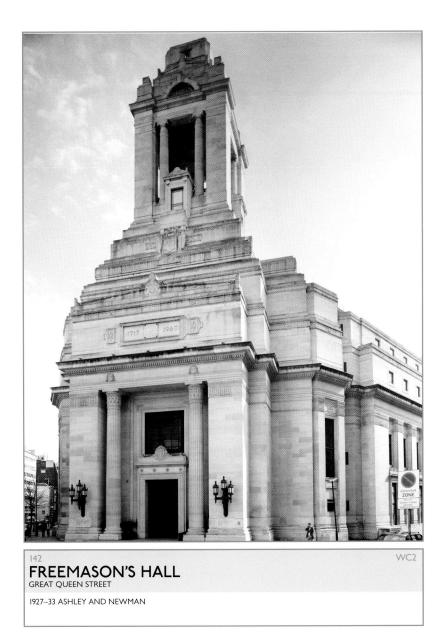

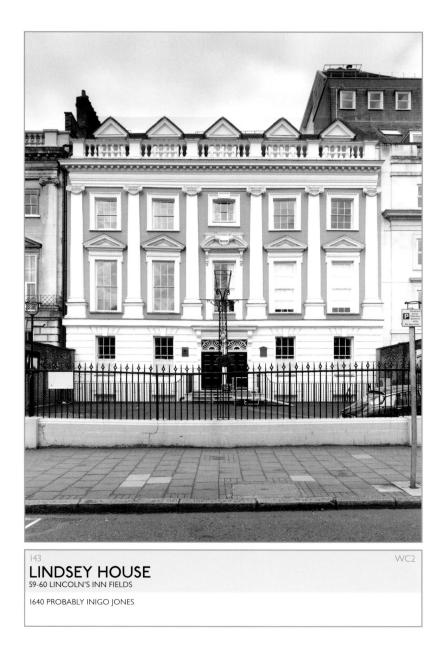

EAST CENTRAL LONDON (EC)

East Central London spreads out from around the City of London—often referred to as the Square Mile, as it is about one square mile (2.6 square kilometres) in area. In the medieval period this was the full extent of London, as distinct from the separate village of Westminster.

The city is where London began. Roman walls still run alongside London Wall, and the remains of a temple to Mithras were found on what was once the bank of the Walbrook stream. The ancient city was surrounded by a fortress wall with seven gates: Aldgate, Bishopsgate, Moorgate, Cripplegate, Aldgate, Bishopsgate, Moorgate, Cripplegate, Aldgatesgate, Newgate, and Ludgate. These have long since vanished, but their names live on in streets and buildings. Just as in Cheapside, the names give clues as to what was once sold here—Milk Street, Bread Street, and Poultry.

There have been over six hundred Lord Mayors of London—the first being Henry FitzAilwyn in 1189, with the citizens' right to elect a mayor formalised by King John in 1215. Sir Francis Child, Lord Mayor in 1698, is credited with having founded the banking profession when he left his goldsmith business for the world of finance.

The major occupations here are still banking and finance, with more foreign banks in London (well over five hundred) than any other centre worldwide. The Bank of England, the 'Old Lady of Threadneedle Street,' was founded in 1694, and has issued banknotes ever since. Author of *The Wind in the Willows* Kenneth Grahame was a secretary here. In 1836, a man working on sewers discovered a tunnel leading into the bullion vaults of the bank. He sent a note arranging to meet the directors there at midnight and duly emerged from below a flagstone. He was rewarded for his honesty and the tunnel was blocked in. The origins of the London Stock Exchange go back to the coffeehouses of 1600s. Lloyds insurance also began here, initially insuring ships and cargoes, but its undertakings since have covered everything from a two-thousand-year-old wine jar to crocodile attacks and spider bites in Australia. They have protected the taste buds of food critic and gourmet Egon Ronay, Betty Grable's 'million-dollar' legs, and a merchant navy officer who sailed from Dover to France in a bathtub; he was insured provided the plug stayed in place!

The first printing press was set up in about 1500 in Fleet Street (named after the River Fleet, which runs close by) and, in time, this area would become the hub of the newspaper industry, just as most of the livery companies and guilds gathered around medieval Guildhall.

A hundred thousand Londoners died in the Great Plague, which struck London in 1664–65, and then the following year, four-fifths of the city burnt down in the Great Fire but the city survived. Now, thousands of people commute into its offices, banks, and shops each day to work.

Here are some incredible buildings, from St Paul's Cathedral to the new Lloyds of London and the Gherkin, but this is also a place that thronged with people from the illustrious names like Samuel Pepys, Doctor Johnson, and Sir Christopher Wren to the unnamed builders who raised these great edifices. One such unfortunate workman is remembered by a little sculpture of carved mice on a building in Philpot Lane. This commemorates the fact that, during its construction, he had been accused of stealing another labourer's sandwiches and was somehow pushed to his death. The real culprits were the mice—now sculpted here. It is in such details that the city's story is encapsulated.

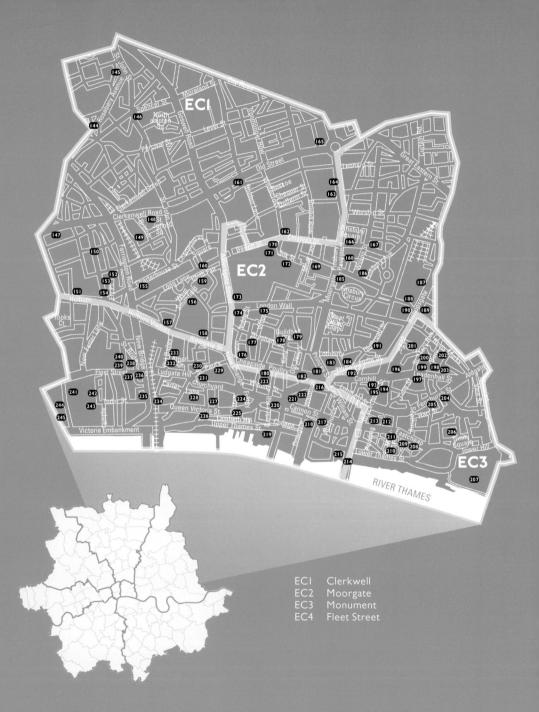

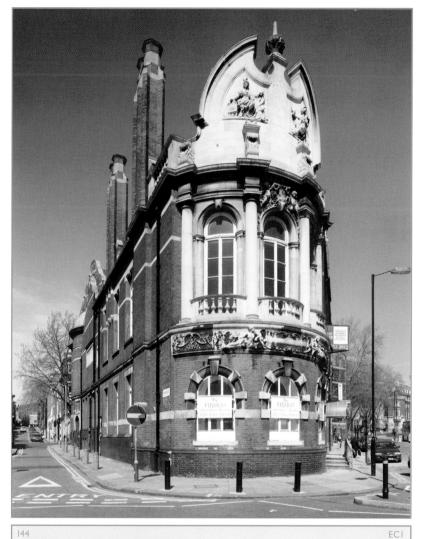

FINSBURY TOWN HALL

1895–99 g. evans vaughan

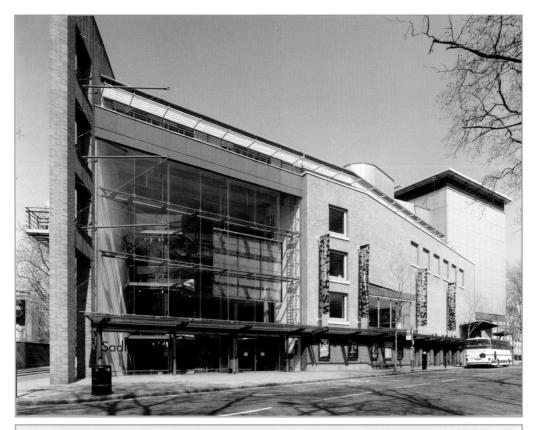

SADLER'S WELL THEATRE

1931 FRANK MATCHAM AND COMPANY; 1998 RENTON HOWARD WOOD LEVIN ARCHITECTS AND NICHOLAS HARE ARCHITECTS

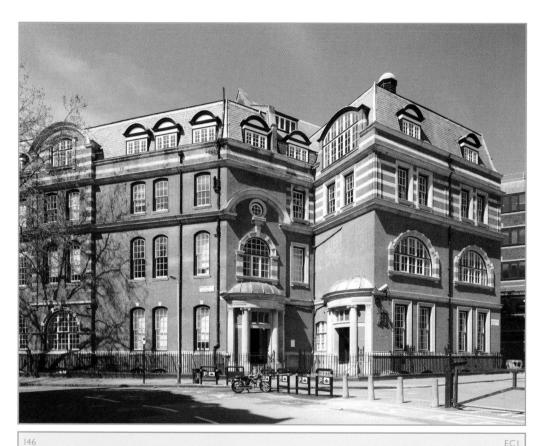

CITY UNIVERSITY COLLEGE ST JOHN STREET, SPENCER STREET, AND NORTHAMPTON SQUARE

1896 EDWARD MOUNTFORD

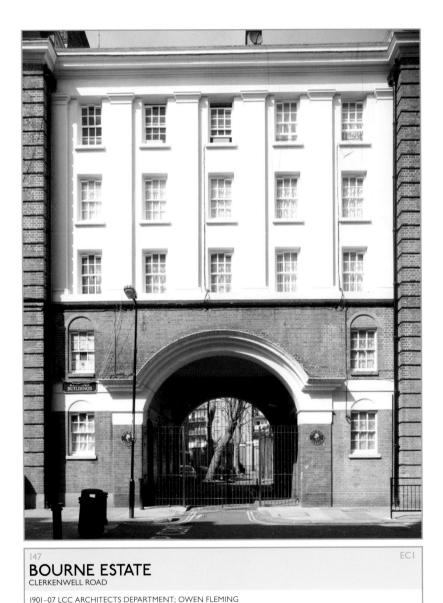

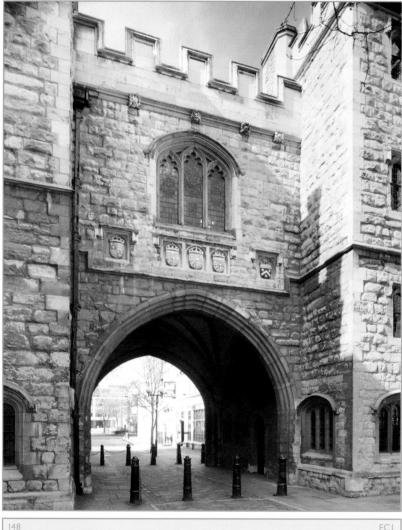

I48 **ST JOHN** ST JOHN'S SQUARE

CRYPT 1140-80; GATE 1504 SIR THOMAS DOCWRA; RESTORED BY JOHN OLDRED SCOTT 1903

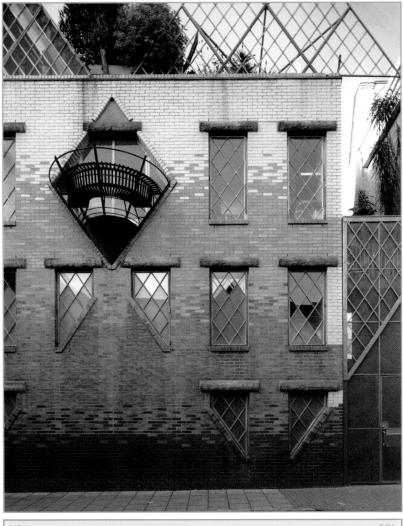

149 A HOUSE OF TRIANGLES 44 BRITTON STREET 1987 CZWG ARCHITECTS (CAMPBELL, ZOGOLOVITCH, WILKINSON AND GOUGH)

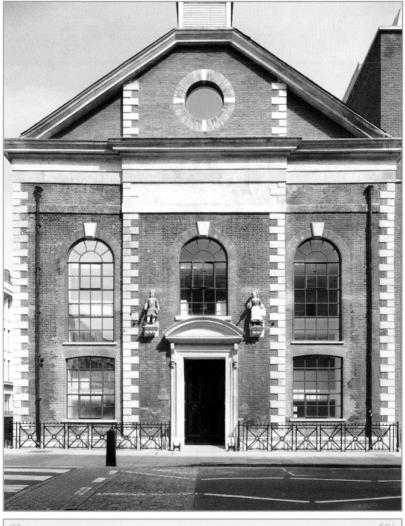

POSSIBLY SIR CHRISTOPHER WREN

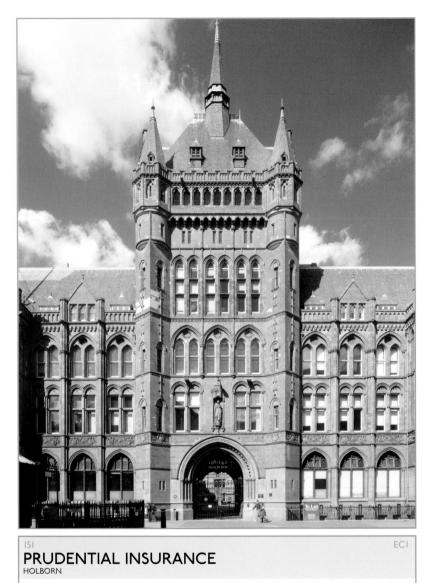

1879, 1899-1906 ALFRED AND PAUL WATERHOUSE

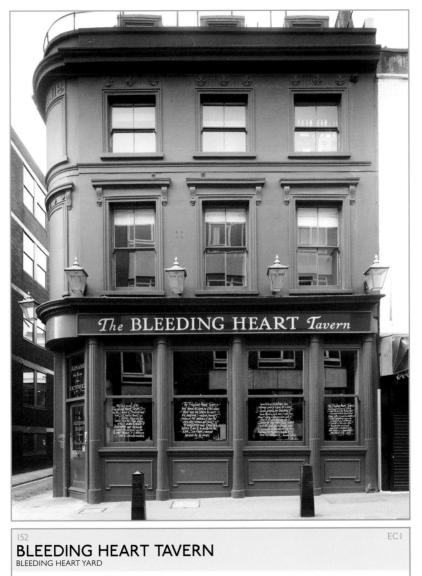

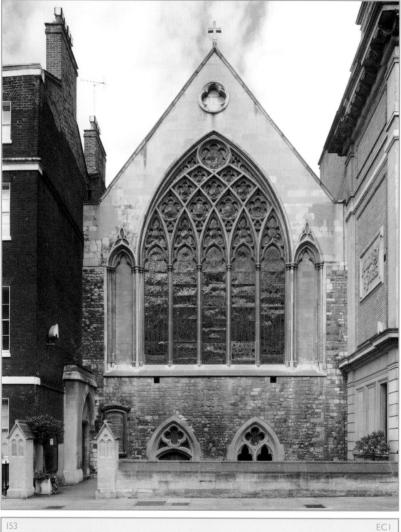

ST ETHELREDA

1291 JOHN DE KIRKEBY; 1874 RESTORED BY FATHER LOCKHART

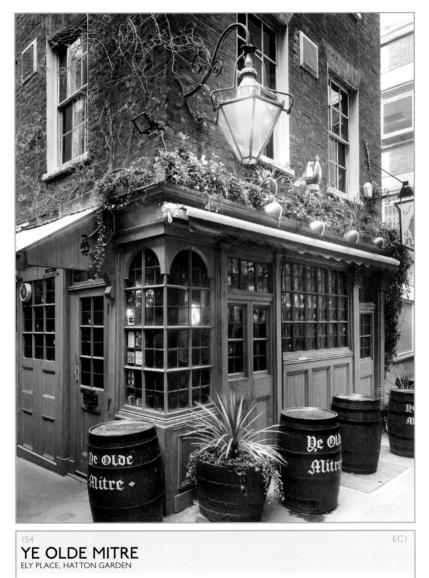

1546; REBUILT AFTER 1772

SMITHFIELD MARKET CHARTERHOUSE STREET, SMITHFIELD

1961–63 T. P. BENNETT AND SON

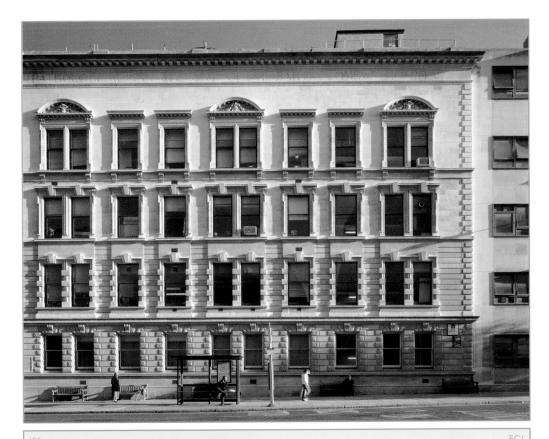

ST BARTHOLOMEW'S HOSPITAL

1729–70, 1834 JAMES GIBBS AND PHILIP HARDWICK

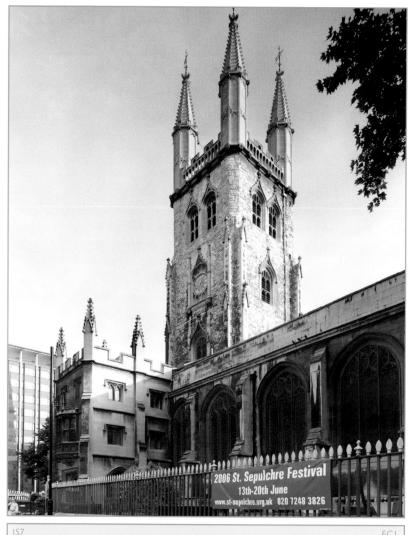

HOLY SEPULCHRE WITHOUT NEWGATE

MID-1400s; 1666-70 REBUILT; 1878 RESTORED

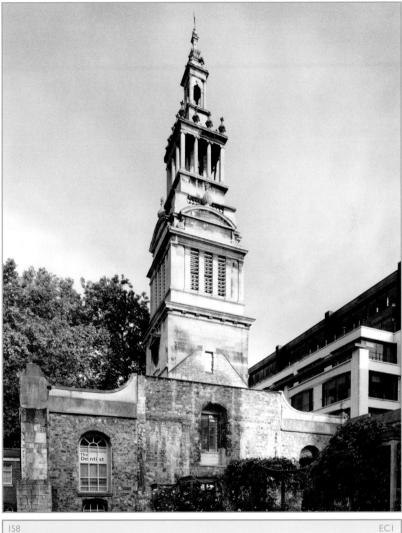

EC

CHRIST CHURCH

1677-87 SIR CHRISTOPHER WREN

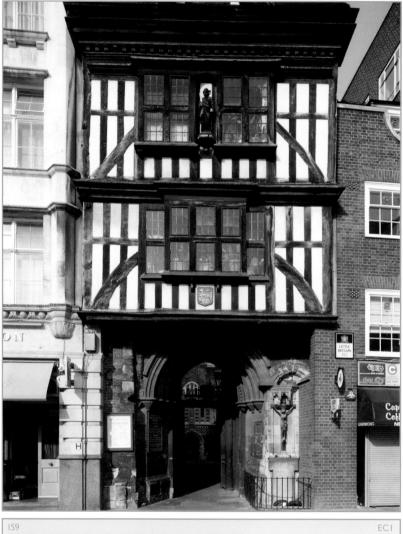

ST BARTHOLOMEW THE GREAT

1123; RESTORED 1880-90 SIR ASTON WEBB

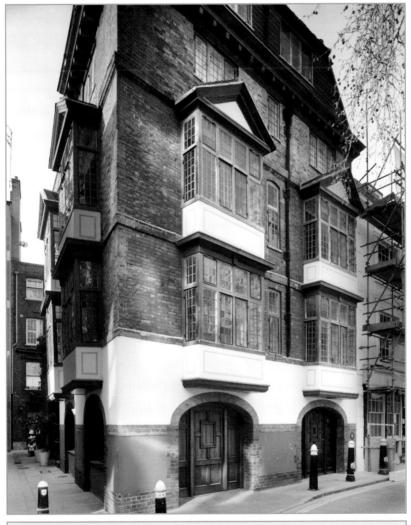

160 TIMBER HOUSES

C. 1640

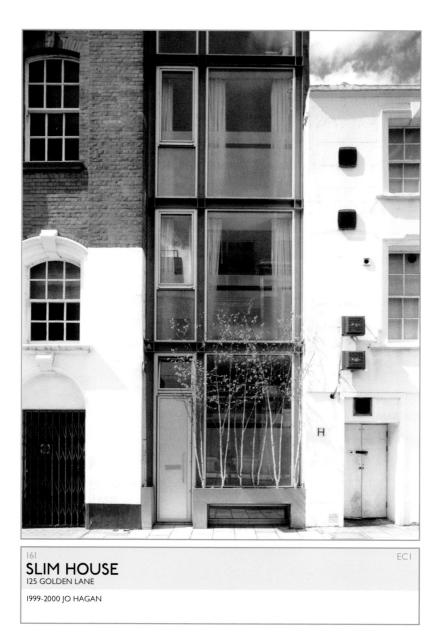

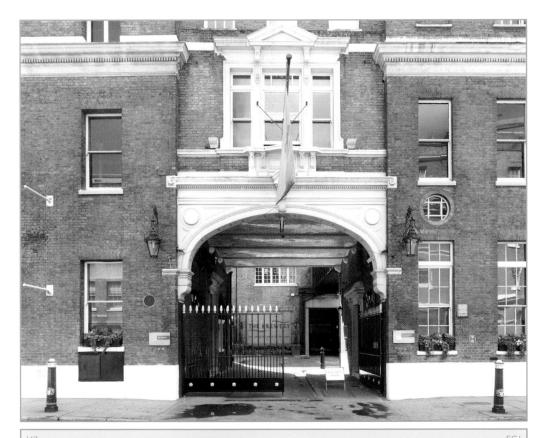

WHITBREAD'S BREWERY CHISWELL STREET

FROM 1749; RESTORED BY WOLF OLINS, RODERICK GRADIDGE, AND JULIAN HARROP

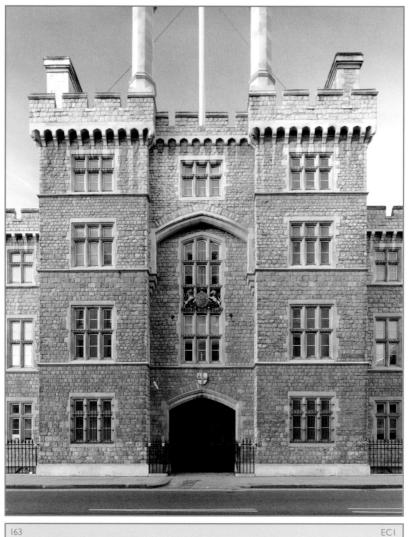

163 ARMOURY HOUSE CITY ROAD AND BUNHILL ROW, GOLDEN LANE ESTATE

1735; 1828; 1857 JENNINGS

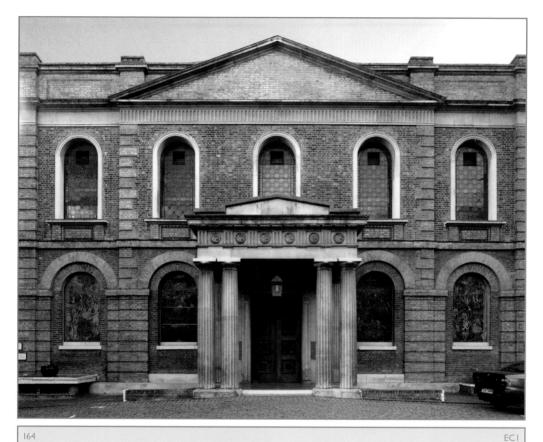

WESLEY'S CHAPEL (AND HOUSE)

1777 GEORGE DANCE THE YOUNGER; 1972-78 RESTORED (1779 HOUSE)

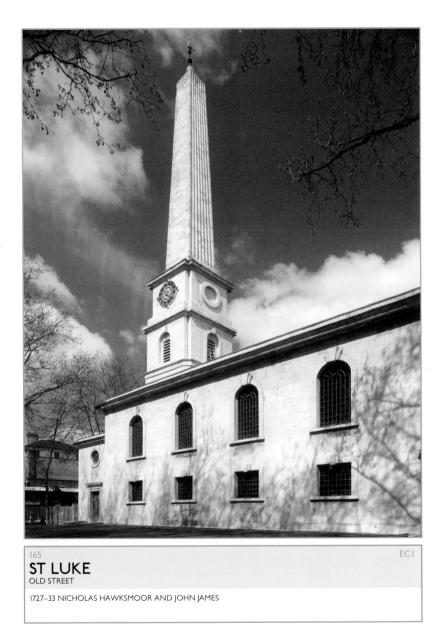

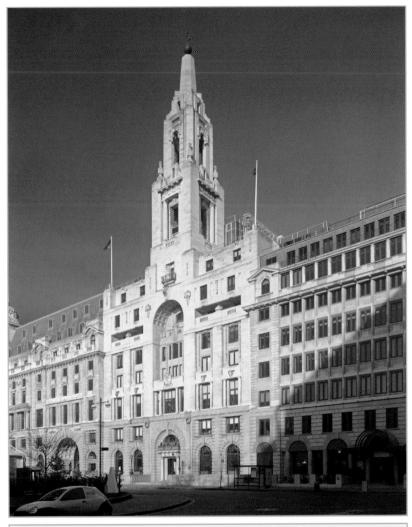

EC2

FINSBURY SQUARE

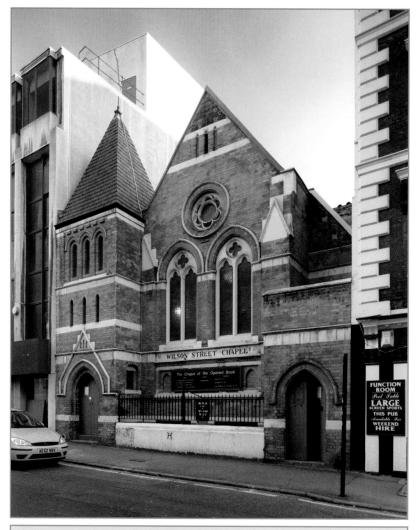

167 EC2 CHAPEL OF THE OPEN BOOK 52a WILSON STREET MID TO LATE 1800s

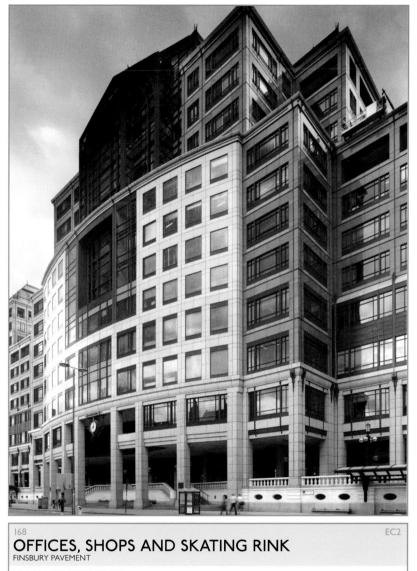

1984-86 ARUP ASSOCIATIONS

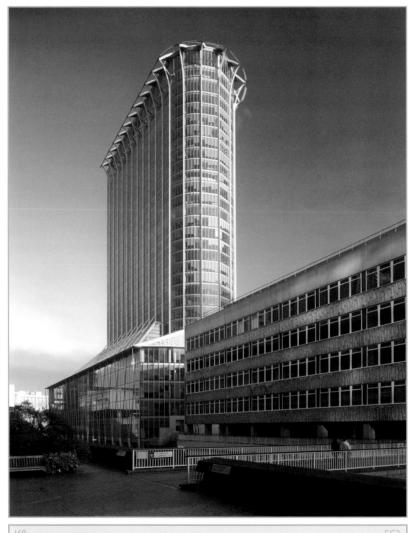

2001 SHEPPARD ROBSON

I ROPEMAKER STREET; FORMERLY BRITTANIC HOUSE

CITY POINT

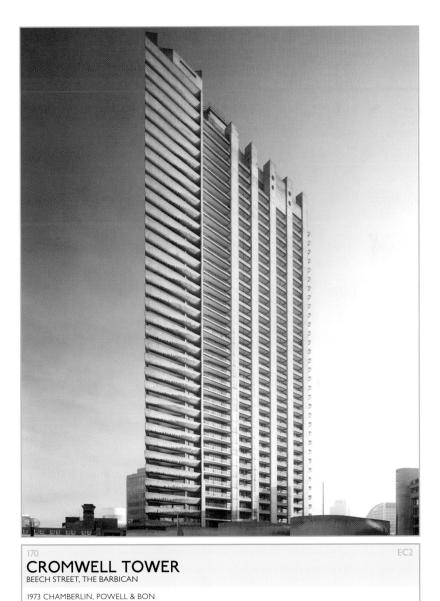

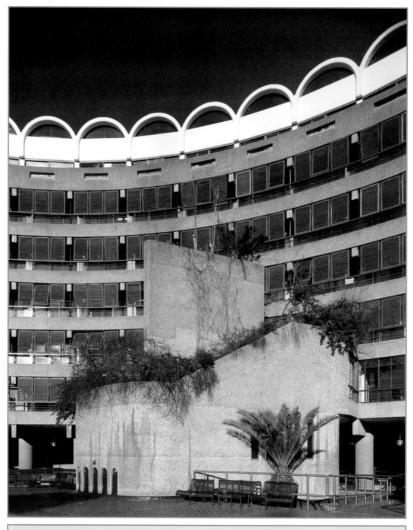

EC2

FROBISHER CRESCENT BARBICAN CENTRE, BEECH STREET

1959–79 CHAMBERLIN, POWELL & BON

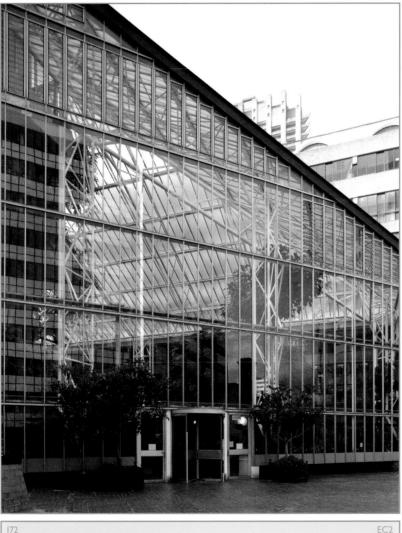

THE CONSERVATORY SILK STREET, BARBICAN ARTS CENTRE

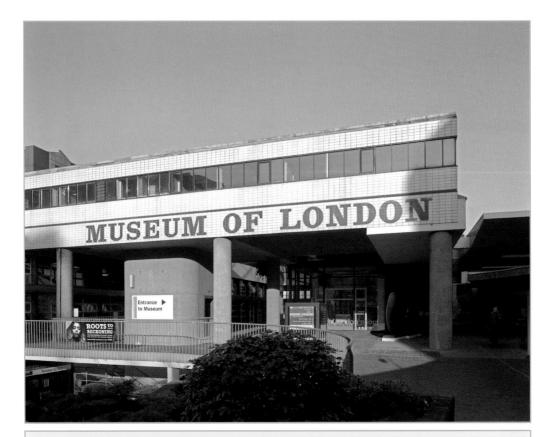

MUSEUM OF LONDON

1975-76 POWELL AND MOYA

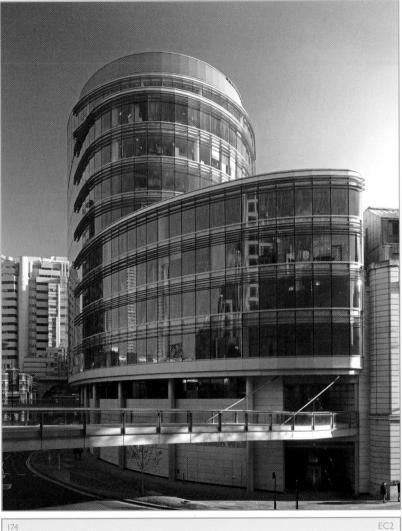

LC,

2003 FOSTER AND PARTNERS

ONE LONDON WALL

OFFICES AND 'PLAISTERERS'

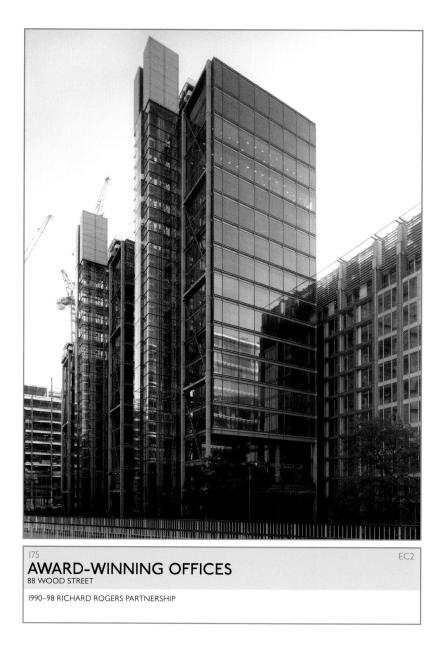

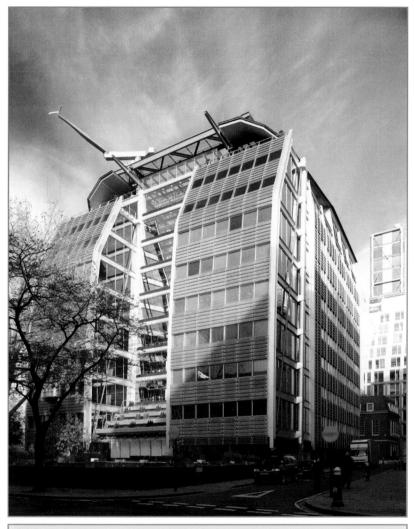

EC2

BUILT ON A ROMAN FORT 25 GRESHAM STREET

2002 NICHOLAS GRIMSHAW AND PARTNERS

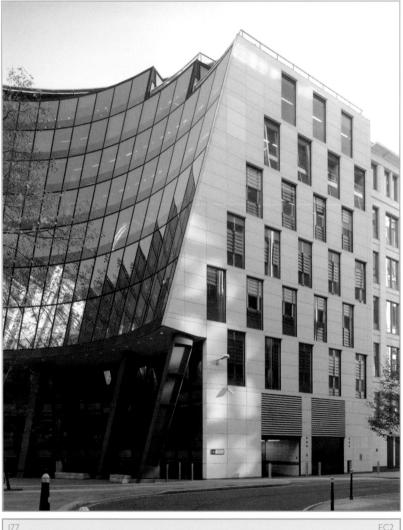

SCHRODERS INVESTMENT BUILDING

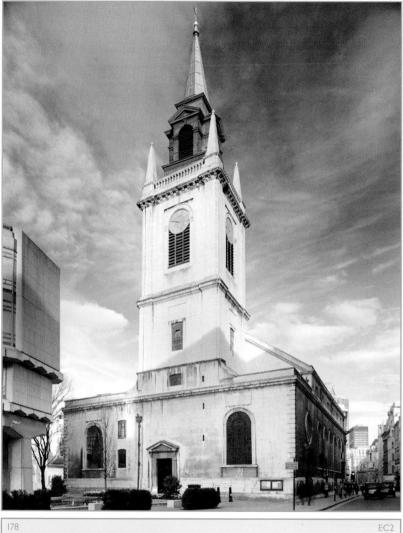

ST LAWRENCE JEWRY

1670-87 SIR CHRISTOPHER WREN

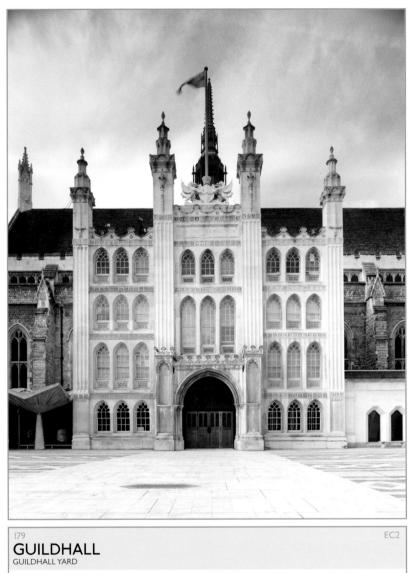

1411-40, 1788-89 JOHN CROXTON AND GEORGE DANCE THE YOUNGER

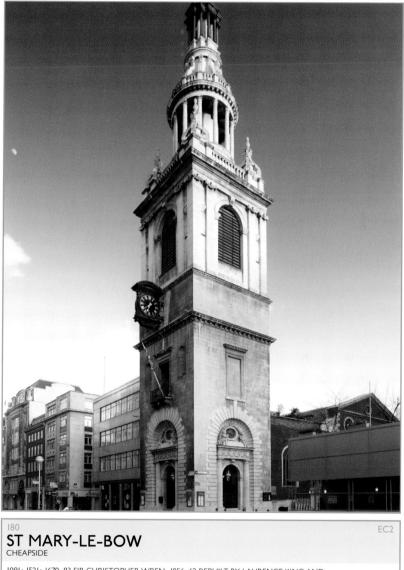

1091; 1521; 1670–83 SIR CHRISTOPHER WREN; 1956–62 REBUILT BY LAURENCE KING AND RECONSECRATED 1964

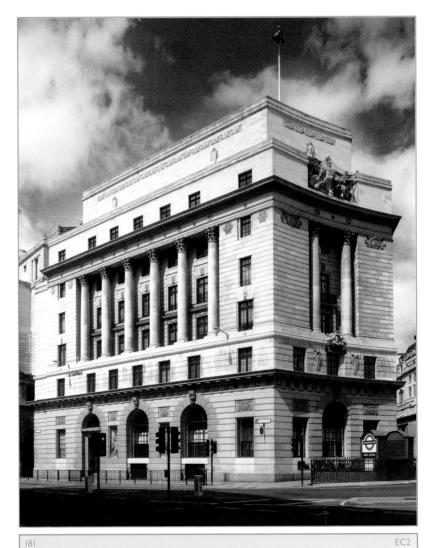

NATIONAL WESTMINSTER BANK

1930-32 SIR EDWIN COOPER

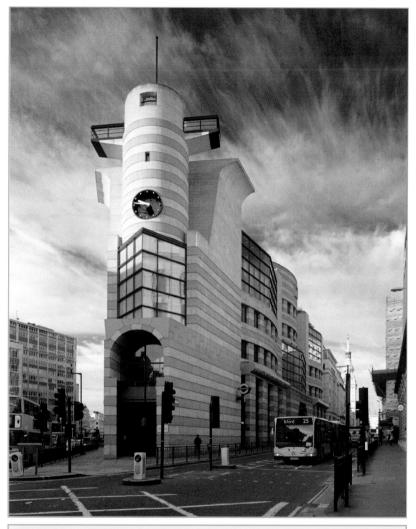

182 NUMBER ONE POULTRY POULTRY AND QUEEN VICTORIA STREET

1994–98 JAMES STIRLING AND MICHAEL WILFORD

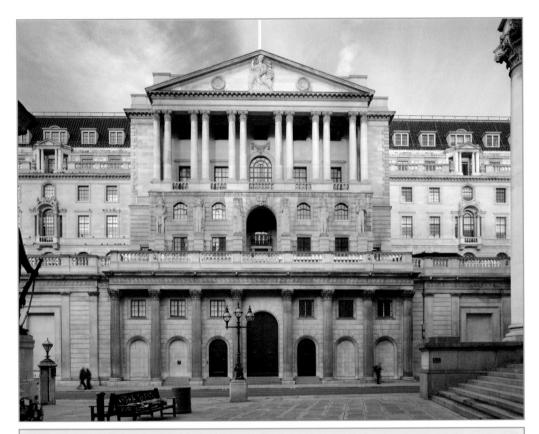

BANK OF ENGLAND

FROM 1732, SIR JOHN SOANE

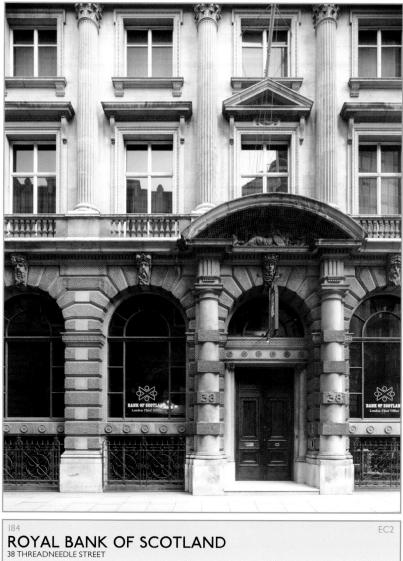

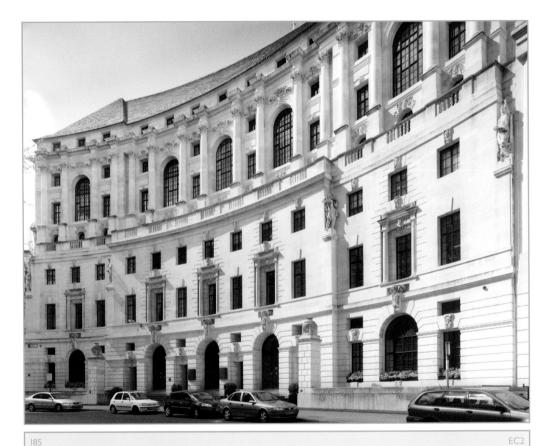

BRITANNIC HOUSE MOORGATE AND FINSBURY CIRCUS; FORMERLY LUTYENS HOUSE

1924–27, 1987–89 SIR EDWIN LUTYENS, PETER INSKIP AND PETER JENKINS ARCHITECTS

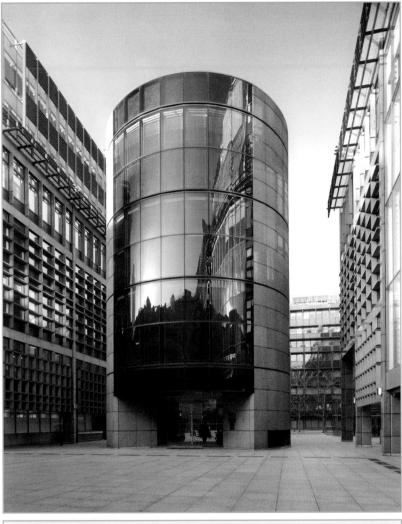

IB6 EC2 THE PAVILION FINSBURY AVENUE

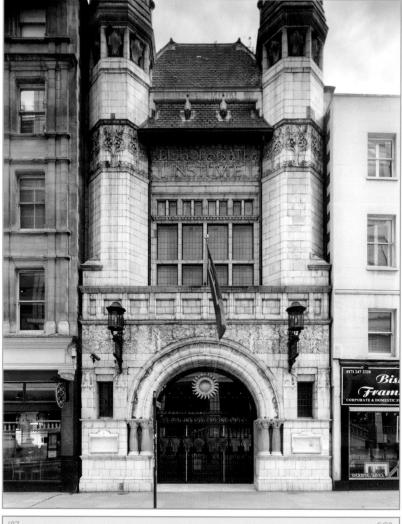

EC2

1894 C. H. TOWNSEND

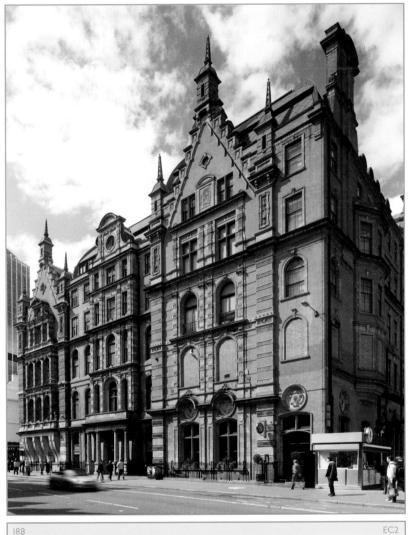

LIVERPOOL STREET STATION AND HOTEL BISHOPSGATE AND LIVERPOOL STREET

STATION 1874 E. WILSON; 1891–94 EXTENSION W. N. ASBEE; 1980s RENOVATED HOTEL 1884 CHARLES BARRY; 1901 ALTERED BY R. EDDIS; 1997–99 REFURBISHED

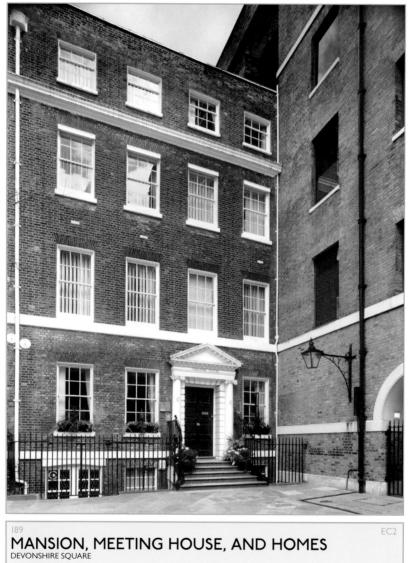

C. 1500s, 1678, 1708, 1740

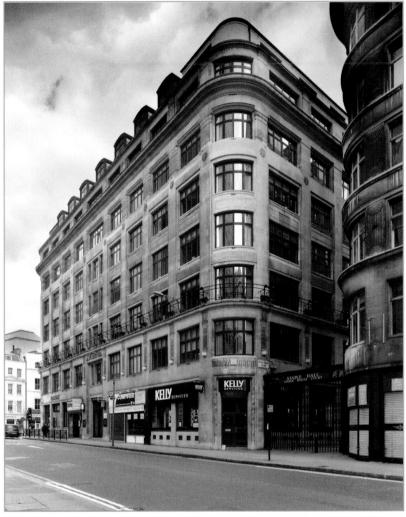

190 EC2 STONE HOUSE 136 BISHOPSGATE 1927 RICHARDSON AND GILL

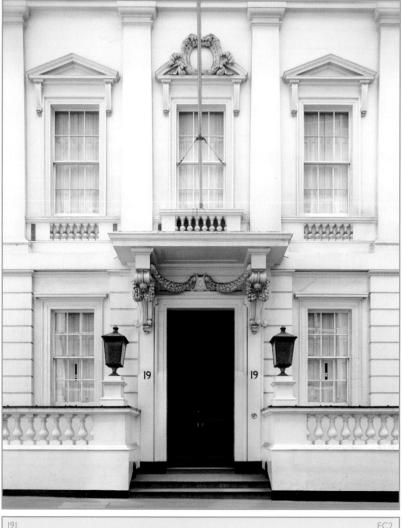

CITY OF LONDON CLUB

1833-34 PHILIP HARDWICK, INTERIORS RESTORED 1980

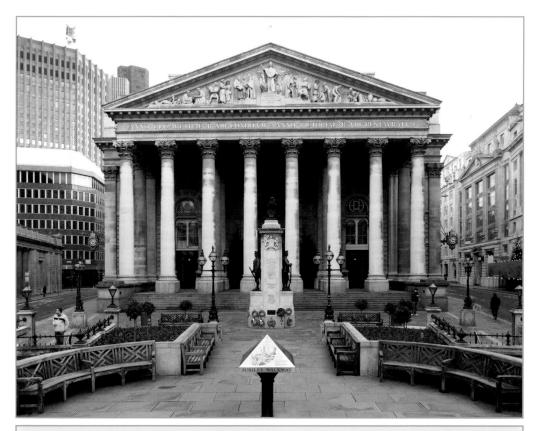

192 ROYAL EXCHANGE THREADNEEDLE STREET AND CORNHILL

1841-44 SIR WILLIAM TITE

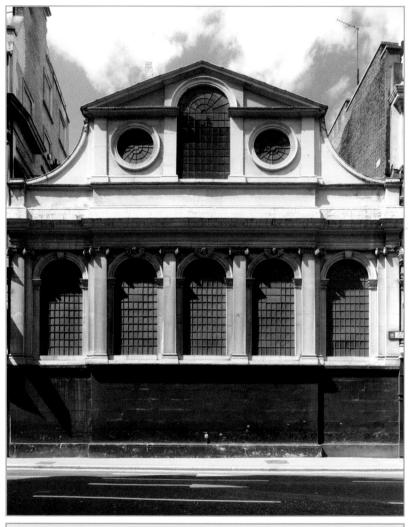

193 E
ST PETER UPON CORNHILL
CORNHILL, VIA ST PETER'S ALLEY AND GRACECHURCH STREET
1680–87 SIR CHRISTOPHER WREN

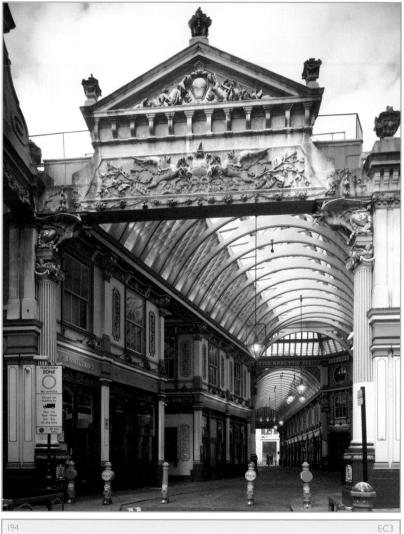

IP4 LEADENHALL MARKET GRACECHURCH STREET

1881 SIR HORACE JONES

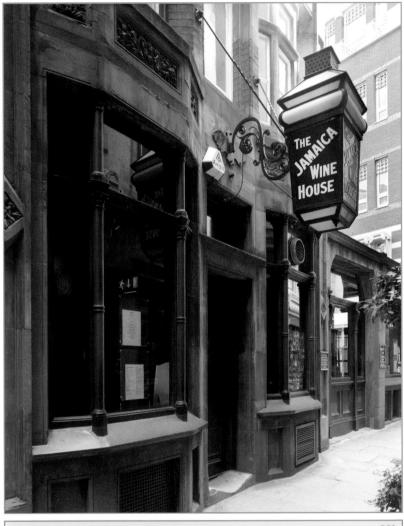

195 JAMAICA WINE HOUSE ST MICHAEL'S ALLEY, CORNHILL

1652

EC3

196 A LUTYENS BANK 140-144 LEADENHALL STREET

1929 SIR EDWIN LUTYENS, WHINNEY AND A. HALL

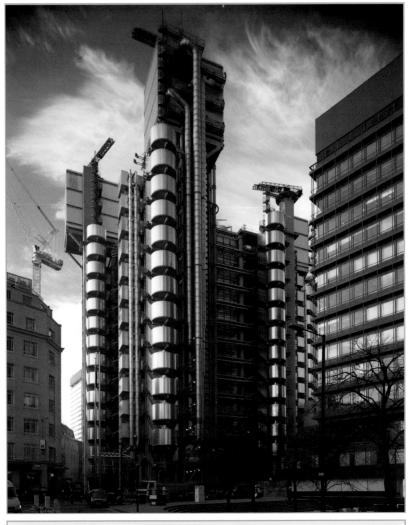

197 LLOYD'S OF LONDON LEADENHALL AND LIME STREETS

1978-86 RICHARD ROGERS PARTNERSHIP

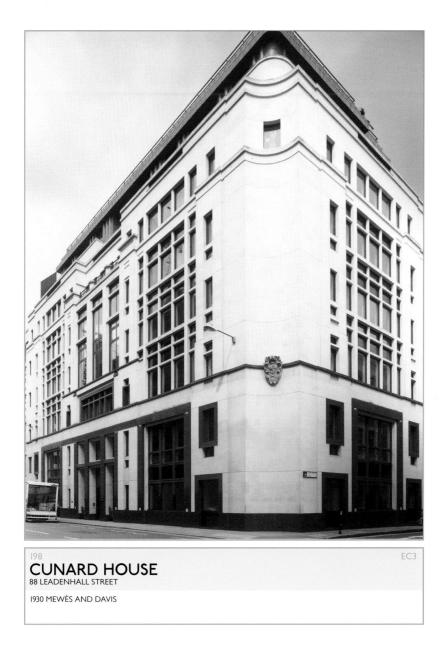

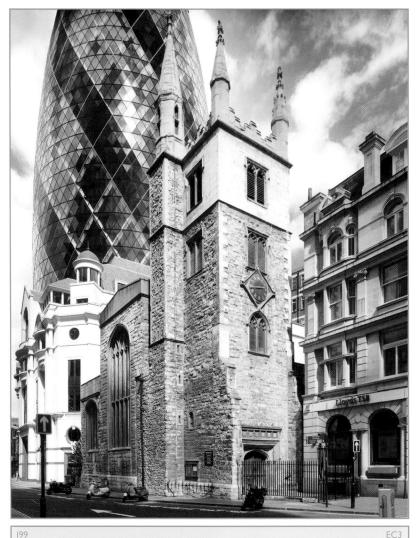

ST ANDREW UNDERSHAFT LEADENHALL STREET AND ST MARY AXE

1147 ST ANDREW CORNHILL; 1520-32 RESTORED 1684

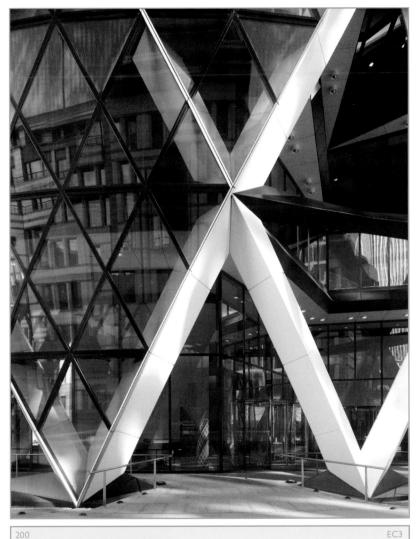

SWISS RE BUILDING 30 ST MARY AXE; OFTEN CALLED THE GHERKIN

2004 LORD NORMAN FOSTER AND KEN SHUTTLEWORTH

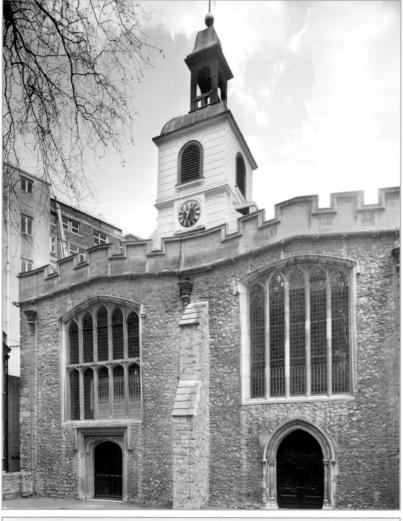

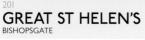

300s; 1200s; 1400s; 1800s; J. L. PEARSON

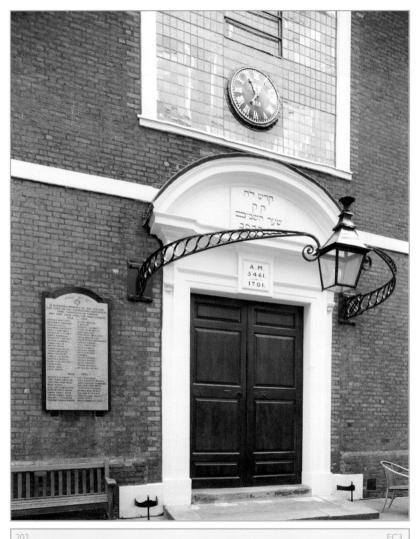

SPANISH AND PORTUGUESE SYNAGOGUE

1700–01 JOSEPH AVIS

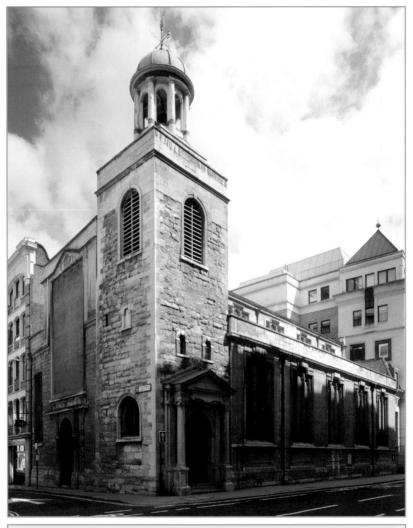

ST KATHERINE CREE

1280; TOWER 1504; CHURCH REBUILT 1504 AND 1628–31; 1700s CUPOLA ADDED; RESTORED BY MARSHALL SISSON 1962

2000 RICHARD ROGERS PARTNERSHIP

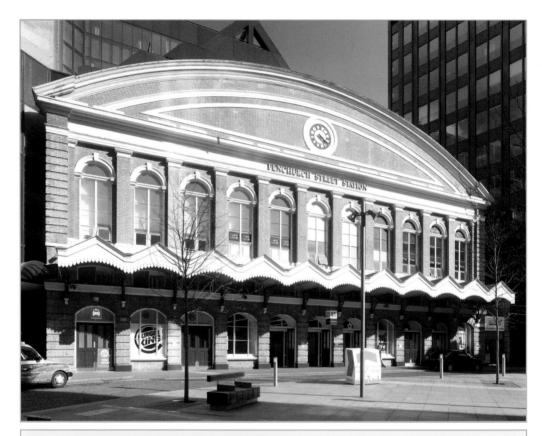

1853-54; 1881-83 GEORGE BERKELEY; REBUILT 1935

EC3

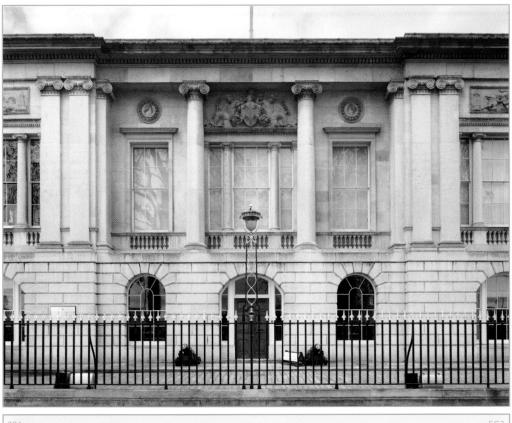

TRINITY HOUSE

1796 SAMUEL WYATT; 1953 REBUILT RICHARDSON AND HOUFE; 1990 REFURBISHED

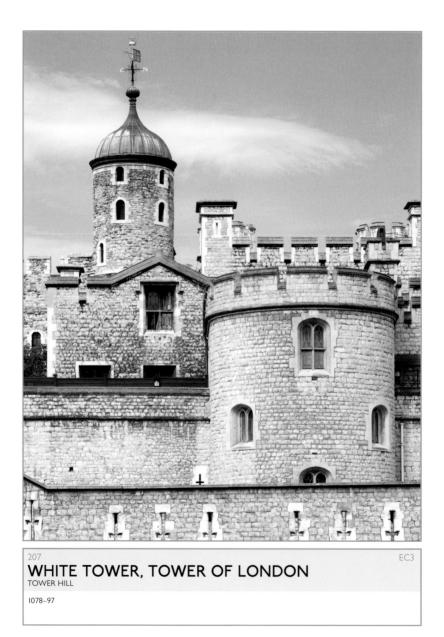

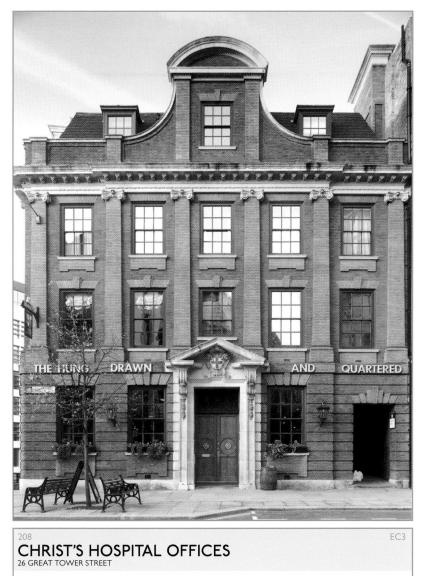

1915 SIR REGINALD BLOMFIELD

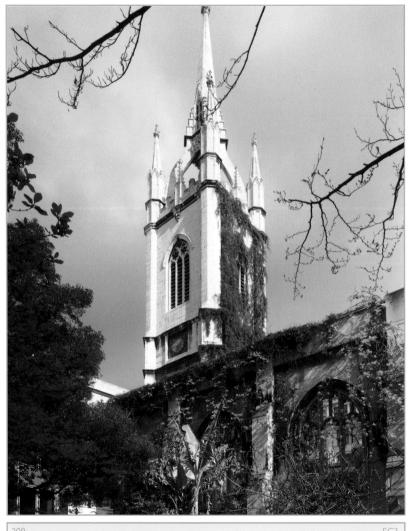

ST DUNSTAN IN THE EAST ST DUNSTUN'S HILL AND IDOL LANE

1697 SIR CHRISTOPHER WREN; REBUILT 1817

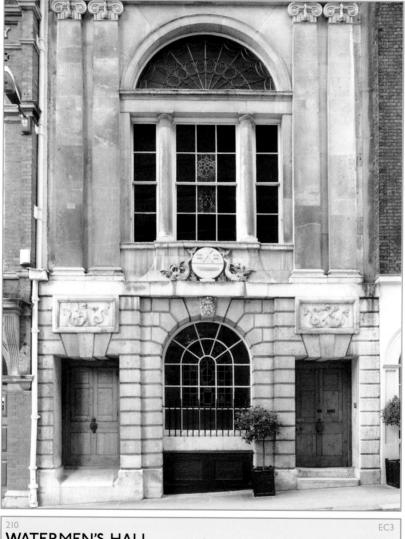

WATERMEN'S HALL

1778-80 WILLIAM BLACKBURN; 1951 AND 1961 HENRY V. GORDON

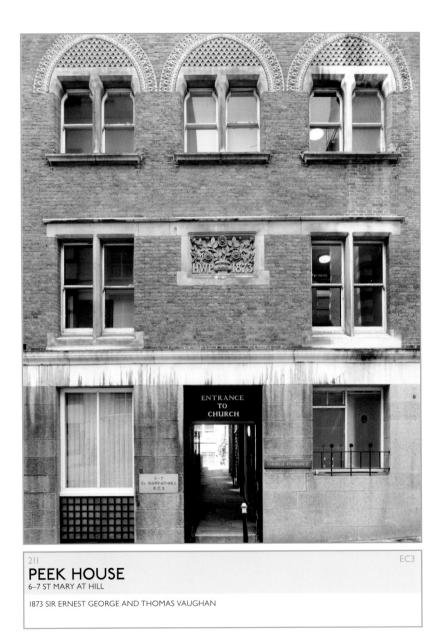

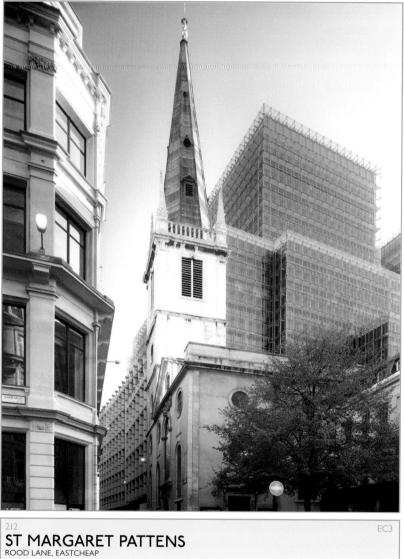

1530 REBUILT; 1684-89 SIR CHRISTOPHER WREN

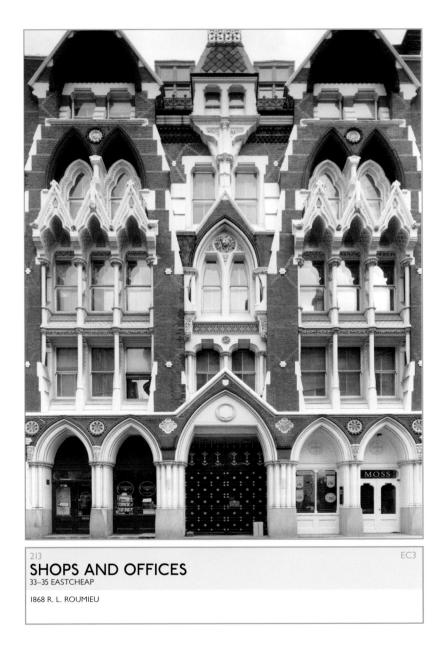

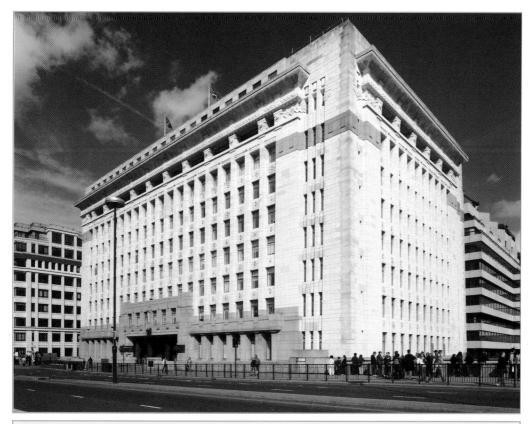

ADELAIDE HOUSE 75 KING WILLIAM STREET

1924–25 SIR JOHN BURNET TAIT AND PARTNERS

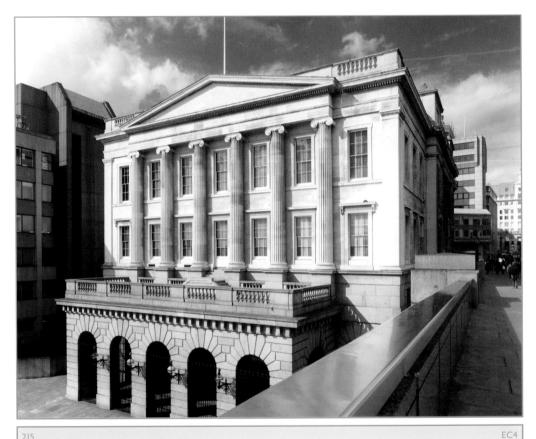

FISHMONGERS HALL KING WILLIAM STREET, NEAR LONDON BRIDGE

1310; 1434; 1671 EDWARD JARMAN; 1831-34 HENRY ROBERTS; 1951 RESTORED AUSTEN HALL

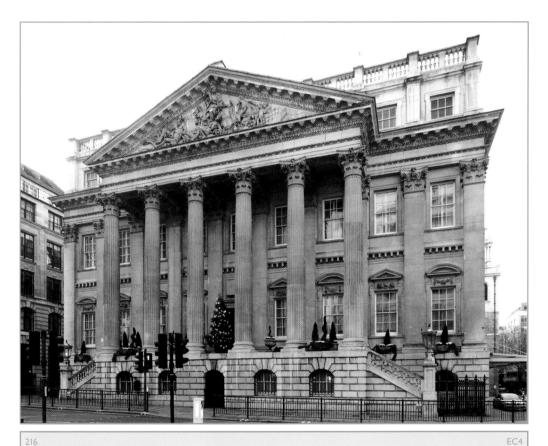

MANSION HOUSE INNER TEMPLE, FLEET STREET, AND VICTORIA EMBANKMENT

1739-52 GEORGE DANCE THE ELDER

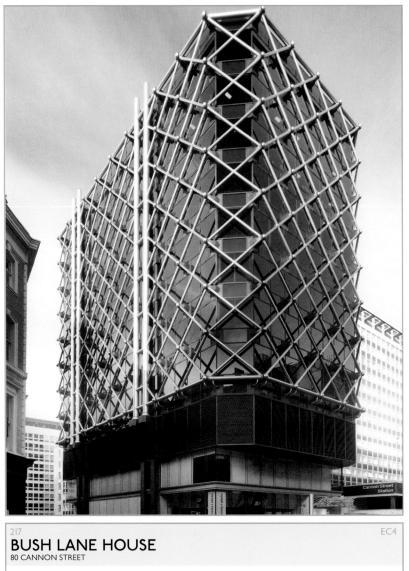

1976 ARUP ASSOCIATES

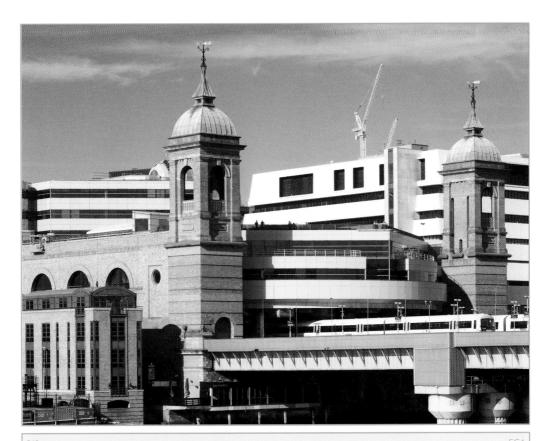

CANNON STREET STATION

1865–66 J. HAWKSHAW AND J. W. BARRY, ENGINEERS

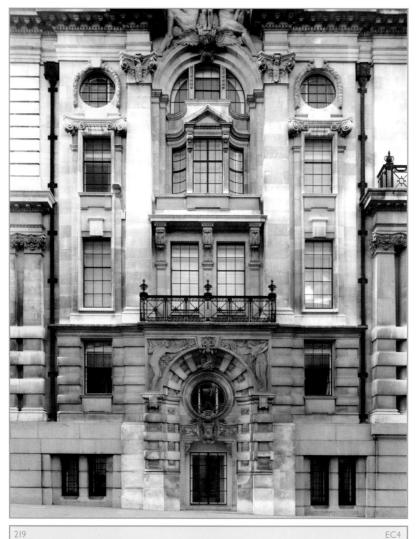

219 THAMES HOUSE QUEEN'S STREET AND UPPER THAMES STREET

1911 COLLCUTT AND HAMP

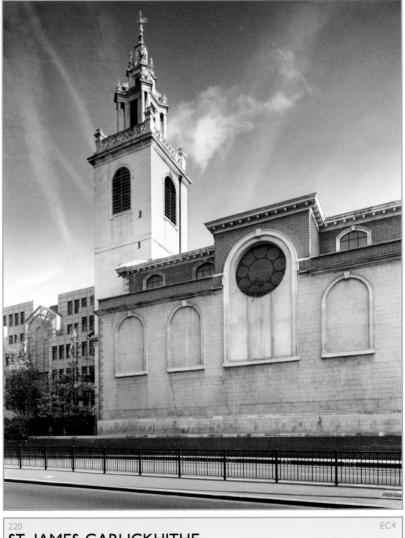

ST JAMES GARLICKHITHE

1100s; 1326 RICHARD DE ROTHING; 1676–83 STEEPLE; 1714–17 SIR CHRISTOPHER WREN; 1954–63 RESTORED LOCKHART SMITH AND ALEXANDER GALE

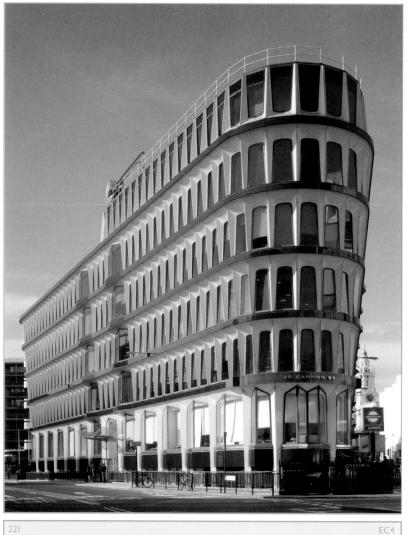

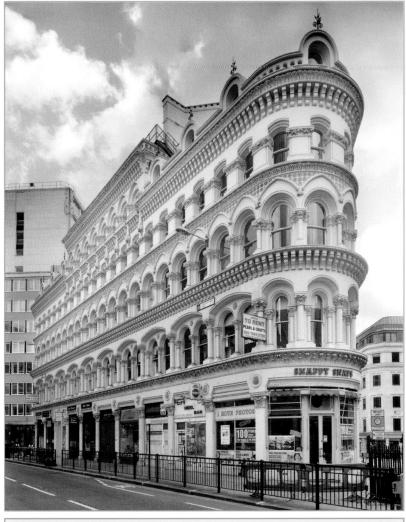

EC4

ALBERT BUILDINGS

1872 FREDERICK J. WARD

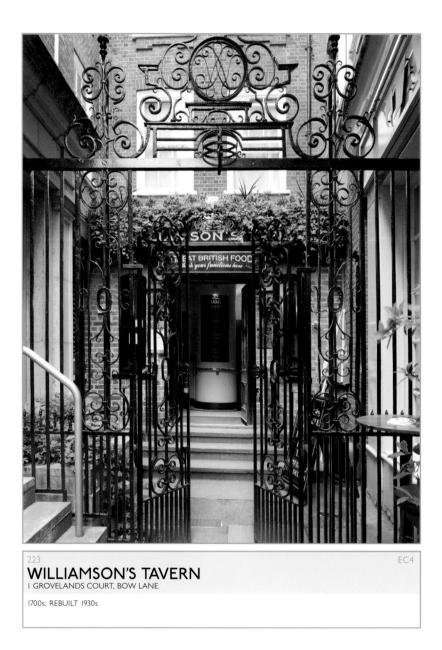

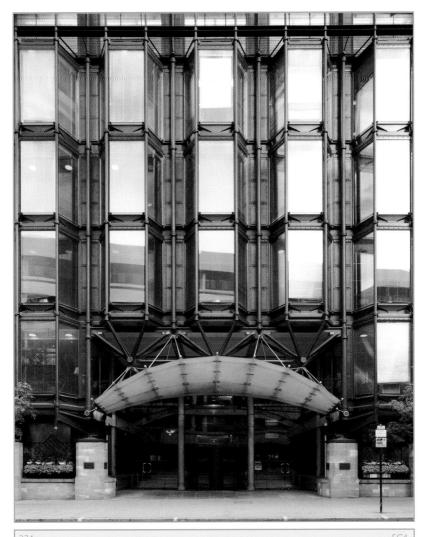

BRACKEN HOUSE CANNON STREET, FRIDAY STREET AND DISTAFF LANE, FORMERLY FINANCIAL TIMES BUILDING

1988–90 SIR ALBERT RICHARDSON; MICHAEL HOPKINS AND PARTNERS

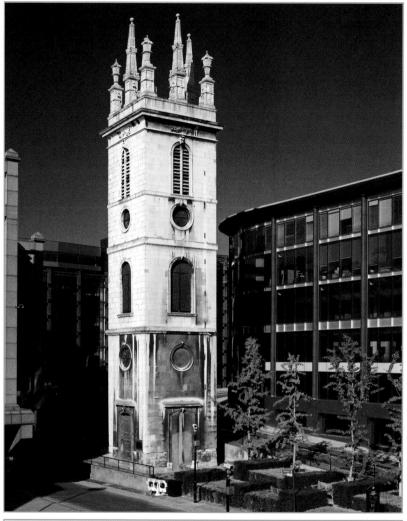

EC4

225 ST MARY SOMERSET UPPER THAMES STREET

1686-95 SIR CHRISTOPHER WREN

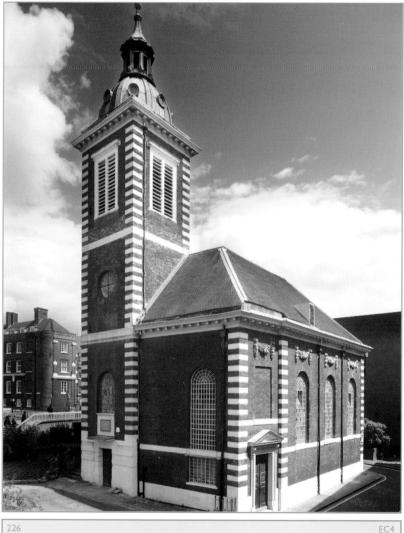

ST BENET PAUL'S WHARF

1100s, 1677-83 SIR CHRISTOPHER WREN AND MASTER MASON THOMAS STRONG

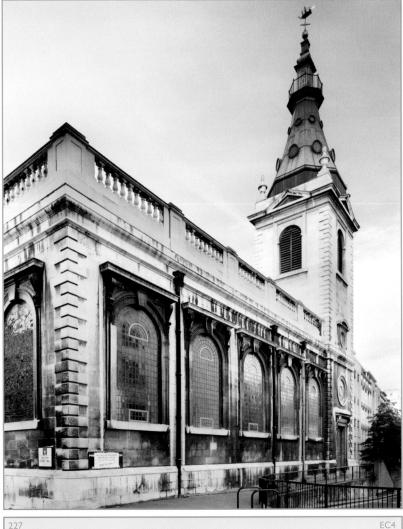

ST NICHOLAS COLE ABBEY QUEEN VICTORIA STREET

1144, 1671–77 SIR CHRISTOPHER WREN; 1962 RESTORATION ARTHUR BAILEY

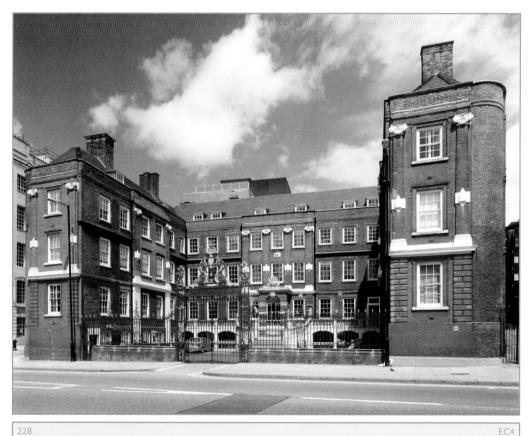

228 COLLEGE OF ARMS QUEEN VICTORIA STREET

1671-77 MAURICE EMMETT (MASTER BRICKLAYER)

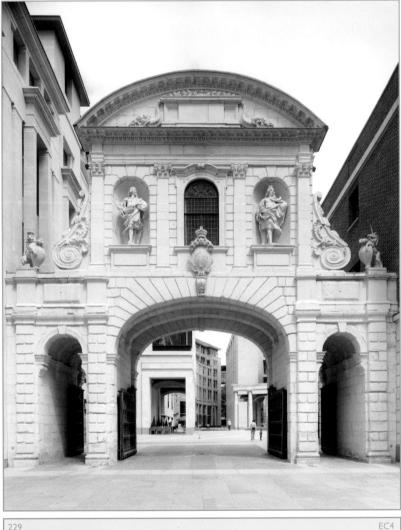

229 **TEMPLE BAR** ST PAUL'S CHURCHYARD

1293; 1533 RESTORED FOR ANNE BOLEYN'S CORONATION; 1672 SIR CHRISTOPHER WREN

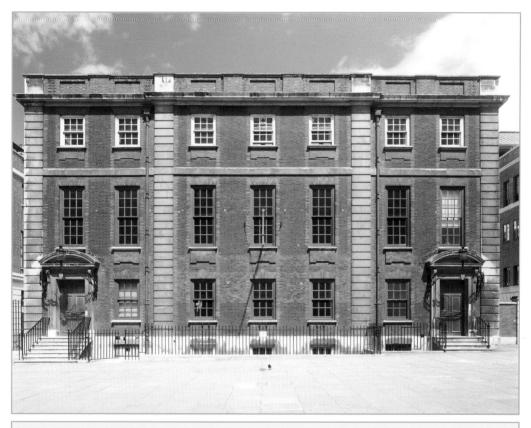

230 CHAPTER HOUSE ST PAUL'S CATHEDRAL, ST PAUL'S CHURCHYARD

1712-14 SIR CHRISTOPHER WREN

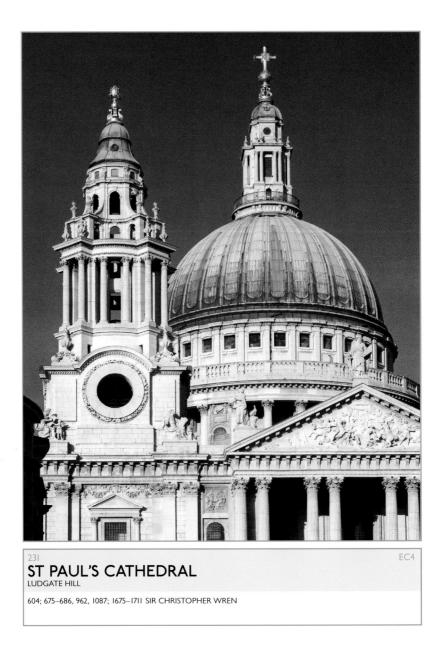

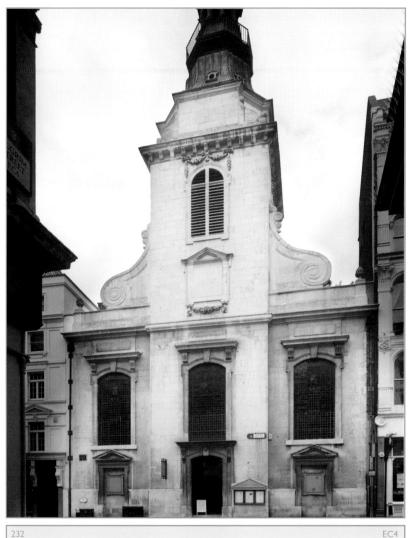

ST MARTIN WITHIN LUDGATE

FOUNDED CADWALLER 600s; 1677-84 CHRISTOPHER WREN

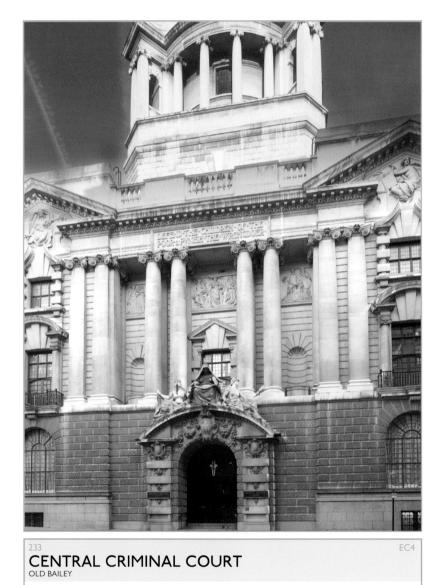

1539; 1774; 1900–07 E. W. MOUNTFORD; 1972 SOUTH EXTENSION DONALD MCMORRAN

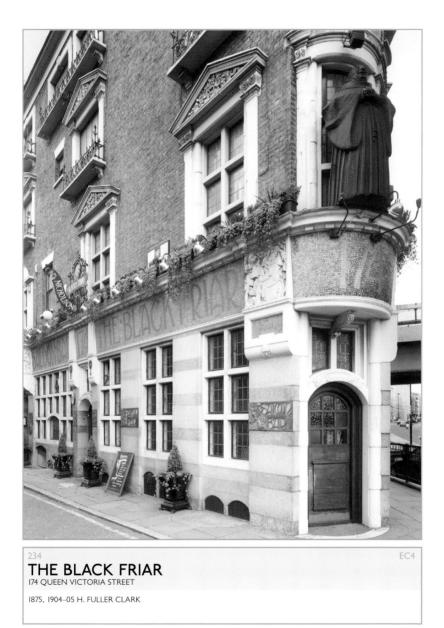

	m
	[]]
	í pr
BLACKFRIARS HOUSE	EC4

19 NEW BRIDGE STREET

1913 F. W. TROUP

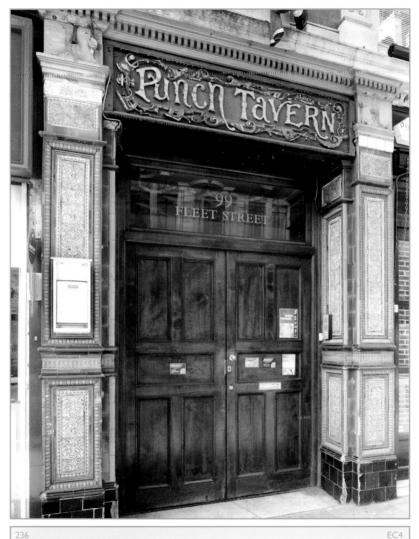

236 PUNCH TAVERN 99 FLEET STREET; FORMERLY THE CROWN AND SUGARLOAF

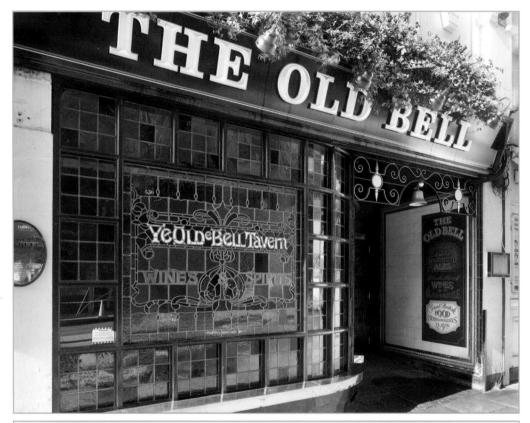

237 THE OLD BELL 95 FLEET STREET, FORMERLY THE SWAN

1678 SIR CHRISTOPHER WREN

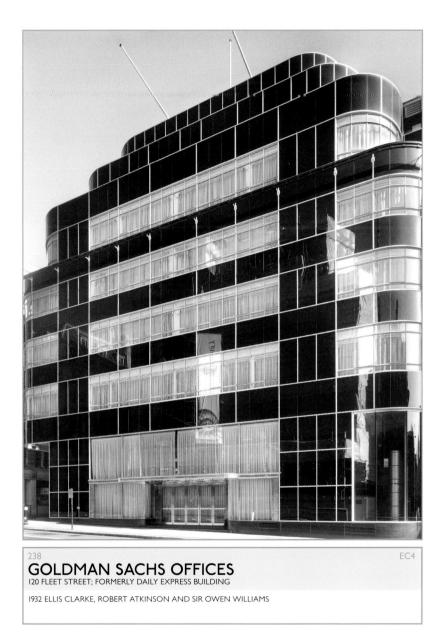

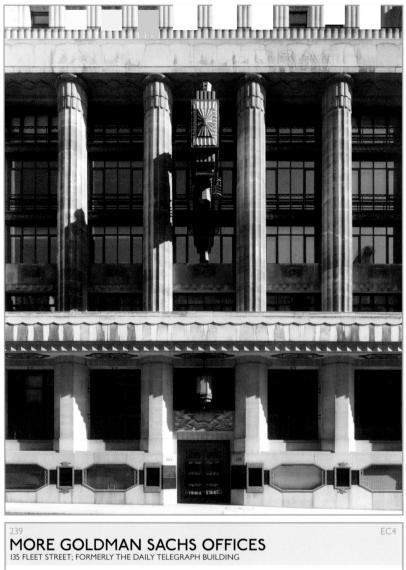

1928 ELCOCK AND SUTCLIFFE WITH TAIT 1990S EXTENSION BY KOHN PEDERSEN FOX

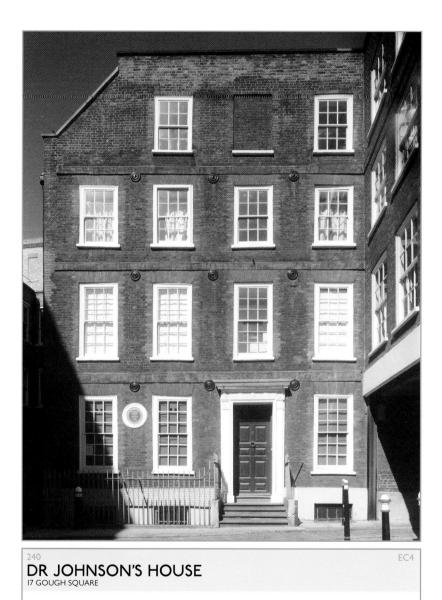

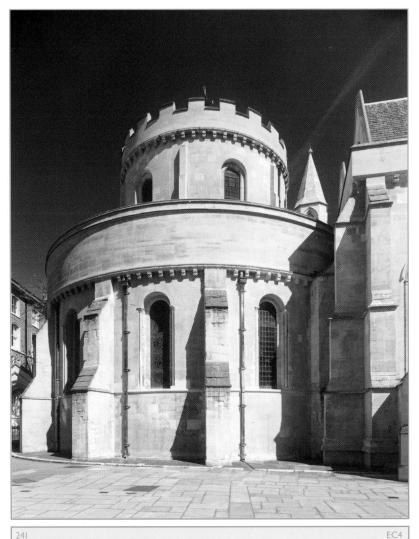

241 TEMPLE CHURCH THE TEMPLE, FLEET STREET, AND VICTORIA EMBANKMENT

C. 1160-85; 1220-40; RENOVATED 1800s SIR ROBERT SMIRKE AND E. LORE; 1948-58 WALTER GODFREY

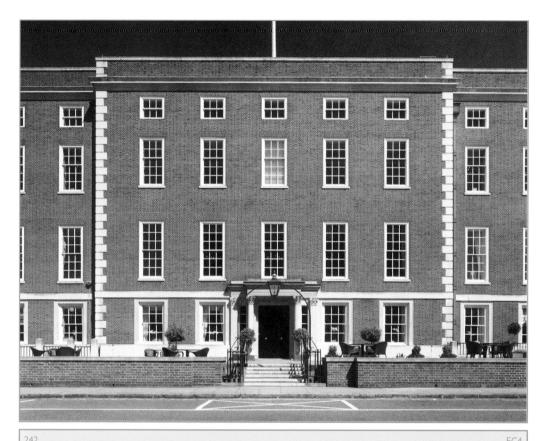

INNER TEMPLE LIBRARY

THE TEMPLE, FLEET STREET, AND VICTORIA EMBANKMENT

1506, 1800s, 1958 SIR HUBERT WORTHINGTON

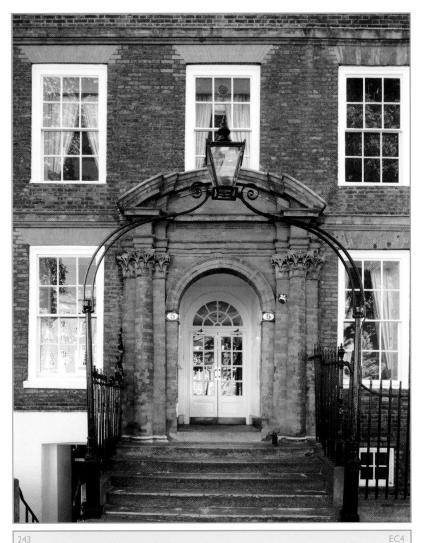

KING'S BENCH WALK THE TEMPLE, FLEET STREET, AND VICTORIA EMBANKMENT

1670s POSSIBLY SIR CHRISTOPHER WREN

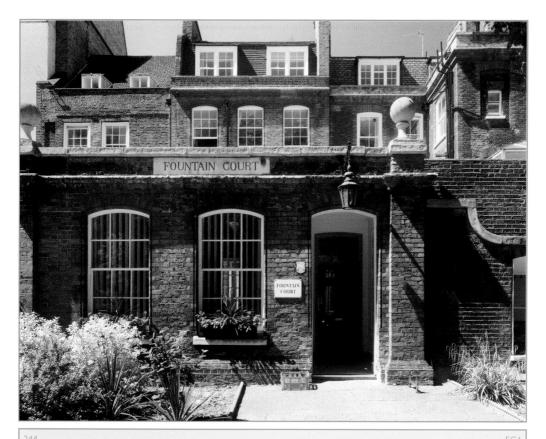

FOUNTAIN COURT THE TEMPLE, FLEET STREET, AND VICTORIA EMBANKMENT

1562-74 MIDDLE TEMPLE HALL; 1680 FOUNTAIN

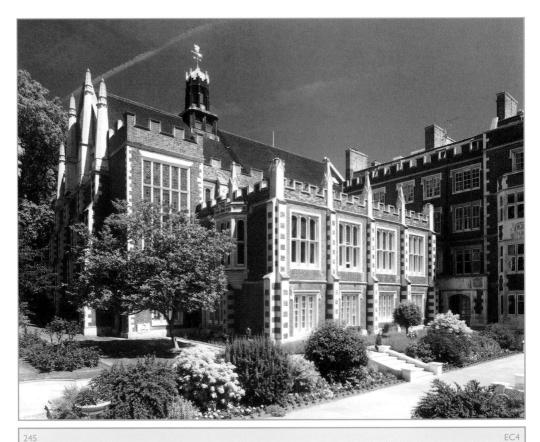

MIDDLE TEMPLE HALL THE TEMPLE; FLEET STREET, AND VICTORIA EMBANKMENT

1320, 1562-73/74

EAST LONDON (E)

Down by the Docks, they consume the slimiest of shell-fish, which seem to have been scraped off the copper bottoms of ships. . . the seamen roam in mid-street and mid-day, their pockets inside out, and their heads no better. . . Down by the Docks, scraping fiddles go in the public-houses all day long, and, shrill above their din and all the din, rises the screeching of innumerable parrots brought from foreign parts, who appear to be very much astonished by what they find on these native shores of ours.

-Charles Dickens, 'The Uncommercial Traveller' 1820

London spread eastward at this, the working end of the metropolis, following the Thames as it looped around the Isle of Dogs, bound for wider waters. Woods, meadows, farmland, and marshland surrendered to the march of industry; hamlets turned into suburbs, while urbanisation pointed a sharp greedy finger northward, too.

Meanwhile, the traffic flowed through—at first cows and pigs being driven to markets, then horses and carts laden with produce and, ultimately, trains and trucks. And all the while, ships plied up and down, to and from the bustling docks—and many a merry inn sprang up at the seafaring end of town where carousers could forget the threat of gallows, pirates, and press-gangs.

In recent years, much has changed. The greatest docks in the world shrank and closed. London paused and did a rethink but then attacked with renewed vigour. Now its eastern edge is an area of massive regeneration, with exciting new architecture to express this energy.

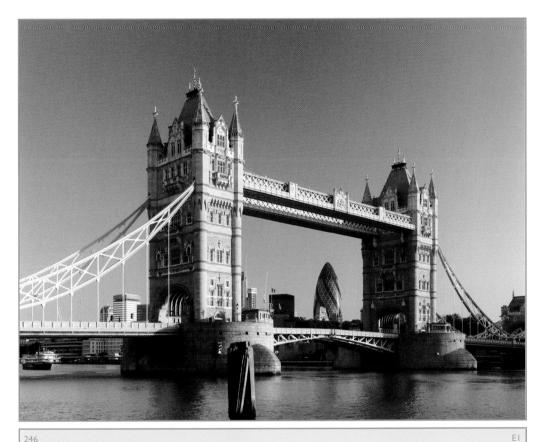

246 TOWER BRIDGE

1886–94 J. WOLFE BARRY, ENGINEER SIR HORACE JONES; 1982 RESTORED

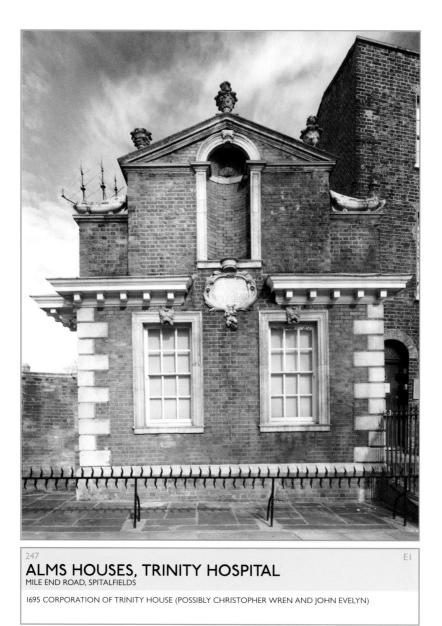

SILKWEAVING HOUSES

1721

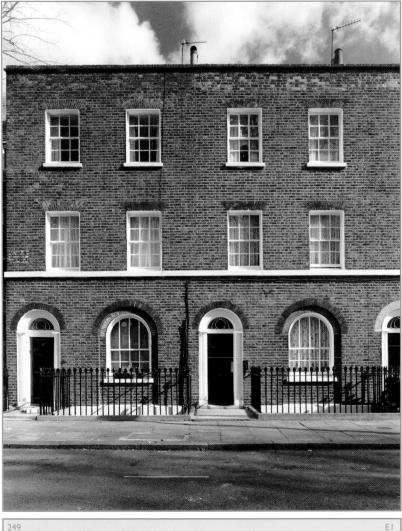

249 ALBERT GARDENS COMMERCIAL ROAD

C. 1810; LATE 1970s RESTORED ANTHONY RICHARDSON AND PARTNERS

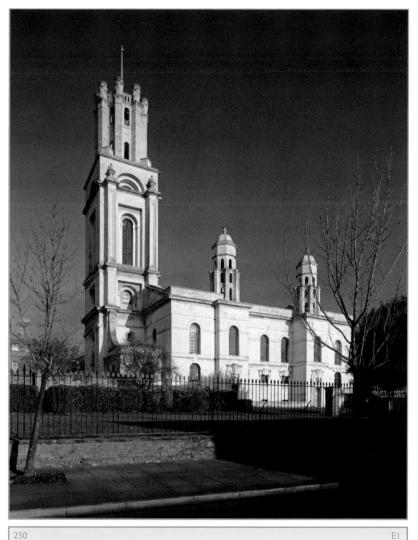

ST GEORGE IN THE EAST CANNON STREET ROAD, ENSIGN STREET

1714-29, NICHOLAS HAWKSMOOR; 1964 RECONSTRUCTED

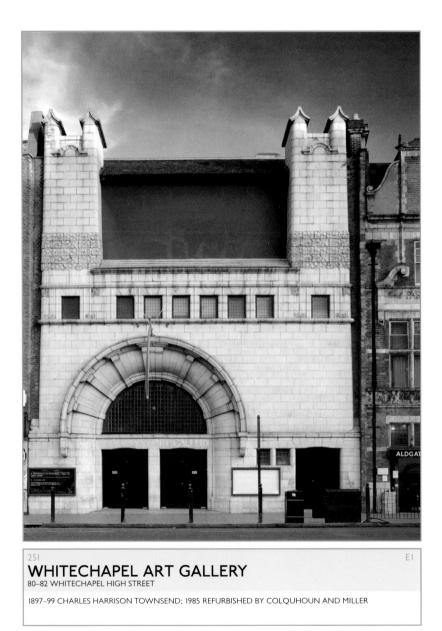

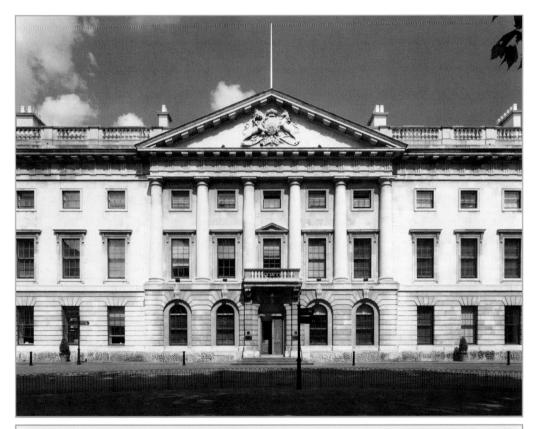

252 THE ROYAL MINT MANSELL STREET

1807–09 JAMES JOHNSON AND SIR ROBERT SMIRKE; 1989 RENOVATED BY SHEPHARD ROBSON

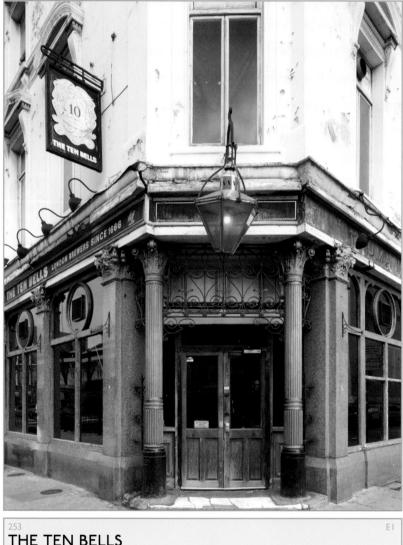

THE TEN BELLS 84 COMMERCIAL STREET

1752

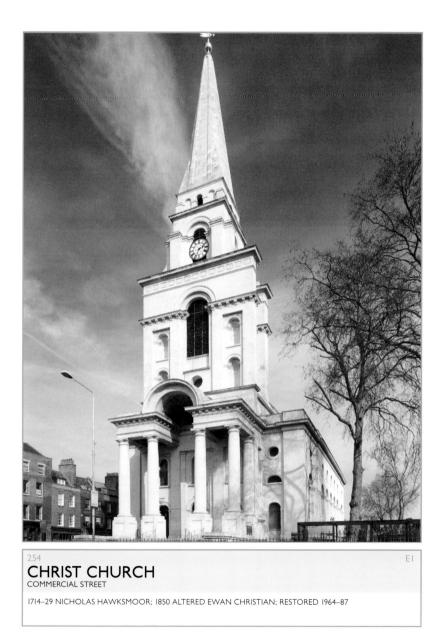

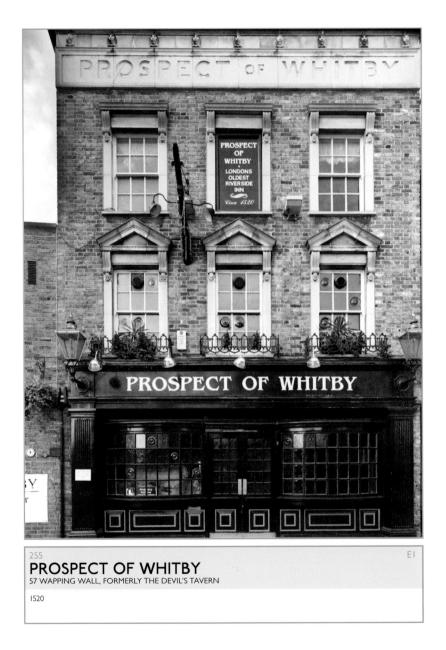

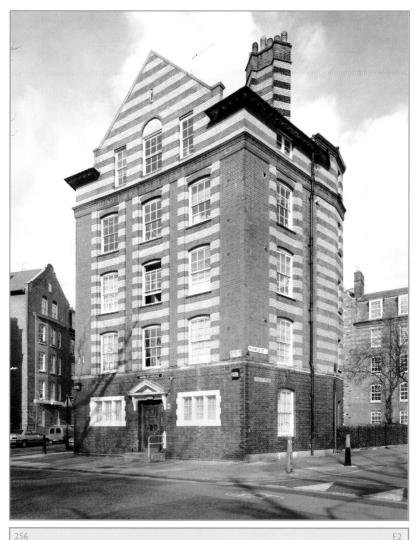

BOUNDARY STREET ESTATE

LATE 1800s EARLY 1900s LONDON COUNTY COUNCIL

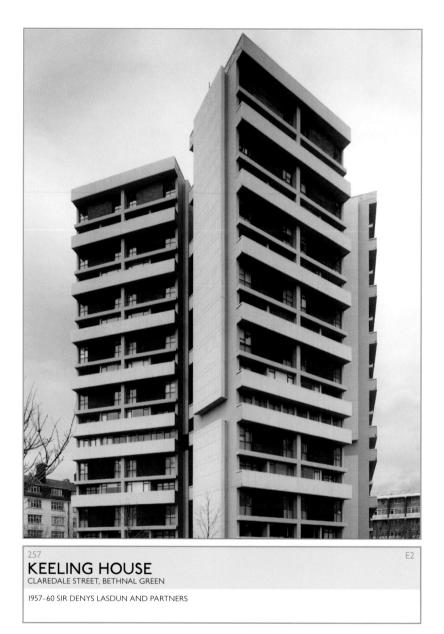

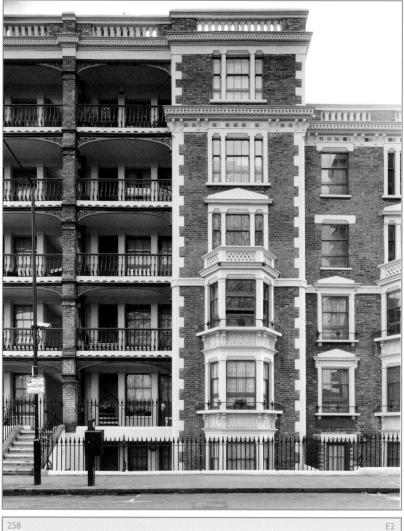

258 MODEL DWELLINGS COLUMBIA ROAD

1860-62 H. A. DARBISHIRE

GARNER STREET HOUSE BETHNAL GREEN, OFF COATE ROAD

2000-02 SEAN GRIFFITHS (FAT)

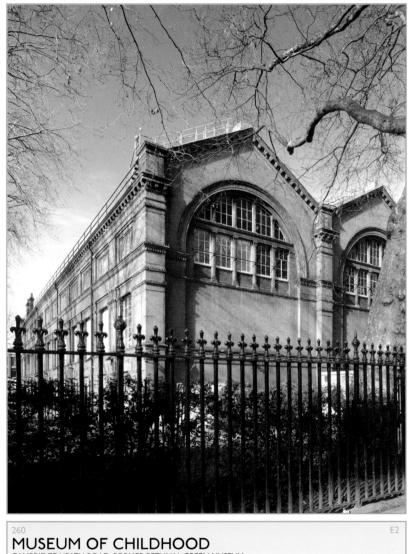

CAMBRIDGE HEATH ROAD, FORMER BETHNAL GREEN MUSEUM

1855–56 AND 1875 J. W. WILD, C. D. YOUNG AND COMPANY, SIR WILLIAM CUBITT

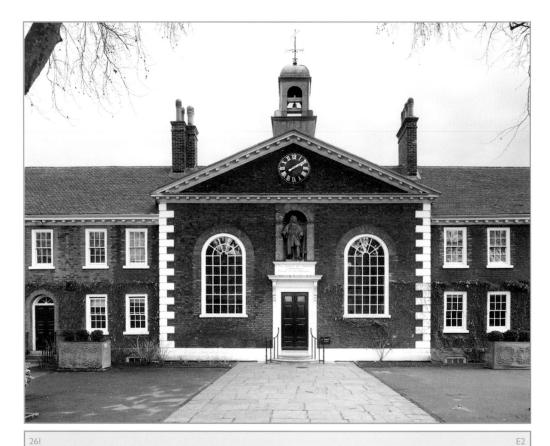

261 GEFFRYE MUSEUM ALMSHOUSES

1715

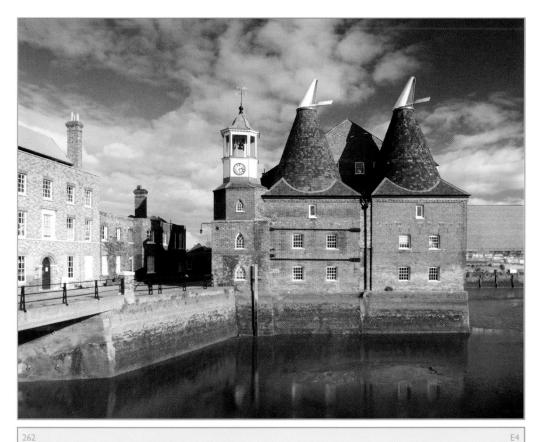

TIDE MILL DISTILLERY

1776, 1813

ALBION SQUARE

C. 1840s ARCHITECTS INCLUDE J. C. LOUDON AND ISLIP ODELL

264 **24 CHURCH CRESCENT** HOMERTON 1984 LONDON BOROUGH OF HACKNEY; COLQUHOUN AND MILLER

E9

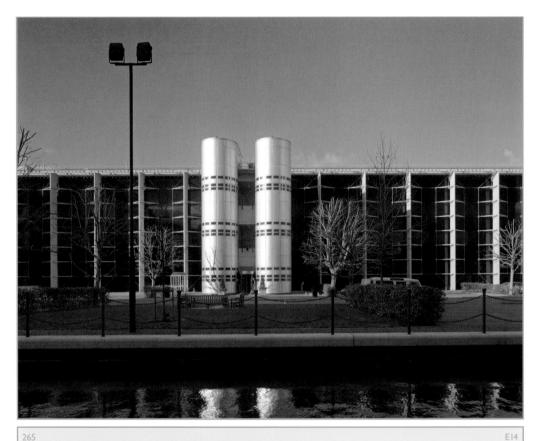

265 FINANCIAL TIMES PRINTING WORKS 240 EAST INDIA DOCK ROAD, BLACKWELL TUNNEL APPROACH

240 EAST INDIA DOCK ROAD, BLACKWELL TOININEL AFFRC

1987-88 NICHOLAS GRIMSHAW AND PARTNERS

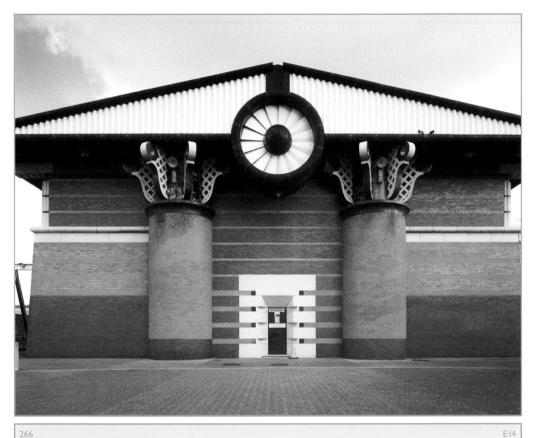

266 PUMPING STATION STEWART STREET

1985–88 JOHN OUTRAM ASSOCIATES

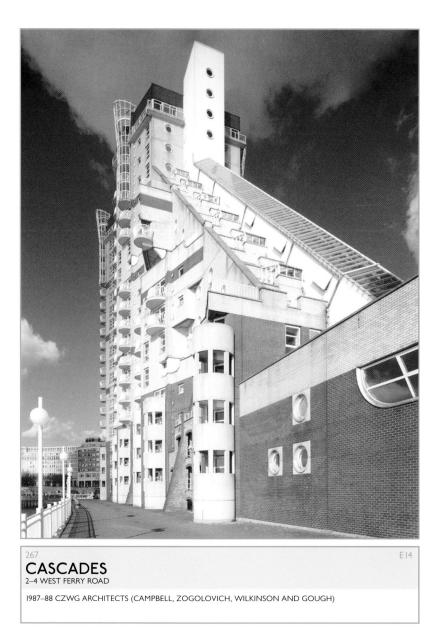

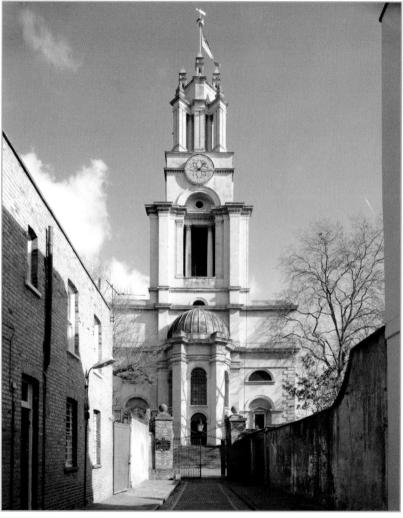

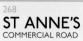

1714–30 NICHOLAS HAWKSMOOR; 1851–57 RESTORED JOHN MORRIS AND PHILIP HARDWICK; 1891 RESTORED SIR ARTHUR BLOMFIELD; 2006 WILLIAM DRAKE E14

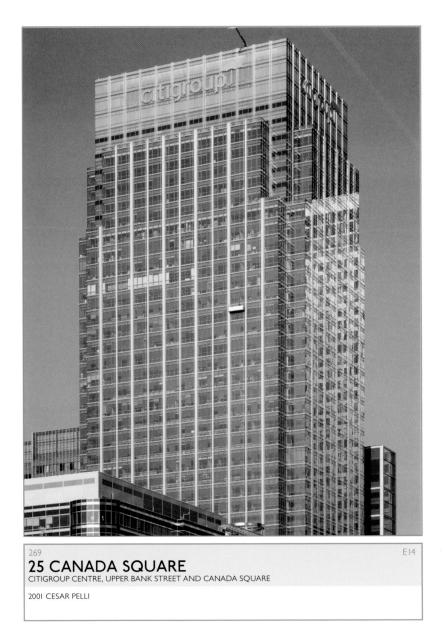

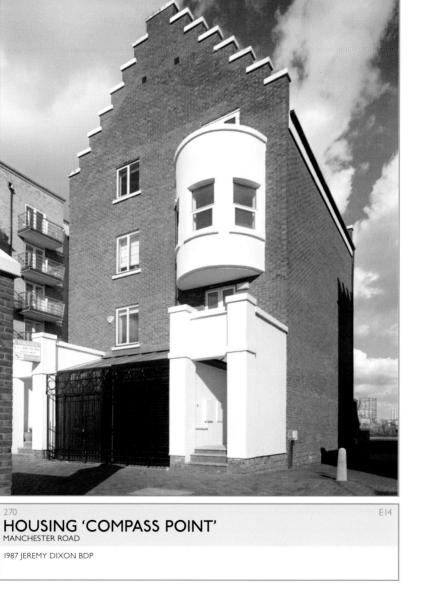

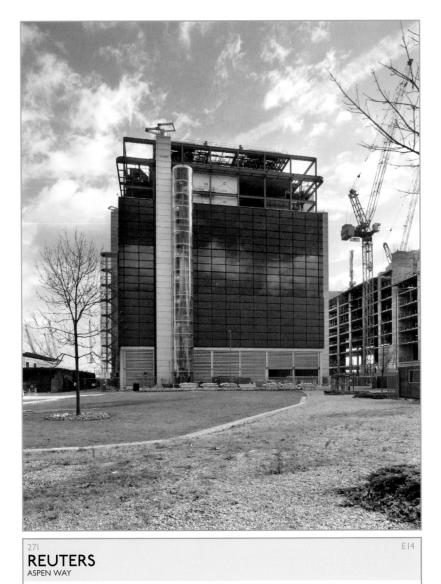

1987-88 RICHARD ROGERS PARTNERSHIP

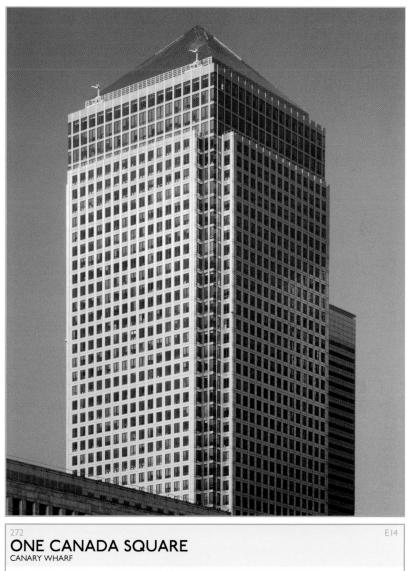

1991 CESAR PELLI AND ASSOCIATES WITH ADAMSON ASSOCIATES (TORONTO) AND FREDERICK GIBBERD, COOMBES AND PARTNERS

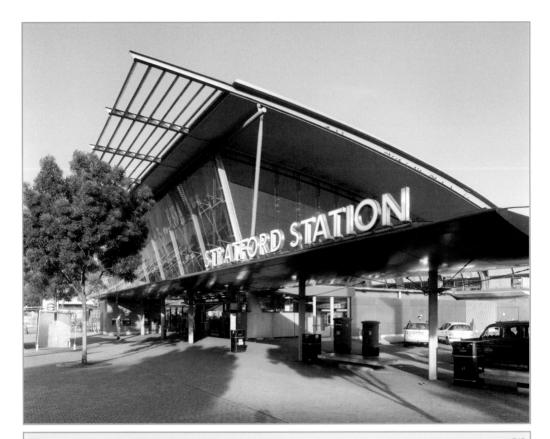

STRATFORD REGIONAL STATION

1994–99 WILKINSON EYRE AND TROUGHTON MCASLAN

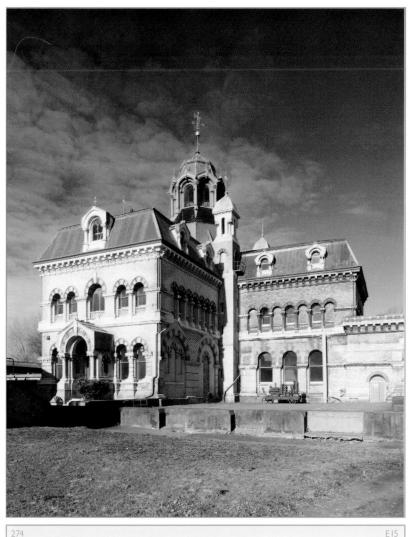

ABBEY MILLS PUMPING STATION ABBEY LANE, STRATFORD

1865–68 J. BAZALGETTE AND E. COOPER

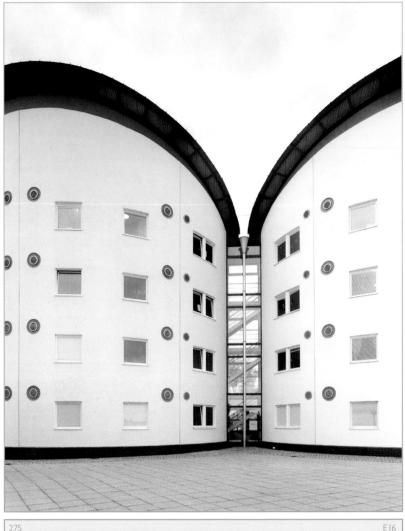

275 UNIVERSITY OF EAST LONDON DOCKLANDS CAMPUS, UNIVERSITY WAY 1997–99 EDWARD CULLINAN ARCHITECTS

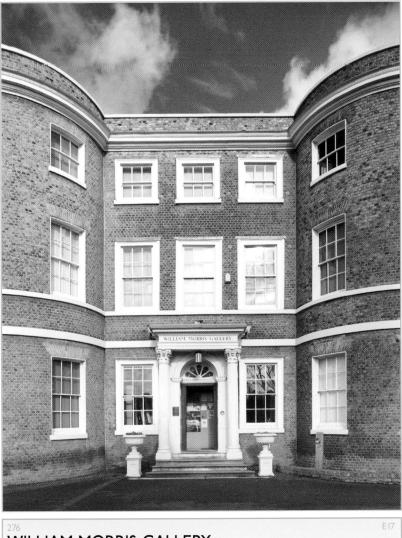

WILLIAM MORRIS GALLERY LLOYD PARK, FOREST ROAD, WALTHAMSTOW

1762

NORTH LONDON (N)

Long ago, parts of these northern climes offered an escape from the city for the rich. Highgate, London's highest point, is renowned for its fine Georgian houses and cemetery, the resting place of many, including Karl Marx. Hampstead Heath comprises vast acres of woodland and ponds, and was once part of the bishop of London's hunting estate. He set up a tollhouse on the main northward road out of the city and many inns sprang up along the route—as did highwayman Dick Turpin.

Sovereigns visited these parts when en route to (or returning from) the midlands, the north, or Scotland. Here, Henry VII was received by the corporation and citizens of London, after the battle of Bosworth Field and, in 1589, Queen Elizabeth I paid a royal visit. Mary, Queen of Scots, was detained for a short time at the house of the Earl of Arundel, on Holloway Hill, where in 1626 philosopher Lord Bacon died—having succumbed to a chill while experimenting with the freezing of poultry in snow. The ghost of a featherless squawking chicken is still said to haunt Pond Square.

Here, too, was a leper hospital, marked with a wayside cross and later the site of the Whittington stone where Dick Whittington, future Lord Mayor, heard the sound of Bow Bells summoning his return to the City. As the railways spread in the 1800s, houses were built and these northern surburban areas thrived.

NI	laliantan.
	Islington
N2	East Finchley
N3	Finchley Circle
	Finsbury Park
N5	Highbury
	Highgate
N7	Holloway
N9	Lower Edmonton
N10	Muswell Hill
	New Southgate
N12	North Finchley
	Palmers Green
	Southgate
	South Tottenham
N16	Stroke Newington
NI7	Tottenham
N18	Upper Edmonton
N19	Upper Holloway
N20	Whetstone
N21	Winchmore Hill
N22	Wood Green

N20

m

Ĩ

N Vitleto

N6

NI

1

294

223

ARoad.

chs

300

877 - 184 888 899 788

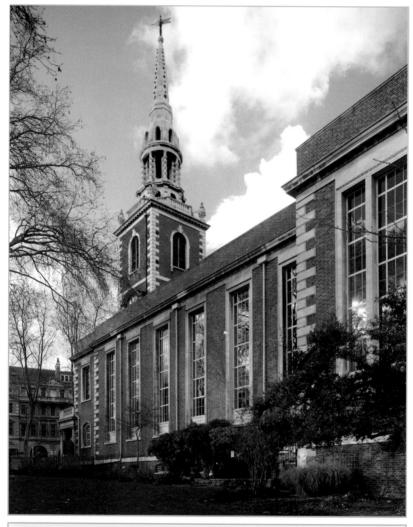

C. 1710 AND 1786

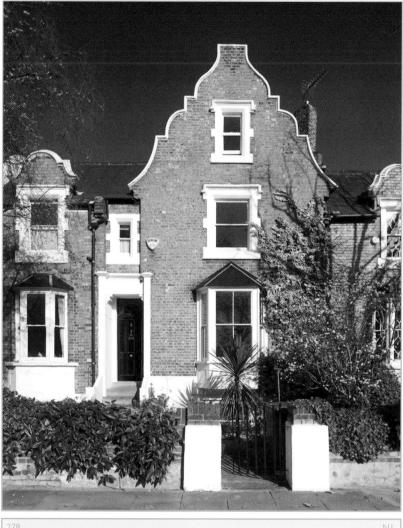

DUTCH-STYLE HOUSES DE BEAUVOIR SQUARE

1838 ROUMIEU AND GOUGH

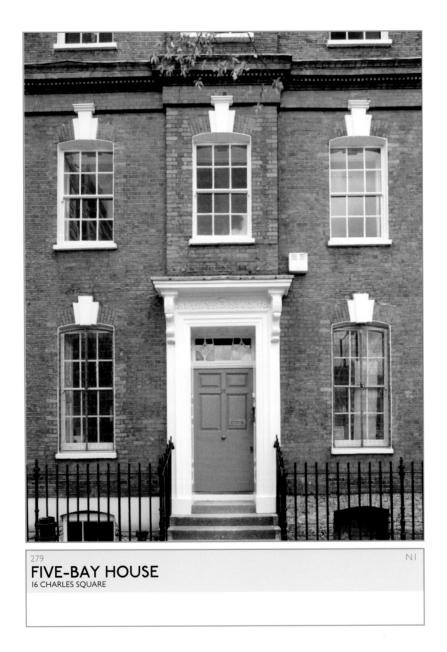

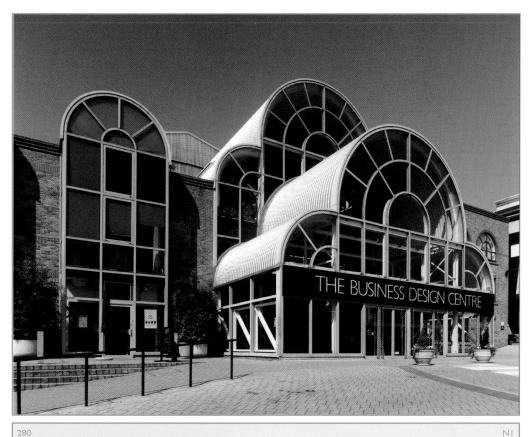

280 BUSINESS DESIGN CENTRE ISLINGTON HIGH STREET AND LIVERPOOL ROAD

1861-62 F. PECK, ENGINEERED BY HEAVISIDE; 1986 CONVERTED

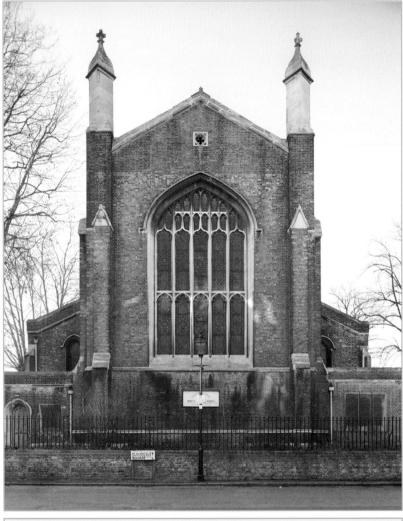

281 HOLY TRINITY CLOUDESLEY SQUARE

1826-28 SIR CHARLES BARRY

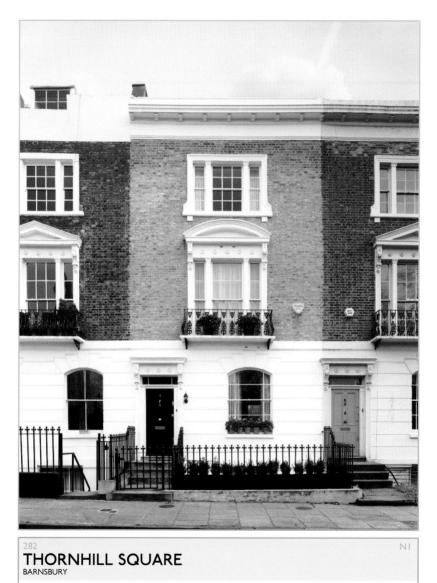

C. 1848 THOMAS CUBITT

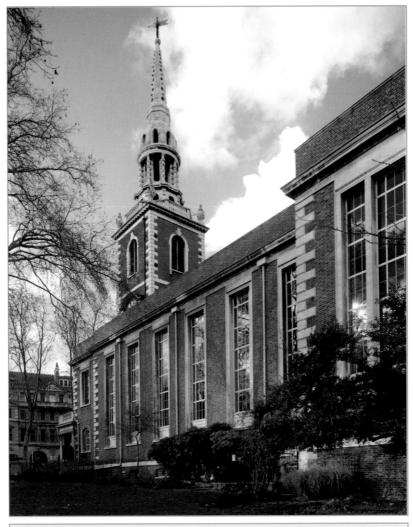

283 ST MARY'S CHURCH

1751-54 LAUNCELOT DOWBIGGIN; REBUILT 1956

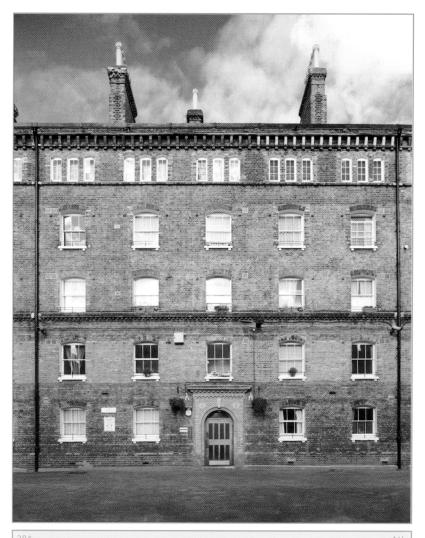

PEABODY TRUST HOUSING

1865 H. A. DARBISHIRE

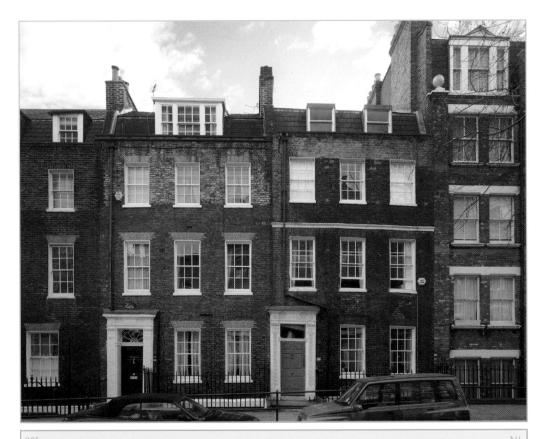

GEORGIAN HOUSES 33-35 CROSS STREET

C. 1780

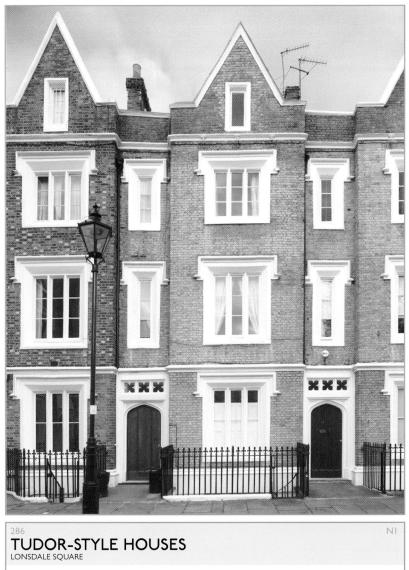

1838-45 R. C. CARPENTER

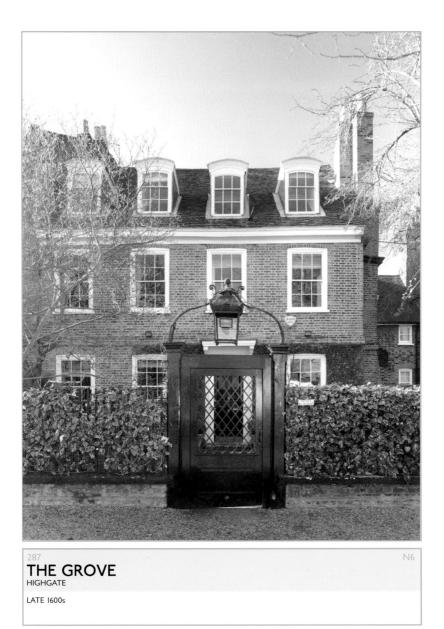

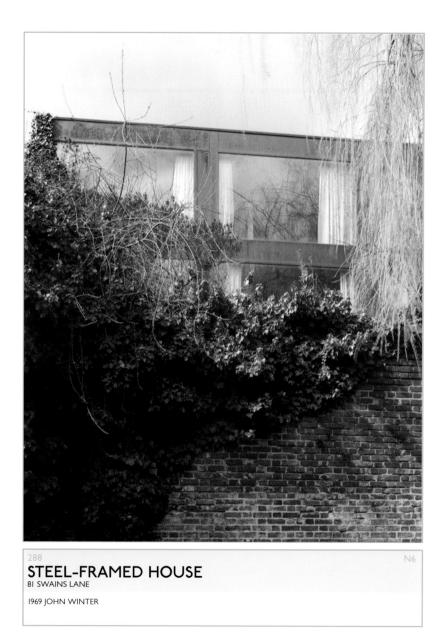

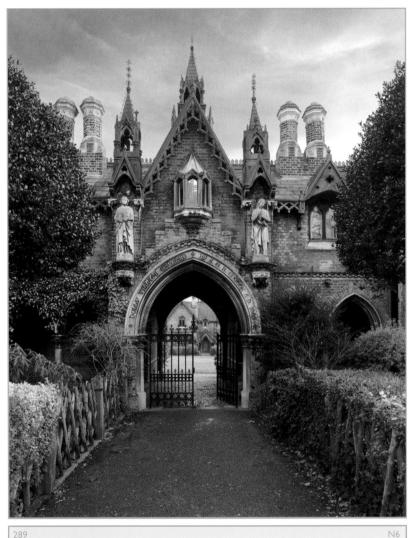

1865 H. A. DARBISHIRE

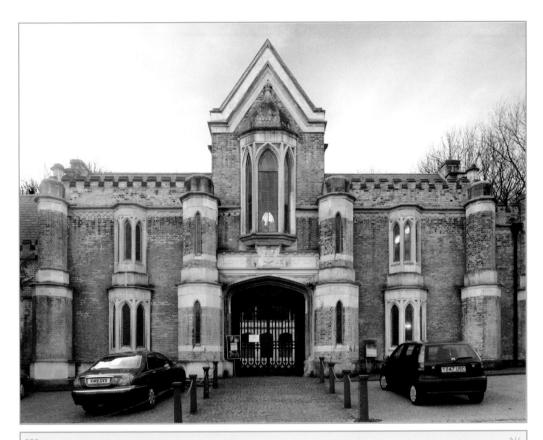

290 HIGHGATE CEMETERY SWAINS LANE, HIGHGATE

1839 STEPHEN GEARY, J. B. BUNNING AND J. OLDRED SCOTT

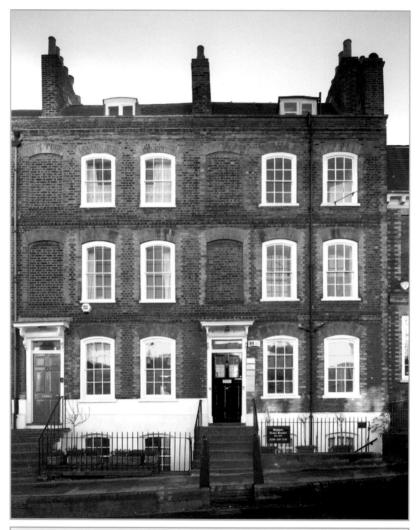

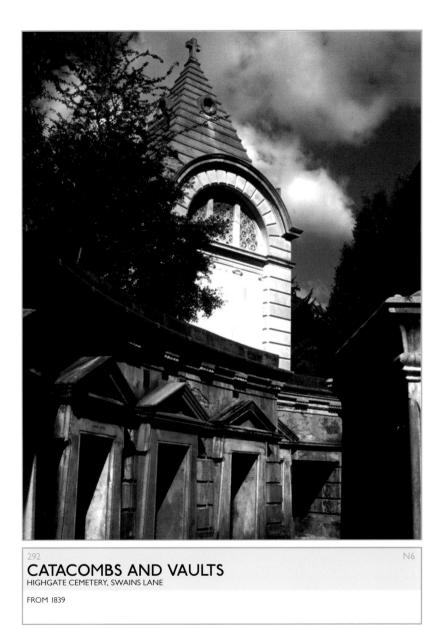

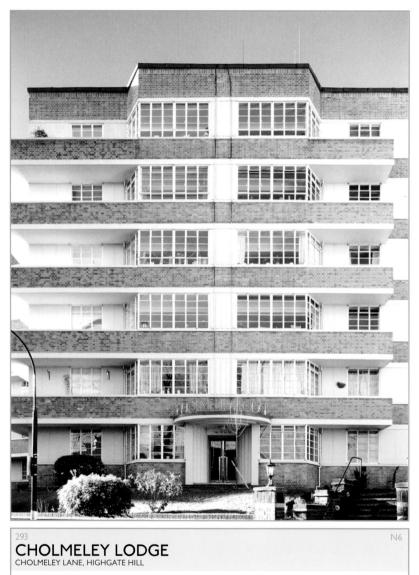

1934 GUY MORGAN

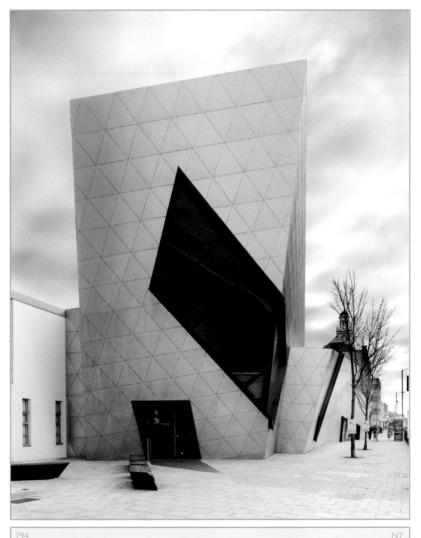

LONDON METROPOLITAN UNIVERSITY I66-220 HOLLOWAY ROAD; GRADUATE CENTRE

2004 DANIEL LIBESKIND

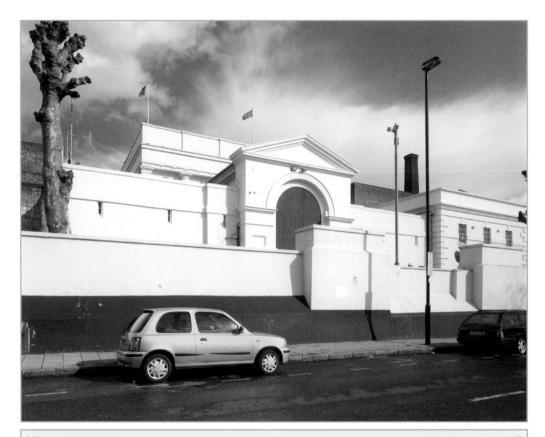

PENTONVILLE PRISON CALEDONIAN ROAD

1840-42 SIR JOSHUA JEBB (FIRST SURVEYOR GENERAL OF PRISON)

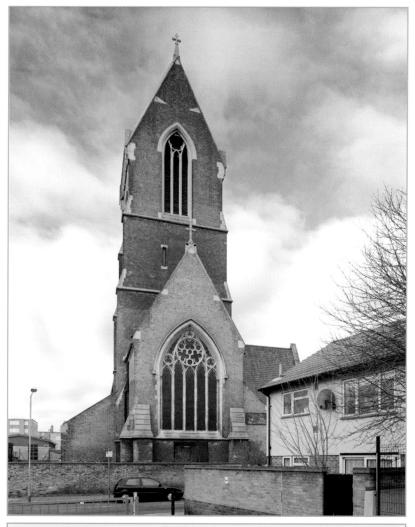

N16

ST MATTHIAS WORDSWORTH ROAD

1851 W. BUTTERFIELD

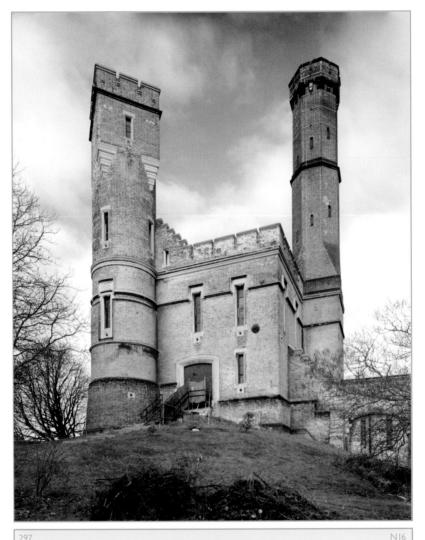

WATERWORKS PUMPING STATION

1854–56 CHADWELL MYLNE

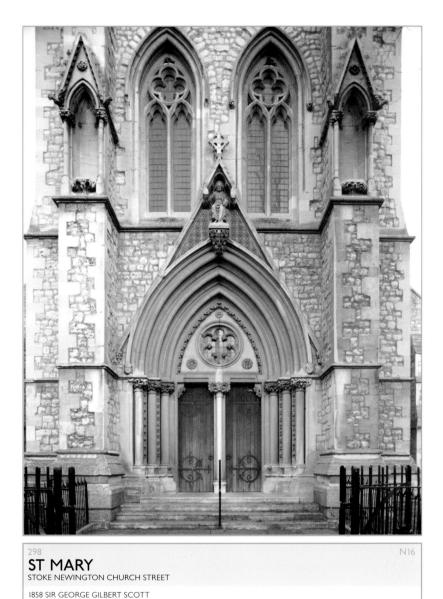

N16

OLD ST MARY STOKE NEWINGTON CHURCH STREET

1563; 1824–29 SIR CHARLES BARRY

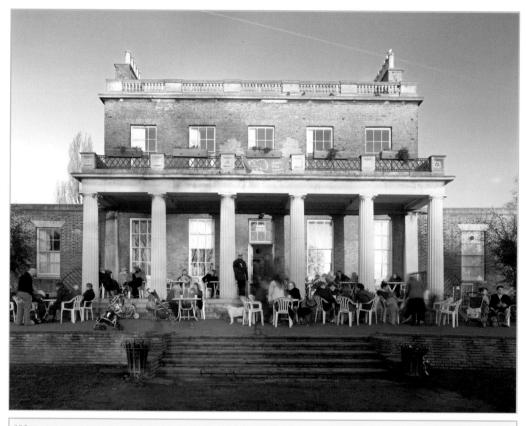

CLISSOLD HOUSE CLISSOLD PARK

1790s; 1820–30 J. WOODS

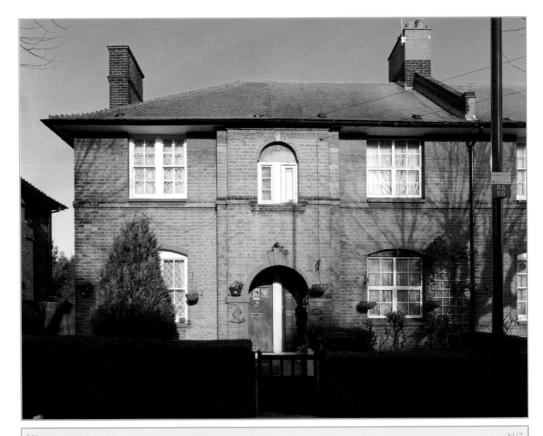

WHITE HART LANE ESTATE

1904-12, 1921-28 W. E. RILEY AND G. TOPHAM FORREST

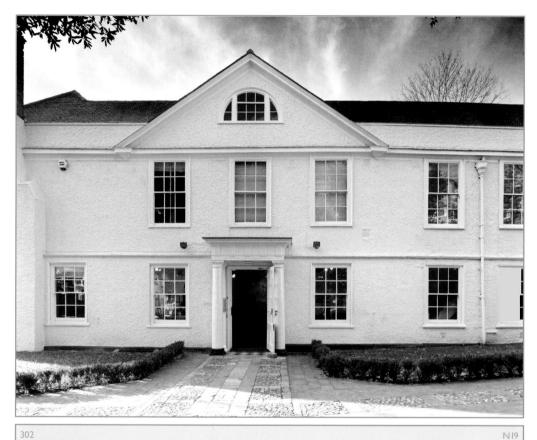

302 LAUDERDALE HOUSE HIGHGATE HILL

FROM 1580

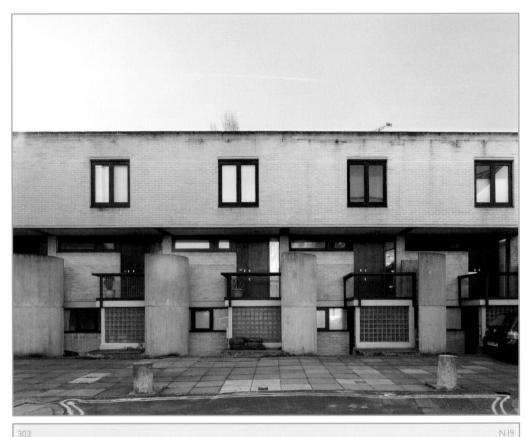

303 **ROW OF HOUSES** 24–32 WINSCOMBE STREET

1966-68 NEAVE BROWN

NORTH WEST LONDON (NW)

This area sweeps through stunning Regent's Park, pretty Primrose Hill, and Somers Town—squeezed between Euston and St Pancras stations. It is served by the solid march of the ancient A5—that began life as Roman Watling Street, striding from Dover to Shropshire—as well as the North Circular road looping around the busy suburbs. The mighty MI has carved its way into the landscape here, too, coming to an abrupt end near Hendon.

Hampstead is a tangle of roads, once a spa, with lovely vistas that attracted writers and artists. In Kentish Town, the River Fleet flows, albeit channelled out of sight; and at Gospel Oak, the custom of beating the parish boundaries used to culminate in biblical readings around the tree. Kilburn—once a northern outpost, has many Victorian and Edwardian houses. St. John's Wood, originally part of the Great Middlesex Forest, was owned by the Knights of St John of Jerusalem and is home to Lords Cricket. Here are Abbey Road Studios where many 1960s Beatles's recordings were made, including *Abbey Road* with its sleeve depicting the pedestrian crossing—now a place of pilgrimage.

Golders Green, once fields and farmland, is today a solid middle-class suburb with a Jewish community, synagogues, and many substantial Edwardian family homes. Hampstead Garden Suburb, meanwhile, began as a utopian housing project in 1907, spearheaded by Lady Henrietta Barnett where (in theory) the several tiers of the rich, the middle-class professionals, and honest artisans would gain from closer contact. Whatever its achievements in merging social stratas, it is regarded as one of the finest examples of early 1900s domestic architecture and planning.

NWI Regent's Park NW2 Cricklewood NW3 Hampstead NW4 Hendon NW5 Kentish Town NW6 West Hampstead NW7 Mill Hill NW8 St John's Wood NW9 Kinsbury NW10 Willesden NW11 Golders Green 930

922

304

325

605

323

90) 920

Î

Œ

313 0

-

님뿐

JUF

<u>"</u>

NWI

E H H H

306

340 339

347

345

322

533 1779 541

349 348

NW7

NW

NW Š

NWIO

350

559

327 328 337

336 330

346

332 ³³³

33

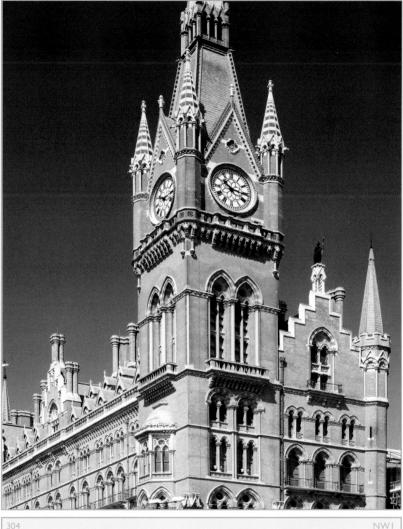

ST PANCRAS STATION, HOTEL, AND OFFICES

1866–76 SIR GEORGE GILBERT SCOTT; W. H. BARLOW AND R. M. ORDISH

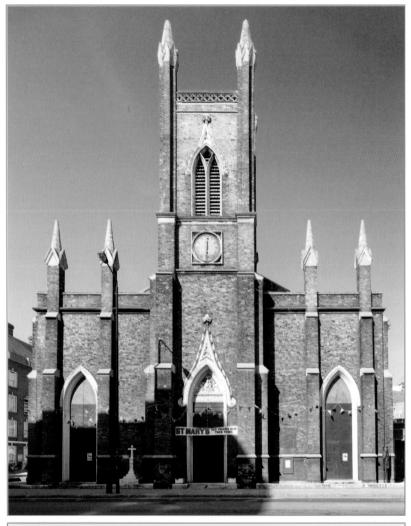

NWI

ST MARY THE VIRGIN

1824 HENRY W AND WILLIAM INWOOD; 1888 EWAN CHRISTIAN

NWI

MARYLEBONE STATION

1898-99 R. W. EDIS

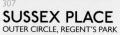

1822 JOHN NASH

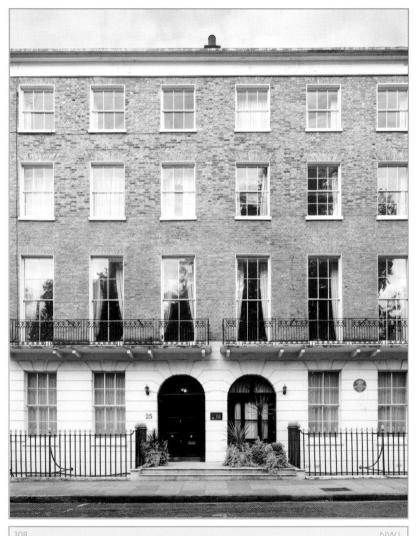

BUILT ON A CRICKET GROUND

C. 1815

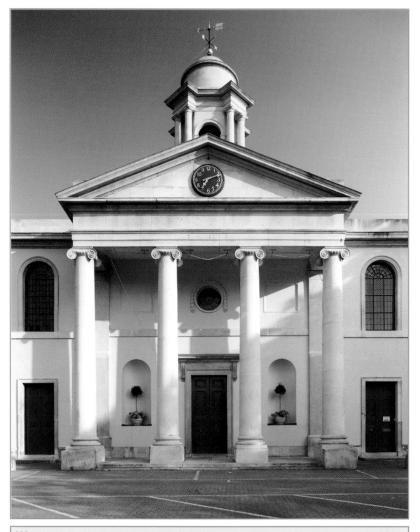

ST JOHN'S WOOD CHAPEL

1813 THOMAS HARDWICK

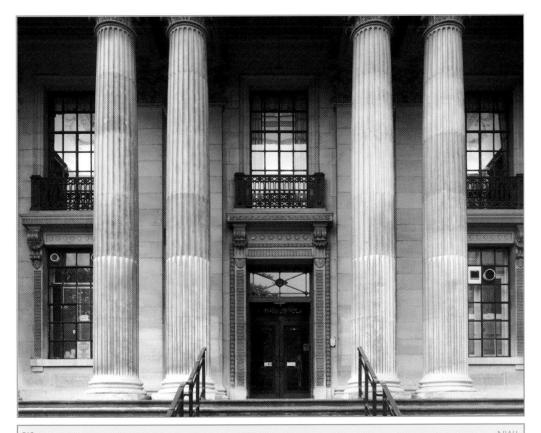

WESTMINSTER COUNCIL HOUSE, MARYLEBONE TOWN HALL

1914–21 SIR EDWIN COOPER

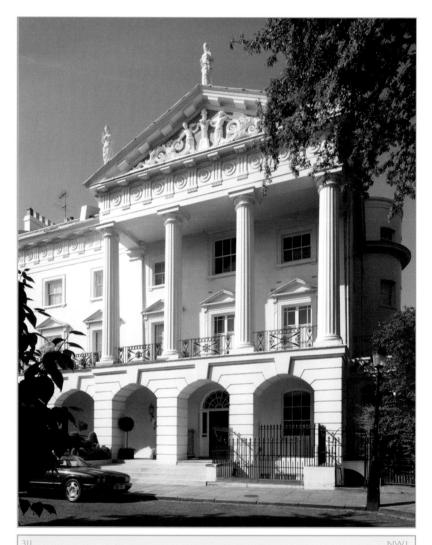

HANOVER TERRACE AND LODGE

1822-23 JOHN NASH; 1827 DECIMUS BURTON

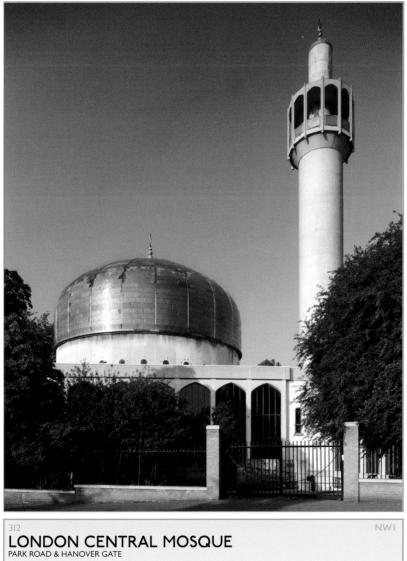

1978 BUILT BY SIR FREDERICK GIBBER AND PARTNERS

RUDOLPH STEINER HOUSE

1926-37 MONTAGUE WHEELER

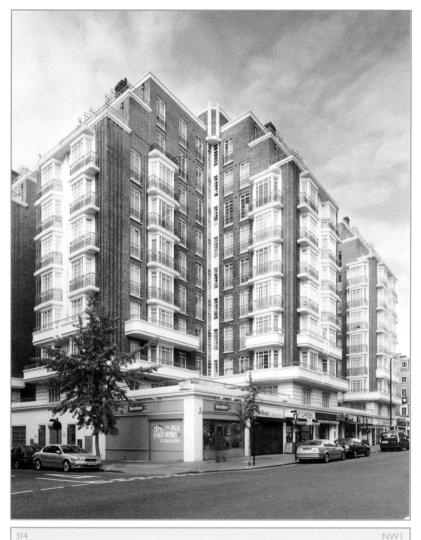

DORSET HOUSE GLOUCESTER PLACE AND MARYLEBONE ROAD

1935 T. P. BENNETT AND JOSEPH EMBERTON

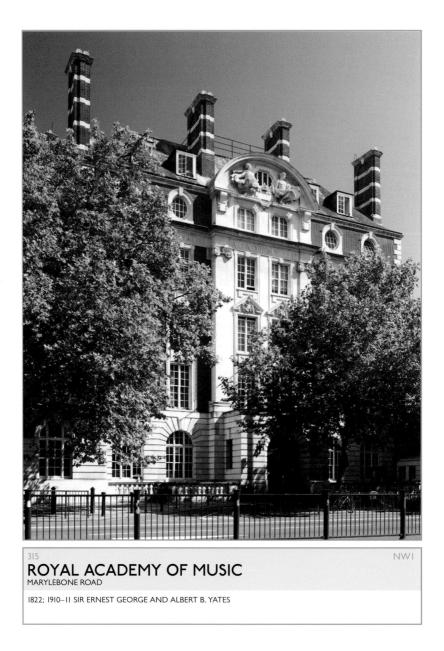

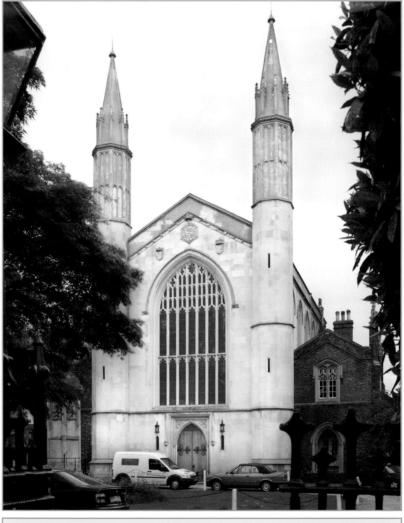

NWI

ST KATHARINE'S HOSPITAL

1826 AMBROSE POYNTER

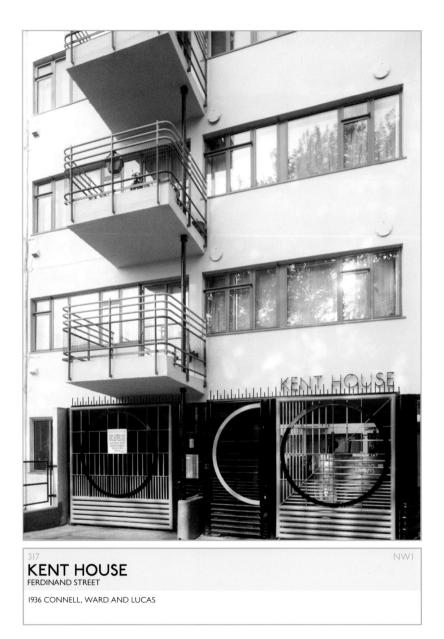

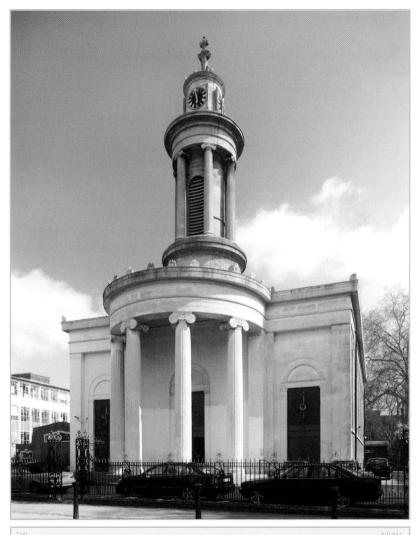

ALL SAINTS, CAMDEN TOWN

1822-24 W. AND H. W. INWOOD

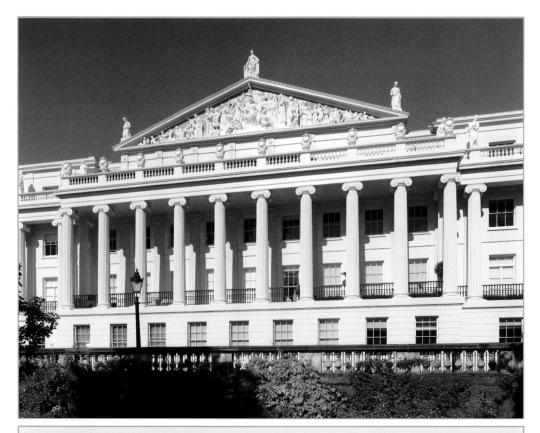

CUMBERLAND TERRACE

1826–27 JOHN NASH AND JAMES THOMSON; POST-WORLD WAR II, RECONSTRUCTED K. PEACOCK

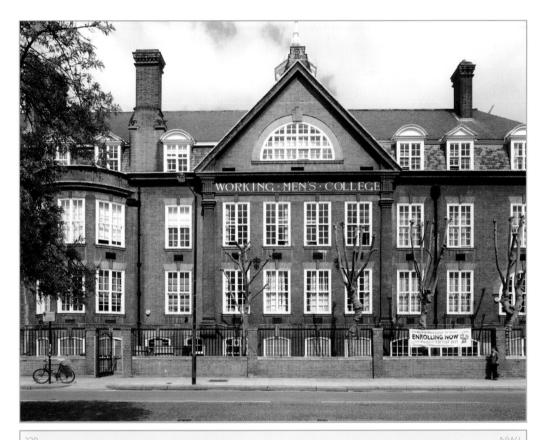

WORKING MEN'S COLLEGE

1905 W. H. CAROË

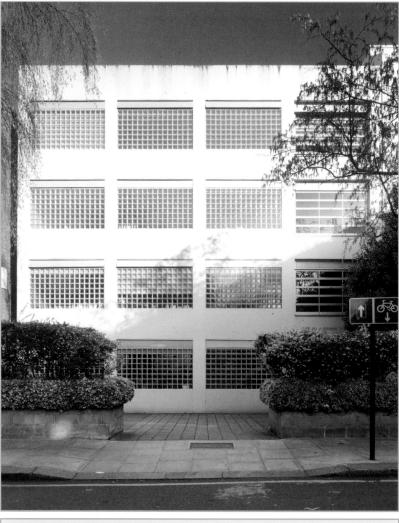

1968-71 GEORGIE WOLTON

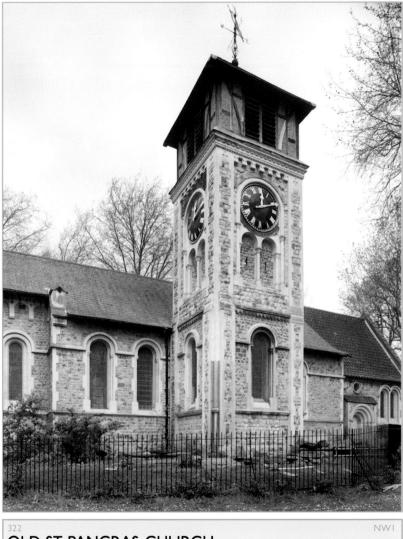

OLD ST PANCRAS CHURCH

313; 1000s; RESTORED 1848 ROUMIEU AND GOUGH

323 UNIVERSITY COLLEGE HOSPITAL GOWER STREET

1828; 1834; 1897-1906 ALFRED WATERHOUSE

NW

NWI

ST PANCRAS CHURCH EUSTON ROAD AND UPPER WOBURN PLACE

1819–22 H. W. AND W. INWOOD

EUSTON ROAD 1974–98 SIR COLIN ST JOHN WILSON

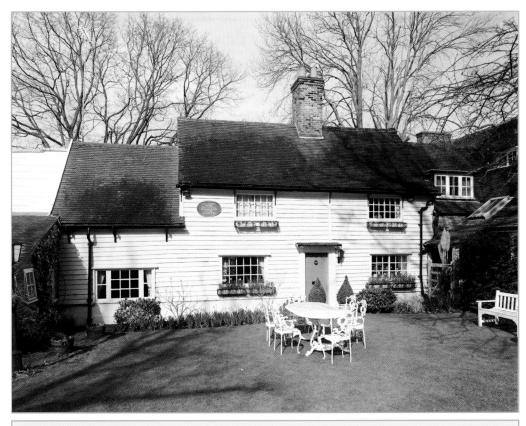

WYLDES FARM

1600s

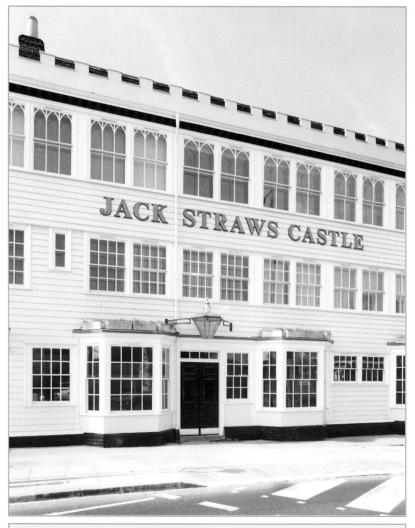

1700s; 1964 RAYMOND ERITH AND QUINLAN TERRY

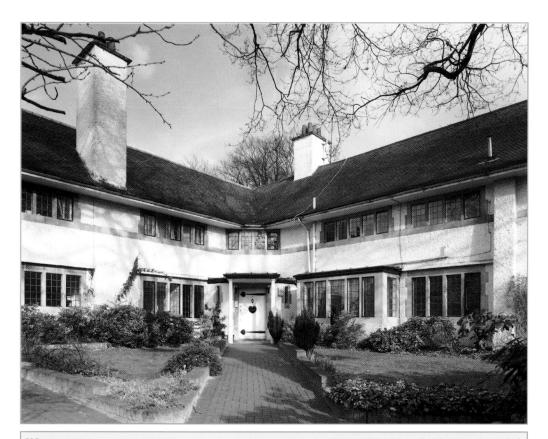

ANNESLEY LODGE

1896 C. F. A. VOYSEY

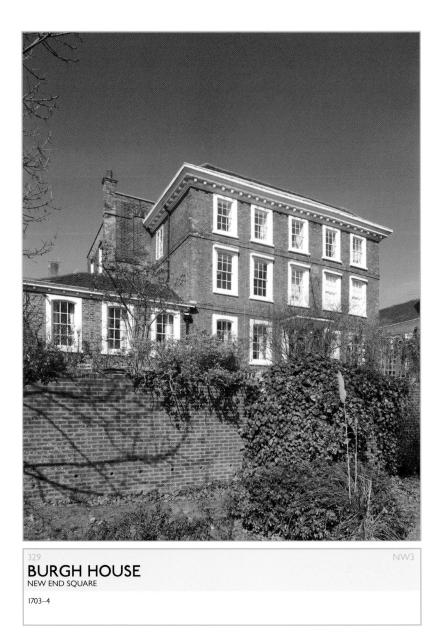

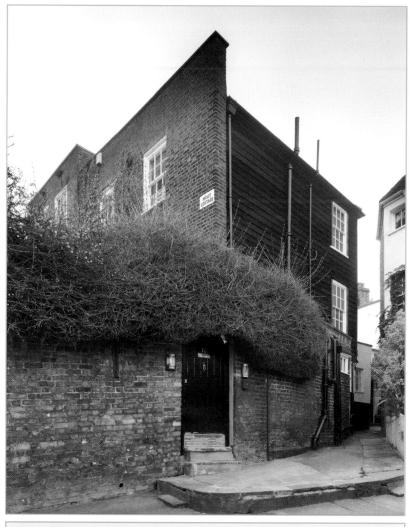

NW3

GEORGIAN HOUSES

1700s-1800s

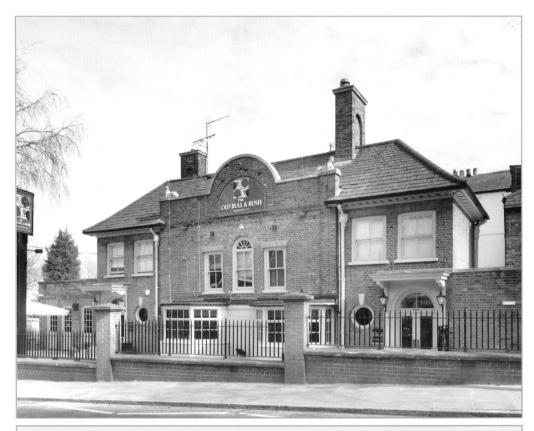

THE OLD BULL AND BUSH

1700s

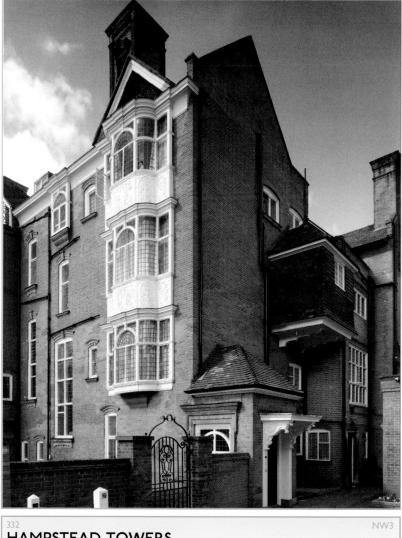

HAMPSTEAD TOWERS

1875 R. NORMAN SHAW

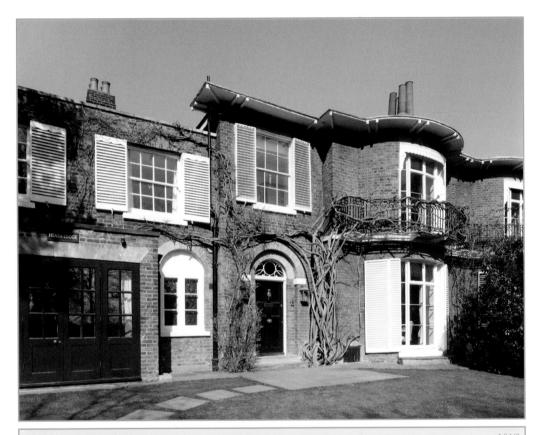

EAST HEATH ROAD

PROBABLY 1770s JAMES WYATT

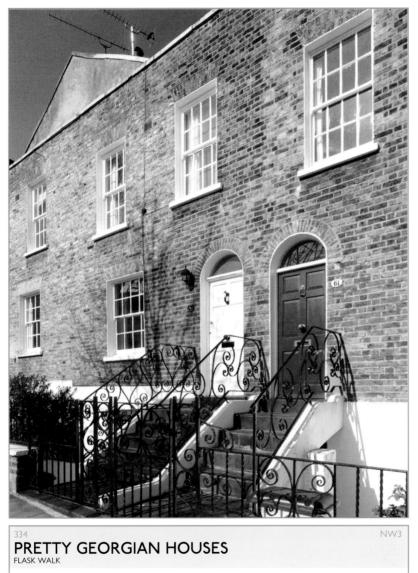

1700s

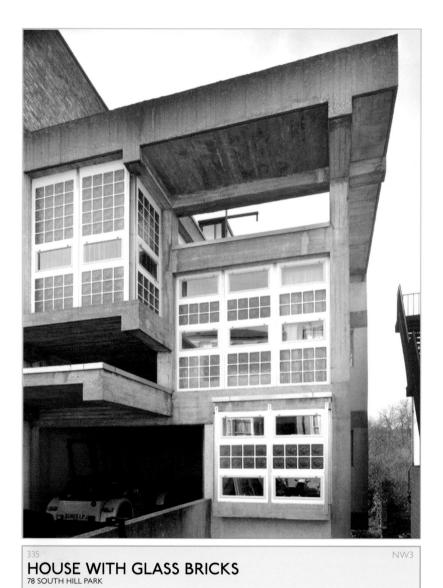

356 FIVE HUNDRED BUILDINGS OF LONDON

1968 BRIAN HOUSDEN

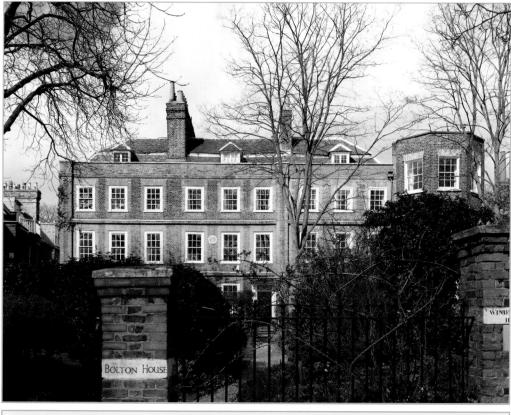

BOLTON HOUSE

1700s

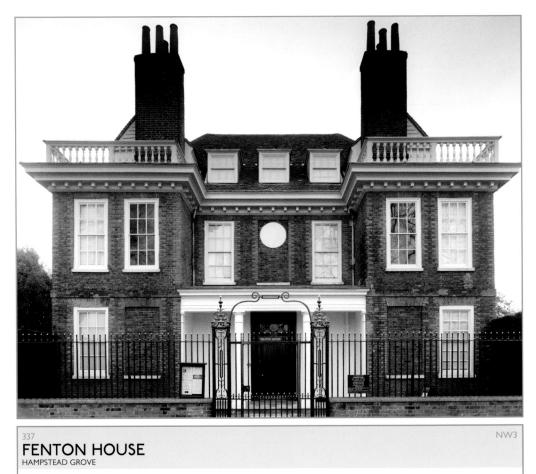

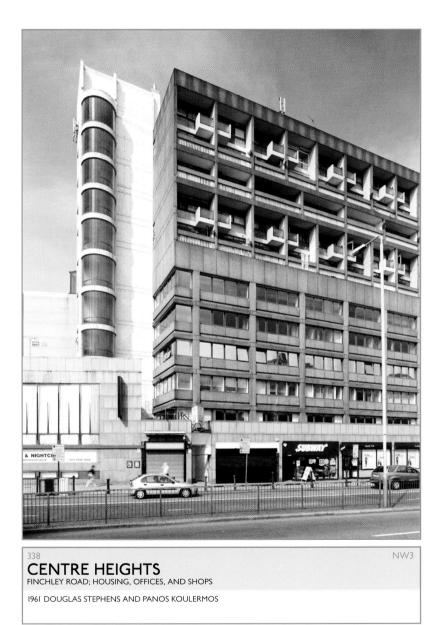

ABSTRACT HOUSING

1973-81 LONDON BOROUGH OF CAMDEN ARCHITECTS DEPARTMENT: ALAN FORSYTH AND GORDON BENSON

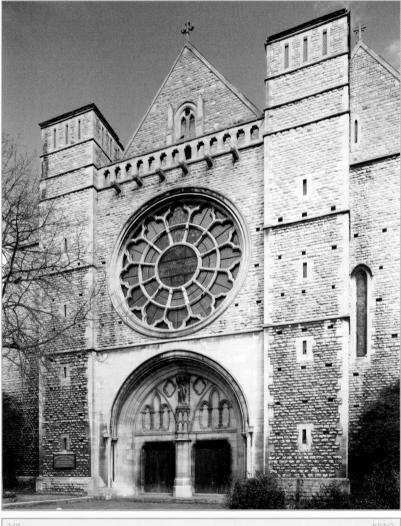

NW.

1889 JAMES BROOKS; CHANCEL 1913 SIR GILES GILBERT SCOTT

ALL HALLOWS SHIRLOCK AND SAVERNAKE ROADS

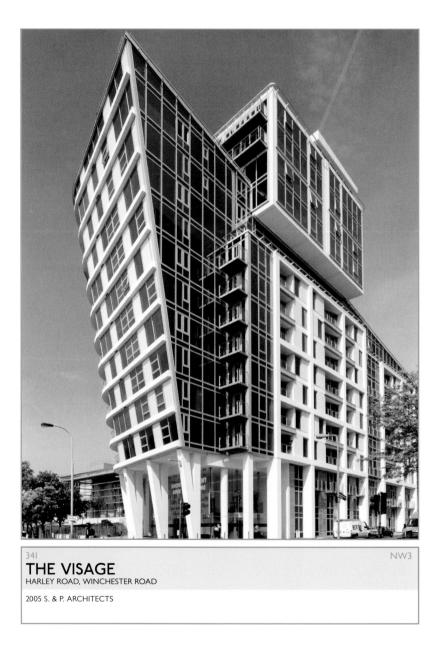

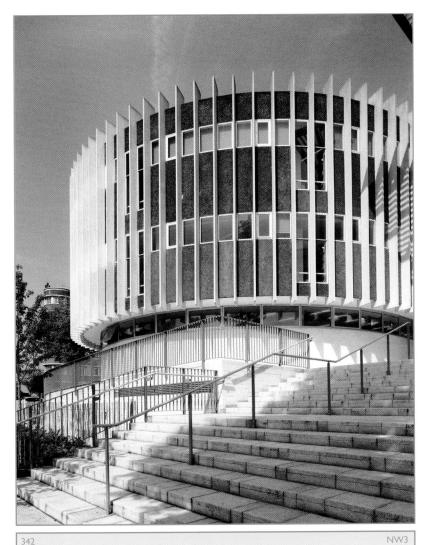

PUBLIC LIBRARY AND SWIMMING POOL

1964 SIR BASIL SPENCE, BONNINGTON AND COLLINS; 2000 RESTORED BY JOHN MCASLAN AND PARTNERS

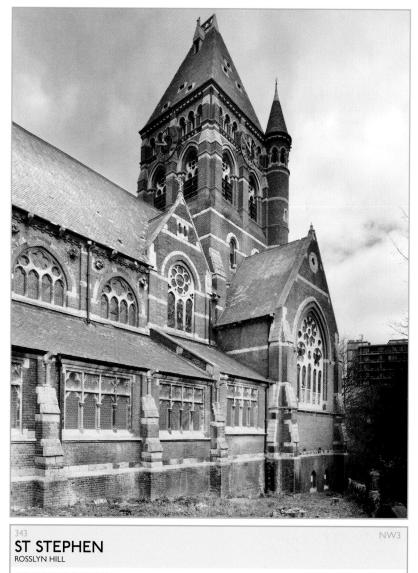

1869-71 SAMUEL S. TEULON

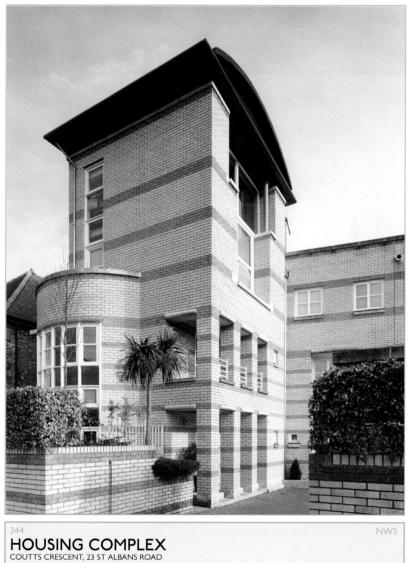

1986-89 CHASSAY WRIGHT ARCHITECTS

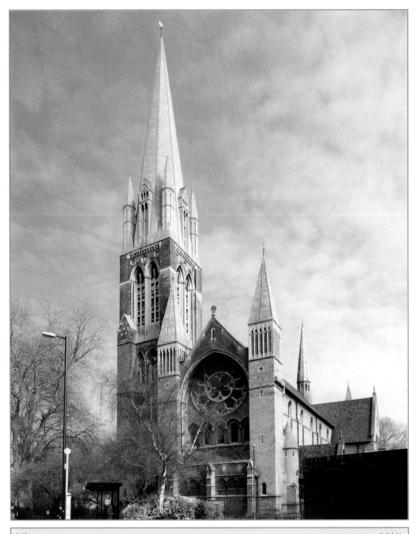

ST AUGUSTINE, KILBURN

1870–98 J. L. PEARSON

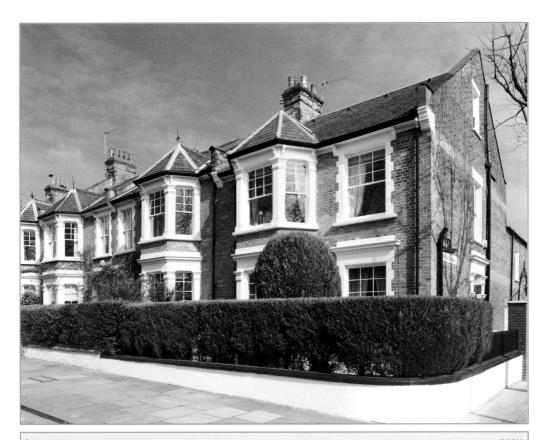

KINGSWOOD AVENUE

1875-87 AUSTIN, ROLAND PLUMBE (CORPORATION OF THE CITY OF LONDON)

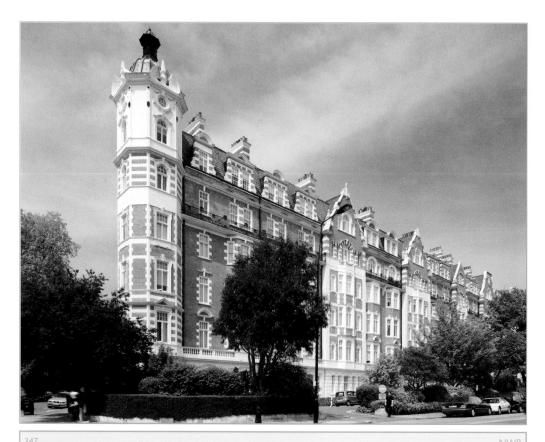

NORTHGATE MANSION

1910

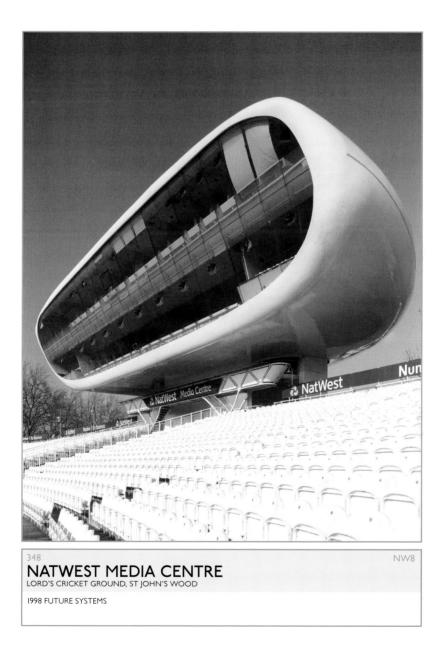

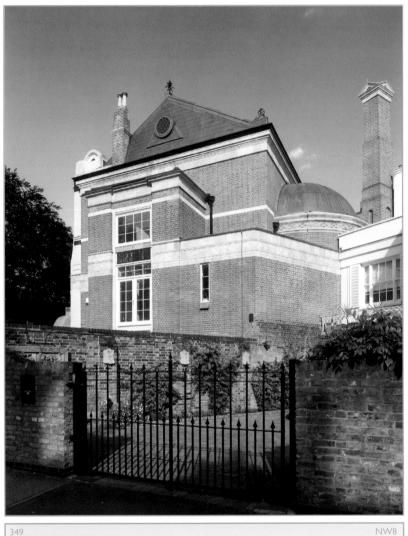

349 NW8 HOUSE AND STUDIO 44 GROVE END ROAD C. 1825; 1883 SIR LAWRENCE ALMA-TADEMA; 2006 RESTORED BLEIER ESTATES LTD

NW10

ACAD CENTRE CENTRAL MIDDLESEX HOSPITAL PARK ROYAL

1995-2000 AVANTI ARCHITECTS

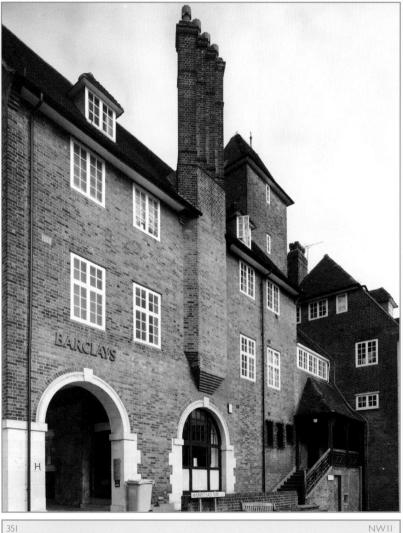

351 SHOPS AND FLATS TEMPLE FORTUNE, HAMPSTEAD GARDEN SUBURB

1907 RAYMOND UNWIN

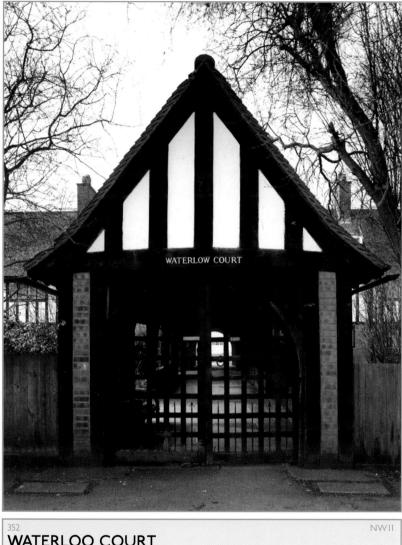

WATERLOO COURT HEATH CLOSE, OFF HAMPSTEAD WAY

1908–9 M. H. BAILLIE SCOTT

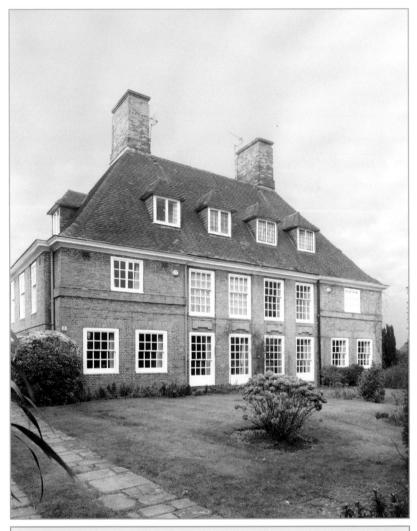

NWII

ELEGANT SYMMETRY ERSKINE HILL, HAMPSTEAD GARDEN SUBURB

1908-10 SIR EDWIN LUTYENS

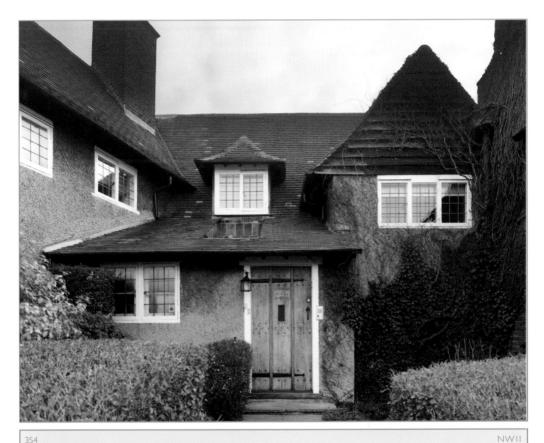

COTTAGE-STYLE HOUSES 22 HAMPSTEAD WAY

C. 1910 BAILLIE SCOTT

SOUTH WEST LONDON (SW)

South West London is one of the city's most historic areas, thronging as it is with all the magnificent buildings in Westminster, such as the Houses of Parliament, Westminster Abbey, Westminster Cathedral, and the tower of Big Ben. There are numerous famous sights, including Buckingham Palace, Horse Guards Parade, St James's Palace, and Hyde Park Corner. Tate Britain is found in this region, as well as the wonderful store, Harrods, and the glorious Royal Albert Hall.

Kensington is home to a great concentration of magnificent museums, including the grandiose Natural History Museum with its incredible dinosaurs and Blue Whale, the fascinating Science Museum, and the treasures in the Victoria and Albert Museum. Belgravia and Chelsea are wealthy; Chelsea has been described as 'a village of palaces' but is also famous for Chelsea buns and Chelsea china—and was where Henry VIII was rowed upriver to visit his chancellor, Sir Thomas More, in the I500s.

Further south lie . . . Battersea, renowned for its power station and dog's home; Wimbledon, known for its common, the Wombles, and the tennis tournaments; and Crystal Palace (destroyed by fire in 1936), where the Great Exhibition of 1851 displayed 13,000 exhibits to over 6,200,000 visitors in a magnificent glass edifice—later transferred to Sydenham from Hyde Park. Tooting Bec and Streatham rose on a former Roman route linking Roman London with Chichester to the southwest—eventually the turnpike road from London to Brighton, and the forerunner of today's A23. South West London includes the Bishop's Palace in Lambeth, the largest open-air swimming pool in the United Kingdom in Tooting, and regal Victoria Station.

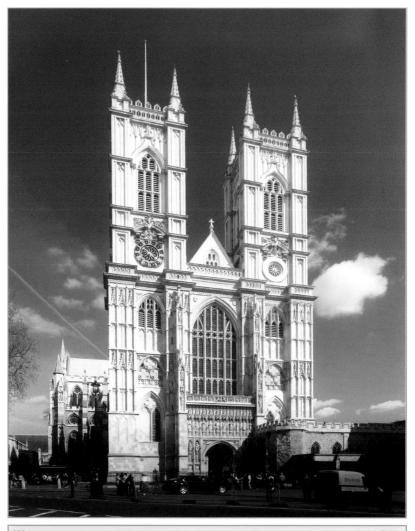

WESTMINSTER ABBEY PARLIAMENT SQUARE

FROM 1066; 1245; 1375, HENRY YEVELE

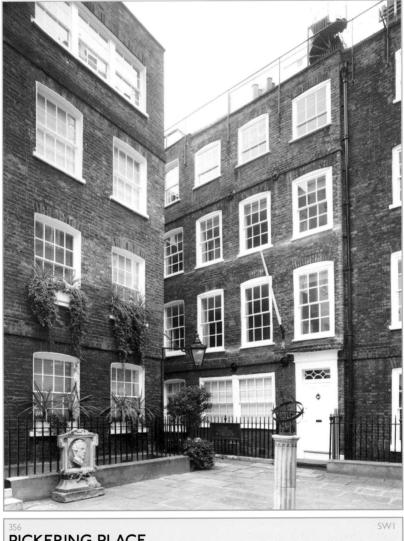

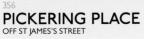

1731 WILLIAM PICKERING

SWI

ROYAL AUTOMOBILE CLUB 89 PALL MALL

1908-11 MEWÈS AND DAVIS, WITH E. KEYNES PURCHASE

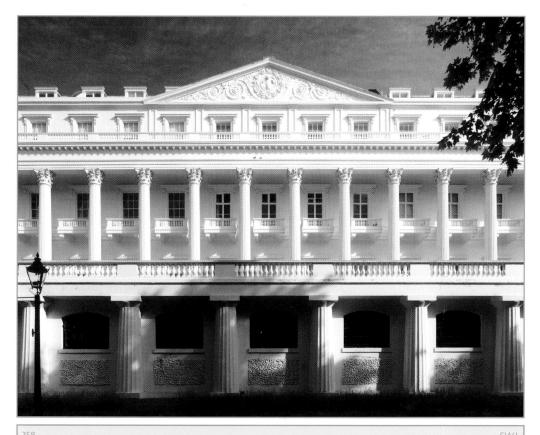

CARLTON HOUSE TERRACE

1827–32 JOHN NASH

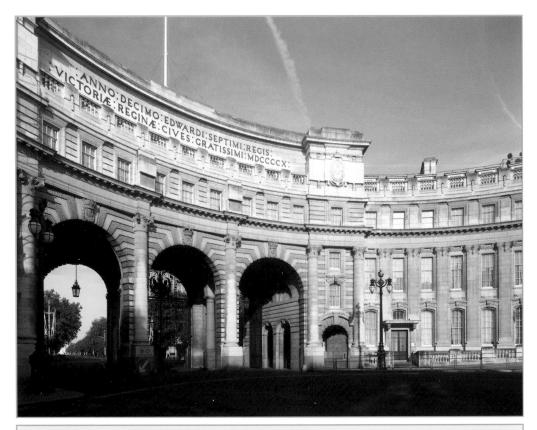

ADMIRALTY ARCH BETWEEN THE MALL AND TRAFALGAR SQUARE

1906-11 SIR ASTON WEBB

SWI

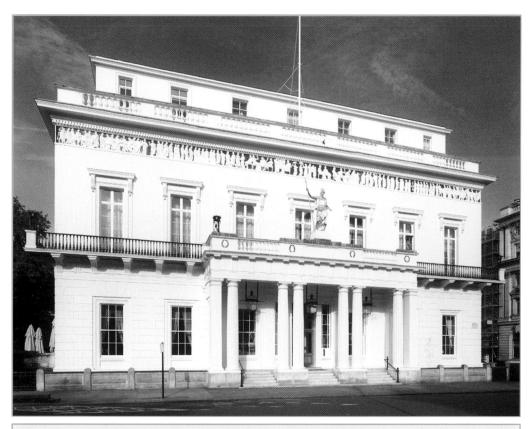

THE ATHENEUM CLUB

1828-30 DECIMUS BURTON

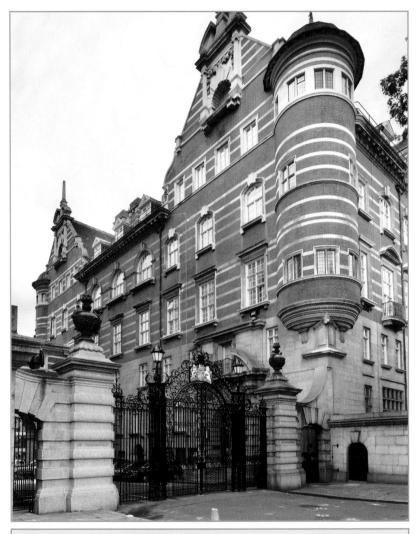

361 NORMAN SHAW BUILDING VICTORIA EMBANKMENT; FORMERLY NEW SCOTLAND YARD

1886–90 R. NORMAN SHAW

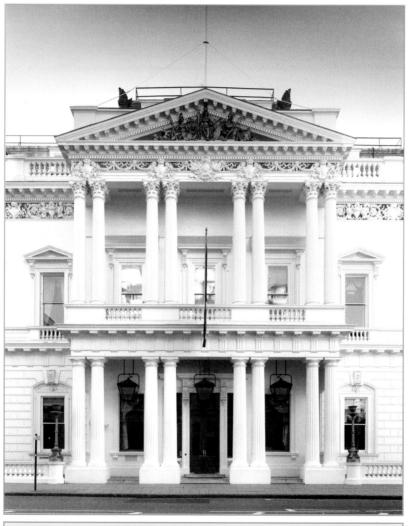

362 SWI INSTITUTE OF DIRECTORS PALL MALL AND WATERLOO PLACE; FORMERLY UNITED SERVICES CLUB 1827, 1842 JOHN NASH, DECIMUS BURTON

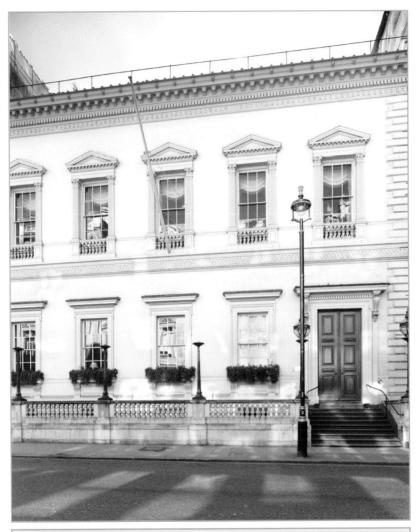

SWI

TRAVELLER'S CLUB

1829-32 SIR CHARLES BARRY; 1952-53 RESTORED F. ROWNTREE

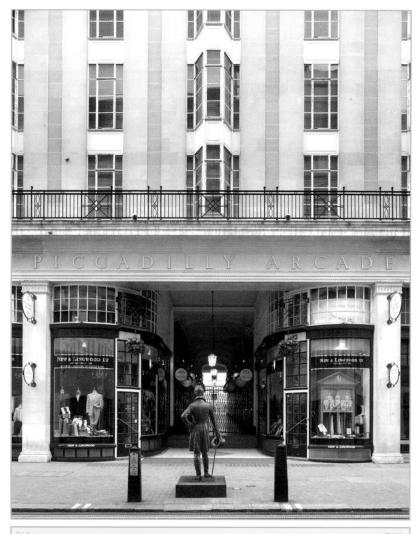

PICCADILLY ARCADE CONNECTING 174 PICCADILLY TO 52 JERMYN STREET

1909–10 THRALE JELL

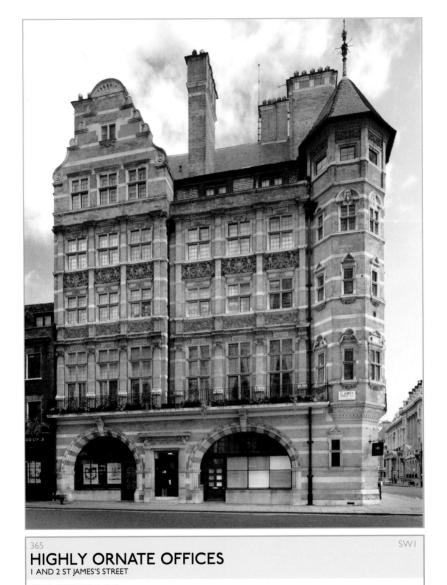

1882 R. NORMAN SHAW

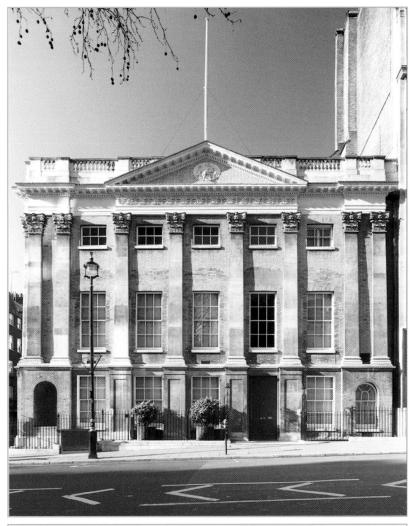

366 BROOKS'S CLUB 60 ST JAMES'S STREET FOUNDED 1764; 1777-78 HENRY HOLLAND

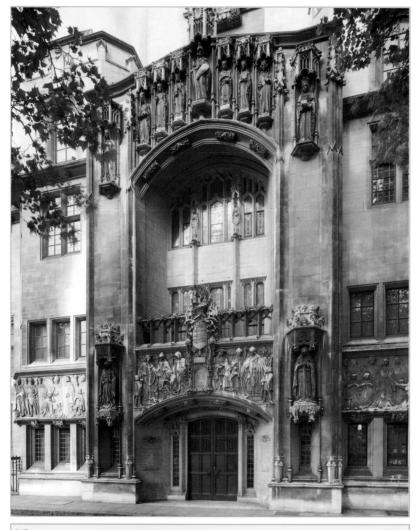

367 MIDDLESEX GUILDHALL PARLIAMENT SQUARE AND BROAD SANCTUARY

1868; 1906-13 J. S. GIBSON AND RUSSELL

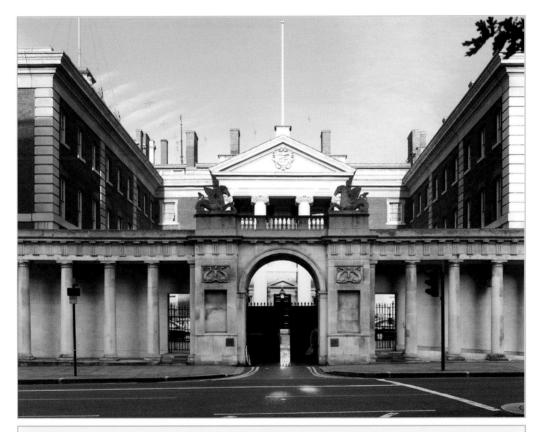

ADMIRALTY SCREEN AND ADMIRALTY HOUSE

1759-61 ROBERT ADAM; 1786-88 S. P. COCKERELL

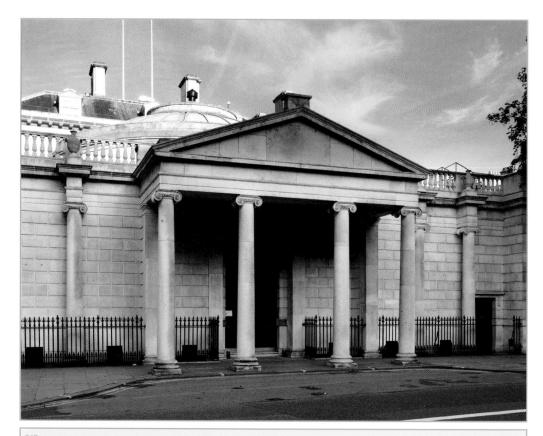

DOVER HOUSE

1754–58; 1787 JAMES PAINE, HENRY HOLLAND

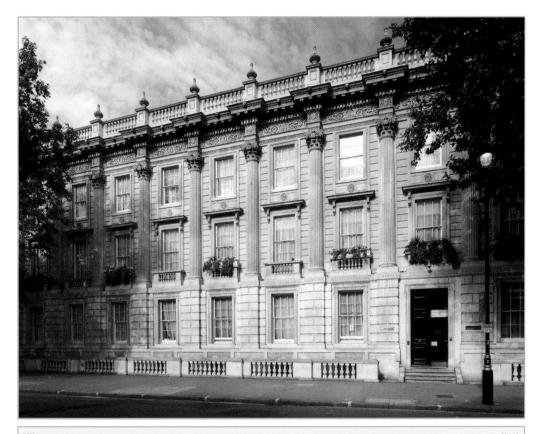

1733-36 WILLIAM KENT; 1824-27 SIR JOHN SOANE; 1844 SIR CHARLES BARRY

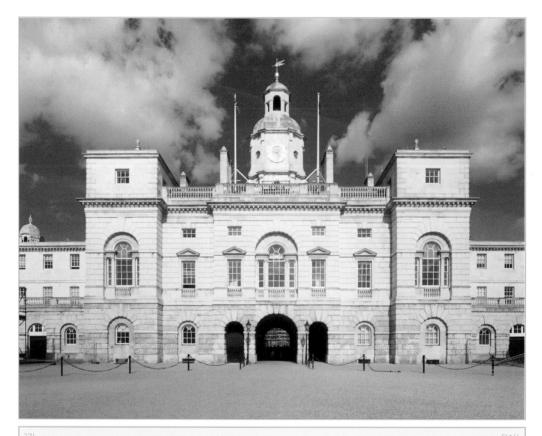

THE HORSE GUARDS

1745-55 WILIAM KENT, JOHN VARDY

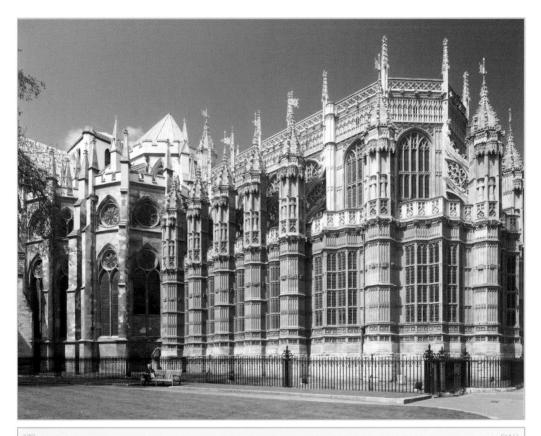

HENRY VII'S CHAPEL, WESTMINSTER ABBEY

1503-12 SIR REGINALD BRAY

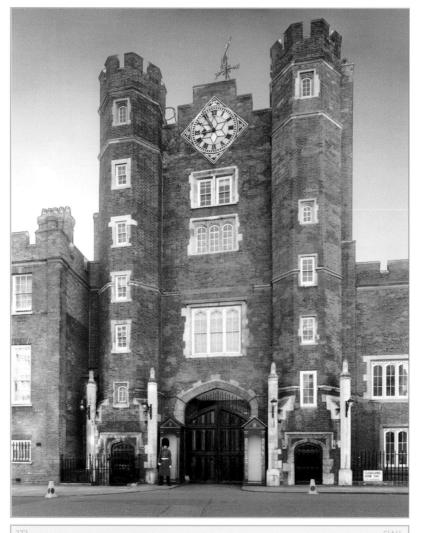

ST JAMES'S PALACE CLEVELAND ROW, MARLBOROUGH GATE

1530s HENRY VIII; FROM 1698 MODIFIED BY CHRISTOPHER WREN

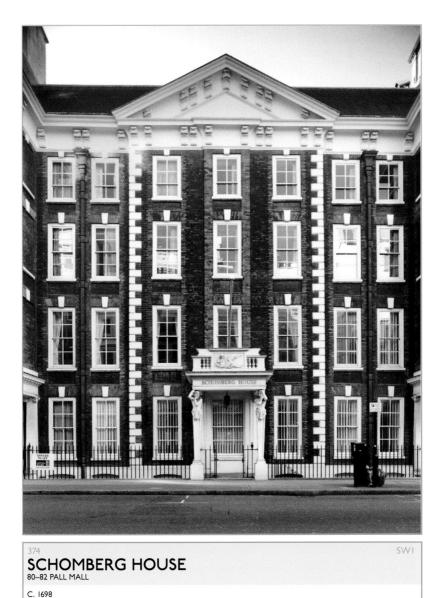

SOUTH WEST LONDON (SW) 397

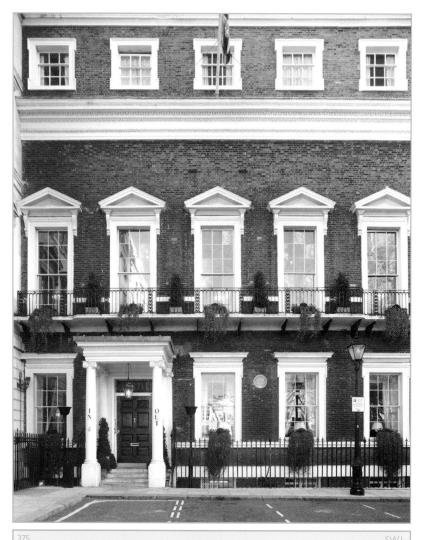

THE NAVAL AND MILITARY CLUB

1726-28 EDWARD SHEPHERD

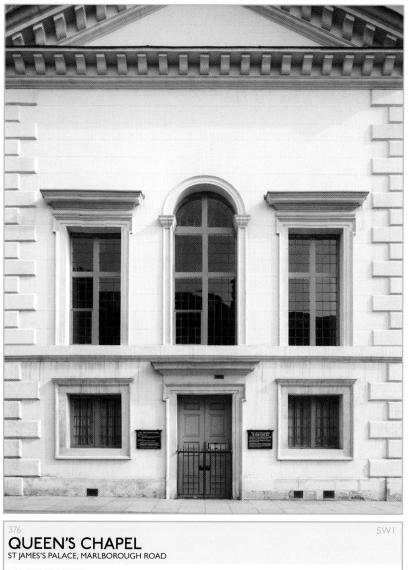

1623–27 INIGO JONES

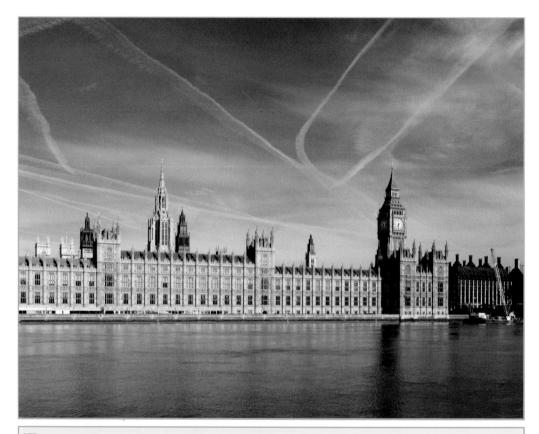

HOUSES OF PARLIAMENT

1835-60 SIR CHARLES BARRY; AUGUSTUS WELBY PUGIN; 1940s SIR GILES GILBERT SCOTT

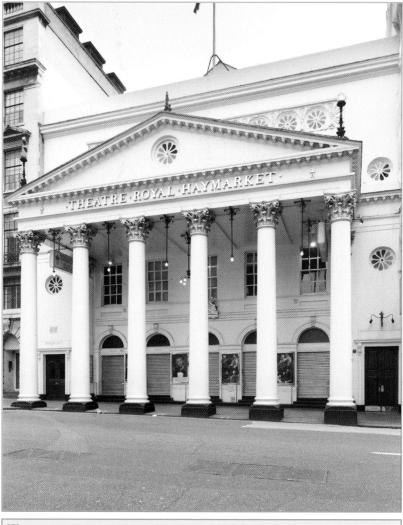

378 THEATRE ROYAL HAYMARKET

1720; 1831 RECONSTRUCTED JOHN NASH; 1994 REFURBISHED

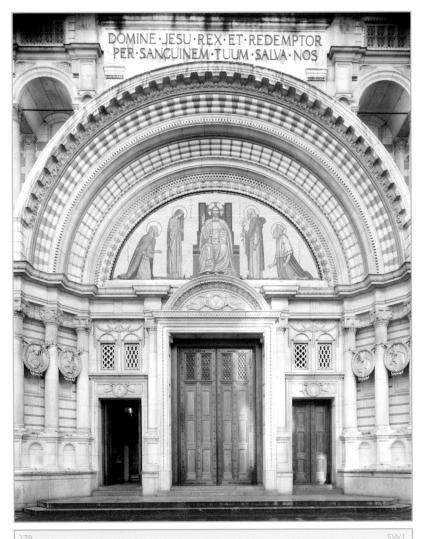

WESTMINSTER CATHEDRAL, ARCHBISHOP'S HOUSE, AND CLERGY HOUSE VICTORIA STREET, FRANCIS STREET, AND AMBROSDEN AVENUE

1895–1903 JOHN FRANCIS BENTLEY

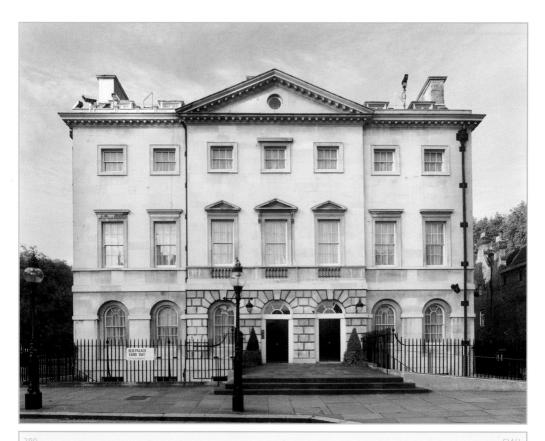

HOUSE ON AN HISTORIC SITE

6-7 OLD PALACE YARD

1756–60 JOHN VARDY

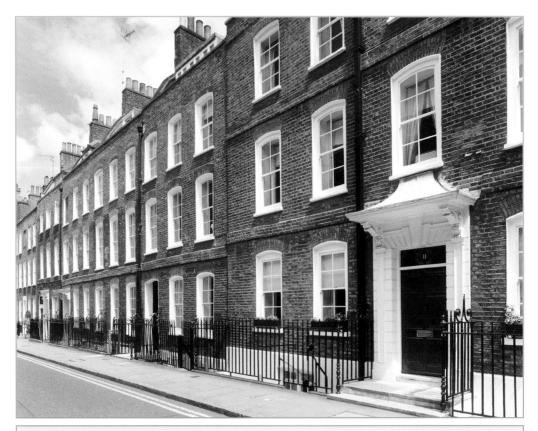

381 NEAT GEORGIAN STREETS LORD NORTH STREET AND COWLEY STREET

C. 1720

THE HORSE AND GROOM

1864

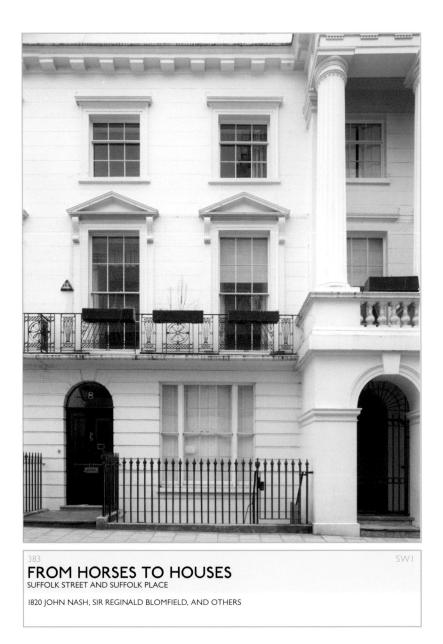

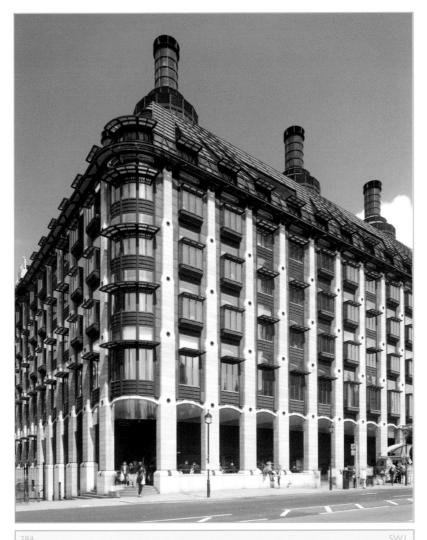

PORTCULLIS HOUSE NEW PARLIAMENTARY BUILDING BRIDGE STREET

1997 (OPENED 2001) MICHAEL HOPKINS AND PARTNERS

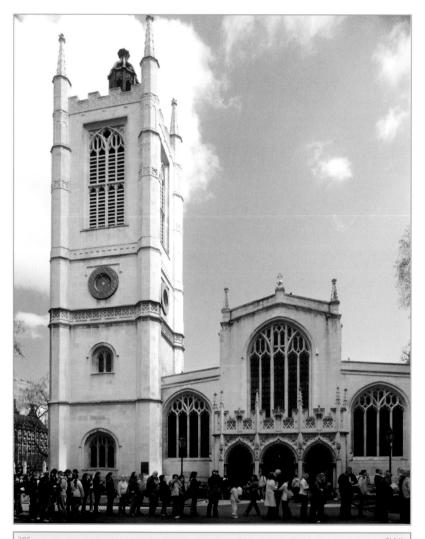

ST MARGARET'S WESTMINSTER

SW

1120–40 FOUNDED; 1480–1523 REBUILT; 1735–37 TOWER REBUILT JOHN JAMES; 1758 APSE KENTON HOUSE; 1877 RESTORED GILES GILBERT SCOTT

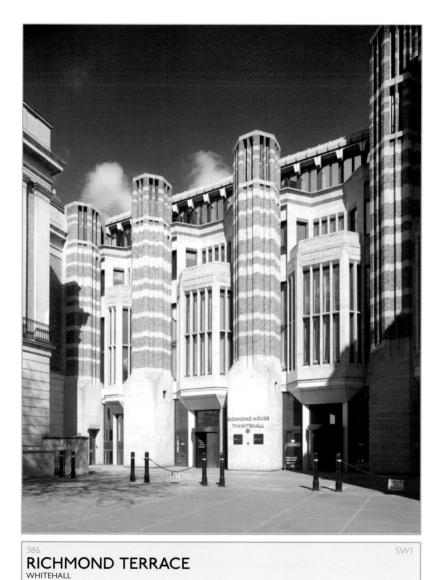

1822–25 HENRY HARRISON; 1980s ENTRANCE WILLIAM WHITFIELD AND PARTNERS

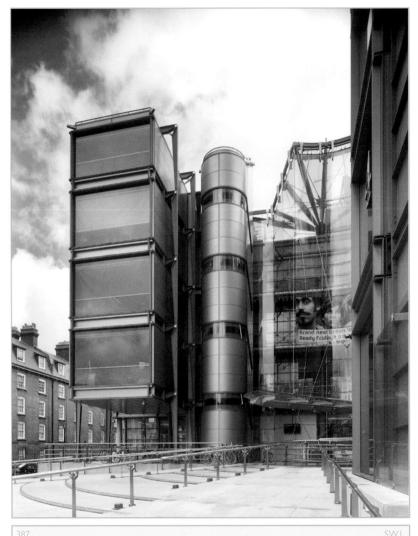

CHANNEL 4 TELEVISION HEADQUARTERS

1994 RICHARD ROGERS PARTNERSHIP

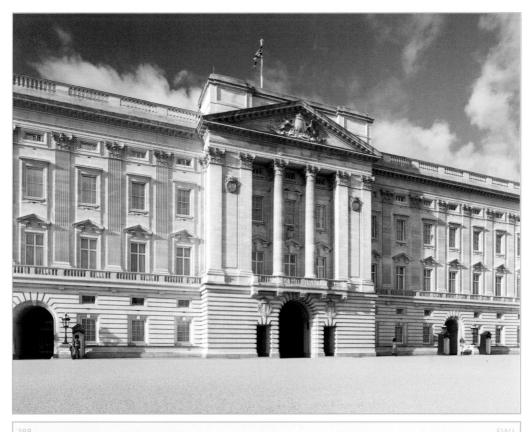

BUCKINGHAM PALACE

1715; 1825-30 JOHN NASH; 1830-47 EDWARD BLORE; 1912-13 SIR ASTON WEBB

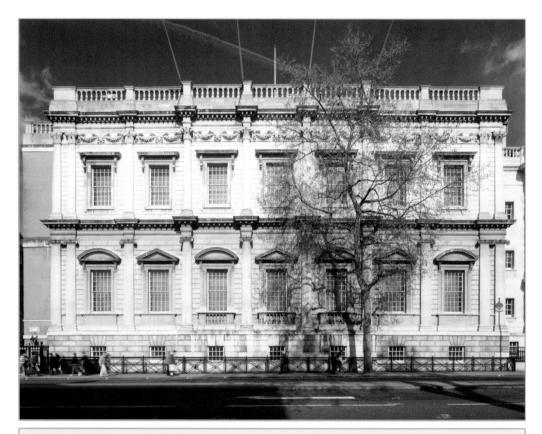

BANQUETING HOUSE

1619-22 INIGO JONES AND JOHN WEBB

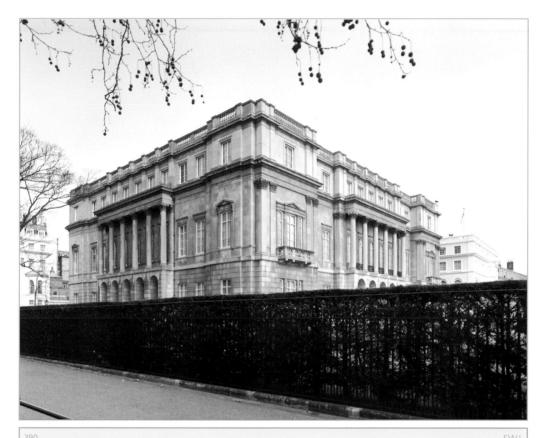

LANCASTER HOUSE STABLE YARD ROAD

1825–40 BENJAMIN WYATT, SIR ROBERT SMIRKE, AND SIR CHARLES BARRY

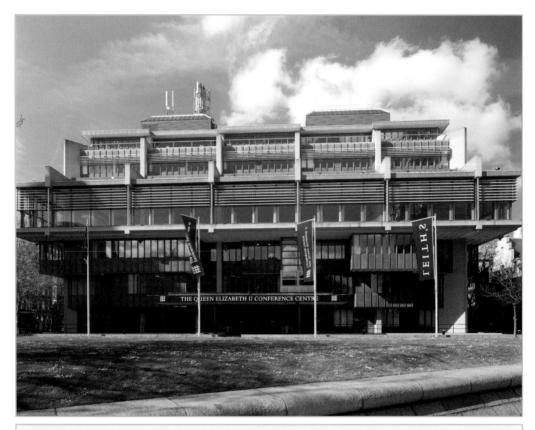

QUEEN ELIZABETH II CONFERENCE CENTRE

1979-86 POWELL MOYA AND PARTNERS

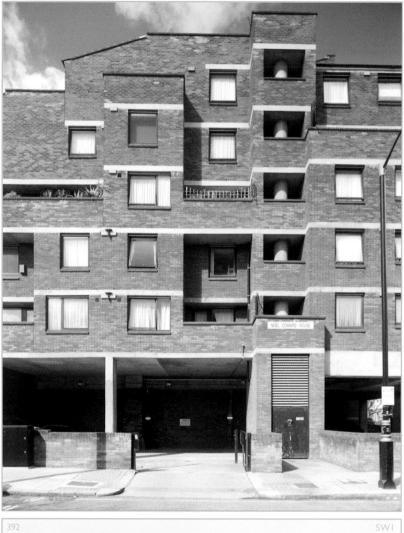

NOEL COWARD HOUSE LILLINGTON GARDENS ESTATE, VAUXHALL BRIDGE ROAD

1961-70S DARBOURNE AND DARKE

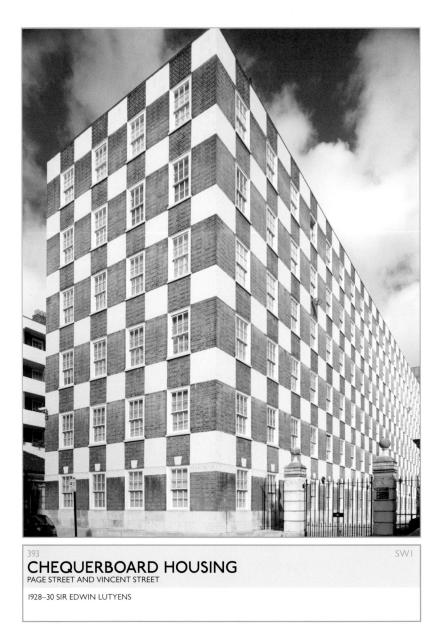

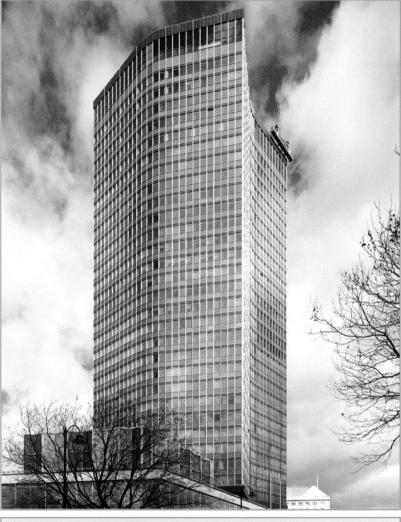

394 MILLBANK TOWER MILLBANK; FORMERLY VICKERS TOWER

1963 RONALD WARD AND PARTNERS

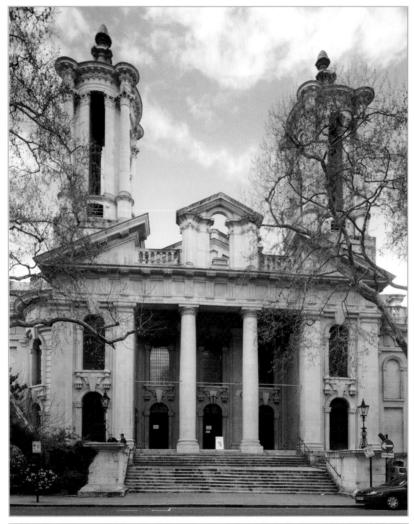

395 **ST JOHN** SMITH SQUARE

1714-28 THOMAS ARCHER

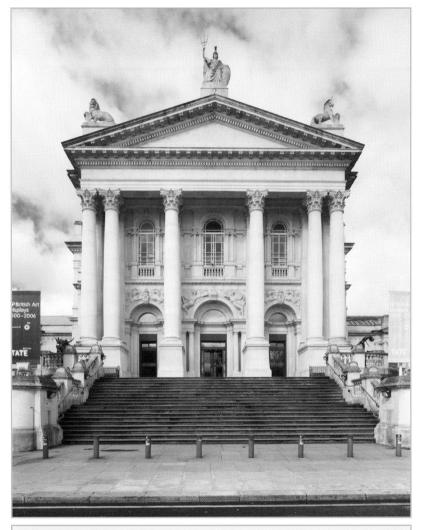

TATE BRITAIN MILLBANK; FORMERLY TATE GALLERY

....

1897 SIDNEY SMITH; 1909 ADDITIONS ROMAINE WALKER; 1937 NEW SCULPTURE GALLERY J. RUSSELL POPE; 1971–79 EXTENSION J. LLEWELYN DAVIES, WEEKS, FORESTIER-WALKER & NOR; 1990–2000 JOHN MILLER AND PARTNERS

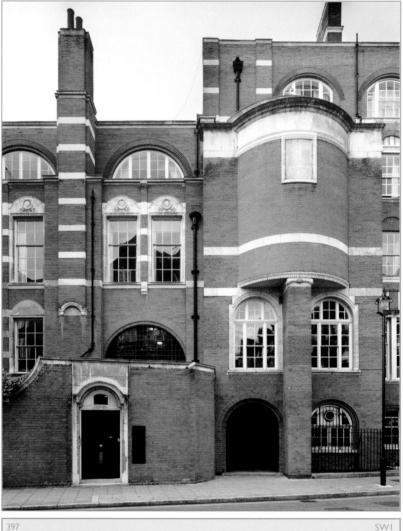

397 CLERGY HOUSE FRANCIS STREET AND AMBROSDEN STREET

1895–1903 JOHN FRANCIS BENTLEY

PANTECHNICON MOTCOMB STREET; FORMERLY SOTHEBY'S AUCTION ROOMS

1830 SETH SMITH

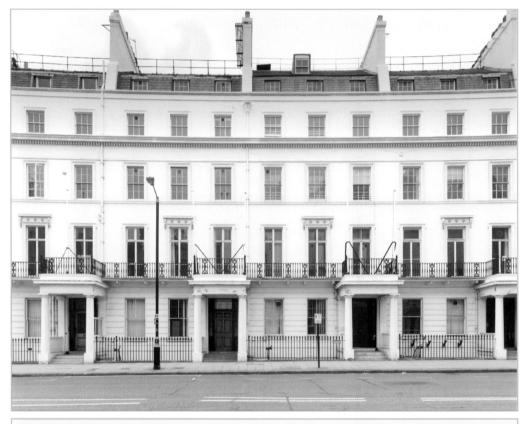

399 **REGENCY HOUSES** GROSVENOR CRESCENT

1860 SETH SMITH, THOMAS CUBITT

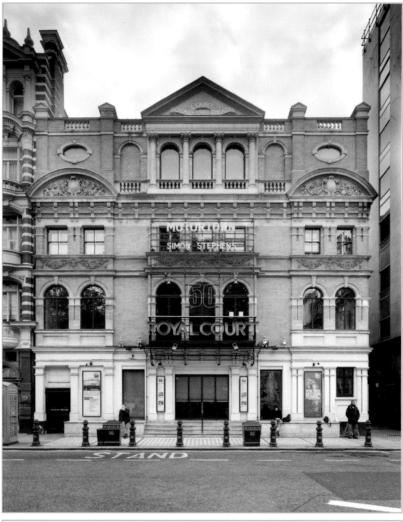

400 SWI **ROYAL COURT THEATRE** SLOANE SQUARE 1888 WALTER EMDEN; 2000 RECONSTRUCTED HAWORTH TOMPKINS ARCHITECTS

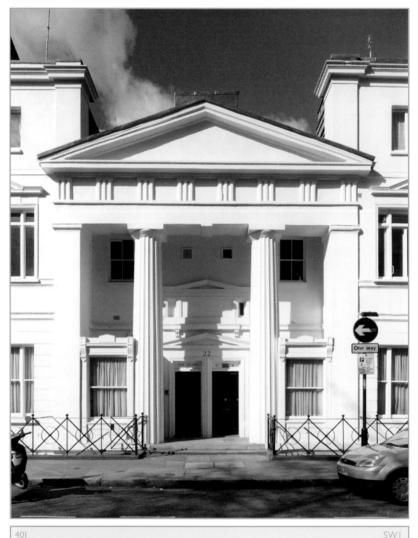

GREEK REVIVAL FLATS 22 EBURY STREET; FORMERLY PIMLICO LITERARY INSTITUTE

1830 J. P. GANDY-DEERING

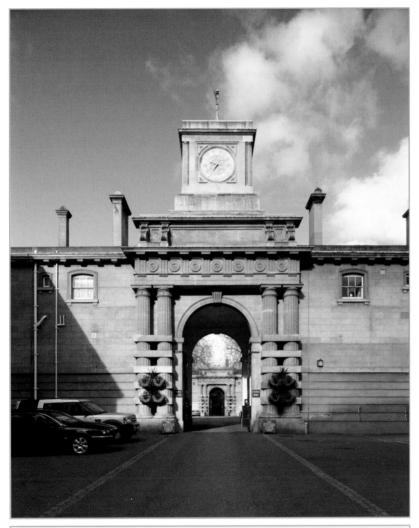

SW

1760 AND 1820 WILLIAM CHAMBERS

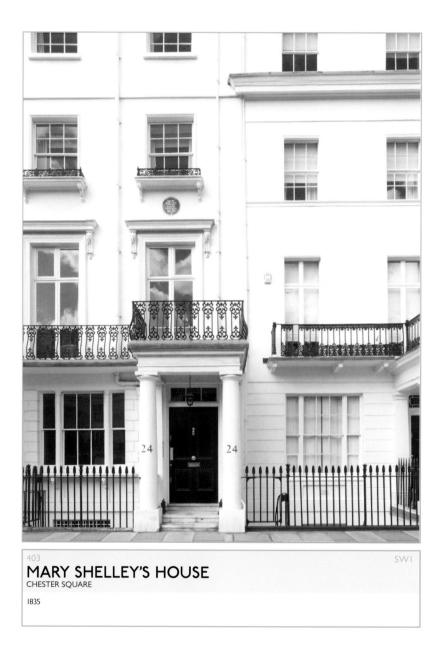

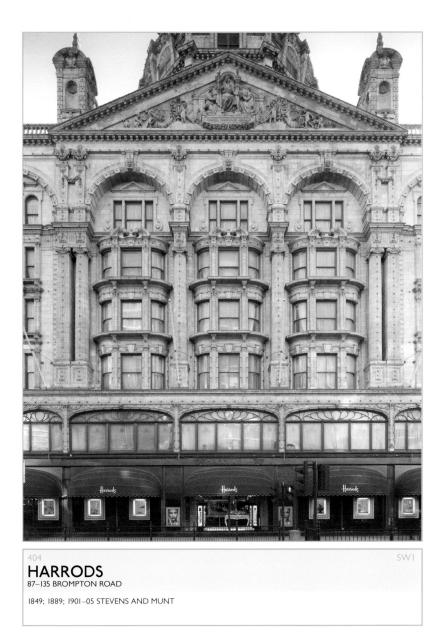

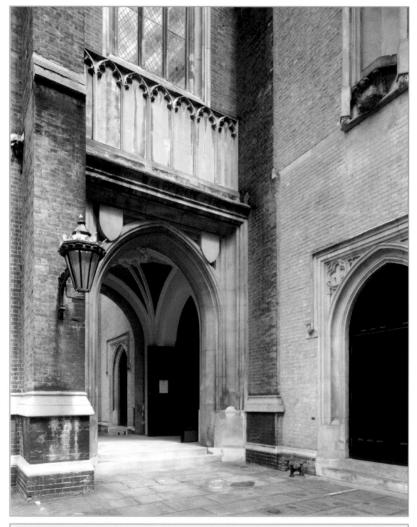

ST PAUL'S CHURCH

1840-43 THOMAS CUNDY III

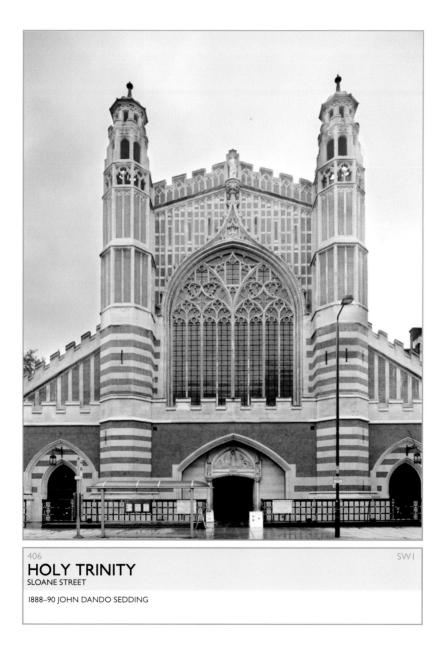

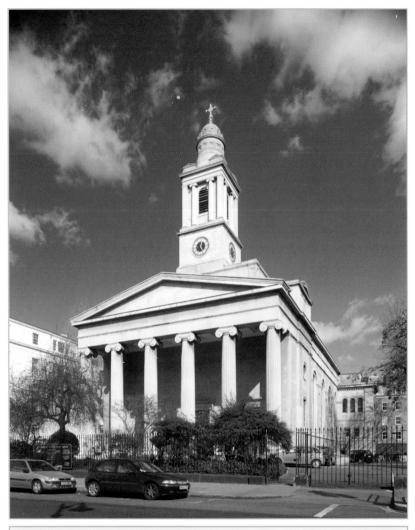

407 CHURCH OF ST PETER EATON SQUARE

1824–27 HENRY HAKEWILL

NUMBER				 		1
TRE	1 mm				I	
T						1
		T				* 11
I	1		*			NIIII

LANESBOROUGH HOTEL HYDE PARK CORNER; FORMERLY ST GEORGE'S HOSPITAL

1827-29 WILLIAM WILKINS

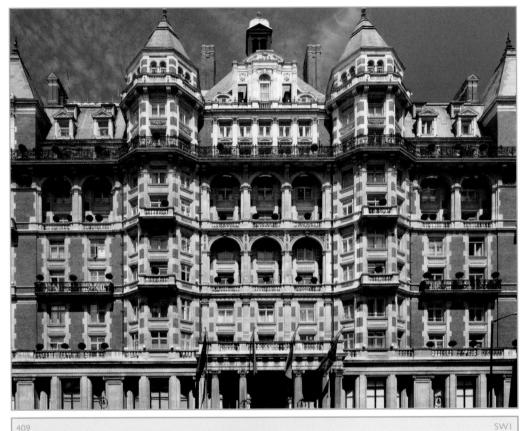

MANDARIN ORIENTAL HYDE PARK 66 KNIGHTSBRIDGE; FORMERLY HYDE PARK COURT

1889; 1999-2000 RENOVATED

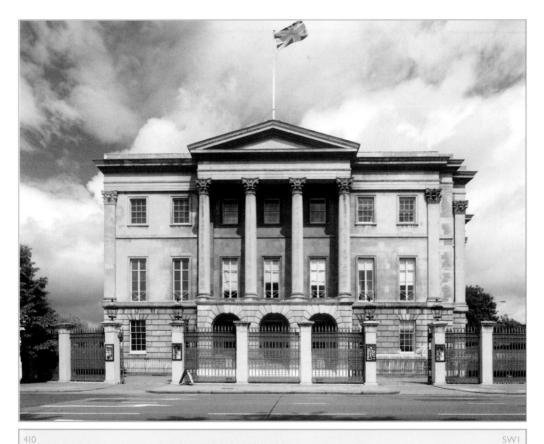

APSLEY HOUSE AND WELLINGTON MUSEUM

NUMBER ONE LONDON, HYDE PARK CORNER

1771–78; 1828-29 ROBERT ADAM BENJAMIN AND PHILIP WYATT

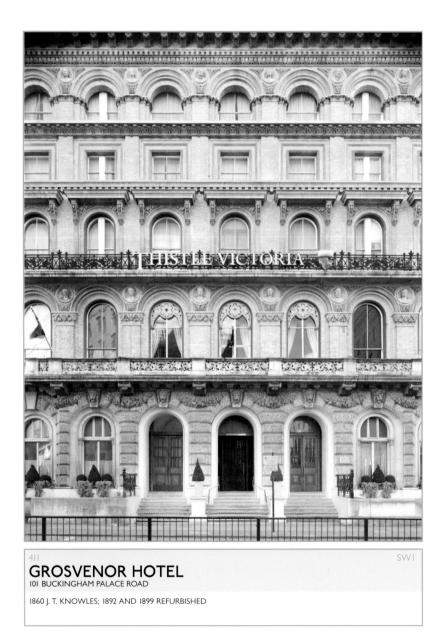

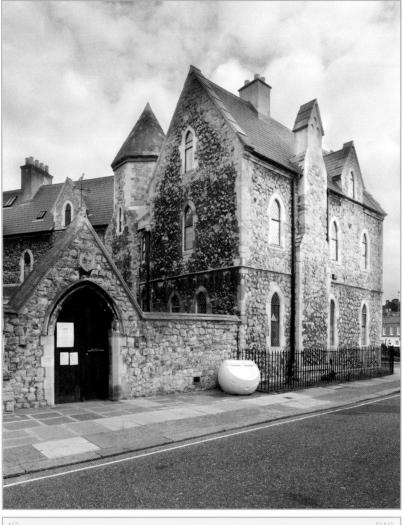

SVI

ST BARNABUS: SCHOOL AND HOUSE ST BARNABUS STREET, PIMILICO

1846-50 WILLIAM BUTTERFIELD

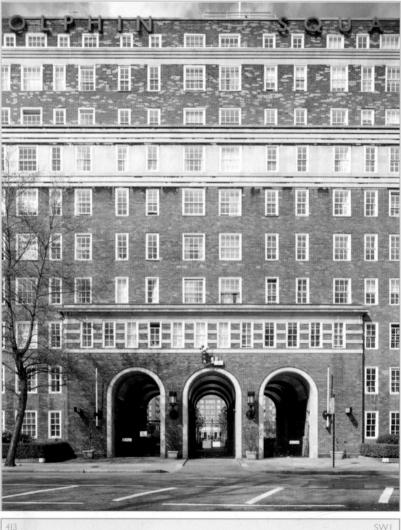

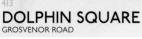

1937 GORDON JEEVES

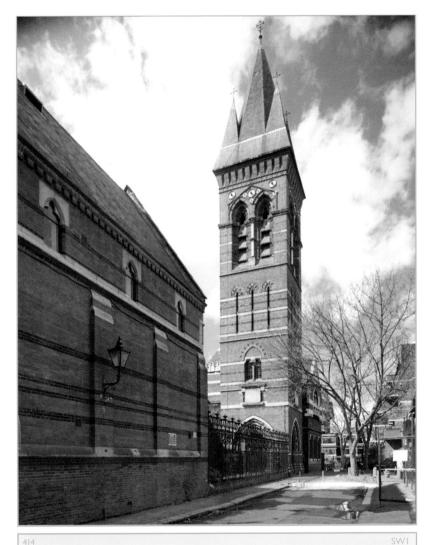

ST JAMES-THE-LESS PARISH HALL AND SCHOOL THORNDIKE STREET AND MORETON STREET

1858-61 GEORGE EDMUND STREET

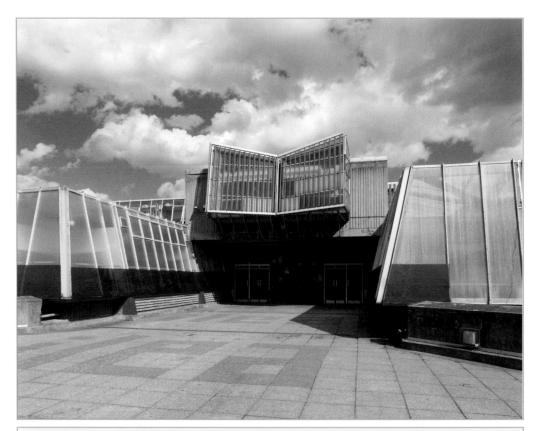

415 **PIMLICO SCHOOL** ST GEORGE'S SQUARE AND LUPUS STREET

1966–70 GLC ARCHITECTS DEPARTMENT (DESIGNED BY SIR HUBERT BENNETT AND MICHAEL POWELL WITH C. A. BELCHER AND F. HALLOWES)

438 FIVE HUNDRED BUILDINGS OF LONDON

SWI

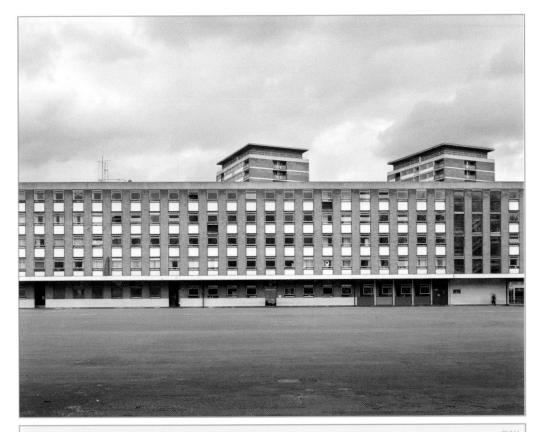

CHELSEA BARRACKS

1960-62 TRIPE AND WAKEHAM

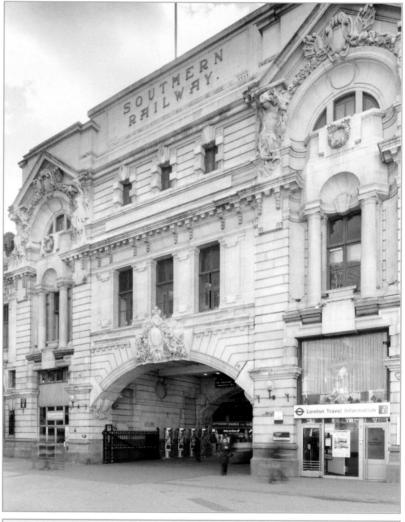

417 VICTORIA STATION VICTORIA STREET 1862 J. FOWLER; 1898–1908 PARTIALLY REBUILT; 1920s FRONTAGE ALFRED BLOOMFIELD

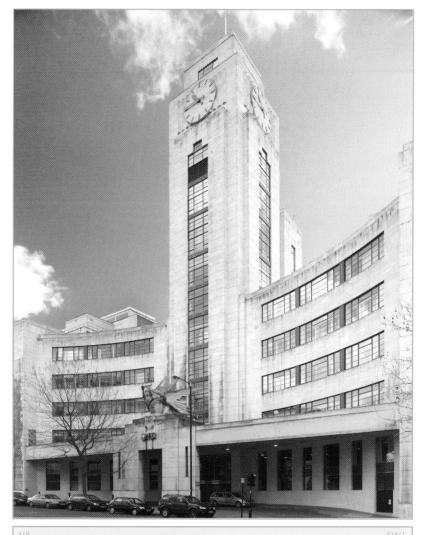

NATIONAL AUDIT OFFICE BUCKINGHAM PALACE ROAD; FORMERLY BRITISH AIRWAYS TERMINAL

1939 A. LAKEMAN

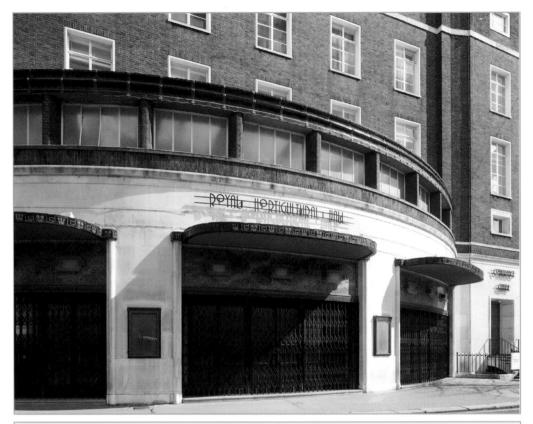

THE LAWRENCE HALL (THE ROYAL HORTICULTURAL SOCIETY) GREYCOAT STREET AND EVERTON STREET 1923-28 EASTON AND ROBERTSON

PULLMAN COURT

1935 FREDERICK GIBBERD

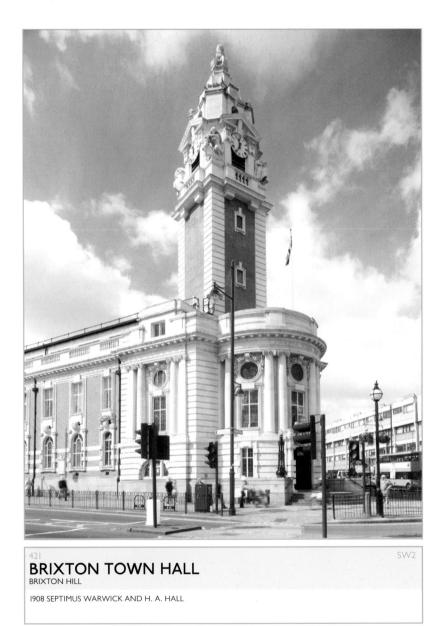

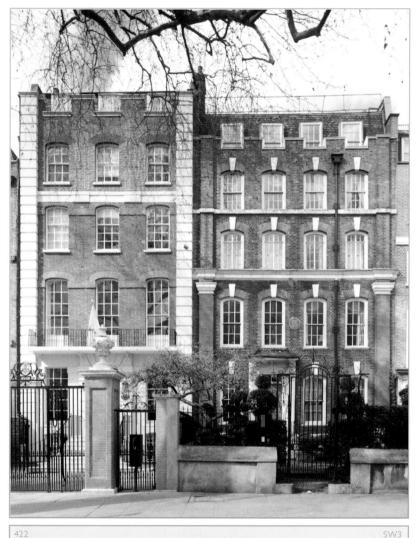

AUTHORS, DOCTOR, AND MISER

1708

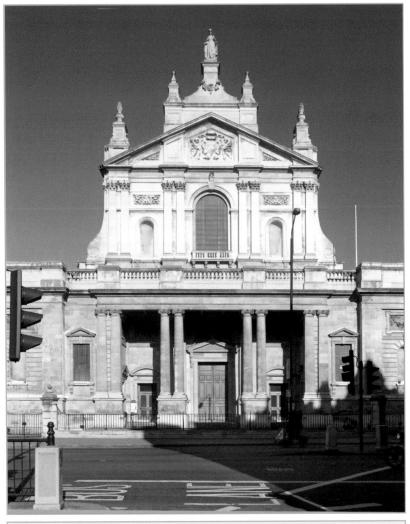

423 LONDON ORATORY BROMPTON ROAD

1880-93 HERBERT GRIBBLE; HOUSE BY J. J. SCOLES

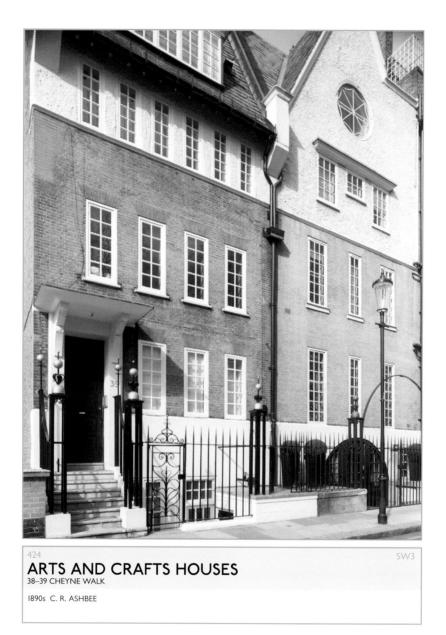

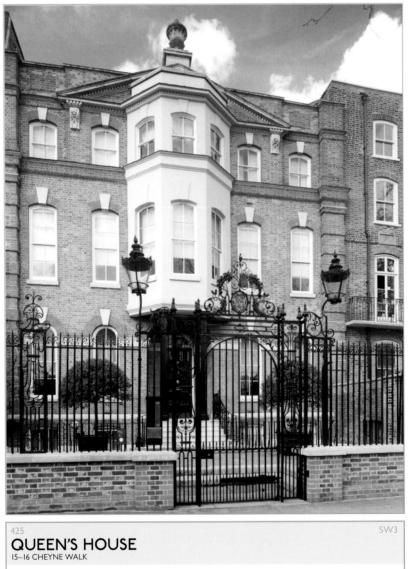

1717–19 JOHN WIT AND RICHARD CHAPMAN

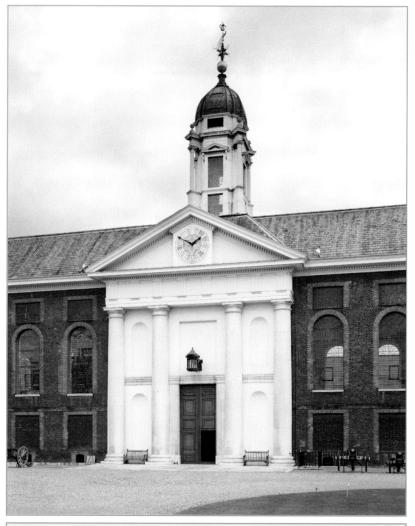

426 ROYAL HOSPITAL ROYAL HOSPITAL ROAD

1681–91 SIR CHRISTOPHER WREN, NICHOLAS HAWKSMOOR, JOHN VANBRUGH

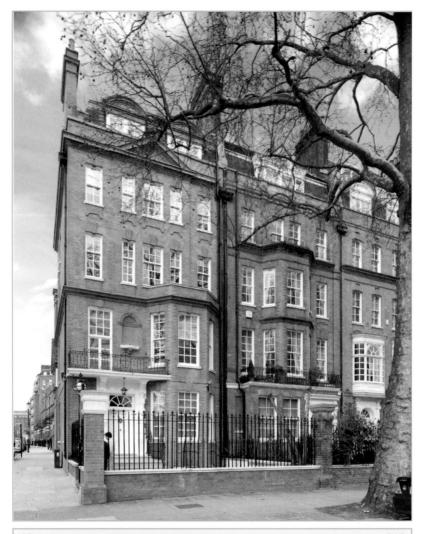

HOUSES BY THE RIVER 7-12 CHEYNE WALK

C. 1880s

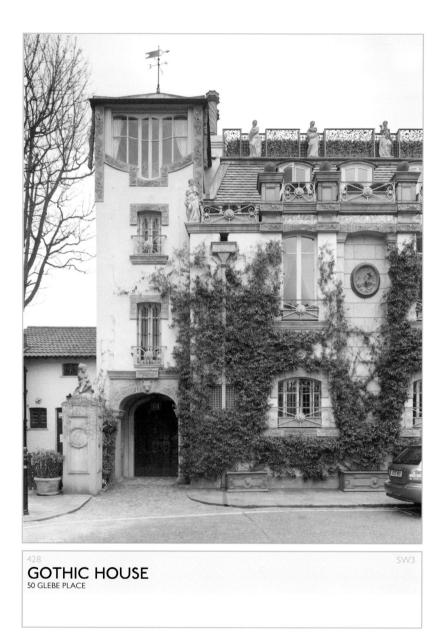

1905–11 FRANÇOIS ESPINASSE; 1984–88 REBUILDING AND RESTORATION BY CONRAN ROCHE YRM

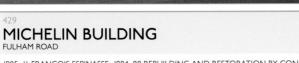

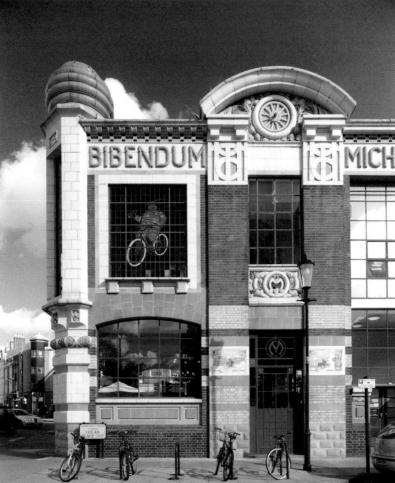

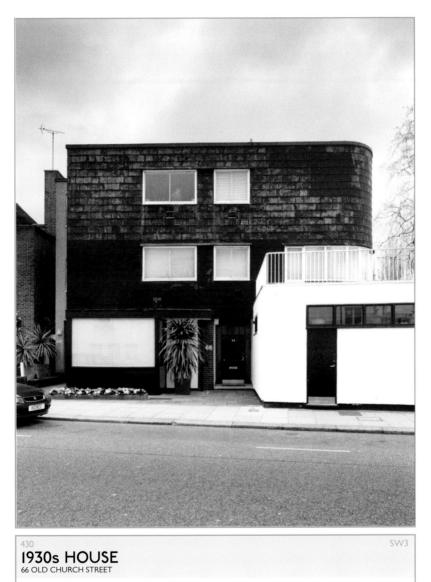

1936 WALTER GROPIUS AND EDWIN MAXWELL FRY

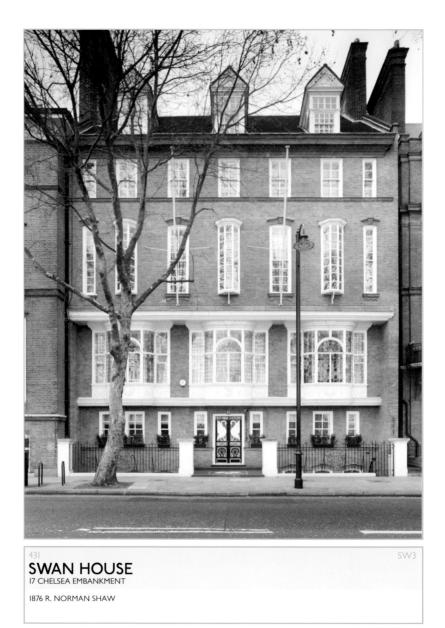

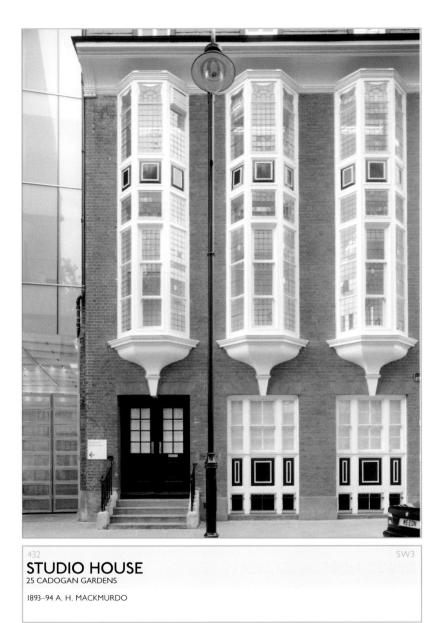

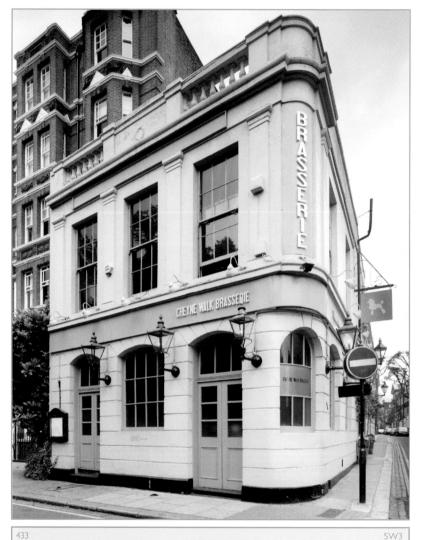

KING'S HEAD AND EIGHT BELLS

ESTABLISHED 1580

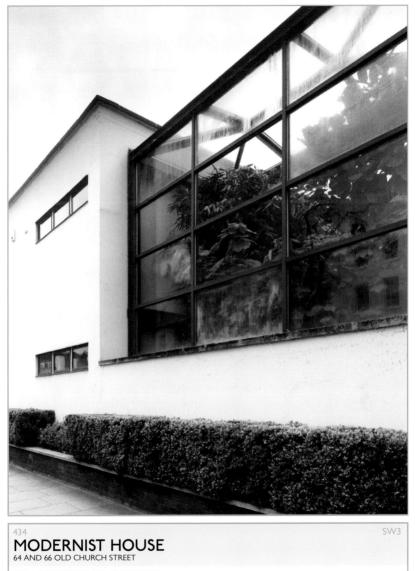

1930s MENDELSOHN AND CHERMAYEFF

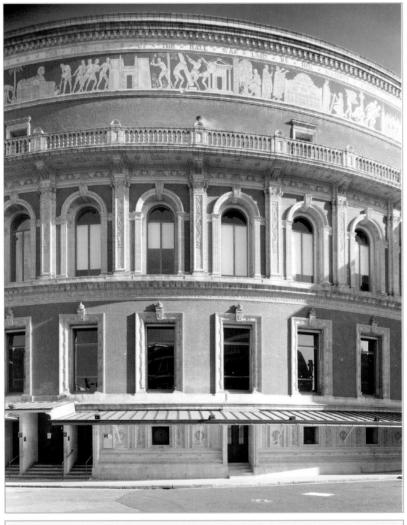

ROYAL ALBERT HALL KENSINGTON GORE

1867-71 CAPTAIN FRANCIS FOWKE, WITH MAJOR-GENERAL H. Y. D. SCOTT

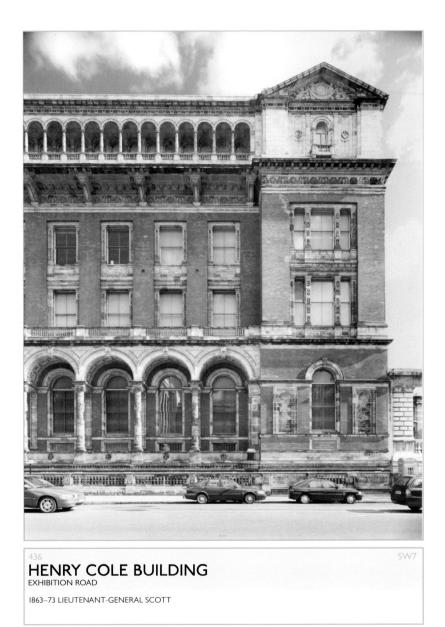

437 **1930s APARTMENTS** 59–63 PRINCES GATE

1935 GEORGE ADIE AND FREDERICK BUTTON

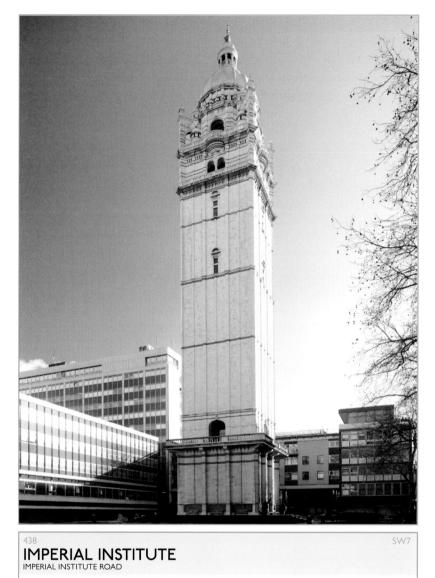

1887-93 THOMAS EDWARD COLLCUTT

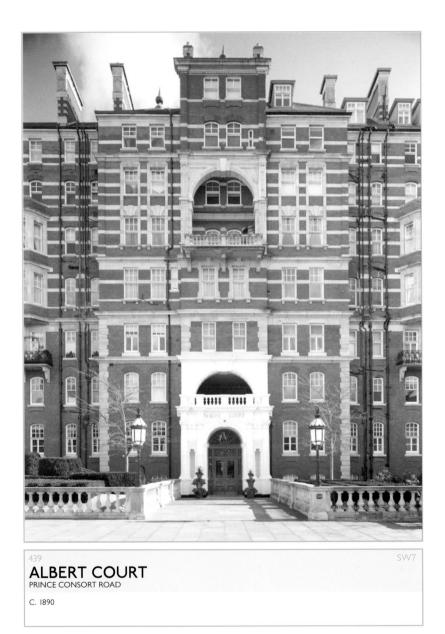

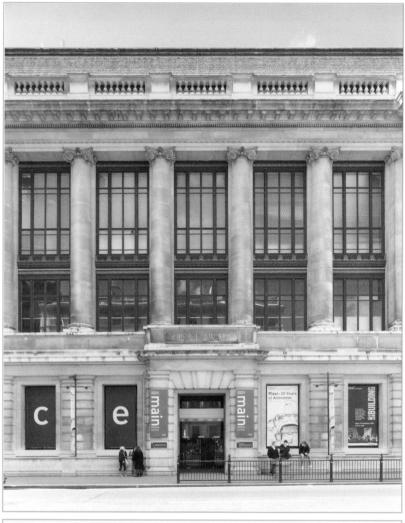

1913 SIR RICHARD ALLISON

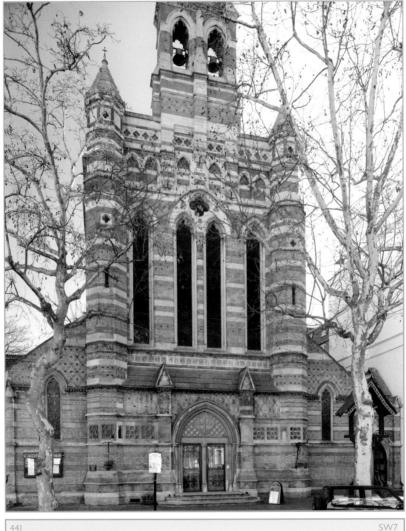

ST AUGUSTINE

1870-77 W. BUTTERFIELD

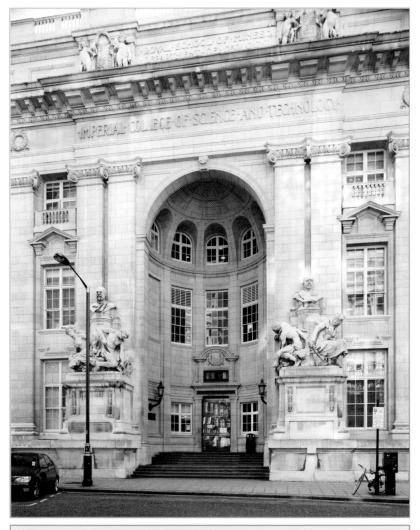

ROYAL SCHOOL OF MINES PRINCE CONSORT ROAD

1909–13 SIR ASTON WEBB

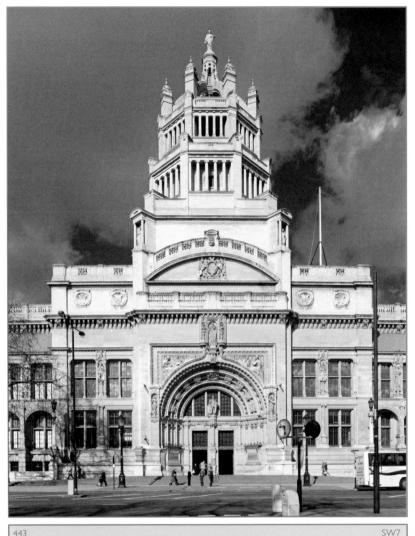

443 VICTORIA AND ALBERT MUSEUM CROMWELL ROAD 1856–84 CAPTAIN FRANCIS FOWKE, GODFREY SYKES, AND OTHERS (MAIN QUADRANGLE);

1899–1909 SIR ASTON WEBB (CROMWELL ROAD FAÇADE)

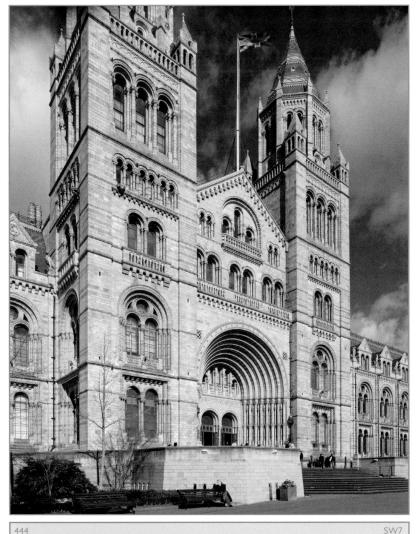

THE NATURAL HISTORY MUSEUM

1873-81 ALFRED WATERHOUSE

DARWIN CENTRE

1992-2002 HOK INTERNATIONAL

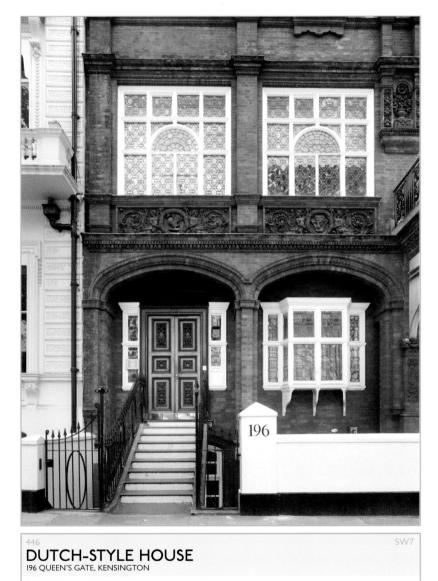

1875 R. NORMAN SHAW

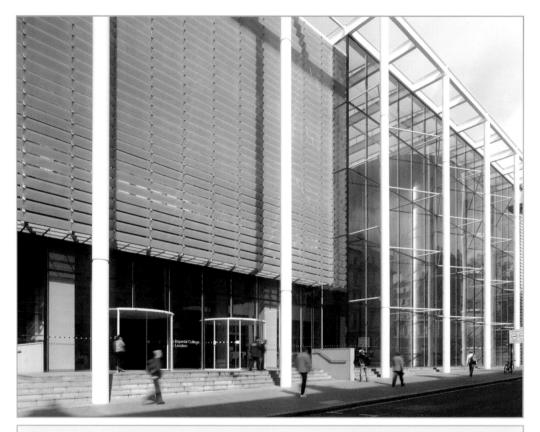

TANAKA BUSINESS SCHOOL

2002–04 FOSTER AND PARTNERS

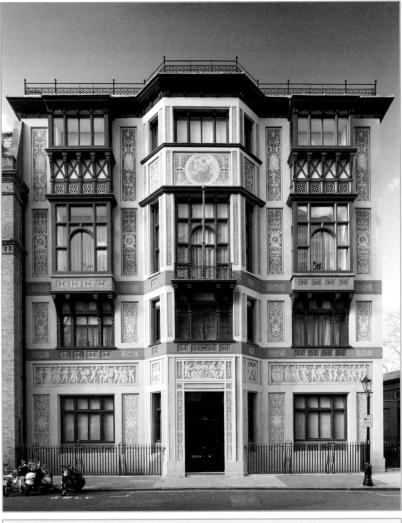

A48 **ROYAL COLLEGE OF ORGANISTS** KENSINGTON GORE 1875 H. H. COLE

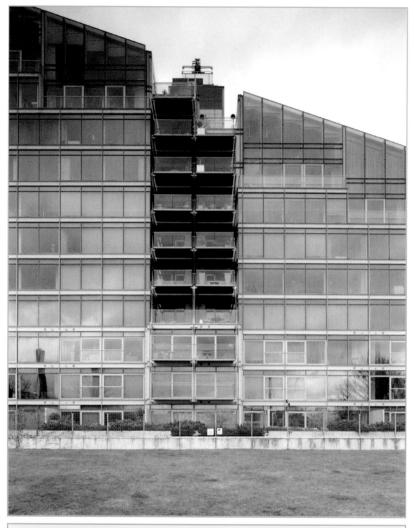

SWII

449 MONTEVETRO 112 BATTERSEA CHURCH ROAD

1994–99 RICHARD ROGERS PARTNERSHIP

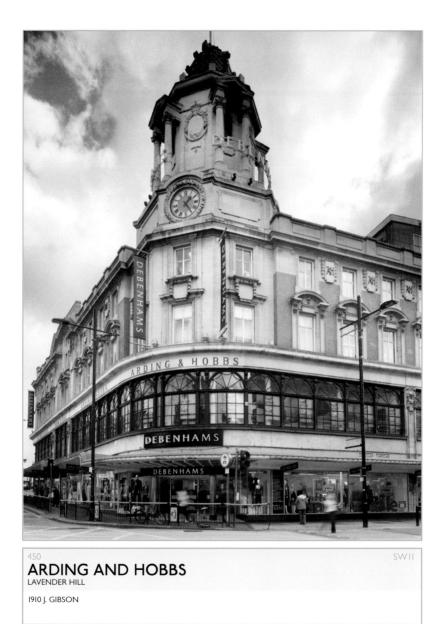

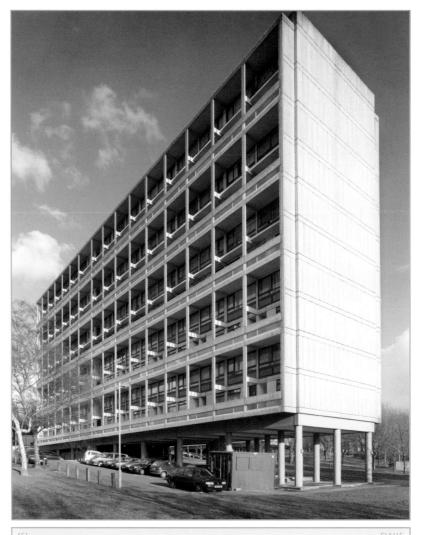

HOUSING, ALTON WEST ESTATE

SVV 15

1955-59 LCC ARCHITECTS DEPARTMENT

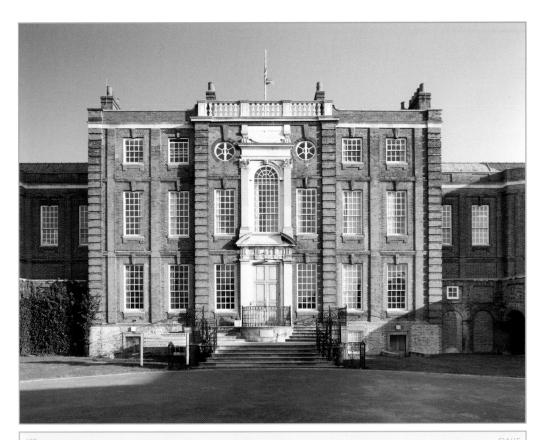

ROEHAMPTON HOUSE

ROEHAMPTON LANE

1710-12 THOMAS ARCHER; ENLARGED BY SIR EDWIN LUTYENS

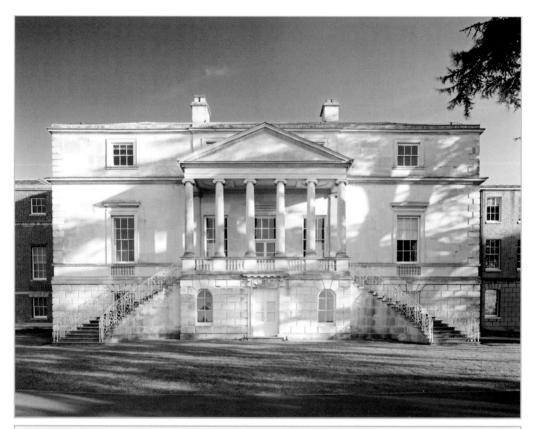

PARKSTEAD HOUSE ROEHAMPTON LANE

1750-68 SIR WILLIAM CHAMBERS

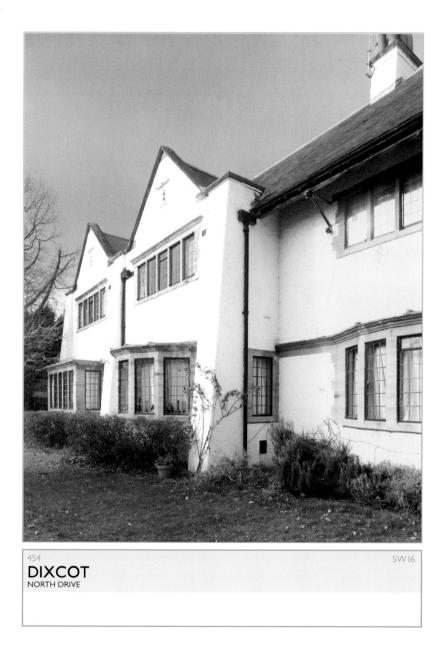

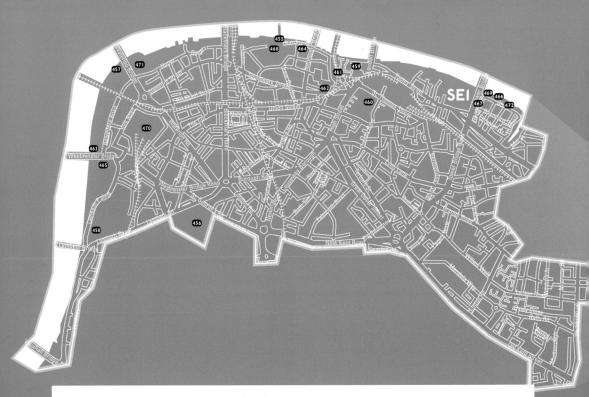

SOUTH EAST LONDON (SE)

This area of London sweeps out from the Thames towards the Kent border and includes some of the greenest acres of the capital, such as Greenwich Park, Blackheath (where the Danes camped in 1012), Dulwich Park, and Peckham Rye Common.

The South Bank has long been equated with culture, with such gems as the National Theatre, the Royal Festival Hall (under scaffolding now and so, sadly, not in this edition), Tate Modern, and the New Globe Theatre.

Greenwich is steeped in history and home to the Queen's House, the Royal Naval College, and the *Cutty Sark*. Here, at the Greenwich Meridian Line at the Royal Observatory, East meets West at 0 degrees longitude. This is also the home of Greenwich Mean Time (GMT)—upon which all the time zones in the world are based.

Nearby Deptford means 'deep ford' and is where the road from London to Dover crosses the Thames tributary over the river Ravensbourne. It was on the pilgrims' route to Canterbury and those in Chaucer's *Canterbury Tales* crossed the river here.

This area has associations with famous names like Sir Francis Drake and diarist John Evelyn. Back in 1513, King Henry VIII sited a naval dockyard here, where, in 1698, the young Russian tsar, Peter the Great, studied shipbuilding for three months.

SEI	Waterloo
SE2	Abbey Wood
SE3	Blackheath
SE4	Brockley
SE5	Camberwell
SE6	Catford
SE7	Charlton
SE8	Deptford
SE9	Eltham
SEIO	Greenwich
SEII	Lambeth
SEI2	Lee
SEI3	Lewisham
SEI4	New Cross

SEI5 Peckham SEI6 Rotherhithe SEI7 Walworth SEI8 Woolwich SE19 Upper Norwood SE20 Anerley, Penge SE21 Dulwich SE22 East Dulwich SE23 Forest Hill SE24 Herne Hill SE25 South Norwood SE26 Sydenham SE27 West Norwood

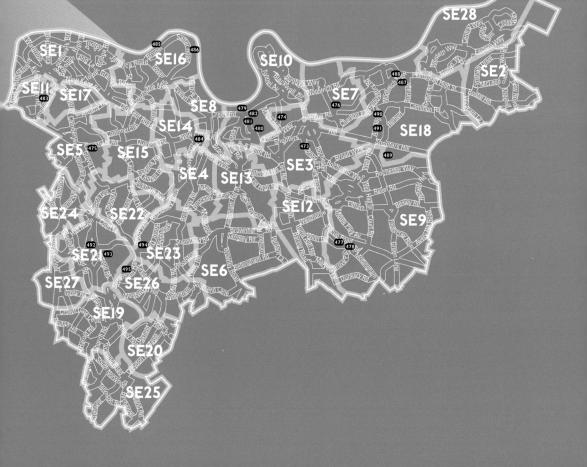

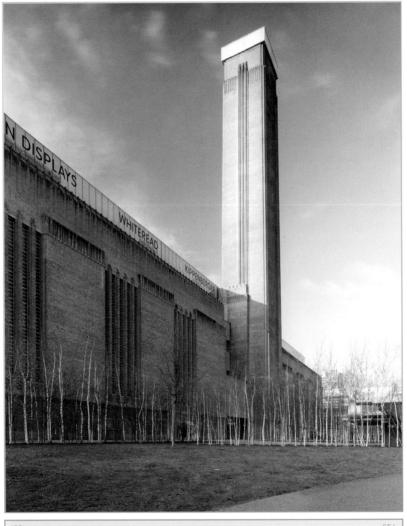

ASS TATE MODERN BANKSIDE; FORMERLY BANKSIDE POWER STATION

1947 AND 1963 SIR GILES GILBERT SCOTT; 1994–2000 HERZOG AND DE MEURON

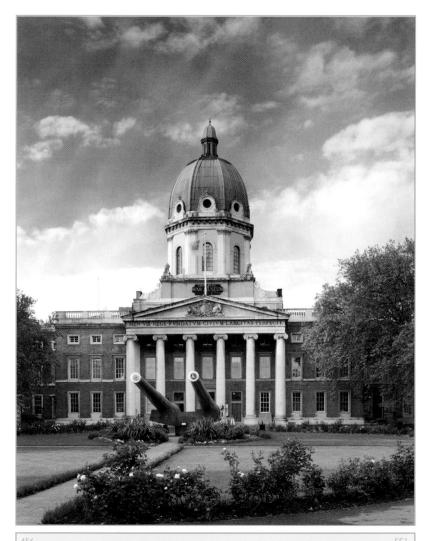

IMPERIAL WAR MUSEUM

1812–15 J. LEWIS; 1839 SIDNEY SMIRKEP; 1989 ARUP ASSOCIATES

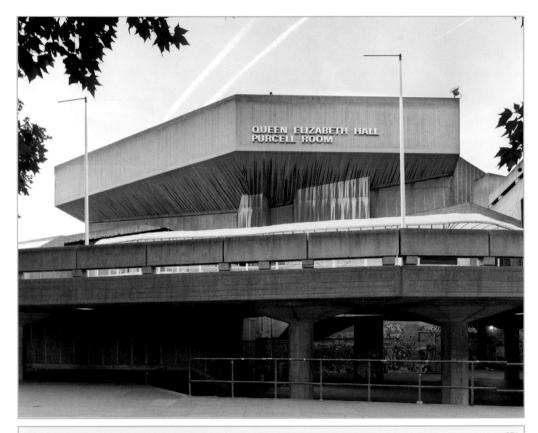

QUEEN ELIZABETH HALL

1964 LCC / GLC ARCHITECTS DEPARTMENT; SIR HUBERT BENNETT AND JACK WHITTLE

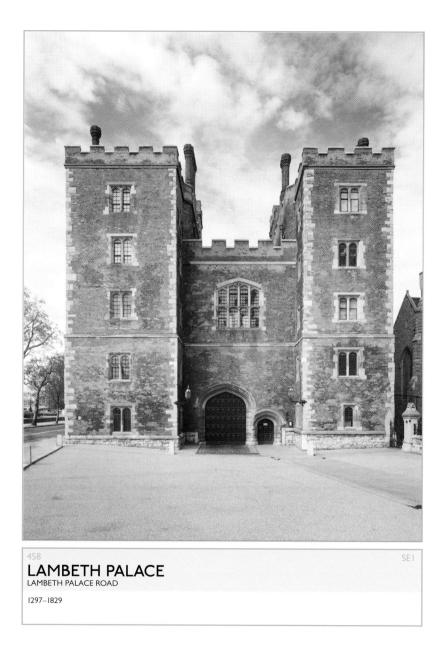

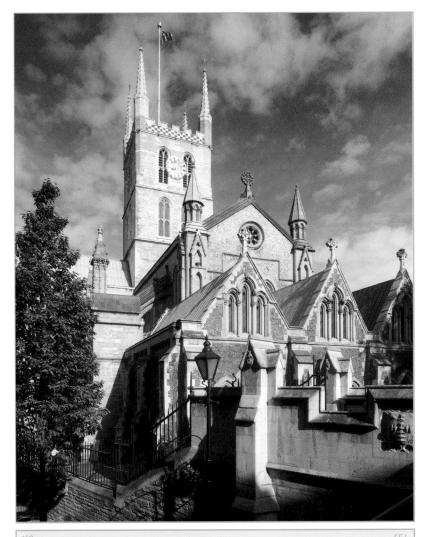

SOUTHWARK CATHEDRAL BOROUGH HIGH STREET

1106–1420; 1822 TOWER RESTORED; 1838 NAVE REBUILT; 1890–99 NAVE REPLACED BY SIR ARTHUR BLOMFIELD

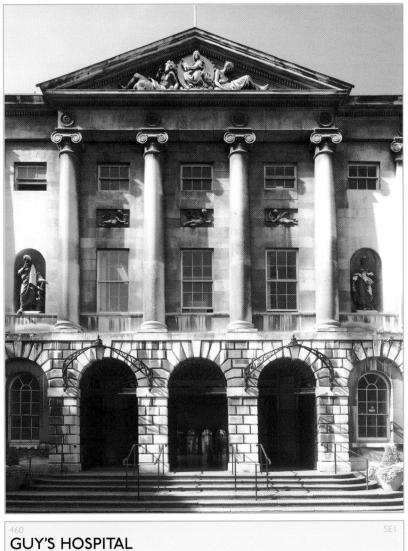

ST THOMAS STREET

1722-80 AND 1780 W. JUPP; 1974 GUY'S TOWER

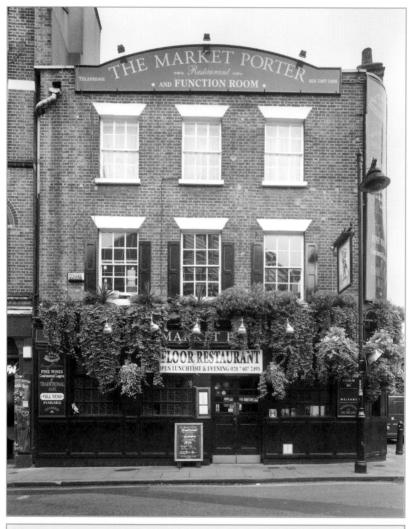

461 MARKET PORTER 9 STONEY STREET; FORMERLY THE HARROW

1638; C. 1890

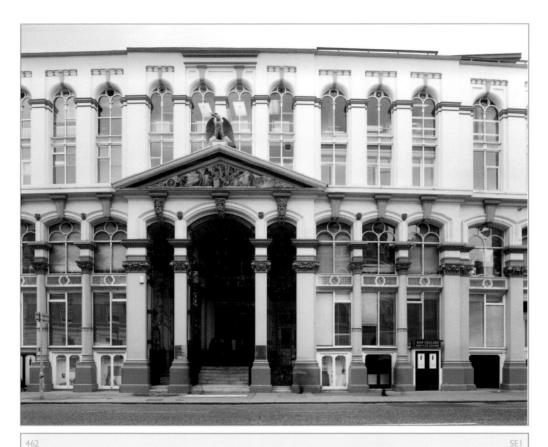

CENTRAL BUILDINGS AND THE HOP EXCHANGE 24 SOUTHWARK STREET

1867 R. H. MOORE

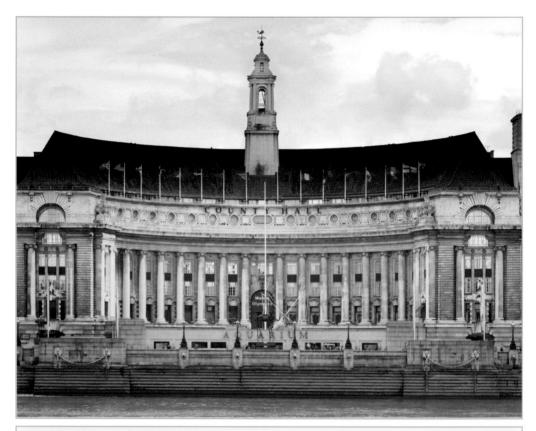

463 FORMER COUNTY HALL SOUTHEAST END OF WESTMINSTER BRIDGE

1911-22; 1931-33 RALPH KNOTT

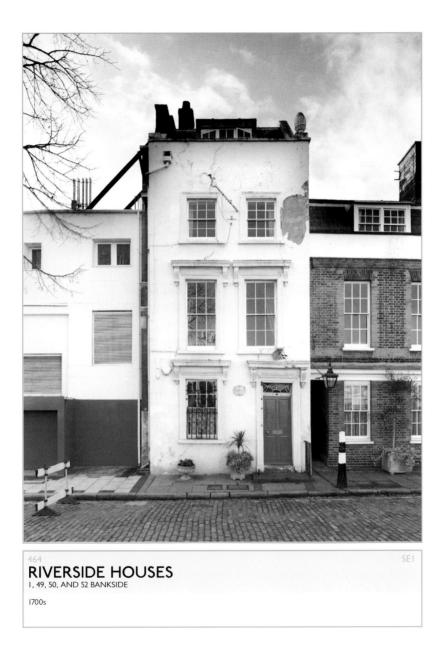

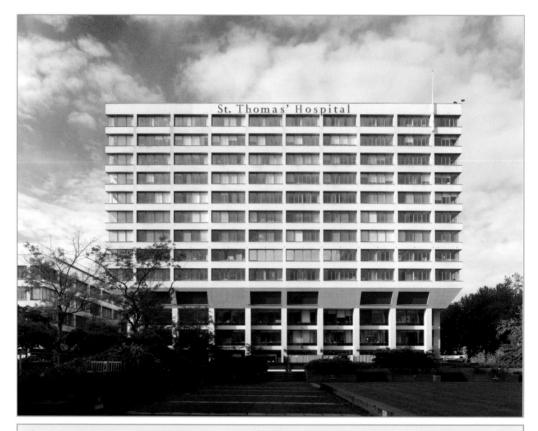

ST THOMAS'S HOSPITAL

1106; 1860s; 1956 FOWLER HOWITT; FROM 1963 YORKE ROSENBERG MARDALL

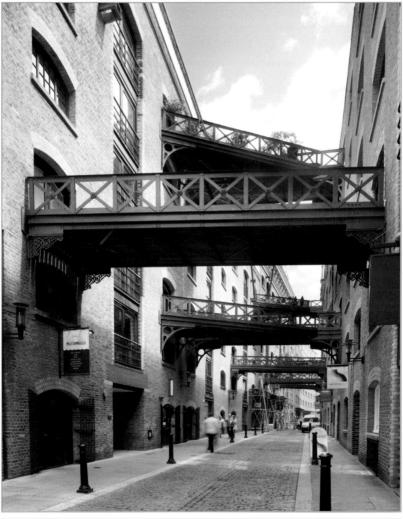

SE

466 WAREHOUSES SHAD THAMES

1800s; 1980s RECONSTRUCTION CONRAN ROCHE

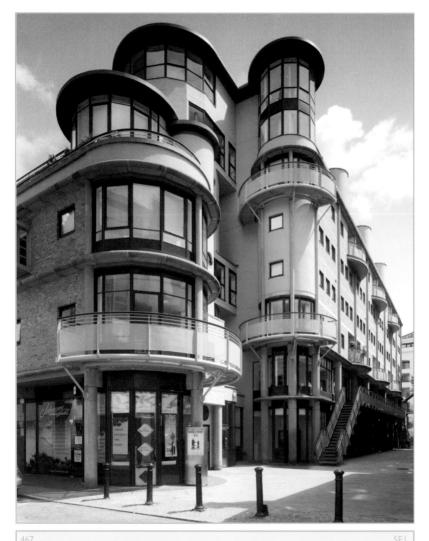

HORSELYDOWN SQUARE GAINSFORD STREET, COPPER ROW, HORSELYDOWN LANE, SHAD THAMES

1986–91 WICKHAM AND ASSOCIATES

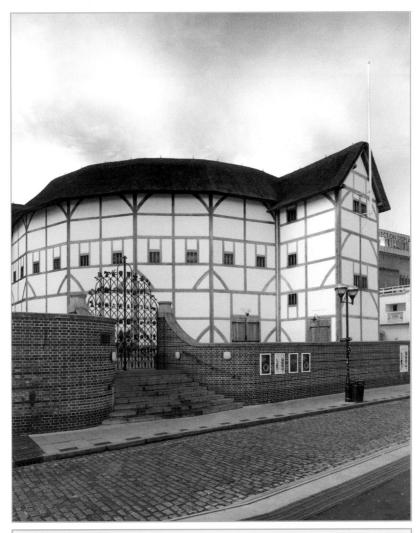

468 THE NEW GLOBE 21 NEW GLOBE WALK

1997 NORDEN AND HOLLAR

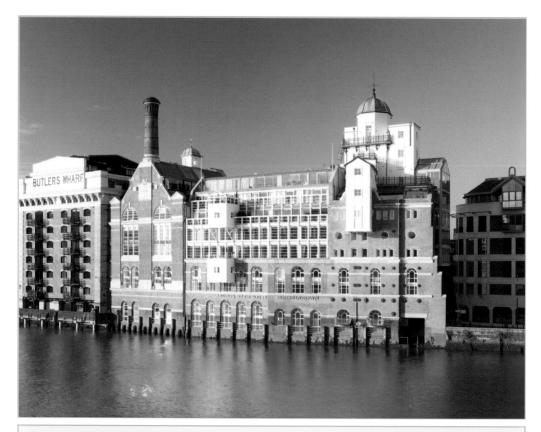

COURAGE BREWERY

1787; 1891 REBUILT AFTER FIRE; 1980s CONVERTED

WATERLOO INTERNATIONAL TERMINAL

1848; 1900-22; 1994 NICHOLAS GRIMSHAW AND PARTNERS

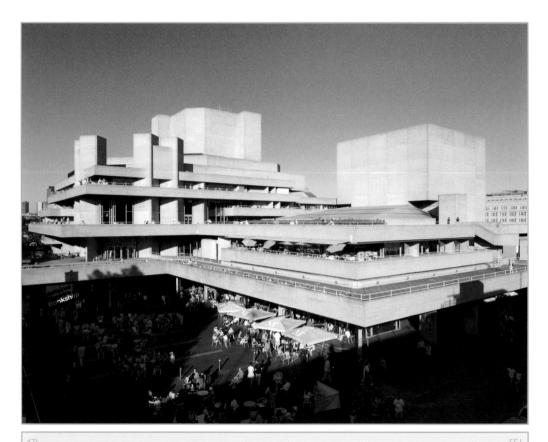

ROYAL NATIONAL THEATRE

1967–76 SIR DENYS LASDUN AND PARTNERS

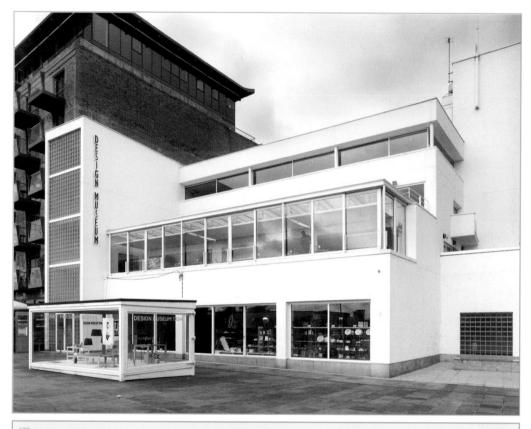

472 DESIGN MUSEUM SHAD THAMES

1989 CONRAN ROCHE

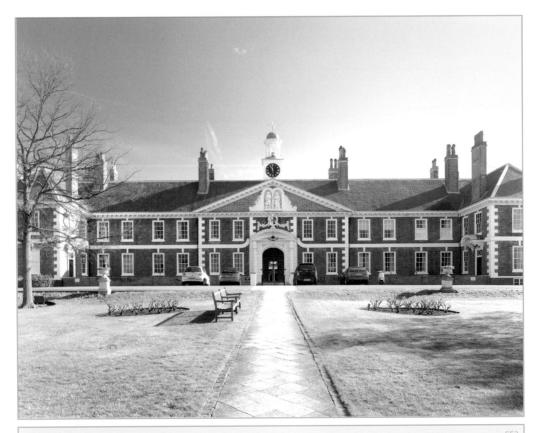

473 MORDEN COLLEGE MORDEN ROAD

1695 POSSIBLY SIR CHRISTOPHER WREN AND EDWARD STRONG

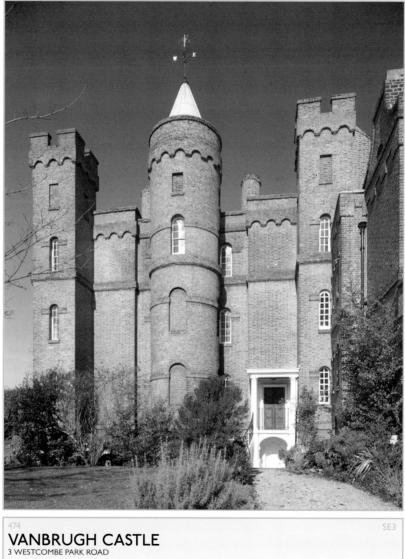

1770–26 SIR JOHN VANBRUGH

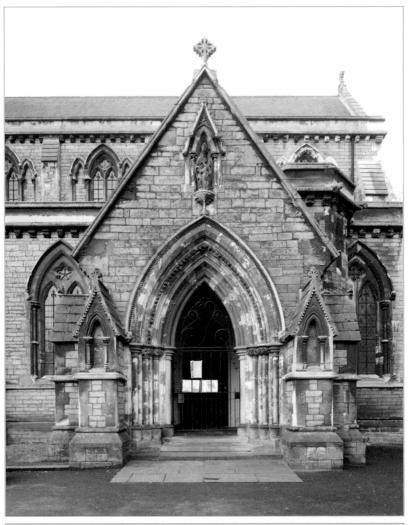

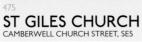

1842-44 SIR GEORGE GILBERT SCOTT; WEST FRONT SIR ARTHUR BLOMFIELD

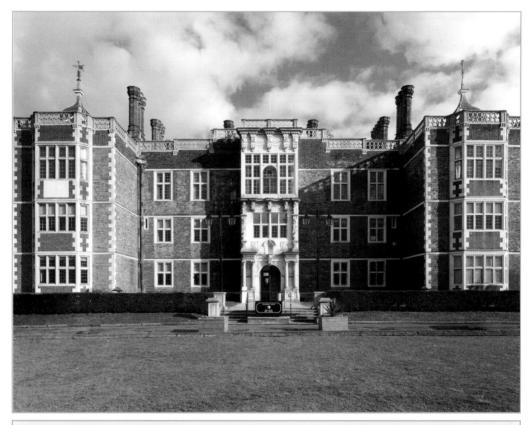

CHARLTON HOUSE

1607–12 ATTRIBUTED TO JOHN THORPE

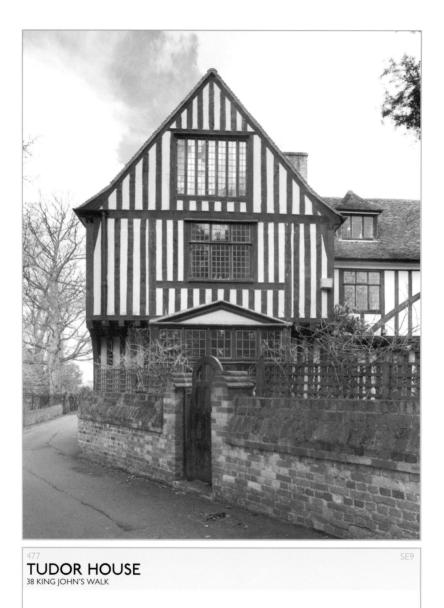

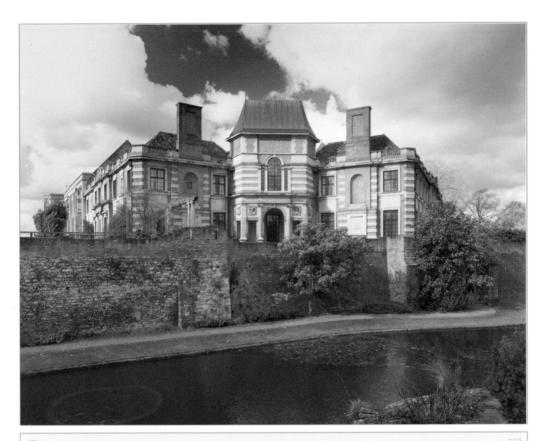

ELTHAM PALACE

1300s; 1479; 1931-37 RESTORED STEPHEN COURTAULD

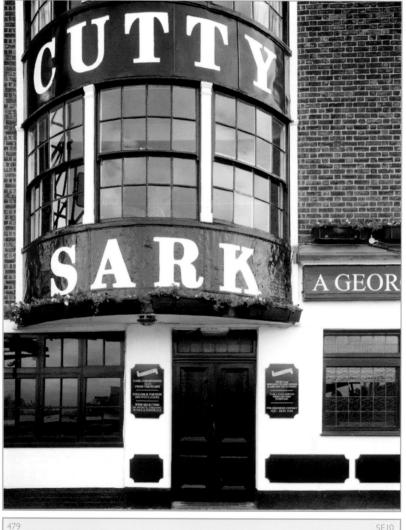

1805

CUTTY SARK 4–6 BALLAST QUAY; FORMERLY THE UNION TAVERN

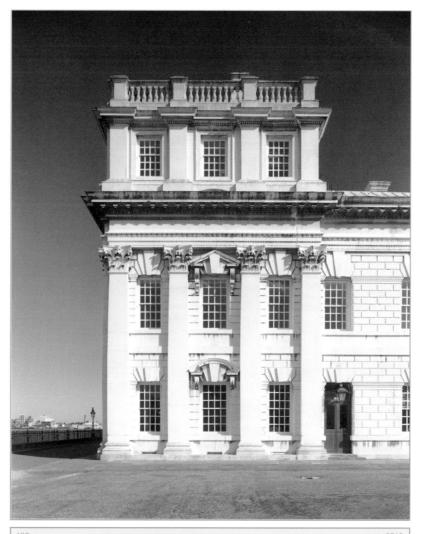

ROYAL NAVAL COLLEGE GREENWICH PARK; FORMERLY ROYAL NAVAL HOSPITAL

SEIC

1694–1742 SIR CHRISTOPHER WREN, NICHOLAS HAWKSMOOR, SIR JOHN VANBRUGH, JOHN WEBB,

AND OTHERS

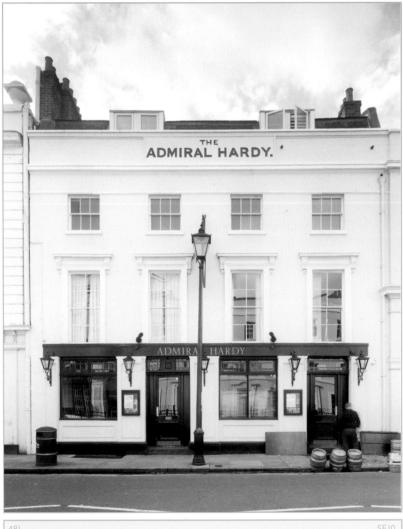

481 ADMIRAL HARDY 7 COLLEGE APPROACH

1830

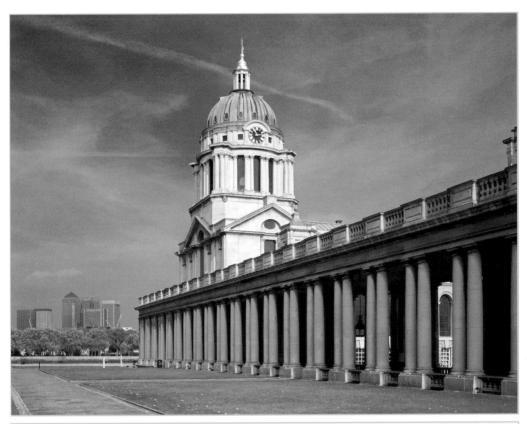

SEIC

CHAPEL GREENWICH HOSPITAL

1600s CHRISTOPHER WREN AND THOMAS RIPLEY; 1789 JAMES 'ATHENIAN' STUART AND WILLIAM NEWTON

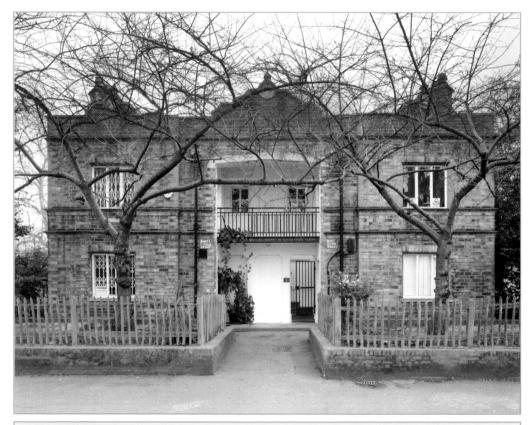

483 A PARK LODGE KENNINGTON PARK ROAD

1851 HENRY ROBERTS

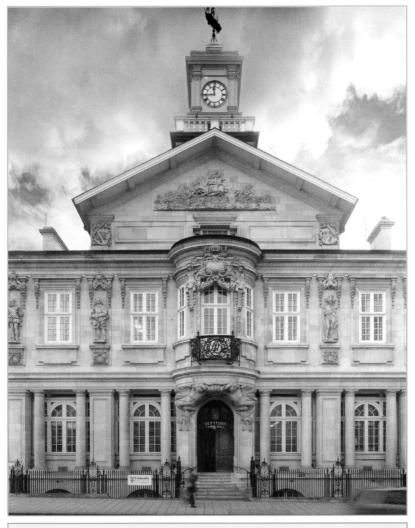

SE14

A84 DEPTFORD TOWN HALL NEW CROSS ROAD

1900–03 LANCHESTER, STEWART AND RICKARDS

SOUTH EAST LONDON (SE) 509

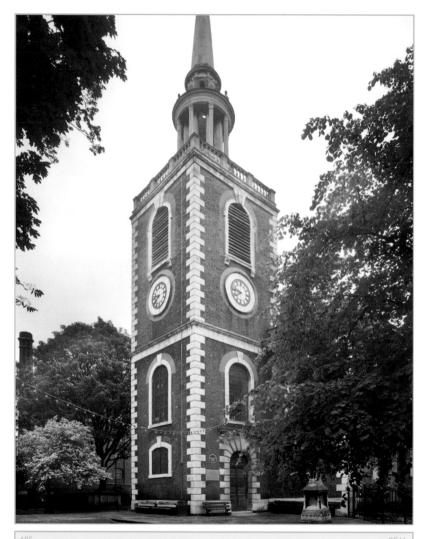

ST MARY ROTHERHITHE ST MARY CHURCH STREET

1282; 1714 JOHN JAMES; 1739 STONE SPIRE. LAUNCELOT DOWBIGGIN SPIRE; 1876 RESTORED WILLIAM BUTTERFIELD

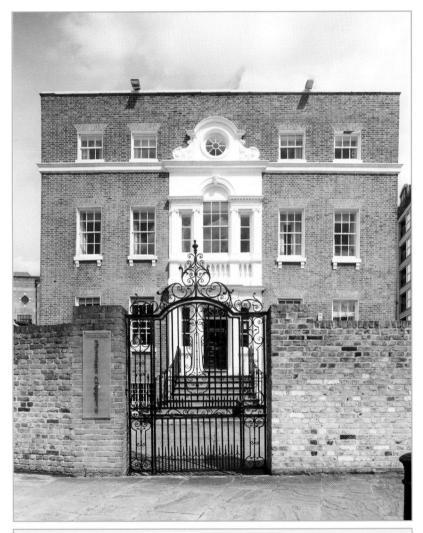

486 NELSON HOUSE 265 ROTHERHITHE STREET

C. 1770

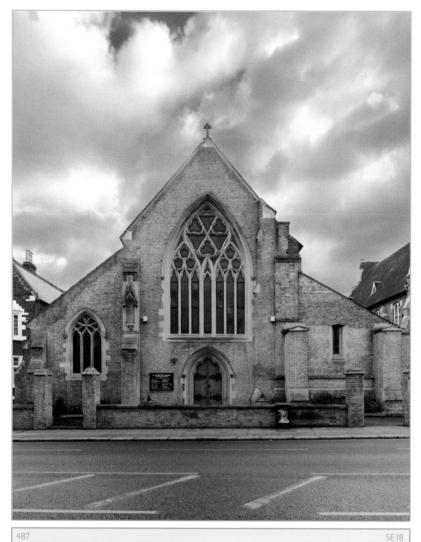

ST PETER THE APOSTLE

1843 AUGUSTUS WELBY NORTHMORE PUGIN

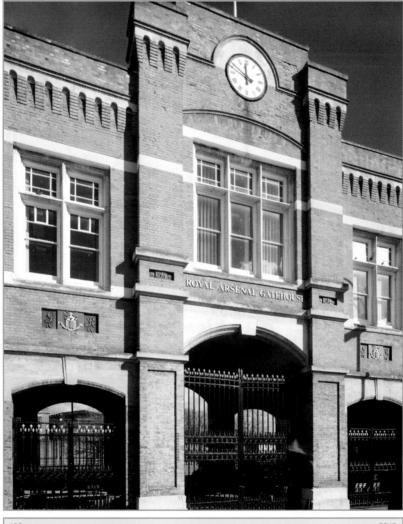

488 SE 18 ROYAL ARSENAL BERESFORD SQUARE 1717–20 SIR JOHN VANBRUGH

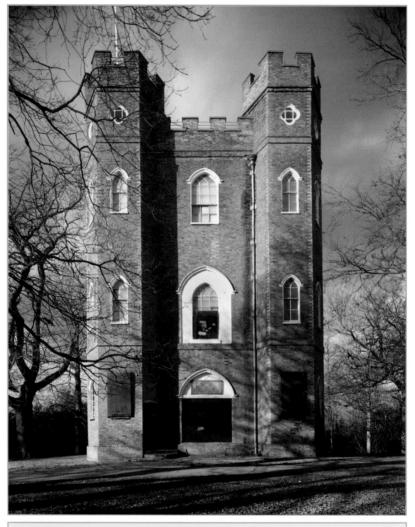

SE18

SEVERNDROOG CASTLE CASTLEWOOD, OFF SHOOTERS HILL ROAD

1784 W. JUPP

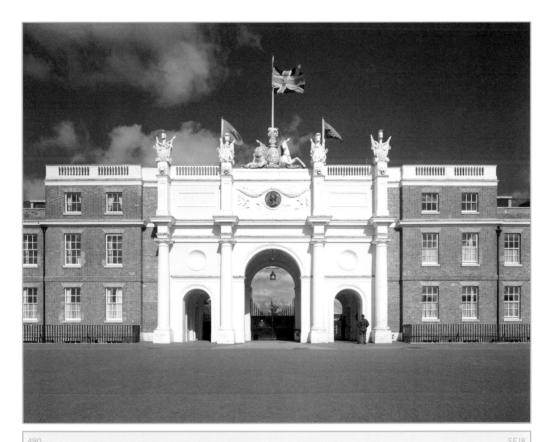

ROYAL ARTILLERY BARRACKS

1775-1802

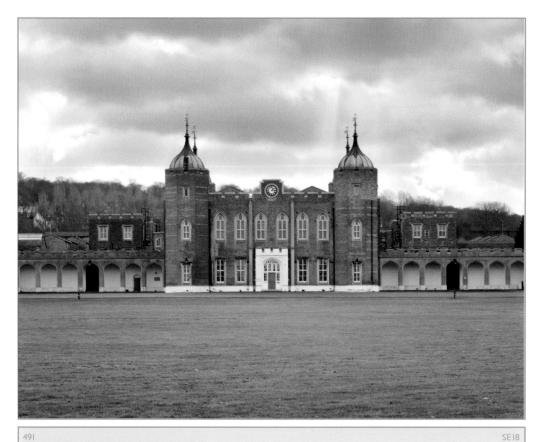

491 WOOLWICH GARRISON ACADEMY ROAD, WOOLWICH COMMON

1805–8 J. WYATT

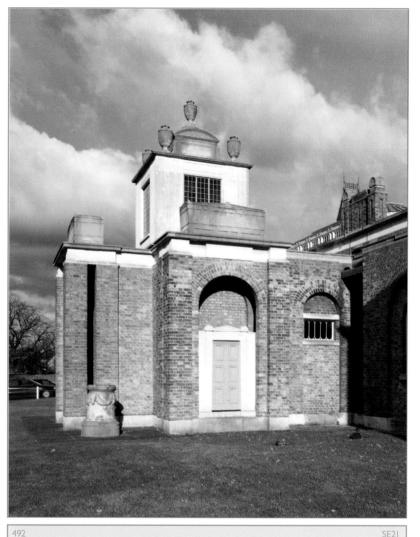

DULWICH MUSEUM, MAUSOLEUM AND PICTURE GALLERY COLLEGE ROAD AND GALLERY ROAD

1811–14 SIR JOHN SOANE

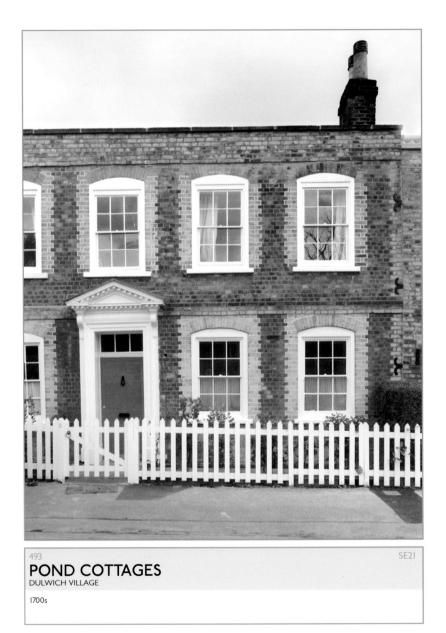

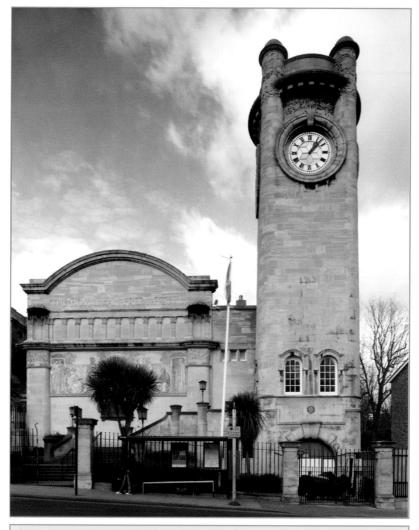

SE23

494 HORNIMAN MUSEUM 100 LONDON ROAD, FOREST HILL

1896-1901 C. H. TOWNSEND; 2002 NEW EXTENTION

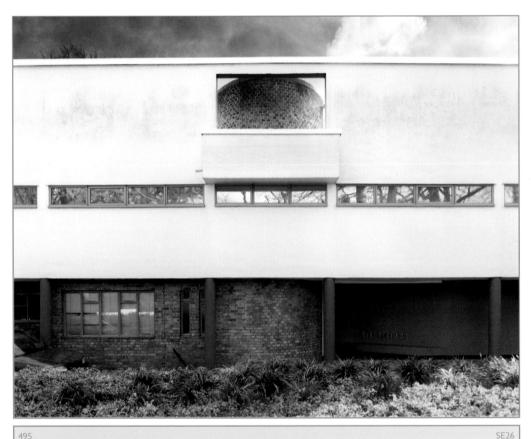

495 SIX PILLARS CRESCENT WOOD ROAD

1935 VALENTINE HARDING AND BERTHOLD LUBETKIN

CLOSE TO LONDON

London is a huge city, and the previous sections of this book have concentrated on the more central areas because there is so very much to explore there. However, the capital's fringes have many fascinating treasures. Through the centuries, old Roman and drovers' roads turned into routes for horse and cart and coach; then railways, main roads, and motorways arrived—as they did, bringing more people into the city, the opportunities to escape from the centre also multiplied. This selection is only a taste of what can be discovered just a little farther out—and looks in particular at Kew. Other places within easy reach include Windsor Castle and Hampton Court.

St Albans, for example, is only twenty-odd miles north of central London and has an abbey, cathedral, old town hall, market place, medieval clock tower, and Roman Verulamium—this was a major city in A.D. 130. To the west, Wembley boasts one of the world's most famous football stadiums, the English national football ground since 1923—where a new state-of-the-art stadium is presently rising. In the southwest, Richmond Park was enclosed by Charles I in 1637, and has red and fallow deer that are descendants of the original herd stocked by Henry VIII; the town has lovely Georgian dwellings. To the east, Romford has been a market town since 1247, and since mediæval days has had rights that stopped its neighbour Ilford from holding a market until the 1990s. It grew along the old Roman road to Colchester, named after a ford over a small stream called the Rom.

Meanwhile, the city of Rochester in Kent developed from a tiny Saxon village and Roman town (in A.D. 43). Charles Dickens lived here for a while and many of his novels included references to Rochester. Here, in the 1000s, busy Bishop Gundolf constructed a stone castle on the remains of the old Roman fort, a magnificent cathedral (the second oldest in the country.) and a leper hospital—as well as raising Maidstone cathedral and 'commuting in' to build the Tower of London.

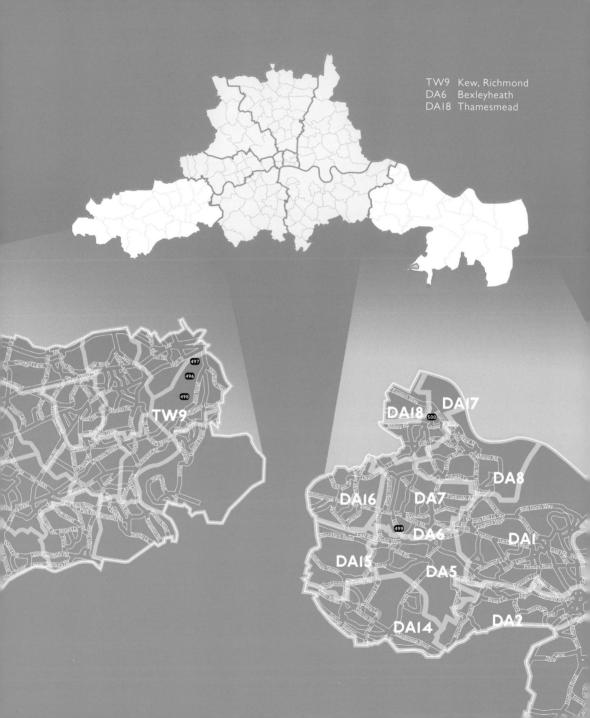

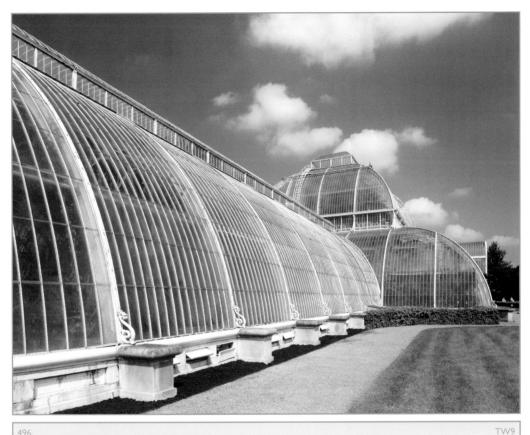

496

PALM HOUSE

ROYAL BOTANIC GARDENS, KEW, RICHMOND

1844-48 DECIMUS BURTON AND RICHARD TURNER

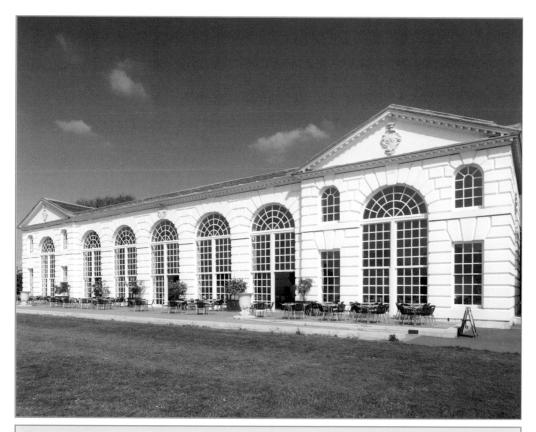

497 ORANGERY ROYAL BOTANIC GARDENS, KEW, RICHMOND

1761 SIR WILLIAM CHAMBERS; RESTORED 1959 AND 2002

TW9

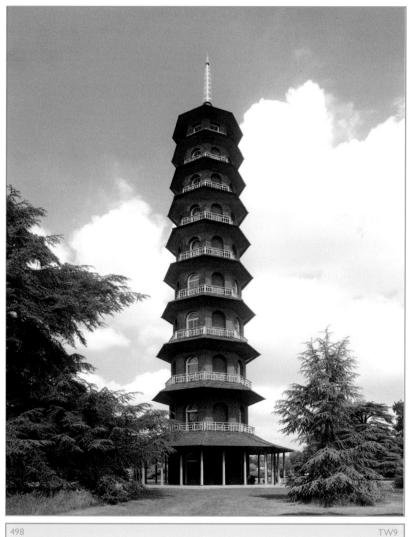

498 PAGODA ROYAL BOTANIC GARDENS, KEW, RICHMOND

1762 SIR WILLIAM CHAMBERS

DA6

RED HOUSE RED HOUSE LANE, BEXLEY HEATH

1859 PHILIP WEBB

MODERN ART GLASS LIMITED

1973 SIR NORMAN FOSTER

I

MARBLE ARCH

Marble Arch. reputedly inspired by the design of the Arch of Constantine in Rome, was originally located in front of Buckingham Palace, and was intended to be the building's main entrance for royalty. It was moved to its present site when the palace was extended in 1851. Today, it serves as a gateway between Bayswater and Marylebone but only senior members of the royal family, Royal Horse Artillery, and King's Troop, are allowed to pass beneath. It has three archways of Corinthian columns with sculpted reliefs that represent England, Scotland, and Ireland, Once upon a time. Tyburn Gallows stood here and, from the twelfth century, was where criminals, thieves, and political prisoners were hung in public executions that continued until 1783. A condemned man was permitted one last drink at an ale house on the road to the gallows, hence the popular phrase, 'one for the road.' One of the guards was left in charge of the cart and not allowed to drink, so the saying 'on the wagon' also arrived!

2

THE INCOMPLETE CIRCUS

This 1700s crescent is the only curved section of road realised of the intended circus originally planned here. It was named for George II's son, William, Duke of Cumberland, who was known as the 'Butcher of Culloden' after the battle he fought there with Bonnie Prince Charlie and the Scots. The sweep of crescent is graced with beautiful, elegant lamp holders and railings. Today, the central portion is occupied by a synagogue.

3

ST MARY'S

Sir William Portman, Lord Chief Justice, bought the land here in 1553. The names of many streets in the area are associated with the family, including one Anne Wyndham who married Henry William Portman. This splendid church was built to the designs of Sir Robert Smirke, who revelled in Greek Revival style. Some fifty years on, the church was altered by Sir Arthur Blomfield (1875) and it was redecorated by Sir Albert Richardson after World War II. Its glorious semicircular portico is set on a paved forecourt and graced with Ionic columns, above which rise a delicate round stone tower and cupola. Its square body is built of stock brick, with two-tier windows. The interior has a gallery and Doric columns that rise to a gently curved, coffered ceiling. This Grade I-listed building has recently had a £3.7-million renovation to restore the original Georgian splendour.

HOME TO THE BEATLES

Montagu Square, named after literary hostess Mrs Elizabeth Montagu, is now the only square left in Westminster that is purely residential. It has a peaceful, shady garden. Here the houses, some with shallow bay windows, form a narrow oblong of brick terraces. Ringo Starr lived here in 1965–69 (he also rented the house to Jimi Hendrix), and John Lennon and Yoko Ono first lived together here at number 34, the location for their nude Two Virgins album cover. This is also where Paul McCartney wrote and, in a temporary studio, recorded a demo version of *Eleanor Rigby*. Mick Jagger lived in the nearby Bryanston Mews East. In earlier times, novelist Anthony Trollope lived from 1815–82 at number 39—now turned into flats.

THE WALLACE COLLECTION

Manchester Square is small but has many grand houses. It was developed and named for the Duke of Manchester, who raised a fine edifice on the north side in the 1770s, when the square was conveniently close to good duckshooting country. A century later, this house was altered to its present form by Sir Richard Wallace, an illegitimate but favoured heir. It has a lovely pillared entrance with semicircular windows above and a very pleasing simplicity of form. Wallace owned a vast and impressive collection of paintings and decorative art—including the *Laughing Cavalier* by Fans Hals and works by Rembrandt, Rubens, Watteau, and Poussin—plus porcelain, furniture, and armour. When he died in 1890, Wallace left these treasures to his wife—who later bequeathed them all to the nation. The Wallace Collection, one of the finest private collections assembled by one family, is now a national museum but the house still largely retains the 1800s room layout of Sir Richard's day. In 1998, a new glazed roof was added to the courtyard.

6

ELEGANT HOUSES

The square was first developed in the eighteenth century by Henry William Portman, on meadowland passed down from a Tudor ancestor. Numbers 20 and 21 are particularly fine properties. Home House is one of only two remaining great houses in London designed by Robert Adam. Adam developed a continuous sequence of rooms for the London base of the Countess of Home, with appropriate designs and styles that included some fine delicate. linear decoration. The elegant drawing rooms and Music Room are particularly lovely. Adam led the classical revival in England for both architecture and interior decoration. Sadly, these buildings were unoccupied from the late 1980s and ended up on the Buildings at Risk Register until a full restoration programme rescued the fine rooms and reroofed the entire building. The wilderness gardens, laid out in about 1780 with a moveable temple built by the Turkish ambassador, were also restored in 2005. Home House is now used as a private club.

7

SELFRIDGES

When Selfridges opened in 1909, women had just gained the freedom to go out alone, without gentleman escorts; 90,000 people visited the largest store ever designed as a single shop. It had eight floors, nine passenger lifts, and one hundred departments. The first public demonstration of television was made here by John Logie Baird, in 1925. There was a silence room where the sign today still orders, 'Ladies Will Refrain From Conversation.' A recent £300-million development plan encompasses a new five-star hotel. It remains one of London's grandest shop façades with its huge, richly decorated lonic columns. The store probably originated the saying 'The customer is always right.'

STRATFORD HOUSE

This magnificent Adam-style mansion was built for Edward Stratford, the second Earl of Aldeborough at the north end of the close. It is a rather splendid stone-faced classical building with dignified Ionic pilasters and a central pediment. An east wing with a ballroom was added in 1909. The house was occupied in the early 1900s by the seventeenth earl, who was war secretary in 1916–18 and ambassador to France in 1918–20. After World War II, the publishers Hutchinson took up residence, but it is now the Oriental Club.

HANDEL'S HOUSE

From 1723, this was the residence of composer George Frideric Handel (1685–1759), who wrote *The Messiah*, *Zadok the Priest*, and the *Royal Fireworks Music* here. On his death, the tenancy passed to his servant, who purchased Handel's remaining chattels for £48. In about 1790, a bowwindow block replaced closets at the rear. In the 1830s, the garrets were raised to full-storey height. By 1905, the house was a shop but, from 1969–70, rock star Jimi Hendrix lived upstairs; blue plaques now honour both these 'poles-apart' musicians. Today, meticulous restoration has restored the fine, early Georgian interiors and the house (with number 23) hosts a museum celebrating Handel's life and works.

10

KENZO

WI

9

\otimes

David Chipperfield began his career working for Richard Rogers and then Norman Foster, and is renowned for his modernist creations that may be restrained and austere but are always appropriate. Here, there is interesting use of both natural light and artificial lighting, and interesting subtle changes of floor level. To its east, a smaller shop at number 26, called Equipment, was also designed by Chipperfield and opened one year later. His practice, founded 1984, undertakes a wide range of projects—from high-rise buildings and museums to interior design and made-to-order furniture.

11

ST PETER'S

The building of Cavendish Square began in 1717, but this work was interrupted in 1720 when the bursting of the South Sea Bubble created financial chaos. Lady Mary Wortley Montagu, the famous traveller and letter-writer, lived at number 5 from 1723–38, and Lord Nelson was in residence here in 1791. The Wren-inspired chapel is set on an island site and has decorative brickwork, a fine porch with pillars and pediment, and a small, doublecupola tower. Inside are a curved ceiling, huge columns, and decorative plasterwork. It was designed by the very talented James Gibbs who studied in Rome, the first English architect to do so—with Carlo Fontana. Gibbs is probably most famous as the architect of St Martin-in-the-Fields.

12

ST GEORGE'S

In the late 1600s, as new suburbs spread westward, parish boundaries changed and many new churches were raised. In 1711, Parliament passed Queen Anne's act for the erection of fifty new churches in and around the City and Westminster. This is one of them; its new parish stretched from Regent Street to the Serpentine and south to include Mayfair, Belgravia, and Pimlico. The first stone was laid on June 20, 1721, and it took three and a half years to complete, at a total cost of £10,000. The architect, John James, was one of Sir Christopher Wren's assistants. The church was consecrated by Edmund Gibson, bishop of London, in 1725. The west front has a large Roman temple-style portico with an elegant steeple set behind. The interior was restored by Sir Arthur Blomfield in 1894. Here the Grinling Gibbons reredos frames a 1724 painting of The Last Supper, by William Kent. The windows contain early 1500s Flemish glass (from Antwerp). George Frideric Handel was a regular worshipper at St George's-which now hosts Great Britain's annual Handel Festival. St George's is presently the parish church of Mayfair.

13

ALL SAINTS

William Butterfield had a grand opportunity here to ex-

press both his religious and architectural ideas, and created one of the most influential urban churches of its era—in early High Victorian, Gothic Revival style. The narrow plot would prove quite a challenge but Butterfield also created two houses for clergy, a choir school, and a small courtyard. The soaring tower and steeple reach nearly 70 metres (227 feet). The church interior revels in chequered patterns, polished granite piers, rich stained glass, marble, alabaster, and coloured tiles. John Ruskin said it was, 'the first piece of architecture I have seen built in modern days which is free from all signs of timidity.'

1

GRANGE LANGHAM COURT HOTEL

Langham Street was laid out in the early 1800s and takes its name from Sir James Langham, a local, wealthy, eminent man. Scholar and editor Edward Malone lived at number 40 from 1779–1812. Today, the Grange Langham Court Hotel offers a tranquil haven in a central location in a rather unusual building. Although completely rebuilt in 1989, the splendid Victorian styling has been retained—including its façade of shiny, white, glazed brick, with lovely diamond patterning, striped decoration around the window arches, and elegant balustrades and chimneys.

WI

ALL SOULS

This was part of John Nash's grand scheme for the area and, by the entrance, his bust gazes down Regent Street. The church gives Regent Street a fine flourish, despite the difficult angles of the site; the front circular portico acts as a pivot to the flow of roads. The conical spire mimics the larger portico below (a feature ridiculed at the time), and the church is faced with Bath stone. Winged cherub heads on the columns are based on Michelangelo's designs. Inside, a flat coffered ceiling is set above Corinthian columns and galleries, and there is bright blue and gold decoration. The altarpiece was a gift from King George IV. The BBC used the church to broadcast its daily service from 1951–94.

BROADCASTING HOUSE

The 'Beeb's new headquarters, Broadcasting House, was officially opened in May 1932. This heroic building was soon a symbol of national unity during World War II, with its towering Portland stone façades, sculptures by Eric Gill, and a vast rounded frontage that resembles the prow of a ship. Inside, the demands of soundproofing, artificial lighting, air-conditioning, and new technical innovations have impacted on the original architecture but greater changes are underway. Soon, a new state-of-the-art centre for BBC national and international radio, television, and online services will transform Broadcasting House into a fine modern centre for global broadcasting.

17

 \mathbb{V}

A GRAND 1700S STREET

This was planned as a single, very wide street. It was named after the ground landlord, the Duke of Portland, and owes its breadth to a mandate given by the planners to Lord Foley that the view northwards from the windows of his house, at the southern end of the street, should never be obscured. Today, with all the rebuilding since its inception and World War II bomb damage, it is hard to visualize the original grand plan. Later, the road became part of Nash's grand route from Carlton House to Regent's Park, with the halfcircus of Park Crescent crowning Portland Place. There is a fairly complete section of original houses on the east side, between Weymouth Street and New Cavendish Street. Here the brick house-fronts have fine stucco pilasters and sunken panels decorated with honeysuckle. Famous residents include: Admiral Lord Radstock, who died at number 10 in 1825 (the site is now covered by Broadcasting House): Anne Isabella Milbanke, who was courted at number 63: authors John Buchan (who lived at number 76) and Frances Hodgson Burnett (who wrote Little Lord Fauntleroy and lived at number 63); and Admiral Jellicoe, resident of number 80.

18

PARK CRESCENT

This remarkable curve of buildings marks the formal entry

to Regent's Park. It was originally planned as a complete circus, the largest in Europe, but, in the event, became a beautiful sweeping crescent that just tips the base of the park. Single-storey colonnades of paired lonic columns run the length of the wide quadrants, and act as a screen set before the individual doorways—so creating uniformity and flow. Lord Lister, the surgeon, lived at number 12 from 1877–1912, and Joseph Bonaparte stayed for a short while at number 23. Today, the crescent is home to many learned societies and important bodies. With its grace, proportion, and elegant simplicity, Park Crescent remains one of the finest architectural set-pieces in London.

ROYAL INSTITUTE OF BRITISH ARCHITECTS

RIBA was founded in 1834 as the Institute of British Architects. Its Royal Charter was granted by William IV in 1837 and, in 1866, the title was conferred by Queen Victoria. Its presidents have included architects C. R. Cockerell, Sir George Gilbert Scott, Charles Barry, Alfred Waterhouse, Sir Reginald Blomfield, H. S. Goodhart-Rendel, Sir Edwin Lutyens, and Sir Basil Spence. Here, very appropriately, the architect for the building was chosen through a competition. The impressive Grade II-listed structure that resulted is a sturdy edifice in Portland stone that encloses a complex interior, created with much decorative craftsmanship. The building functions as a learned institute-with one of the best architectural libraries in the world, lecture theatres, committee rooms, and a club for members. There is a café with an outdoor terrace, galleries hosting exhibitions, and a good architectural bookshop.

AN ELEGANT SQUARE

Henry Fitzroy was the son of Charles II and Barbara Villiers, and it was one of his descendants that built this square, regarded by some as London's finest. It was planned in its entirety but the buildings arrived in several bursts. The east side is a streamlined palazzo of individual houses in Portland stone with unfluted columns. The south side was destroyed in World War II but has been replaced. The north and west sides have stuccoed fronts—using stone for homes was then unusual in London. Blue plaques record that writer-artist William de Morgan and Prime Minister Lord Salisbury lived here. Virginia Woolf and George Bernard Shaw lived at number 29 (at different times); at number 37, Ford Madox Brown entertained fellow artists Rossetti, Holman Hunt, William Morris, Swinburne, and Whistler. In 1913, artist and art theorist Roger Fry gathered many brilliant, creative people here and opened the Omega Workshops to produce ceramics, painted furniture, textiles, glass, and jewellery—all marked with , the Greek letter Omega. The square is now a pedestrian precinct.

21

THE BRITISH TELECOM TOWER

At 174 metres (580 feet) high-plus a mast and weather radar aerial that extends it to 188 metres (620 feet)-this was the tallest building in London until the National Westminster Tower (now Tower 42) arrived in 1981. Its construction cost over £2 million. The tower is made of 13,000 tonnes of concrete, plus steel, and is clad in glass with a special tint to prevent heat build-up. Its circular shape reduces wind resistance and lends it both stability and grace. The tower initially transmitted microwave telephone, radio, and television-and today incorporates fibre optic links and Internet transmission. Many enjoyed the view from the observation gallery until this was closed after a bomb exploded on the 31st floor in 1971. The revolving restaurant was closed, except for corporate events, in 1980, but not before over 4.5 million people had visited the tower. Two internal high-speed lifts travel at 6 metres (over 2 yards) per second, and take just thirty seconds to reach the top. An Act of Parliament was required to change fire regulations, allowing this to be the only building in the United Kingdom that can be evacuated by lifts (the only means of exit). Despite its very obvious presence, it was, curiously, classed as an 'official secret' until the mid-1990s; the tower was omitted from Ordnance Survey and other official maps and taking its photograph was technically an offence! It was Grade II listed in 2003.

21

HEAL AND SON LIMITED

Heal's has been famous for its stylish, modern designs ever since it opened its first store nearly two hundred years ago. John Harris Heal came to London in 1805 to work with a feather-dressing firm and in 1810 set up his own business. In 1893, Ambrose Heal Junior, a cabinet maker, joined the family firm and soon the company's simple oak Arts and Crafts vernacular furniture proved enormously popular. The building has been extended but the original store's façade reflects the functional, craft-based lines. Stone casings run the full height of the store, divided by blue spandrels depicting the tools of the trade. Today the store offers high-quality furniture, rugs, fabrics, bed linens, and home accessories, and has continued to reflect the fashions of the day—whether Art Deco, Pop Art, or Flower Power.

COLVILLE PLACE

Colville Place stands near the site of an eighteenth-century windmill on what was, in much earlier times, called Crabtree Field. Coleville Place derives its name from John Colville, a builder and carpenter who was contracted to build the first streets and houses here. It is a rare example of a surviving Georgian court—a small alley of houses, and shop fronts. Today, this is a quiet corner, where ornamental stone pots and urns overflow with plants. There is a stone flagged pavement, plus a line of trees and a green park on the southern side.

ST PATRICK'S CHURCH

Soho Square was once graced by ambassadors and aristocrats. A chapel opened here to serve settlers in 1791 in an area 'inhabited principally by the poorest and least informed of the Irish' St Patrick's stands on the site of Carlisle House, in 1690 the residence of Mrs Cornelys, an opera singer from Venice, who had a child by Casanova. The house became the hub of London society, with masquerade balls, concerts, and operas, until Mrs Cornelys was imprisoned for bankruptcy. Today's church has a strong Italian flavour, with a redbrick exterior. A relic of Tyburn martyr Blessed Oliver Plunkett is housed here. Entertainer Danny la Rue was an altar server for many years and numerous celebrities have been married here, including Tommy Steele.

25

SOHO THEATRE

Obliged to quit the Cockpit Theatre in 1995, a small theatrical company set about converting a former synagogue, helped by an £8 million Lottery grant from the Arts Council. A lightweight canopy marks the street entrance. The ground floor and basement house the box office, bar, and restaurant while the new, 200-seat auditorium, with its steeply raked bench seating, is set at first and second floor level. The third floor is used for rehearsal and administrative space and, above all this, apartments occupy the top three floors. This has been a highly successful new project. The theatre company has grown from just five people with a turnover of £250,000 to have twenty-two full-time staff and a turnover closer to £2 million.

26

LIBERTY'S

Arthur Lasenby Liberty began by importing shawls from India and opened his first shop in 1875, selling soft silks, and goods from Japan, Java, Indochina, and Persia. By 1883, he had acquired two more shops. In time, he owned all of 140-150 Regent Street. In 1881, Gilbert and Sullivan enhanced Liberty's fame by using their fabrics for costumes in Patience. Liberty's went on to pioneer the sale of Art Nouveau. Customers included Ruskin, Charles Keene, Rossetti, and Whistler. In time the shop sold furniture, silver, pewter, jewellery, and wallpapers. The Tudor House building was built in 1924 (at the height of the 1920s Tudor revival) so that trading could continue while the Regent Street shop was renovated. The two buildings are linked by a threestorey bridge over Kingly Street. Built with the timbers of two battleships, the HMS Impregnable and HMS Hindustan, the opulent building has handmade roof tiles, linen-fold panelled lift doors, leaded lights, and stained glass made by Liberty's craftsmen and Italian master carvers. The central well was surrounded by galleries on which exotic rugs and

quilts were displayed in intimate 'rooms' with fireplaces. The shop's Regent Street façade (1926) is neo-classical, and features a vast screen of columns above a rectangular base, with a group of figures and Britannia on top. Some figures peep over the parapet, on which a frieze portrays exotic goods being transported by sailing ship, camel, and elephant. The shop was famous for dress fabrics—including dainty, floral Liberty Prints and Tana Lawn. Liberty has continued to be at the forefront of fashion, promoting craftsmen and designers (including Mary Quant and Yves Saint Laurent). In 1975, the store celebrated its centenary with an exhibition at the Victoria and Albert Museum.

7

THE CLACHAN

The 1924 Liberty store expansion involved a mock-Tudor extension and the Bricklayers Arms was incorporated into this grand plan. For some sixty years, it remained a part of the complex and Liberty's holdings but, in 1983, was sold and became a Nicholson Inn (pubs of historical or architectural interest). It was renamed the *Clachan*, which, in Scotland, means 'a small village'. Built in mellow brick, the pub has a marble fascia, huge carved stone window cases, ornate dormers, and a turret and dome. Within are rich wood carving, interesting structural ironwork, copious old prints and sepia photographs. The cosy, raised seating area at the back was probably once the landlord's parlour.

28

WESTMORLAND HOUSE

The rebuilding of Nash's Regent Street and Quadrant had been interrupted by World War I but, by the 1920s, was once again surging ahead. Just north of Blomfield's contemporary Quadrant on the acute corner of Vigo Street, Westmorland House was Burnet and Tait's first post-war commission and is an example of their renowned use of end pavilions enclosing plainer, classical building. Its rounded ends, decorated with columns and copper-covered domes, enclose six storeys of shops and offices. Sir John James Burnet was awarded the Royal Gold Medal for the promotion of architecture in 1923; this coveted annual award, made by the Sovereign, honours an architect (or practice) for excellence or advancement of architecture.

29

VIRGIN MEGASTORE

This is a store that has had many faces. During Blomfield's rebuilding of Regent Street Quandrant, much of the John Nash's original mid-1800s vision was lost, but Blomfield did at least recapture the Barogue style in the street—albeit French rather than English. Here, Swan and Edgar ran their famous haberdashery shop. William Edgar had progressed from a stall in St James Market to join forces with Mr Swan and, after the redevelopment of Piccadilly Circus, the two moved premises from Ludgate to number 20 Piccadilly in 1812-14and then, after the redevelopment of Piccadilly Circus, arrived at 49 Regent Street, By 1841, a new shop front had appeared in Piccadilly Circus. The store flourished, patronised by the Royal Family, and by 1848, occupied numbers 45-51 the Quadrant, plus a good part of the Piccadilly Circus corner. The shop front was one of the businesses targeted by window-breaking suffragettes in November 1911. The premises were rebuilt in 1910-20 to Sir Reginald Blomfield's design. The store was hit during London's last zeppelin raid in 1917. By 1927, it had been taken over by the Drapery Trust, and was later absorbed by the Debenham Group. It was bought by Richard Branson of the Virgin Group in 2003 and is now a Virgin Records Megastore, transformed by French architects Collet & Burger into an 'entertainment emporium,' with many exciting new design features.

30

RUSTICATED GRANDEUR

Once an insurance office and then the County Fire Office, this building on the north of Piccadilly Circus is a most impressive feature, in monumental style with a grand arcade, and enormous archways that open onto the adjoining streets. It has splendid frontages on all aspects and echoes the stately east front of the former Swan and Edgar store across the road (now a Virgin Megastore). The curved intricacy of the balconies seems especially delicate in this robust setting.

31

NATWEST BANK

There is quite a concentration of banks in this area. Occupying a corner site on Piccadilly and Albemarle Street, this one by renowned architect William Curtis Green has a plethora of columns and arches that create interesting curves at all floor levels. At the top, a loggia of two storeys is placed behind slender lonic columns under the green slate roof, and there are interesting runs of balconies at two levels. NatWest Bank (formerly the National Westminster bank), with its now familiar three-arrowheads logo, commenced trading in January 1970. It owes its origin to National Provincial Bank (established 1833) and Westminster Bank (established 1836), which can trace their histories back to the 1650s.

CHINA HOUSE

Set on the south side of Piccadilly (at the corner of Arlington Street), this design was inspired by a bank in Boston, but initially it served as an elegant Edwardian showroom for Wolseley Motors Limited, whose automobiles were displayed on marble floors. The showroom was sold to Barclays Bank and then Curtis Green undertook its conversion in 1926, adding extra ironwork and bronze doors. Arches on the ground floor, decorated with glorious ironwork, support giant Corinthian columns. The interior was enriched with lacquered Japanese-style decorations and Venetian red paint (said to be some twenty-six coats thick) on the banking hall columns. Now, a glossy noodle bar serves its delicacies here, surrounded by red lacquer, massive pillars, dramatic chandeliers, and vaulted ceilings.

3

LE MERIDIEN

Shaw was a highly influential British architect who pioneered Old English and Queen Anne styles and also designed country houses, commercial buildings, and churches. This robust, large-scale hotel, in his late, heavy baroque style, was part of his scheme for the redevelopment of Piccadilly Circus. The frontage sports giant, triple-height, lonic

 \mathbb{W}

WI

columns, with the bedrooms set back from a screen of columns. It is decorated in classic Edwardian style, and has nine floors and some 260 luxurious bedrooms—plus a vast indoor swimming pool. This grand hotel was renovated in 2001, and today its Edwardian details blend with contemporary styling; there are light marble floors, dark ash furnishings, fan-shaped windows, friezes, and leaded-glass domes.

34

BURLINGTON ARCADE

Set on a strip of Burlington House garden, this was built for Lord George Cavendish—to prevent passers-by from throwing debris into his garden. It became the fashionable place to purchase jewellery and luxury items in its tiny, neat shops, set under a lovely arched glass roof. The arms of Lord Chesham were placed over the Piccadilly entrance but, in 1926, the Chesham family sold the arcade to the Prudential Assurance Company for £333,000 and, in 1931, the entrance was redesigned. Former soldiers of the Tenth Hussars, Lord Chesham's regiment, used to act as beadles—to maintain order: to deter running, singing, and the carrying of open umbrellas or large parcels. Now reliable ex-serviceman from any regiment maintain this role. H. Simmons, the tobacconist, was founded in 1838.

35

THE ROYAL ACADEMY OF ARTS

This building is in an Italianate style, with many pillars, towers, and splendid statues. In 1854, the government bought the Burlington estate from the Cavendish family, and leased Burlington House and a part of the garden to the Royal Academy for 999 years. From 1902 until 1970, it was used by the civil service; and then the Museum of Mankind (part of the British Museum) occupied the elegant building, exhibiting collections and treasures from many indigenous peoples, and both ancient and modern cultures. The Royal Academy is presently developing this newly acquired £5-million site, into a complex for the visual arts—with lecture theatres, workshops, conference rooms, and a new large gallery. At last the public will be able to visit the historic vaults of Burlington House.

36

BURLINGTON HOUSE

The third Earl of Burlington, inspired by a visit to Italy in 1714–15, had the façade of this great mansion remodelled, with a splendid curved colonnade mutating from Baroque to Palladian. In Portland stone, his façade has lonic columns and Venetian windows. In 1815, the house was bought by Lord Cavendish, and the grand staircase arrived. The splendid saloon has a magnificent ceiling. From the mid-1800s until 1982, the building was the headquarters of the Royal Academy. The arched Italianate front was added in 1873. Exhibitions include the celebrated summer exhibitions of some 1,200 new works by living British artists. The new 1991 Sackler Galleries provide three top-lit vaulted rooms, reached by a new glass lift and stair set in a light well.

WATERSTONE'S

This pioneering store design, now a listed building, used the combined energies of architect Joseph Emberton, structural engineer Felix Samuel, and designer László Moholy-Nagy. The Piccadilly façade has horizontal strip windows with a canopy projecting over the top storey. Its welded steel structure implemented huge girders in the upper storeys. There is some fine external metalwork and, internally, the store has the feel of a large house, with cosy rooms rather than the vast open areas common to most department stores. Two storeys were added in the 1960s. Today, this is Europe's largest bookstore, with a vast selection of books, comfortable sofas and chairs for a rest and a read—plus a gift shop, art gallery, coffee bars, a good French restaurant, and a café in the basement.

THE ROYAL ARCADE

The High Victorian Royal Arcade has a pretty glass roof running its full length—echoed by the glass of the shop fronts that are faceted at the corners with black-painted window frames and columns of gold piping. Built in 1879, the neo-Gothic arcade is 40 metres (132 feet) long with expensive shops lining both sides, selling cashmere jump-

WI

ers, golfing knickerbockers, hunting jackets, and specialities such as pipe tobacco and chocolate. Each shop is separated by arches, with an open pediment above. The arcade connects Brown's Hotel and Bond Street and was, at first, simply called the Arcade (as stated on its entrance pediment), but, in 1882, it received royal patronage when Queen Victoria patronised H. W. Brettel's (hosiers and shirt-makers), buying her riding skirts and shirts, handkerchiefs, undervests, and wool here. The shop is still in business, at number 12. The Folio Society showrooms are at number 5. Today chocolate manufacturers Charbonnel et Walker Ltd, at number I (famous for its chocolate-covered strawberries) is patronised by Queen Elizabeth II.

39

THE RITZ HOTEL

This first steel-framed building in London, in French château style, was built for Swiss hotelier César Ritz. (The architects had already built his Paris Ritz.) In fine Norwegian granite and Portland stone, it is crowned by a two-storey roof; here large copper lions add stature to the corners while tall chimneys and dormers soar behind. The interior is in Louis XVI style. A long vaulted gallery with marble floors and crystal chandeliers runs its entire length. The restaurant has glorious chandeliers linked by gilt bronze garlands. Some former famous guests are depicted in murals in the foyer; the hotel has been patronized by King Edward VII (as Prince of Wales), King Alfonso of Spain, the Aga Khan, and Paul Getty. Here, Pavlova danced, Noel Coward wrote songs, and Churchill, de Gaulle, and Eisenhower held summit meetings during World War II. In 1921, Charlie Chaplin needed forty policemen to escort him inside through ranks of fans and, in the 1950s, Tallulah Bankhead sipped champagne from her slipper here. The Palm Court has remained a popular place for tea. In 1995, the Ritz was restored—at a cost of over £50 million. In 2002, it received a Royal Warrant from the Prince of Wales. The terms 'ritzy' and 'putting on the ritz' sprang from this opulent, glamorous setting that oozes Edwardian elegance.

40

THE BISHOP OF ELY'S HOUSE

Famous Dover Street residents have included diarist John Evelyn, poet Alexander Pope, brewer and politician Samuel Whitbread, architect John Nash, and composer Frédéric Chopin. The London residence of the acting bishop of Ely moved from Ely Place to the newly built Ely House (built for and by Edmund Keene, then the bishop of Ely, as his town residence) in 1772—and this remained their official London home until 1909. The street name derives from Henry Jermyn, Earl of Dover, and has several large mid-Georgian houses; this tall house is considered the finest. The central medallion between the first and second floors carries the bishop's coat of arms. It has a very high first floor and its precise architectural features are emphasised by the simple façade. The three-bay stone-faced front is a superb example of Palladianism and, despite considerable alteration for the Albemarle Club in 1909, the interior still has some fine features. Sir Robert Taylor was a notable English architect who in due course was appointed architect to the Bank of England.

41

HOUSES WITH ORNATE TILING

This was ever a busy place with both shops and houses. A poulterers, John Baily and Son, had been established at number 116 in 1720, but then the first Duke of Westminster (the Most Noble Hugh Lupus Grosvenor) had this whole street rebuilt in 1880–1900. By the time of his dukedom, the family's property in Mayfair, Belgravia, and Pimlico had made the Grosvenors the richest family in the United Kingdom. Here, much use was made of the pinkish red terracotta that the duke so approved. J. T. Smith's work on numbers 118–121 shows wonderful ornate examples of this tiling, in a street that has many fine examples. There were luxury shops at one end, with accommodation above, and fine, large, private houses towards the other end.

42

CONNAUGHT HOTEL

Originally a 'home from home' for the landed gentry of England when visiting the capital, this hotel was rebuilt and named the Coburg Hotel in 1896, after Prince Albert of Saxe-Coburg. When World War I broke out, it was renamed to avoid any German associations, and became the Connaught (after Queen Victoria's third son, Arthur, first Duke of Connaught). It served as the London home for landed families, many of whom had permanent suites here and, in World War II, was the London headquarters of General de Gaulle. Its handsomely proportioned interior has a majestic mahogany winding staircase and exquisite pieces of antique furniture. In 1956, the hotel was acquired by the Savoy Group. It is popular with film stars, and its Terrace Restaurant is run by superchef Gordon Ramsay (with Angela Hartnett).

43

TUDOR-STYLE HOUSE

The row takes its name from Mount field, where there was once a small earthworks called Oliver's Mount, a Civil War fortification. The street arrived about 1720–40 with small, unpretentious houses, a parish workhouse set on its south side, plus shops and respectable lodging houses. In 1880–1900, the whole street was rebuilt under the first Duke of Westminster, with many pink terracotta Queen Anne-style houses (the workhouse moved to Pimlico). Soon luxury shops and substantial private houses sprang up. This little group of offices takes the form of an Elizabethan house with overhanging eaves, a Tudor-arched entrance with windows projecting above, and a rear court with decorative plasterwork trees. Architect Frederick Etchells was also a notable artist.

44

HOMES FOR 'PERSONS OF QUALITY'

These buildings have superb terracotta tiles by W. H. Powell. The rebuilding was undertaken on behalf of upholsterers Allen and Mannooch, stationers Henningham and Hollis, saddlers Miller, Owen, and Company, and D. A. Lewis—linen-draper. Number 129 was planned as a model 'sanitary house' on behalf of the National Health Society but this project never reached fruition due to lack of funds. W. H. Powell, chosen as the architect in 1885, produced a disciplined Queen Anne-style design with straight gables and tall chimneys. The facing, in bands of yellow brick with buff Doulton's terracotta, has sometimes been referred to as 'streaky-bacon style.' The construction cost about £20,000 and was home to 'persons of quality.'

45

GROSVENOR HOUSE HOTEL

This grand hotel by stately Hyde Park was built on the site of Lord Grosvenor's 1800s mansion. It has luxurious suites, clubs, restaurants, a splendid Edwardian wood-panelled library, the Bollinger Bar (a renowned champagne house), and the largest ballroom in Europe, the Great Room, which has hosted many gala events—especially in the 1930s. The hotel has a massive base, square-roofed pavilions, and a screen of huge Corinthian columns. Recent renovations cost £35 million. Guests who stay in Le Royal Club bedrooms have a valet who unpacks suitcases, presses suits, and shines shoes; they receive temporary business cards printed with this London address.

46

DUDLEY HOUSE

Dudley House is a small property on prestigious Park Lane, with an lonic colonnade and a lovely first-floor glazed iron loggia. It survives as the only aristocratic dwelling left here where once there were so many. The Dudley family had already been associated with the site for some two centuries when the Earl of Dudley added a wonderful ballroom and picture gallery in 1855–58. The building survived bombing in 1940 and was remodelled by Sir Basil Spence in 1969–70 for the Hammerson group of companies. In January 2006, it sold for $\pounds37.4$ million to a private investment company controlled by a Middle Eastern investor.

47

WI

ROYAL HOMES

This street was named after Hugh Audley, whose heirs acquired the estate in 1677. In about 1720, larger properties were built at the south end, many with fine Georgian

WI

plasterwork inside. Charles X of France lived at number 72 and Prime Minister John Stuart at number 75 in 1754–92; this became the Egyptian Embassy in 1927. In 1969, a ceiling painting proved to be a Tiepolo and was sold to the National Gallery. The street's architecture is a mixture of calm Georgian façades and vigorous Victorian implants. James Boswell often stayed at a house here , and Queen Caroline, wife of King George IV, lived at number 77 for a short while in 1820.

48

GROSVENOR CHAPEL

This modest little chapel in brown brick, with St George's Gardens set behind, was built to serve the newly developed Grosvenor Square estate to the north. In 1831, it became a chapel-of-ease to St George, Hanover Square. Set before its small park, the chapel evolved through the labours of its craftsmen rather than a grand architectural scheme. It has a certain flavour of New England and, indeed, was used by American armed forces in World War II. Its renowned organ was built by Abraham Jordan in 1732. Here are buried the Duke of Wellington's parents, as well as Lady Mary Wortley Montagu and John Wilkes—a flamboyant, rakish, ugly but charming politician—and Lord Mayor of London.

49

45 PARK LANE

This is the site of the famous Playboy Bunny Club in the 1960s. Gropius (founder of the Bauhaus, and famous for his New York Pan Am Building—now Met Life) collaborated with several other architects to create this eight-storey building with a pre-cast concrete façade and a rounded end facing Stanhope Gate. Here, the arrival in London of Hugh Hefner's bunny girls caused a huge stir in the Swinging Sixties. (Hugh Hefner conceived the idea for *Playboy* while he was in college and plans to be buried in a crypt next to Marilyn Monroe in the USA.) The Playboy Club opened here in 1966 but soon came under attack from the emerging feminist movement, led by such women as Germaine Greer. In due course, the club became the preserve of the rich and famous—from pop stars (and some criminals) to businessmen and politicians. In 1989, a brother of the sultan of Brunei, the world's richest man, was accused in the High Court of keeping prostitutes in the former Playboy Club in London, where he had bought the upper floors for $\pounds 21$ million.

)

DORCHESTER HOTEL

In the eleventh century, William the Conqueror gave this site (in the manor of Hyde) to Geoffrey de Mandeville. Dorchester House was raised in 1751 and renamed later after its owner became Earl of Dorchester in 1792. In 1928, Sir Robert McAlpine and Sons and Gordon Hotel Ltd built a hotel here—a modern, progressive piece of architecture. The building rose quickly—one floor each week-and 40,000 tons of soil were excavated to create space below for kitchens, garages, and Turkish baths. The exterior facade is faced in faience with octagonal window towers. A thick raft of concrete over the public rooms supported eight floors of bedrooms. The new reinforced concrete allowed vast public spaces to be uncluttered by pillar supports and this sturdy structure encouraged General Eisenhower to choose it as his headquarters during World War II. The vast, pillarless ballroom has mirrored walls set with sparkling studs. Examples of cocktails created by one barman, famed for his cocktailshaker expertise, were later sealed into the wall of a new bar. In the 1950s, the hotel was extended: Oliver Messel, a celebrated theatre designer, created extravagant floral themes, including an enchanted-forest penthouse suite. Illustrious hotel guests have included Alfred Hitchcock, Laurence Olivier and Vivien Leigh, Richard Burton and Elizabeth Taylor, Brigitte Bardot, Danny Kaye, Noel Coward, Marlene Dietrich, Cecil Beaton, Judy Garland, Duke Ellington, Sir Winston Churchill, Somerset Maugham, the Beatles, James Mason, Charlton Heston, Yul Brynner, Julie Andrews, Warren Beatty, Peter Sellers, Tom Cruise and Nicole Kidman, Arnold Schwarzenegger, and Kim Basinger. In 1977, the hotel was sold to an Arab consortium and, by 1990, the building had been refitted, with superb new facilities and restaurants plus all the latest entertainment and business technology.

51

SHEPHERD MARKET

This development of small shops was originally built to serve the grand residences of Piccadilly. Now, the charming enclave is busy with outdoor cafés, shops, pubs, restaurants, and people thronging the thoroughfares. It is named for architect Edward Shepherd, who lived in nearby Crewe House. Mr Shepherd received a royal grant for a cattle market in 1738 and by the 1760s the fair bustled with jugglers, prize fighters, fire eaters, merry-go-rounds, bullbaiting, eel-divers, and Tiddy-Dol, the Gingerbread Man, who dressed in white satin and sang to attract customers. The fair ended in 1764 when the Earl of Coventry objected to the noise and disturbance near his premises—but the market still continues.

52

STATESMEN AND BOOKS

This beautiful square, with magnificent plane trees over two hundred years old, is the setting for these lovely Georgian townhouses with elegant entrances, plant-filled balconies, and sash windows. Established in 1853, Maggs Brothers Rare Books occupies number 50, with many antiquarian volumes and first editions. Statesman, twice foreign secretary, and finally prime minister in 1827, George Canning lived here—one of the first prominent politicians to use the term Tory openly (in the 1790s), and then the word Conservative (in 1824). He died in Chiswick, in the house of the Duke of Devonshire, in the very room in which politician Charles Fox had died some two decades before.

53

ST MARY

W2

This rather charming, small church is built of yellow brick with white stone dressings in a Greek cross plan. Its square centre is set below a shallow dome above four main columns that branch out to encompass segmental curves and vaults to form a chancel, Venetian window, and a threesided gallery. The church's main façade has a grand Tuscan portico. Above the small dome rise a clock tower and cupola. Nearby, a glass canopy covers the grave of Sarah Siddons, the actress who rose to great acclaim in Drury Lane Theatre in the late 1700s and early 1800s. Napoleon's surgeon, Barry O'Meara (1786–1821), is also buried here.

54

HILTON LONDON METROPOLE

This gracious hotel was set at the front of Paddington Station, with decorative twin towers rising above its ornate white façade. A pediment by John Thomas illustrates Peace, Plenty, Industry, and Science. This was one of Victorian London's grandest hotels—refurbished in the 1930s. Today, after a $\pounds 60$ million restoration of its Art Deco interiors, it offers luxurious bedrooms, a swimming pool, and many other facilities including an Executive Floor with both bedrooms and suites. Passengers can take the escalator from Paddington Station concourse straight into the lobby.

TYBURNIA

Hyde Park Estate was built on land owned by the bishop of London and later, starting with Connaught Square in the 1820s, by church commissioners. The name Tyburnia derived from the River Tyburn and the notorious Tyburn Tree-the king's gallows, where many met a grisly end from 1196-1783. Up to twenty-four prisoners could be hung at once, watched by huge numbers (200,000 on one occasion). By the early 1800s, Tyburnia referred to the south-eastern corner of the parish, the first part of the Paddington Estate to really develop. City merchants and artists had already discovered the area but the arrival of Paddington Station in 1838 really boosted its growth. Here is a fascinating tapestry of domestic streets, wider avenues, strips of green and squares (some exclusive and gated), and many eighteenth-century buildings. Westbourne Terrace was possibly London's most elegant street in the 1850s and now PM Tony Blair has bought a house in the area where Winston Churchill grew up-Connaught Square.

W2

PADDINGTON STATION

In 1842, Oueen Victoria arrived here after her very first railway journey. Reputedly, the speed of 70 kilometres per hour (44 mph) provoked Prince Albert to say, 'Not so fast next time, Mr Conductor,' In 1851, the Great Western decided to build a new station a little further east and it was designed by the renowned engineer, Isambard Kingdom Brunel. Wyatt and lones added the architectural decorations. The magnificent triple barrel-vaulted roof of wrought iron and glass is supported on elegant cast-iron columns-with ironwork decoration on both roof and capitals. A fourth aisle was added to the north side when the station was extended in 1909-16, making the total area 13 acres. A plaque by Platform One marks the station's 1954 centenary, and depicts Brunel, wearing his signature stovepipe hat. The children's book character Paddington Bear was named after this splendid station and Paddington itself was named after Padda, an Anglo-Saxon chieftain.

57

W2

1930s MODERNIST HOUSE

This fine street, first built in the 1850s, is lined with charming mid-Victorian villas. Raised nearly ninety years later, number 32 is a very different structure, a Grade II–listed building, now well screened by trees. This is an early design by the controversial Modernist architect, Denys Lasdun made when he was only twenty-four years old—and it is clearly influenced by Le Corbusier's work. Lasdun was awarded the RIBA Royal Gold Medal in 1977.

58

1960s MAISONETTES

In the I730s, descendants of the First Earl of Craven (after whom the gardens are named) moved a pest (quarantine) house here from Soho—where it had been built after the I665 plague. Despite this macabre start, the area became popular. During the I830s, Unitarian minister William Fox lived at number 5 with housekeeper, Eliza Flower, a friend of Robert Browning. The forty-eight dwellings cross over and under central access corridors so that the living rooms all face the street and the bedrooms and their balconies face the garden. The painted concrete façades create a neat chequered pattern.

59

THE SWAN

This very old pub appears in a list of licensed victuallers of I721. From I790, it was a tavern for the Floral Tea Garden on the site of a physic garden set up by apothecary and herbalist Sir John Hill (a favourite of George III.) The pub claims to have been (but probably was not!) a coaching inn and a haunt of highwayman Claude Duval, who, after ten years as a robber, swindler, card-sharp, and lover, was hanged at Tyburn in I620. Before being hung at Marble Arch, prisoners were allowed a final drink in this pub while the vehicle waited outside to take them where no more drinks would be forthcoming!

50

A DETACHED ILLUSION

John Claudius Loudon was a famous landscape architect and city planner who lived at number 3 until his death in 1843. He recommended the now-familiar plane tree for London streets and squares, and was one of the first planners to envision how green places in cities would improve the city air. This villa appears to be a detached, independent dwelling but that is an illusion: the verandas and dummy windows disguise party walls and there is more than one home here. The lovely, central, domed conservatory, flanked by the verandas, is a very pretty feature. Some later Victorian impositions were removed in 1972, allowing the original design to emerge once again.

51

WHITELEYS

Young William Whiteley arrived in London with only ± 10 in his pocket. He worked hard, studying the retail market until he had saved ± 700 to buy a small shop in Bayswater. By 1875, he was buying up other shops, cutting prices, and selling a vast range of goods: 'Everything from a pin to an

BUILDING DESCRIPTIONS

541

Elephant,' By 1885, he had a staff of six thousand and, in 1896, earned a Royal Warrant from Queen Victoria. In Shaw's Pygmalion, Eliza Dolittle is sent to this store to be attired. In 1907, William Whiteley was murdered here by a man claiming to be his illegitimate son, demanding his inheritance. Apparently, Hitler adored Whiteley's and—planning to make it his headquarters had he seized Britain—ordered the Luftwaffe not to bomb the store. Whiteleys pioneered mail order and had a theatre and a golf course on the roof. After its closure in 1981, the store was renovated. The majestic, curved building on a corner site is crowned by a tower and dome. Metal was used for the intermediate-floor facings, allowing vast expanses of shop windows. Now its Edwardian interior has become a shopping mall, but the great marble staircase still dominates the main atrium. Diana, Princess of Wales, used to shop here and insisted that her two boys queue along with the commoners for the cinema

62

CHISWICK MALL

This stately mall has many riverside mansions from the 1700s and 1800s, mainly built in brown brick with red brick dressings. All along Chiswick Mall are grand façades and fine, sweeping gardens. Its eighteenth-century houses include Walpole House-named after the Walpole family. This house may have been the home of Barbara, Duchess of Cleveland, favourite of Charles II, and was probably the school at which Thackeray boarded; it may have inspired Miss Pinkerton's Academy in Vanity Fair but some believe that was Boston House. Strawberry House (with its delightful, late-1700s cast-iron porch) and Morton House were built about 1700 and refronted some thirty years later. Some houses here are considerably older. Bedford and Eynham Houses, near the corner of Church Street, were once one building, built (or rebuilt) in the mid-1600s by Edward Russell, son of the Fourth Earl of Bedford. The corner of Chiswick Lane was the site of College House (demolished 1875), leased by Westminster School in 1570 as a retreat from London during plague, and later home to the Chiswick Press (1810–52). Politician Daniel O'Connell (1775-1847) lodged here as a law student, and the actormanager Herbert Beerbohm Tree lived in Chiswick Mall in 1904–5.

HOGARTH'S HOUSE

Hidden behind a high redbrick wall beside the very busy A4, is the former rural retreat of the great painter, engraver, and satirist William Hogarth (1697–1764). His main house and studio was in Leicester Fields (later Leicester Square) so this country abode allowed him to escape the bustle of the city, upriver at Chiswick, from 1749 until his death. The three-storey house, with attic dormer windows in the roof above, is in a lovely medley of mottled pink and red-brown brick, and was restored for the Hogarth Tercentenary in 1997. Its interior has been completely renovated, as has the beautiful white casement window. damaged by bombing during World War II. Here, today, an exhibition documents Hogarth's life and work, with copies of many of his engravings such as The Harlot's Progress, A Rake's Progress, Marriage à la Mode, Gin Lane, and Beer Street. The garden boasts a mulberry tree that is at least three hundred years old, introduced in the vain hope of breeding silk worms in England. Hogarth is buried in the graveyard of St Nicholas (see page 67).

64

W4

CHISWICK HOUSE

This was the architect's own sumptuous classical country villa—a showpiece of British architecture in the 1700s, albeit inspired by Italian glories (especially Palladio's villa at Vicenza). Lord Burlington used the new, elegant villa to display his works of art and entertain friends, including Pope, Swift, and Handel. Steps lead up to the portico, with statues of Palladio and Inigo Jones by Rysbrack. An art gallery faces the garden, its circular and octagonal rooms lit with single Venetian windows. The library was a long room facing the garden. On the stuccoed first floor, a suite of state rooms are set around a domed saloon. The villa's wonderful, detailed, plaster ceilings and the Inigo Jones– inspired chimney-pieces and fireplaces are by Burlington's protégé, William Kent. He also (with Bridgman) landscaped

W4

the natural-style gardens—now a public park—which have statues of Caesar, Pompey, and Cicero from Hadrian's villa at Tivoli, and an Inigo Jones gateway brought from Beaufort House in Chelsea. Strangely, both Charles James Fox (politician and antislavery campaigner) and prime minister and statesman George Canning died in the same room here, in 1806 and 1827, respectively. In the 1950s, the villa was restored, with many original pieces finding their proper home again.

65

BEDFORD PARK

In 1875, cloth merchant and property speculator lonathan Carr bought 24 acres that would become London's first garden suburb, built on the grounds of a Georgian Bedford House, whose owner in the 1860s, Dr John Lindley, had been curator of the Royal Horticultural Society gardens. The preservation of his arboretum's trees led to interesting, curved streets and many T-junctions in a semi-rural setting. Bedford Park, with its leafy avenues and relatively cheap but handsome Queen Anne-style houses, would create a model for later low-density development. It became identified with bohemianism, attracting artists and idealists. It was Godwin who created the first models, but Shaw who set the style. The houses had rubbed-brick arches, balconies, bay-windows, terracotta decoration, Dutch gables, tile-hung gabled walls, huge chimneys, white painted balustrades, and wooden garden fences instead of iron railings. Bedford Park, an important landmark of suburban planning, was declared a conservation area in 1969-70. It was portrayed it as Saffron Hill in G. K. Chesterton's The Man Who Was Thursday, and famous residents include playwright, Arthur Wing Pinero (1855–1934); painter and father of W. B. Yeats, J. B. Yeats (1865-1939); and painter Lucien Pissarro (1863-1944).

66

CHISWICK PARK

This major business park development offers 140,500 square metres of office space for some ten thousand employees. Locating the parking areas below the buildings has made cars less intrusive but, in any case, 75 percent of those working here arrive either on foot, bicycle, bus or train. The façades of the twelve concrete-framed buildings incorporate sun screening as part of a low-energy agenda, with blinds activated by light sensors—while steel columns support louvred screens, walkways, and escape stairs. The complex incorporates a restaurant, bar, swimming pool, and fitness centre, while the lush green parkland at the heart of the site includes an open-air performance area, lake, and nature reserve.

6

RIVERSIDE HOUSES

Strand-on-the Green was described in the 1930s as London's last remaining village. Strande is an old term for a riverside walk, and these modest but quaint houses are set by a riverside path that stretches eastward from Kew Bridge. This is a most attractive setting with boats on the little stretch of beach below. The opening of the first Kew Bridge in 1759 made this a more popular residential area but it remained a small narrow strip, mainly associated with fishing and river traffic. Most of the houses are brown brick but some several have been painted or stuccoed. Numbers 45, 56, 60, 61, 63-66, and 71-72 are especially pleasing. John (or Johann) Zoffany lived at number 65 (1790–1810) and this is probably the finest in the row. Numbers 52-55 form a well-conserved terrace of houses, faced with white brick and built 1793-96. Writer Nancy Mitford resided at Rose Cottage, Lord Cudlipp at 14 Magnolia Wharf, Air-Marshall Sir John Slessor at Carlton House, and Dylan Thomas at Ship House Cottage.

68

W4

THE CITY BARGE

The famous City Barge public house was so-named because the Lord Mayor's State City Barge had its winter moorings at this point on the river, from 1775—stationed here for the collection of tolls—until 1816. The pub is mainly brick built with some white ground floor areas and a wooden white-painted balcony running along at first-floor level. Its lower half is at the level of the Thames path and has a watertight steel door to keep out the river when high tides threaten. Inside is a tiny, cosy bar with a flagstone floor; the upstairs bar is rather more modern. This pub featured in the Beatles's film *Help* and today is a favourite haunt of TV presenters Ant and Dec.

69

PITSHANGER MANOR MUSEUM

Pitshanger means 'a wooded slope frequented by kites.' An earlier house had been raised here by George Dance the Younger on the site of Pitshanger Farm. His pupil, John Soane, rebuilt this for himself, leaving just the south wing. A central block joined a detached north wing with a colonnade and a low wall, beyond which he built mock Roman ruins. The frontage is small and simple but grand—in Portland stone, with a triumphal classical arch of lonic columns and four free-standing classical female statues. There are also eagles in wreaths, roundels with lions, and a fat cherub. At the back, horizontal bands of brick and stucco plus vertical ashlar strips create nine sections, each with a window. Inside are ornate ceilings, a fireplace designed by Dancea, and a lovely breakfast room with dark-red porphyry and grey marbling; Egyptian caryatids support a shallow domed ceiling, painted as a sky with clouds. The small library room also has rich decoration. After 1811, when Soane sold up, the house saw a succession of owners-including Spencer Walpole, the cabinet minister, who lived next door-until it was bought by the council in 1900 and became a public library until 1980. Then the building's interiors were restored. Today, it is a Grade I-listed building and houses the PM Gallery, West London's largest contemporary art gallery, and a museum.

70

HOOVER BUILDING

Lord Rochdale officially opened the Hoover Building on 2 May 1933. In the 1930s, this moderne vacuum cleaner factory plus offices was built as a veritable palace of industry. The magnificent Western Avenue elevation has towers at both ends, with spiral staircases and corner windows. White pilasters frame long windows. The white stuccoed Art Deco exterior has decorative bands of dark blue and red faience tiles. The building was floodlit. Parts for aircraft were made at the factory during the war. In 1992, the supermarket company Tesco was allowed to buy the premises on the condition that Wallis and Gilbert's façade was conserved.

5

HAMMERSMITH SURGERY

The white sweeping curves of this dramatic building are set close to the church, built on a disused car park near a busy traffic roundabout—almost below a concrete flyover. Because of this proximity to noisy traffic, there are no windows on the street side, while its interesting sculptural shape, curved in two dimensions, also helps to baffle road noise. Upstairs, roof glazing and narrow windows in the 'steps' of the outer wall create a lovely light corridor. There are black slate floors, and bright white walls with turquoise and orange areas. The waiting and consulting rooms all overlook an internal courtyard, where a calm, secluded Japanese-style garden offers an escape from the frantic world outside.

2

THE ARK

This stunning building, a truly imaginative piece of Post-Modern architecture, stands proudly beside the A4 western approach to London and Heathrow. Here, the busy Hammersmith Flyover is elevated, as if to provide a better view of the Ark-and several other glass towers nearby. The Ark's floors of offices (nine floors on one side and five on the other) sweep around a curved, gleaming shape with 4,500 brown-tinted glass panels. The Ark does indeed resemble the swelling hull of an ocean liner, steering forward to the metropolis. It is 76 metres (250 feet) tall. Inside, white walls and a floor-to-roof atrium provide a light, sky-bright setting for open-plan office space-linked by scenic elevators in multilevel decks that continue the ship theme. Hidden below the 'waves' of the overpass, columns, faced in decorative brick, act as buttresses to support the concrete floors.

PEMBROKE STUDIOS

In this south west corner of W8, many places are named either Edwardes or Pembroke. Here a very elegant, single-arched entrance with a small central lantern leads through to two rows of glazed studios with a long rectangular garden. This modest mews conversion was inspired by (and given financial support from) the Great Exhibition of 1851. There are neat lawns and many pretty features such as the tiny-paned bow windows.

74

BENETTON

This towering store is in a mixture of a French Art Deco style and rather more traditional department store architecture. Both Barkers (now Benetton and Jigsaw) and next-door Derry & Toms rise high over their neighbours. This exuberant building, steel-framed and faced with Portland stone, reflects the era's fascination with technical progress. There are magnificent bronze and glass towers and stone reliefs of cars and aeroplanes. In 1998, some restoration work was carried out. Original staircases can be seen in the eastern tower.

75

THE GREYHOUND

Situated on one of the oldest squares in London that dates from 1685; philosopher John Stuart Mill, actress Mrs Patrick Campbell, and Pre-Raphaelite painter Edward Burne-Jones all used to live here. In the 1800s, the Greyhound publican would grill pork chops or steaks presented to him by local labourers at lunchtime—provided that they bought a pot of beer to wash it down with. This facility vanished when the new Greyhound opened in 1899. Its lovely glasswork was destroyed by a gas explosion in 1979 and the façade was rebuilt as before, but the interior has been turned into an enormous single room, with a low ceiling.

76

W8

ST MARY ABBOTS

This is the parish church of Kensington. The present building is nineteenth century but people have been

worshipping here through most of the millennium. The abbot of Abingdon founded the first church here in the 1100s. It was rebuilt in 1370, and again in about 1696—except for its tower, rebuilt 1772. Monarchs William and Mary worshipped here, and the king helped to finance the new building and contributed a pulpit and reading desk. Today's church has the tallest spire in London at 85 metres (278 feet), and its fine stained-glass windows include the Healing window, funded by the Royal College of Surgeons. Its renowned past worshippers include Sir Isaac Newton, William Wilberforce, George Canning, Beatrix Potter, and Joseph Addison. In 1997, some thousand people gathered in the church to mourn the death of parishioner Diana, Princess of Wales.

77

W8

W8

W8

THE CHURCHILL ARMS

Originally called the Marlborough after John Churchill, Duke of Marlborough, this pleasant mid-Victorian pub was renamed after his equally celebrated prime minister descendant. It has a vast, wood-panelled, horseshoe-shaped lounge full of Churchill bric-a-brac, and a picture gallery featuring countless other prime ministers and American presidents. There are also copper vessels, hat boxes, numerous chamber pots—and a collection of butterflies mounted on the walls of the back bar. The conservatory has a glass roof and a jungle-like canopy of foliage; this doubles as a restaurant with Thai food a speciality.

78

KENSINGTON PALACE ORANGERY

Designed for Queen Anne as a greenhouse, dining room, and a place for elaborate court entertainment during the summer months (together with the Sunken Garden), the Orangery is a magnificent building with a splendid brick exterior and fine woodcarvings by Grinling Gibbons. Corinthian columns separate tall windows where sunlight flows into the stunning, long white interior—this now serves as a restaurant.

W/8

KENSINGTON PALACE

Originally called Nottingham House, and then Kensington House, the palace stands at the western end of Kensington Gardens. Sir Christopher Wren designed many improvements and added the Clock Court and South Front. including the Long Gallery. It remains, however, a functional domestic building rather than a place of splendour, with the structure grouped around three courtyards and with relatively simple interiors. The palace has been a royal residence since it was bought by William and Mary in 1689. Originally a private country house, it was adapted so that, in winter, the asthmatic sovereign could escape the damp and smoke of Whitehall. In 1702 it became home to Oueen Anne. George I and George II added rich, ornate furnishings and elaborate ceiling decorations by William Kent. George II was the last monarch to live at the palace during his reign, until 1760. It was the birthplace and childhood home of Queen Victoria; here, in June 1837, she learned of her accession to the throne. More recently, it was the home of Princess Diana and is still the residence of several members of the Royal Family. Its State Apartments include the Kings Apartments and a magnificent collection of paintings. The Court Dress Collection here has everything from elaborate eighteenth-century costumes to underwear.

80

W10

WII

HOUSES AND FLATS The architect Jeremy Dixon was only three years into his fruitful professional partnership with his wife, Fenella, when he undertook this commission. As with his later work in Lanark Road in W9, Dixon masked the modern nature of this complex of forty-four flats and houses behind a traditional façade that resembles those of the surrounding older buildings. The development included back gardens and novel access arrangements—which Dixon hoped would reinterpret the tradition of

the London house and its relationship to the street.

81

LANDBROKE ESTATE

The Ladbroke Estate was laid out by Thomas Allom on the

site of the old Hippodrome racecourse as a revolutionary experiment in suburban planning. The houses are arranged so that each has a small private back garden that gives access to a larger communal garden, which is private to the residents. It was the landowner, James Weller Ladbroke, who insisted on the large houses and informal road layout that came to be the hallmark of the area. The layout of the streets and the Italianate style of the house, were both hugely influential—copied with varying degrees of success in other suburban development around London.

82

WII

W14

W14

LANSDOWNE HOUSE

Some fifty years after the Ladbroke Estate was laid out, this seven-storey block of studios was erected to cater for artists, and quickly attracted the likes of Charles Ricketts, Charles Shannon, and Glyn Philpot. The airy rooms and north-facing windows proved to be ideal for artists, but the rental prices soon forced out all but the most successful. Since 1958, the elegant brick-and-stone building has been home to Lansdowne Recording Studios, which boasts one of the city's finest suite of electronics and prides itself on discretion when dealing with famous clients.

83

HOLLAND HOUSE

This elegant Jacobean mansion took its name from its previous owners, the Earls of Holland, and later the Barons Holland. It had passed to the Earl of Ilchester by the time it was destroyed by World War II bombs. In 1952, the ruins were bought by the London County Council, which opened the grounds to the public and restored the East Wing as headquarters for the King George VI Memorial Youth Hostel Association. The grounds include woods and formal gardens, such as the tranquil Kyoto Japanese Garden.

84

DEBENHAM HOUSE

When Ricardo was commissioned to build a house for Sir Ernest Debenham of department store fame, he took advantage of the fact that the de Morgan tile company had recently closed down. He bought up the entire stock of plain and decorative tiles, then designed the house to act as a showcase for them. In a riot of ceramic colour, bold panels of green- and blue-glazed bricks break up the white tile façade. Even the chimneys are tiled. More were used inside, combined with fine timber. Debenham must have been fond of glazed tiles; he had already covered the façade of his main store with them.

85

W|4

OLYMPIA EXHIBITION HALL

The imposing façade of the Olympia Exhibition Hall was erected in brick and steel to give a united appearance to the collection of buildings that lie behind it. The Grand Hall was built in 1884 and extended in 1895; the National Hall was added in 1923, and the Empire Hall in 1929. The rather untidy appearance of these buildings was thought to be one reason why some businesses preferred to use the newer Earls Court Exhibition Building, so the new façade was put up to try and overcome this image problem. Emberton also designed the four-storey car park just around the corner in Maclise Road.

86

TOWER HOUSE

When William Burges designed this house to be his home, he set out to recreate 'a model residence of the fifteenth century,' equipped with all the modern conveniences of the Victorian age. The house takes its name from the circular tower, topped by a conical roof, which dominates the façade and houses the main staircase. The Gothic style is continued within, where the library has a stone fireplace complete with battlements, and the dining room is based on the House of Fame described by Geoffrey Chaucer. Burges had earlier worked on Cardiff Castle and Cork Cathedral as an architect, but he also designed wallpapers, furniture, and iewellery.

UNIVERSITY CHURCH OF CHRIST THE KING

This university church boasts the steeple that never was! It was planned that the building would be surmounted by a pinnacle some 90 metres (295 feet) high—which would have made it even higher than Senate House (still the highest London building at the start of the 1950s). The large Victorian church, which was raised in traditional Gothic style, was originally built for the Catholic Apostolic Church—a fraction that split from the Catholic Church in 1870.

88

WCI

BOW-FRONTED SHOPS

Here there are some lovely well-preserved, bow-fronted shops in a short but pretty pedestrian street. This was designed as a whole to serve as a small shopping centre by Thomas Cubitt—who designed much of the area to the north and east of Russell Square. It was restored in the 1960s and today its façade would serve well on nostalgic Christmas cards. W. B. Yeats lodged here from 1865–1919. Now it is the home of many art galleries, newsagents, bookshops, museums, and places to eat.

89

WCI

MARY WARD HOUSE

This free-style building with a Charles Rennie Mackintosh flavour explores a variety of arches and canopies, with interesting patterns created by the windows and their positions and lovely entrances. Areas of white on parts of the upper stories and around the windows act as a contrast to the immaculate brickwork. Mary Ward was a late Victorian who acquired fame and riches through her best-selling novels, writing as Mrs Humphrey Ward. She founded the settlement to provide cultural and educational opportunities to those denied these through circumstances of birth. She was also instrumental in setting up Somerville College, the first women's college at Oxford, and introduced to England the first school for physically handicapped children and the play centre movement. This settlement offers facilities to enjoy music, debating, and chess; mother and toddler groups; a 'poor man's' legal service; and retraining facilities for the unemployed.

90

WCI

INSTITUTE OF EDUCATION

Founded by the former London County Council in 1902 as a teacher-training school, this became part of the University of London in 1932, when it received its present name. The school has since diversified into educational research. The institute's main building on Bedford Way was designed by Sir Denys Lasdun. The face of the building that looks out over Bedford Way is an impressive 236-metre (774-foot) sweeping curtain wall, broken only by powerful buttress-like, triangular-edged concrete and the multiple windows that stripe its dark blue-grey façade.

91

LONDON'S LARGEST SQUARE

At 210 by 205 metres (690 by 673 feet), the centrepiece of this huge square is a fountain with jets coming straight from the pavement. Some of the large terraced houses have survived on the southern and western sides. The nearby street lamps carry the Bedford Arms, after the Duke of Bedford, who originally set out the square and surrounding streets. Author T. S. Eliot worked here for many years, and self-exiled Oscar Wilde spent his last evening in London at 21 Russell Square on May 19, 1897, before leaving for Victoria Station to catch the boat for Dieppe. On the eastern side of the square is the rather formidable Russell Hotel, built in 1898.

92

THE RUSSELL HOTEL

The first large Victorian-style building to rise in these Georgian Bloomsbury surroundings was twice as high as the tallest of the surrounding 'domestic' buildings. It is an imposing nine storeys of terracotta with many arches, tall chimneys, and motifs in beige faience. Fitzroy Doll also worked on the grand facilities of the Titanic, and the hotel restaurant that carries his name is almost identical to the one on the ill-fated ship. It has over 370 guestrooms, and interior features include Sicilian marble columns, large chandeliers, high vaulted ceilings, oak panelling, a grand marble staircase, and two ballrooms. The building underwent a $\pounds 12$ million refurbishment in 2004–5.

WCI

WCI

WCI

WCI

WCI

93 DICKENS MUSEUM

WCI

Charles Dickens and his family lived here from 1837–39. At that time it was a private street, sealed off at both ends with gates and porters. The move to this address from previous cramped chambers in Furnival's Inn, Holborn, was made possible by the success of *The Pickwick Papers*. Here, Dickens completed some of his most important works, including *Oliver Twist* and *Nicholas Nickleby*. Doughty Street was saved from demolition in 1923 by the Dickens Fellowship, and the society has since lovingly restored the building. Inside, a fascinating collection of memorabilia includes the author's letters, furniture, portraits, and even the quills with which he penned his masterpieces.

94

WCI

EDWARD VII GALLERIES

Part of the British Museum, this lovely sweep of galleries, with tall windows set behind a façade of fine columns, was a north-wing extension to the earlier museum building. Helped by a legacy from Vincent Stuckley Lean, work began on the galleries and the foundation stone was laid by King Edward VII in 1907. The building cost £200,000 and was opened by the king in May 1914. Then the outbreak of World War I delayed the transfer of many of the collections until the early 1920s. The British Museum was also bombed in air raids of 1941, but was not seriously damaged. This extension was the first of a planned series of three galleries for which the land was bought back in 1894.

95

SENATE HOUSE

Although completed by 1937, a lack of funding and the imminence of World War II meant that some elements of the initial plan had been abandoned. When war broke out, the building's library was moved out and some of the offices of the Ministry of Information moved in. The author George Orwell worked for the ministry, so this building is thought to be the inspiration for the Ministry of Truth buildings in his book *1984*—written in 1951, when the Senate House was the tallest building in London at 64 metres (210 feet) high. The building is also thought to have a mention in John Wyndham's *Day of the Triffids*, and legend claims that Hitler intended the building to be his headquarters after the invasion of Britain. It houses the chancellor's offices, one of central London's largest restaurants, and the vast Senate House Library that flows from the fourth to the nineteenth floor.

96

A 'CIRCULAR SQUARE'

Named after the Dukes of Bedford, once a major landlord in Bloomsbury, this 'circular square' is the only complete Georgian square in the area. The central garden has remained private, its keys held by the owners of surrounding buildings. Many of the Grade I–listed buildings have fourstoreys, and are brick-built with Coade stone ornaments. Most have been converted into offices—many focused on the publishing industry. Residents have included Lord Eldon (a long-serving Lord Chancellor), scientist Henry Cavendish, and architect William Butterfield. Led by Dante Gabriel Rossetti, the Pre-Raphaelite Brotherhood was founded in 1848 in a house here.

CENTRAL YMCA

Central YMCA was established in 1844 and was the world's first YMCA. One of the founders, George Williams, lived nearby in Russell Square. The new YMCA was raised on the site of an older 1911–12 building—designed by architect R. Plumbe. The tall concrete towers of today's Central YMCA have strips of windows set into the building's interestingly angled narrow facets, stepped one behind another. As well as accommodation, the current building offers an excellent range of facilities and fitness programmes, and has a superb gymnasium and swimming pool.

98

CONGRESS HOUSE

This Grade II-listed building is home to Britain's Trade Union Congress (TUC), which campaigns for workers and for social justice at home and abroad (member unions represent over 6.5 million working people). The building sprang from an architectural competition to design a new headquarters in 1948 and was officially opened in March 1958. Within the courtyard, a sculpture by American-born Jacob Epstein remembers the trade unionists lost during the two world wars. There are splendid bronze window frames and impressive areas of plate glass, marble, and mosaic—in a style that both fits and sets the building apart from the rest of the street.

99

ST GEORGE

In October 2001, St George's became a World Monuments Fund heritage site, and generous donations have allowed the church to begin a $\pounds 6.7$ million restoration, including work on the crypt, churchyard, and ancillary buildings. The Commissioners for the Fifty New Churches Act of 1711 appointed Nicholas Hawksmoor (a pupil and former assistant of Sir Christopher Wren) to design the church that has a stepped tower topped by a statue of George I. None of Hawksmoor's other churches use the grand Corinthian portico-probably based on the Temple of Baalbek, in the Lebanon. St George's is depicted in William Hogarth's well-known engraving, Gin Lane (1751), and Charles Dickens used it as the setting for 'The Bloomsbury Christening' in Sketches by Boz. The funeral of Emily Davidson, the suffragette who threw herself in front of the King George V's horse, took place here in 1937.

00

WCI

BRITISH MUSEUM

One of the largest collections of human history and culture—and the oldest museum in the world—this is home to the Elgin Marbles, Rosetta Stone, Egyptian mummies, and some 7 million other objects. Founded 1753, the British Museum opened (as Montague House) in 1759 and sprang from the collections of physician and scientist, Sir Hans Sloane. The current neo-classical building appeared almost a century later, taking some twenty-four years to complete. Smirke was asked to create a building for the King's Library. The original museum had four wings

arranged around a vast, open courtyard. No sooner had it been completed than storage demands meant that a new, round, copper-domed reading room was raised in the middle of the courtyard and opened in 1857—with a dome the same size as Saint Peter's in Rome. Its famous visitors have included Lenin, Marx, Oscar Wilde, and George Bernard Shaw. A rebellion against classical Italian styling, the wonderful Greek Revival façade of the museum follows the form of ancient Greek temples, and the 1852 pediment over the main entrance is decorated with sculptures depicting *The Rise of Civilisation*.

JAMES SMITH AND SONS

James Smith and Sons, founded in 1830 to sell and repair umbrellas, moved here in the 1850s. The shop is a perfect example of a Victorian shopfront with original typography. It has remained virtually unaltered for almost 150 years, and is still run by direct descendants of the original Mr Smith. Row upon row of umbrellas and walking sticks line the walls in racks, glass-fronted cases, and baskets. Customers have included prime ministers Gladstone and Bonar Law. Custom-made umbrellas and walking sticks cost from \pm 130 and many are sold to the USA. One client asked for sticks to be made in every English wood possible—over seventy in total.

1

CENTRAL SCHOOL OF ARTS AND CRAFTS

This was established in 1896—spearheaded by the Arts and Crafts leaders William Morris and John Ruskin—to provide specialist art teaching for the craft industries and art scholars. This sturdy but elegant building has many arches, reliefs, and fine details. The first principal, architect William Lethaby, was involved in its design. Central Saint Martins arose from the merger of the Central School of Arts and Design (formerly Arts and Crafts) with St Martins College of Art in 1989. Famous alumni include designer Terence Conran, painter Lucien Freud, and fashion designer Stella McCartney.

INNS OF COURT

Once, this square was in two halves, with a hall and chapel on the south side. The Inns of Court, dating back to the 1300s. were originally eating and lodging places for law students. Of some thirty inns, only four survive-including Gray's Inn. During the 1500s, these were supported by various statesmen and judges, including Thomas Cromwell, and hosted colourful celebrations and street processions. William Shakespeare may have performed here. In the 1680s, there were several disastrous fires, and, in 1684, the library on Gray's Inn Square burnt down—lots of ancient records were lost and 30.000 books destroyed. At this time, being called to the Bar often depended on gaining the favour of a judge or bencher, or consuming a certain number of dinners in the hammerbeam main hall of Gray's Inn. but from about the 1850s. legal examinations were imposed. Gray's Inn Hall has been its present size since it was 're-edified' in 1556-58. Despite heavy war damage in 1941, some sixteenth-century walls and stained glass have survived. Tradition claims that the screen at the west end is made from the wood of a captured Spanish Armada galleon-a gift from Queen Elizabeth I.

104

CENTRE POINT

One of the first London skyscrapers and the world's tallest pre-cast concrete office building then, Centre Point's thirty-five floors reach 117 metres (384 feet)—permitted in return for the provision of a new road junction at St Giles Circus. This controversial building , unoccupied for twelve years, was described as coarse but, with the passage of time, gained credential stature and, by 1995, had been Grade II listed. It cost £5.5 million. Since 1980, it has been the headquarters of the Confederation of British Industry. Now there are plans to create a restaurant at the top. This area was once notorious for its slums, and in earlier times had been occupied by a gallows.

105

WC.

ST GILES-IN-THE-FIELDS

The church was built on the site of an 1100s leper hospital

WCI

and chapel, when leprosy was a most serious health risk more feared than the plague—and it is named after the patron saint of outcasts. In later centuries, prisoners passing by on the way from Newgate prison to Tyburn gallows were given 'cups of charity' by the church wardens—in the form of a drink at the next-door pub, the Angel. The Great Plague of London started in this parish, and the churchyard is full of its victims. The galleried, Palladian design of the present church was based on sixteenth-century Italian and early Christian basilicas. Architect John Soane was buried in the churchyard here in 1818.

06

WAREHOUSES

Earlham Street warehouse has impressive mid-Victorian brickwork and simple arched windows. It has been used by a brewer, a paper manufacturer, one of the first 1920s film companies to use colour, and as a place to ripen bananas. From the 1970s, many warehouses here have provided space for local community groups, shops, studios, and galleries—helping the area's regeneration. In 1960, Donald Albery bought and converted 41 Earlham Street into a rehearsal studio for the London Festival Ballet, naming it the Donmar (after himself and Dame Margot Fonteyn). After a 1977 renovation, the theatre was leased to the Royal Shakespeare Company.

07

ORION HOUSE

WC2

Built by a pivotal 1900s architect, this tall, white tower rises above many of the older buildings and was one of the first in London to be set on a podium, albeit a low, two-storey one. Renamed Orion House, it was redesigned in 1990. Its many offices include those of publishers Orion that, by pure coincidence, share the building's name. Another tenant is the Now and Zen restaurant. A long, spiky sculpture on the north face is by Geoffrey Clarke. From the 1700s until 1926, this site was occupied by Aldridge's Horse and Carriage Repository—providing horses for the middle classes and tradesmen.

CANADA HOUSE

This building was originally used by the Union Club and the Royal College of Physicians but the Canadian government took it over in 1923. Home to the High Commission of Canada to the United Kingdom, it hosts conferences, receptions, lectures, and vernissages (where Canadians and Britons meet). It also houses the Canada House Gallery. It was originally built in Bath stone, with a recessed portico to the square and additional porticoes set either side of the building but only the Royal College of Physicians portion remains unchanged. The building, restored in 1993 and reopened by Queen Elizabeth II in 1996, has an impressive staircase and library.

109

THE SALISBURY

Long ago, there was a tavern here called the Coach and Horses. Its landlord was the great prize-fighter Ben Caunt (whose father had been a servant to Lord Byron), who won the national title in 1841. Prize fights were held here. In 1892, the tavern was replaced by the ornate, magnificent, Salisbury Stores—restaurant and wine merchant's. It was named after then current prime minister, the third Marquis of Salisbury. Rich, glittering mirrors, bronze, nymphs, Art Nouveau lamps and gleaming mahogany arrived in an 1898 refurbishing. In time, the Salisbury became a theatre pub with a gay clientele and had a starring role in the film Victim, with Dirk Bogarde.

110

LAMB AND FLAG

This is one of the oldest pubs in London and claims a Tudor past. Over 380 years old, it is one of the few woodenframed buildings left, in what was once a rough area with gambling houses, overcrowded tenements, and riotous inns. It was nicknamed the Bucket of Blood, after the prize bare-fist fights held here. In 1679, poet John Dryden was set upon in an alley outside and nearly killed by thugs after being accused of penning verses about a mistress of Charles II; today, the upstairs bar is called the Dryden Room in his honour. Now a more respectable entity, the pub has a Georgian exterior, a dark pressed-paper ceiling, a parlour fireplace, and decorated glass screens.

WC2

WC2

NATIONAL GALLERY

This grand, neo-classical Grade I–listed building forms a splendid theatrical backdrop to Trafalgar Square. It has thirteen sections, six set each side of a central portico, and holds one of the world's greatest collections of paintings. Forty-six rooms show the development of European painting from the 1200s by artists such as Leonardo da Vinci, Raphael, Rembrandt, Van Dyck, Rubens, Hogarth, Constable, Stubbs, and Gainsborough. The galleries' first director, Sir Charles Eastlake, travelled through Italy every year from 1854–65, buying many Italian Renaissance works. As war loomed, in 1939, the National Gallery closed for the duration, having evacuated its collection to secret destinations in Wales and Gloucestershire—the removal completed just the day before war was declared.

2

WC2

WC2

WC2

NATIONAL PORTRAIT GALLERY

The National Portrait Gallery was opened in 1856, and moved to its present building in 1896. It has been extended twice, with the wing along Orange Street, funded by Lord Duveen, opening in 1933. Ondaatje Wing, funded in 2000 by Christopher Ondaatje, occupies a slither of land between the National Gallery and the National Portrait Gallery. Its two-storey escalator takes visitors to the early part of the collection at the top of the building. Above the entrance to the gallery are busts of the three men responsible for the its existence—Philip Henry Stanhope, Thomas Babington Macauley, and Thomas Carlyle. The gallery was established with the criteria that it was to be about history (the status of the sitter), not art. The site was previously occupied by St Martin's Workhouse. There are three distinct components: the east block, the entrance block, and the north block, the entrance block acting as a pivot between the others. Each was faced with Portland stone and realised in Florentine Renaissance style, while

respecting the architecture of the National Gallery in the east block. The entrance block was recessed to fit into the angled corner of the site with its design based on the façade of Santo Spinto oratory in Bologna. The north block is modelled on Florentine Renaissance palazzi. The exteriors of the entrance block and north block are decorated with Portland stone and images of eminent portrait artists.

113

WC2

ST MARTIN-IN-THE-FIELDS

In 1222, monks used a church here. It was rebuilt by Henry VIII in the middle of fields—an isolation that helped it to survive the Great Fire. The building has a classical-style pediment, huge Corinthian columns, and a high steeple with a gilt crown. Traditionally the bells are rung to proclaim a victory in naval warfare. Among the sixty thousand buried here are Robert Boyle, Nell Gwynn, William Hogarth, and Thomas Chippendale. Charles II was christened here and, allegedly, George I was a churchwarden. The church hosts the Pearly Kings and Queens Costermonger's Harvest Festival. During World War I, the chaplain set up a refuge for the homeless—still in operation today.

114

WC2

WC2

SOUTH AFRICA HOUSE

This sturdy, white building houses the offices of the High Commissioner of South Africa, and the South African Consulate. Built on the site of a derelict hotel, African animals feature on its stone arches, and it has sweeping porticoes. During World War II, Jan Smuts (South Africa's Prime Minister) lived, and conducted his war plans, here. During the 1980s, the building was the focal point for anti-apartheid protestors and, in the 1990s, poll tax rioters set it alight. Today, it is a focal point for South African culture and, in 2001, Nelson Mandela appeared on the balcony to mark the tenth anniversary of Freedom Day, when the system of apartheid ended.

115

CHARING CROSS STATION HOTEL

As the railways boomed, hotels sprang up to serve travel-

lers. Here, as in many other places, a hotel façade created a decorative front to disguise the practical necessity (but less attractive view) of train sheds. Built on the site of the Hungerford Market in a French Renaissance style—with appropriately styled motifs—this hotel boasts one of the first English frontages to use reconstituted stone. It opened on May 15, 1865, and was extended in 1878 and again in 1952, when its two top floors were added. This Grade I– listed building has 239 bedrooms.

THE METROPOLE

The crumbling Metropole hotel—with its regal, curved, Bath stone façade—was once the place for 'ladies and families visiting the West End during the Season ... to Officers and others attending the levees at St James; to Ladies going to the Drawing Rooms, State Balls, and Concerts at Buckingham Palace; and to colonial and American visitors unused to the great world of London.' A popular venue for banquets and balls, it is said that the Prince of Wales (later Edward VII) entertained guests here. It became a Ministry of Defence office in 1936 and continued to house government staff, many from the Air Ministry. The building was vacated in 2004 and is now in the hands of the Crown Estate.

П

CHARING CROSS STATION

The original station was raised on the site of Hungerford market and opened in 1864. In 1905 a section of its elegant original roof and part of the western wall collapsed, killing six people – five workmen on the station and nearby theatre roof and a bookstall seller. Situated on the forecourt is the Eleanor Cross: Edward I of England erected these lavishly decorated stone monuments in memory of his beloved wife, Eleanor of Castile. The name Charing Cross comes from this, plus the original hamlet of Charing (the old English word *charing* means a bend in the river). Often regarded as the very centre of London, it was one of twelve places where Eleanor's coffin rested overnight during her funeral procession from Lincoln to Westminster. The long mural along the Northern Line platforms measures 100 metres (328 feet). It was designed by David Gentleman and shows a scene from her funeral journey. The Eleanor Cross here is a larger and more ornate Victorian copy of the original. Over 37 million people pass through Charing Cross every year and some visit the famous gay Heaven Nightclub located below the station. Samuel Johnson once said, very appropriately, 'I think the full tide of human existence is at Charing-Cross.' In 1990 most of the platform area was covered by a post-modern office and shopping complex, Embankment Place.

118

COVENT GARDEN PIAZZA

A settlement has existed here, in London's first square, since Roman times. The name Convent Garden (later changed to Covent Garden) was given to a forty-acre (16-hectare) patch during the reign of King John (1199-1256). The monks of St Peter maintained a large kitchen garden during the Middle Ages, and their surplus became a major source of fruit and vegetables for the city. In 1540, Henry VIII dissolved the monasteries but seized their land. In the 1600s, Inigo Jones designed the new market piazza with Italian styling, fine arches, and elegant facades. The first Punch and Judy show in Britain was said by diarist Samuel Pepys to have taken place here in May 1662. Hitchcock's 1972 film, Frenzy, was shot around the markets and pubs of the area. The wholesale market relocated to New Covent Garden Market in Nine Elms in 1974 and, today, Covent Garden is home to many small shops and is the only part of London licensed for street entertainment.

119

WC2

WC2

THE ROYAL OPERA HOUSE

This building is home to the Royal Ballet and Royal Opera (and its orchestra), granted Royal Charters in 1956 and 1968 respectively. The site was originally a nunnery attached to the Abbey of Westminster. Actor/manager John Rich helped raise funds to build the first Theatre Royal at Covent Garden and, on its opening night, in 1732, was carried there in triumph for a performance of Congreve's *The Way of the* World. Admission to one of the fifty-five boxes was then five shillings; a seat in the pit cost half a crown and, in the gallery, one shilling. A seat on the stage cost ten shillings (servants could arrive at 3.00 p.m. to save places for their masters). In 1743, a royal performance of Handel's The Messiah set in motion the custom of holding oratorio performances here every Lent. Handel bequeathed his organ to John Rich; sadly, it was lost in a fire that destroyed the theatre in 1808. The second theatre was one of the largest in Europe; during its reign a price rise caused riots! The current building is the third theatre on this site, following yet another fire in 1856. During World War I, it was used as a furniture repository and, during World War II, became a dance hall-but after the war it reopened in 1946 with a performance of The Sleeping Beauty by Sadler's Wells Ballet. The royal box has its own private entrance and gold chairs made for Queen Victoria and Prince Albert remain. A settee for her ladies-inwaiting faces away from the stage so that they could remain in constant attendance to her but Victoria had a mirror set on the opposite wall, so that they could still watch the performance reflected there. The frontage, foyer, and auditorium date from 1856 (the main auditorium is a Grade I-listed building) but other parts underwent major reconstruction from 1996 to 2000, costing £216 million. It now seats 2, 174 people and has four tiers of boxes and balconies, plus the 400-seat Linbury theatre and the Clore, which is a Royal Ballet studio. The building was used for shots in the 1990s film The Fifth Element.

12

WC2

PALLADIA HUDSON HOUSE

The magazine *Country Life* was first published by Edward Hudson in 1897 in this grand company headquarters. It has a magnificent stonework façade and rich traditional rooms, where high ceilings and tall windows create light and space. The new building was commissioned as Lutyen's first building in London and was meant to symbolise refined country life set in the centre of town. It is a palatial building in a transitional style—exhibiting 'Wrenaissance' and Edwardian baroque. Today, this unique Grade II–listed building houses a modern business centre, with offices, suites, and meeting rooms on seven floors. The interiors have been completely refurbished.

COUTTS BANK

Coutts Bank is one of London's oldest surviving banksformed in 1692 by a young Scot, John Campbell. He was a goldsmith-banker, and set up the business in the Strand under the sign of Three Crowns, the national emblem of Sweden. The crowns still form part of the Coutts logo but, today, Coutts is part of the Royal Bank of Scotland. In 1904, the bank moved to its newly built premises at 440 The Strand, on the site of John Nash's West Strand Improvements of 1830-32. More recently, the entire block was threatened with demolition-but, instead, the interior was replaced by enlarged bank premises. The frontage, a four-storey glazed entrance, is a marked variation on The Strand's design. The tall, triangular central hall is visible from the street. Coutts is a private bank: its clients are by invitation only and must have liquid assets in excess of £500,000 or an investment portfolio of over £1 million. It is most famously known in the United Kingdom as being the banker of Oueen Elizabeth II, and has, in fact, held an account for every British sovereign since George III.

7 ADAM STREET

Famous residents in the Adelphi Terrace included Richard D'Oyly Carte (1844–1901), of light opera fame; author Thomas Hardy (1840–1928), and author, playwright, and wit George Bernard Shaw (1856–1950). The London School of Economics and the Savage Club also had their premises here. The terrace was much altered in the 1870s. when, unfortunately, the unique decoration by Adam was destroyed. Here at Adam Street, however, a few buildings remain. At number 7, on the offices of the Lancet building, light stucco work and neo-classic features can be seen with honeysuckle pilasters and delicate lacy ironwork.

SHELL-MEX HOUSE

Ernest Joseph was a Jewish architect who was a leading designer of synagogues. This secular building is, in broad terms. Art Deco, and stands on the site of the Cecil Hotel

(the largest hotel in Europe with 800 bedrooms when it opened in 1886). The Strand facade of the hotel remains. Shell-Mex House is 58 metres (190 feet) tall and has twelve floors plus basement and sub-basement. It takes up a full block between the Embankment and the Strand, and can be recognised easily from the Thames by its clock tower. The building was constructed as the London headquarters of Shell-Mex and BP Ltd-a joint venture company created in 1932. Today, the building is occupied by the companies of Pearson Plc, which include Penguin Books, Back in World War II, Shell-Mex House was home to the Ministry of Supply, which dealt with the flow of equipment to the national armed forces. The building was badly damaged by a bomb in 1940, and did not revert to Shell-Mex and BP Ltd use until July 1948.

THEATRE ROYAL

This is one of the West End's largest theatres and is a Grade I-listed building. In the 1500s, cockfighting was a popular pastime here, but the building was converted from a cockpit into a theatre during the reign of James I, to the design of Christopher Wren. Charles II's famous mistress, Nell Gwynn, made her debut here in 1665. The theatre has an unfortunate history of conflagration. It was razed to the ground by fire in January 1672, succeeded by a larger and more elaborate theatre-again designed by Wren-that was demolished and updated in 1791. The third theatre, designed by Henry Holland, opened in March 1794. This building survived a mere fifteen years before burning down in 1809. The present Theatre Royal opened in October 1812 with a production of Hamlet. Since then, the interior has been redesigned many times but the shell of the building and foyer still date from the early 1800s. The impressive side colonnade was added in 1831 and the present auditorium dates from 1922. Legendary actor David Garrick made his debut here and managed the theatre during the mid-1700s. In 1716, there was an attempted assassination of the future George II here and, in 1800, one on George III. The theatre has a ghost, of course, which appears in the Circle, usually during matinee performances.

SAVOY HOTEL

This five-star hotel, with some 230 rooms, takes its name from the Savoy Palace, commissioned by Count Peter of Savoy (the uncle of Henry III) in the 1240s. A century later, it became the home of John of Gaunt, Earl of Lancaster, and grew into a centre culture—one of its residents was Geoffrey Chaucer. Gaunt's unpopularity as the king's chief minister led to the palace being burned in the Peasant's Revolt. The fame of the palace lasted, and the current hotel on the site was commissioned in the late nineteenth century by Richard D'Oyly Carte (owner of the nearby Savoy Theatre). There are two buildings—the one visible from the Strand was designed by Thomas Collcutt (who also designed Wigmore Hall), whereas the bedroom wing overlooking the Thames is by Mackmurdo. In 1929, the entrance court was restyled by Easton and Robertson, introducing a steel Art Deco look. The first manager was Cesar Ritz, who later founded the Ritz Hotel. The Savoy has boasted several resident artists: Claude Monet and James Whistler both painted river views from here. Famous chefs include Auguste Escoffier and Gordon Ramsey, and Pêche Melba and Melba toast were supposedly invented in these kitchens. Its forecourt is the only street in the United Kingdom where vehicles have to drive on the right-hand side.

126

PALACE THEATRE

This imposing red building dominates the west side of Cambridge Circus. The grand exterior is striped with red brick and cream faience. This was commissioned by Richard D'Oyly Carte in the late 1880s as the home of English grand opera, much as his Savoy Theatre on the Strand had become the home of light opera in the days of Gilbert and Sullivan. The foundation stone, laid by D'Oyly Carte's wife in 1888, can still be seen at the right of the entrance (almost at ground level). The Royal English Opera opened in January 1891 but proved unsuccessful, and D'Oyly Carte sold the theatre within a year. It was renamed the Palace Theatre of Varieties, and then, in 1911, the Palace Theatre. This was the venue for Fred Astaire's final stage musical, *Gay Divorce*, which opened in November 1933. Since 2004. the theatre has been refurbished, its fine marble walls uncovered and restored, and new chandeliers hung.

WC2

WC2

SOMERSET HOUSE

WC2

The first Somerset House was built in 1547-50 as a riverside mansion—one of a row of noblemen's houses—for the Lord Protector and Duke of Somerset. He was executed for treason in 1551 and the house was presented to Princess Elizabeth (gueen by 1558). The bodies of Anne of Denmark, James I, and Cromwell all lay in state here. By 1775, the tired old building was demolished and a new non-royal Somerset House rose on the site. The present neo-classical building dates from 1776 and was later extended by Victorian wings to the north and south. Until Victoria Embankment was built. the building stood on large arches rising directly out of the Thames. It has been used by the Inland Revenue (now HM Revenue and Customs) since 1849, and, during the 1900s. was home to the General Register Office, where the records of births, deaths, and marriages were kept. In the late 1900s, the building became a centre for visual arts. Its Courtauld Gallery, whose holdings are old masters and impressionist paintings, is also home to the Gilbert Collection of decorative arts and the Hermitage Rooms (offering exhibitions on loan from St Petersburg's Hermitage Museum.) The courtyard—which sometimes features outdoor large-screen film events-has become the building's centrepiece, accessed via an impressive triple-arched gateway.

128

WC2

ONE ALDWYCH

This grand Edwardian building was one of London's earliest steel-frame structures and is one of several creations by architects who brought their French styling to Edwardian London with the Ritz Hotel (they also built the Paris Ritz). One Aldwych has sturdy Norwegian granite facings, a Parisianstyle façade and is crowned by a copper dome that makes a pleasing focal point. Like New York's Flatiron Building, it is designed to fit into a wedge-shaped footprint between the angle of the streets. Built initially for the *Morning Post* newspaper, it later housed a Lloyds Bank but, in 1998, was

WC2

WC2

WC2

converted into an luxury hotel, restaurant and bar. This is still 'putting on the ritz' with hundreds of expensive original artworks in both public areas and guest rooms, and with a health club pool that boasts underwater music.

129

ST MARY-LE-STRAND

This parish is an ancient one. The earliest church stood on the site now occupied by Somerset House and, from Norman times to the Reformation, the Strand was home to many bishops and princes. The site of the present church was occupied in medieval times by Strand Cross-thought to date back to Norman times, perhaps as a market cross. Thomas à Becket is said to have been a rector here in the 1100s. The building of the present church was funded by the Commission for Building Fifty New Churches. Gibbs's architectural training had been in Rome-the church's Mannerist design reflects this, and its walls show a Michelangelo influence. The tower is not part of the original design. The present position of the church was, in 1634, the site of the first hackney carriage stand in England. A famous maypole was erected here in 1661—parts of which were sold to Sir Isaac Newton as the base for a telescope; the parents of Charles Dickens married here in 1809. During Edwardian times, the building became surrounded by roads. Today this is the official church of the Women's Royal Naval Service.

130

KING'S COLLEGE

This formed part of an overall river frontage plan with Somerset House. The largest and second-longest-serving college in the University of London with over 21,000 registered students, it was founded in 1829 and named for King George IV. It had Church of England and political support as part of popular opposition to the humanist and egalitarian University College London (UCL). There is still a strong rivalry between King's and UCL, although they are now both part of the University of London. The former claims it is more famous, the latter that it is academically superior. The college's Students' Union is the oldest in London, King's is consistently rated in the top twenty universities in Europe. Its medical school is the largest in the United Kingdom. Perhaps the most famous research performed here was carried out by Rosalind Franklin and Maurice Wilkins; this led to the discovery of the structure of DNA by James D. Watson and Francis Crick. Famous alumni include Florence Nightingale, Sir Arthur C. Clarke, and Nobel Prize-winner Archbishop Desmond Tutu.

31

WC2

WC2

CHESHIRE CHEESE

This is a small, intimate, back-street pub, a handsome, brick-built mid-Victorian hostelry with dark wood settles, panelled walls, and black beams overhead. The Jacobeanstyle leaded windows have frosted glass. Inside there are flagons, plates, a collection of American, Canadian, and English police shoulder-epaulettes and badges, and several butter dishes.

32

THE GEORGE

The George developed from a coffeehouse, founded in 1723, but today this is a late-Victorian-style inn with mock medieval half-timber inside and out, leaded lights, wooden barrels, black oak, and carving that includes monks—one with a blue cat and one with a blue dog. The sign outside depicts King George III, but the pub was actually named after its first owner, George Simpkins. Locals here have included Oliver Goldsmith, Horace Walpole, Samuel Johnson, and notorious conman Henry Perfect, whose aliases included the Rev. Mr Paul and the Rev. Mr Bennett. Today, the legal profession from the nearby Temple and Law Courts seek refreshment here in between court proceedings.

3

ROYAL COURTS OF JUSTICE

This is a grey stone edifice in Victorian Gothic style. It was the last Gothic revival building to be built in London. It houses the Court of Appeal and the High Court of Justice of England and Wales. The courts are open to the public in most cases. This complex of courtrooms, halls, and offices deals mainly with civil litigation through the sessions of the Court of Appeal, the High Court of Justice, and the Crown Court. It was completed in 1882 but its design emulates thirteenth-century building styles. Here are the courts of admiralty, divorce, probate, chancery, appeals, and the Queen's Bench. George Edmond Street was a solicitor turned architect; it is thought that the strain of the construction of the Royal Courts led to his untimely death. The building is surrounded by the four Inns of Court and has almost five kilometres (over three miles) of corridors, more than a thousand rooms (including eighty-eight courtrooms) and 35 million bricks on its 2-hectare (5-acre) site.

134

THE LAW SOCIETY LIBRARY

The Law Society (formerly the Law Institute) dates from 1825, and its extensive library holds some 80,000 books. This building is in stripped classical style, featuring horizontal lines on the cornice and window heads, and Venetian windows arranged symmetrically across the corner. The lovely stained-glass windows of the Law Society's Hall show the arms of the former Serjeants (that were once part of the Serjeants Inn). One of the architects, Holden, also designed the Senate House and two Piccadilly Line underground stations. The Law Society Library may be seen as the first step in this journey towards English modernism.

135

GATEHOUSE

The main entrance into the inn used to be from Chancery Lane through this gatehouse—until the Great Hall was built in the I840s and the present entrance from Lincoln's Inn Fields was constructed. The heavy oak doors date from I564, and the bricks were made on site. Nearly a third of the total cost of £345 for building the gatehouse was contributed by Sir Thomas Lovell, who had been a member of the inn for over twenty years. (He helped to bring the Tudors to the throne at the Battle of Bosworth in I485.) Much of the brickwork is original but the windows were added in the I600s. Above the gateway are three fine coats of arms.

136

CHAPEL

This mixture of Gothic, Perpendicular, and Tuscan styles, stands on pillars over an undercroft where anguished mothers left their babies, trusting the inn to bring them up well; they were often named Lincoln. Distinguished Inn members were interred here. Until 1839, burials of women were not allowed but Lord Brougham fought to change this on behalf of his daughter. Most of the pews were made in 1623 by 'Price the joiner.' The chapel bells toll a 9.00 p.m. curfew. They also ring if a bencher dies—possibly since Dr John Donne (a preacher here) wrote 'No man is an island...any man's death diminishes me...never send to know for whom the bell tolls; it tolls for thee.'

13

LINCOLN'S INN NEW HALL

By the beginning of the 1800s, as its membership grew, Lincoln Inn's Old Hall was beginning to prove too small, and the foundation stone for a new building was laid on April 20, 1843. Ultimately, the new hall was opened by Queen Victoria in October 1845 (an event depicted in an artist's impression at the south end of the hall) and, at twice the size of the Old Hall, was now the largest of any inn. During the four twenty-three-day dining terms, the hall is used for dining. It also provides lunches for members all year. The Great Hall hosts the formal ceremony that calls students of the inn to the Bar—to become barristers.

138

OLD HALL

A tablet on the outside states that the hall was built in the fifth year of King Henry VII—Henry having come to the throne in 1485. Sir Thomas More joined the inn in 1496. In 1624, the hall was enlarged by a southern bay; from 1924–27, Sir John Simpson dismantled the hall stone by stone and brick by brick, and straightened the timbers. You can still see location numbers on the bricks. From 1717, this was a court of justice, and from 1737 served as the High Court of Chancery at certain times of the year. Today, it is used for examinations, lectures, and social

WC2

functions. The opening scene of Dickens's Bleak House is set here.

139

FORMER PUBLIC RECORD OFFICE

At the beginning of the 1800s, public records were scattered among fifty or so buildings, including the Tower of London, the treasuries at Westminster, the State Paper Office, and casual wards, prisons, and castles. In 1807, a commission reported that this was a 'growing national scandal' that encouraged falsification and embezzlement. A central organisation was at last established by Act of Parliament in 1838, and this massive mock-Tudor building in Chancery Lane received its first deposits in the late 1860s. Pennethorne, architect and surveyor to the Office of Works, had studied under Augustus Pugin and John Nash, as well as in Italy. His functional Gothic design faces Fetter Lane; Taylor's later extension and museum (holding such treasures as the Domesday Book and Shakespeare's will) was completed in 1903 and faces Chancery Lane. Selecting, storing, preserving, and making available to the public ever-increasing numbers of documents and housing ancient records (some medieval) had its problems; finally a new office opened at Kew in 1977. This was expanded in the 1990s and, in due course, all records were transferred there or to the Family Records Centre in Islington. The Chancery Lane building was taken over by King's College, London, which uses it as a library.

140

HOLY TRINITY

This church was originally built on Little Queen Street (which became part of Kingsway) in 1829–31, on the site of the house where Mary Lamb had stabbed her mother in a fit of madness in 1796. Galleries on either side of the organ were erected for the use of Holborn Charity Children until they moved to a new church adjoining the workhouse. This church was demolished in 1909, after having been undermined by the excavations for the Piccadilly Line and a new church rose on the site. It has a lovely stone façade in Roman baroque style, with some English baroque influences evident. It is modelled on Pietro da Cortona's church of St Maria Della Pace, in Rome. Its simple interior has white plastered walls with exposed brick above.

[4]

SIR JOHN SOANE'S MUSEUM

Today, this former house and studio of neo-classical architect Sir John Soane (number 13) is—with its neighbour—a museum of architecture, whose best parts are at the rear of the museum. These top-lit rooms provide a miniature version of the ingenious lighting contrived by Soane for the top-lit banking halls at the Bank of England. The picture gallery has walls of folding panels, to house multiple items. The domed ceiling of the breakfast room has influenced architects all over the world. Two courtyards outside contain collections of artefacts and medieval stonework from the Palace of Westminster. Soane demolished and rebuilt all three houses from numbers 12 to 14. Number 12 was externally a brick house, typical of the period, while number 13 was rebuilt in two phases between 1808-9 and 1812. Number 14 was bought in 1823 and turned into a picture gallery. The museum was established by a private Act of Parliament in 1833, taking effect later-on Soane's death in 1837. The trustees bought the main house at number 14 with the help of the Heritage Lottery Fund, and this is being restored to expand the museum's educational activities.

142

FREEMASON'S HALL

Roughly half of the south side of Great Queen Street is taken up by the United Grand Lodge of England, the headquarters of the English Freemasons. It boasts a magnificent tower and door on the corner of Wild Street, but when it was built, its Edwardian style was already twenty years out of fashion. The Grand Lodge has the date 1717 near the top of the building in deference to the first English Lodge formed then. It is Grade II listed—and the only Art Deco building in London that remains unchanged and still used for its original purpose. This is the third Freemason's Hall on the site. In 1775, the Freemason's Tavern stood where the New Connaught Rooms (at numbers 61–65) now

WC2

stand. It was replaced in the nineteenth century. Number 23 Great Queen Street houses the Central Regalia, where Masonic aprons are sold. The current building was a memorial to 3,224 freemasons who died in active service in the World War I. It was initially known as the Masonic Peace Memorial, but was changed to Freemason's Hall at the outbreak of the World War II.

143

WC2

LINDSEY HOUSE

When its houses were originally built, Lincoln's Inn Fields was a very fashionable part of London. This was the city's first garden square—laid out by William Newton in 1640 with houses on three sides. The only building still surviving from this time is Lindsey House, so-named because it was, for a period in the 1700s, owned by the Earls of Lindsey. Its design is attributed to Inigo Jones but this is uncertain. It was built in brick but later stuccoed, and has a very pleasing, almost theatrical symmetry, with double doors and lovely, slender first-floor windows set between tall pillars.

FINSBURY TOWN HALL

Finsbury Town Hall was built in 1895 to serve the Metropolitan Borough of Finsbury. With revived Tudor style and rosy coloured brick, it is a flamboyant building, heavily decorated with pillars and piers, arches, and tall chimneys—not to mention an ornate wrought-iron canopy over the entrance, and a very pretty clock. In 1939–40, its basement housed a civil defence reporting centre to protect key targets in the area, including the Research Building on the opposite side of Rosebery Avenue. During the threat of nuclear attack in the early 1950s, its basement served for a while as a sub-area control unit.

145

SADLER'S WELL THEATRE

This renovated theatre, the sixth on the site, seats 1,500 plus a further 200 in the Lilian Baylis Theatre. It is the first completed London project funded by the National Lottery. The building includes a vast frontage of glass that reveals the principal staircase and the arriving audience—usually here to enjoy ballet, contemporary dance, or opera. Richard Sadler launched his Musick House in 1683, the name Sadler's Wells a combination of his name and the medicinal wells discovered on his property—effective against 'dropsy, jaundice, scurvy, green sickness . . . ulcers, fits of the mother, virgin's fever.' During the 1800s, performers here included actor Edmund Kean, comedian Joe Grimaldi, music-hall star Marie Lloyd, and founder of the theatrical dynasty Roy Redgrave.

146

CITY UNIVERSITY COLLEGE

This powerful building was part of the Edwardian baroque revival. A Grade II–listed college building, its grand entrance with ornate detailing boasts a tower topped by a shallow dome. Behind this, the triangular section of building is set neatly into the taller structures behind. Sadly, in May 2001, a major fire damaged the building and some parts have had to undergo major repairs. City University sprang from the Northampton

ECI

Institute, founded in 1894 and named after the Marquess of Northampton—on whose lands it was built. The university has close links with the city and the professions. A new building for the School of Social Sciences opened in Northampton Square in 2004.

14

BOURNE ESTATE

This five-storey, brick-built mansion block once housed nearly four thousand people, far more than its façade—albeit extensive—would suggest. Arched openings lead to courtyards and buildings beyond. Built in classical Edwardian grand style in a Victorian street on a medieval site, this is a place where history converges. Clerkenwell developed from a tiny hamlet in the 1100s (serving a nunnery and a priory) to crowded slum areas by the 1800s. It wasn't until the 1990s that the neighbourhood became once more fashionable.

18

ST JOHN

EC

St John's Gate was rebuilt as Priory Gate, still standing here. This square was the birthplace of *Gentleman's Magazine* in 1731—to which Dr Johnson contributed. The gatehouse became the headquarters of the St John Ambulance Association in the 1900s. An Early English crypt lies beneath the church where, in the 1100s, stood the priory church—damaged during the Peasant's Revolt in 1381 and dissolved under Henry VIII. The circular site of the original church is marked out in cobbles.

149

A HOUSE OF TRIANGLES

This unusual property in Clerkenwell focuses on diamond patterns and triangular shapes—from the pitched roof that houses a studio to the latticework on the windows and the diagonals of the exterior screens and balconies. It has concrete log lintels, and the brickwork has been used to create interesting patterns as it mutates from dark tones at the base of the building to lighter tones above.

WREN HOUSE

Built by Lord Hatton to serve the needs of the neighbourhood after St Andrew's Holborn had been destroyed in the Great Fire, this church was adapted for use as a charity school in about 1696. Severely damaged by incendiary bombs during World War II, it has been reconstructed to include offices inside—the restored facade includes the fascinating figures of scholars in eighteenth-century costume that, during the war, had been sent for safekeeping to Berkshire.

151

PRUDENTIAL INSURANCE

This piece of Gothic splendour in bright pink-red terracotta reflects the status of insurance companies in the 1800s. The building was extended between 1899 and 1906 to achieve its grandiose effect. The main façade is symmetrical, with tall lancet windows, multiple gables and spires, and a central tower with a fine pyramid-shaped roof (like those of several skyscrapers in New York). Set in a corner of the piazza behind the great building is a little shrine housing a bust of Charles Dickens, who began his writing career in rooms near here, penning *Pickwick Papers* while sitting in Furnival's Inn.

152

BLEEDING HEART TAVERN

This tavern was first recorded in a register of licensed victuallers of 1746. In 1785, the Bleeding Heart and its yard were part of lot 71 when the Hatton family sold the whole area in an auction. The name may derive from the arms of the Douglas family (which include a red heart); or from the Church of the Bleeding Heart on or near the site; or from the 1626 murder in the crypt of Sir Christopher Hatton's widow, Lady Elizabeth, during a ball at Hatton House. She was killed by her jilted lover, the Spanish ambassador Gondemar. Dickens chose it for a location in *Little Dorrit* and *Oliver Twist*, and Fagin's den was set close by. The whole area was cleared and rebuilt in 1845-46. Inside are panelled walls and a collection of Dickens's books and prints.

CI

ST ETHELREDA

St Ethelreda was an abbess who founded Ely Abbey in the seventh century and an Anglo-Saxon saint; part of one of her hands is an ancient relic that has been preserved in a jewelled casket here. Despite being hemmed in on both sides, the church has a pleasing façade with the sweeping curves of its stained-glass windows singularly beautiful. This church served as the private chapel for the bishops of Ely. It also has a crypt and undercroft in what may be the oldest pre-Reformation Catholic church in England. The best strawberries in the city were said to be grown in the gardens here, and a strawberry fayre—mentioned in Shakespeare's Richard III —is still held here every June. The building was used as a prison and hospital during the Civil War.

YE OLDE MITRE

This ancient tavern is hidden down an alleyway with an old crooked street lamp. First built for the servants of the palace of the Bishops of Ely, the tiny tavern is, technically, still part of Cambridgeshire, and the pub license was issued there for centuries. Its small sign is in the shape of a bishop's mitre, and a stone mitre from the bishops' palace gatehouse is built into a wall, nearly hidden under the ivy. There are two cosy, wood-panelled bars. The preserved trunk of a cherry tree, which marked the boundary of the diocese, is in the corner of the front bar. Queen Elizabeth I is said to have done a maypole dance around this.

15

FCI

SMITHFIELD MARKET

Reconstruction and modernisation of this ancient market has cost over £70 million. A new poultry house and fortyfour temperature-controlled stalls have been installed, and now there are proposals for further development by architects KPF. Here, neat roof triangles are echoed by hexagonal features on the walls below. The market began with 'Smoothfield' horse market and fair some eight hundred years ago, and it was long a place for jousting and execution. In 1357, the kings of England and France attended a royal tournament here. It was converted into a proper meat market in 1615. Two centuries later, Horace Jones, the great Victorian architect, was commissioned to build the 'new' Smithfield—a wrought-iron and glass edifice completed in 1868.

156

ECI

ST BARTHOLOMEW'S HOSPITAL

St Bartholomew's (St Bart's) is London's oldest hospital, having provided medical care on the same site for longer than any other hospital in England. It began in 1123 as an Augustinian priory and hospice. Here, after the Peasants Revolt in 1381, Wat Tyler took refuge, only to be dragged out and beheaded at the hospital entrance. The great hall and main staircase are English baroque with murals painted free of charge by Hogarth in 1734. The church was added in 1823. A Venetian gateway leads into a courtyard surrounded by the Palladian Gibbs Court, raised in fine Bath stone. In 1850, Elizabeth Blackwell, a pioneer of medicine as a career for women, was allowed to study here.

157

HOLY SEPULCHRE WITHOUT NEWGATE

Built on the site of a Saxon church, with its west tower still dating from the 1400s, this is the largest parish church in the city. Named in Oranges and Lemons as the bells of Old Bailey, the church bells used to toll for executions in Newgate prison while the church clerk rang the execution handbell (now in a glass case in the nave) outside the condemned person's cell. Conductor Sir Henry Wood, a former organist at the church, is buried here—as are composer John Ireland, singer Dame Nellie Melba, and John Smith, governor of Virginia and friend of Pocahontas.

158

CHRIST CHURCH

ECI

In 1224, an order of the Franciscans was given a poor piece of land around which such streets as Stinking Lane and the Shambles sprang up. In 1306, they raised a magnificent church, possibly the largest in England at the time. After the Dissolution, it became a parish church and, following the Great Fire, was rebuilt by Wren on a smaller scale. In ever smaller stages, triple-tiered squares of columns form the steeple. The bell stage has segmental pediments, and the tiny spire is crowned with a vase. The church was gutted during the 1942 Blitz and only the tower remains as a memorial, now standing in a garden.

15

ST BARTHOLOMEW THE GREAT

This is a piece of medieval London and one of the city's oldest churches. It began in 1123 as an Augustinian priory and hospital, raised under Henry I (who had some twenty-five illegitimate children, more than any other English king, and was the fourth son of William the Conqueror). The church survived the Great Fire of 1666 and the bombs of both world wars, and has appeared in *Four Weddings and a Funeral, Shakespeare in Love, The End of the Affair,* and in BBC television's *Madame Bovary.* Today's church has grown around the old priory building with its apsidal east end—rebuilt in the 1800s when the Lady Chapel (built c. 1330) was restored. Part of the chancel and crossing are original.

160

TIMBER HOUSES

Cloth Fair has long been associated with the drapery and tailoring trade. Near here, in the Middle Ages, was held the largest cloth and clothing fair in the country that, by the 1500s, lasted for a fortnight every August. Sadly, most of the city's timber houses burned to the ground in the Great Fire and brick buildings sprang up in their place. These fine specimens were among those few houses that escaped the flames. Owned by the Landmark Trust, they are set on the corner of narrow Rising Sun Court and Cloth Court. Tall timber windows, capped by pediments, are set above arches at street level. They provide a tantalising glimpse of pre-Wren London.

161

SLIM HOUSE

This narrow house, only 3.5 metres (II feet) wide, was

ECT

built on the site of a shed used by a mini-cab firm, and is squeezed between a brick Victorian commercial block and a bright yellow pub. With space for just one room on each of the five floors—plus a basement and a small set-back behind a roof terrace—the various stages are reached by a lift set into a concrete shaft in a steel-framed structure, or a stairway with a huge light-well. This unusual building's frontage is all gleaming steel and glass.

162

WHITBREAD'S BREWERY

This is a famous English brewery in fine Georgian style. By the late 1700s, it was the largest in England, and in 1787 was visited by King George and Queen Charlotte. Here stands the original early eighteenth-century house, in carved brick 'artisan' style, plus the brewing buildings set around a courtyard with a canopied door and arched window above. A ramped colonnaded exit provided a route for barrels into the cobbled courtyard. There is a wonderful king post timber truss roof, a barrel vaulted ceiling, exposed brickwork, and eighteenth-century lanterns. In 1976, brewing ceased here and the buildings were restored.

163

ARMOURY HOUSE

This is the headquarters of the Honourable Artillery Company that moved here in 1641—to defend the realm and maintain the shooting of longbows, crossbows, and handguns. It has an apt fortress style and cannon-balled parapet—built in 1735—with wings added in 1828. The former artillery grounds are now vast gardens. The armoury houses a museum of uniforms, armour, silver, medals, weapons, and early printed books. Today the HAC provides intelligence for the deep-strike systems of the British Army and NATO, and supplies the saluting battery at the Tower of London and guards of honour for state occasions.

164

WESLEY'S CHAPEL (AND HOUSE)

The foundation stone for the chapel was laid by John

Wesley himself in 1777 when the founder of Methodism was seventy-four years old. The site had been too swampy to build upon—until excavations for the new St Paul's Cathedral led to massive dumping of soil here. This brick chapel, a late Georgian design, was altered in the 1890s, when its elegant porch and columns were added. By 1972, £1 million was raised from all over the world to restore the chapel, which reopened in 1978. The crypt is now a Museum of Methodism. In between his mission travels, Wesley lived in the small Georgian town house and is buried in the churchyard behind the chapel.

165

ST LUKE

Nicholas Hawksmoor worked with Christopher Wren and Sir John Vanbrugh (helping him build Blenheim Palace for John Churchill). He designed six new churches in London plus the west front of Westminster Abbey. The fluted obelisk spire was much admired, but sadly, after decades of settlement, St Luke's was declared unsafe and its roof was removed. Today, this Grade II–listed building is home to the London Symphony Orchestra music education centre and performing arts venue, taking great music into the local community. It has retained the original walls and window alcoves, the church clock has been renovated, and the golden dragon restored at the top of the spire.

66

FINSBURY SQUARE

Sadly, all the original houses raised around the 1770s by George Dance the Younger have vanished, but this southeast corner of Islington, set just a few a blocks north of the city, was once the place of residence for many Georgian merchants. The rectangular square was constructed 1777–92. Here one James Lackington, bookseller, ran the Temple of the Muses—a famous shop with a vast circular counter large enough, it was claimed, for a coach and six to be driven around. Albeit the old houses have vanished but there are still impressive buildings here.

CHAPEL OF THE OPEN BOOK

Set in a conservation area, this non-denominational chapel is picturesque Gothic style and is situated near to the Grade II–listed Flying Horse public house and a terrace of six rather dilapidated Georgian houses. The building is all points and triangles, bar for the window tracery and trefoils.

168

OFFICES, SHOPS AND SKATING RINK

Here 150,000 square metres (1,615,000 square feet) of office buildings are arranged informally to compose two new linked squares, one left empty, the other filled with an terraced elaborate circular feature under glazed roofing that contains shops and a skating rink. The entrance to the offices is through semi-public atriums with glass roofing. The decorative treatment of the Broadgate exteriors uses 'curtains' of fretted granite. The gently curved frontage shown here has multiple windows, square and rectangular, while other complex structures rise beside and behind it.

169

CITY POINT

First called Brittanic House in its 1967 guise, this was sold as the headquarters for British Petroleum. Wates City bought the building for £143 million, making it the most expensive real estate in the world (per acre) in 1999. At over 122 metres (400 feet) tall, it remains the largest single available-for-let building in the whole of the city and it has been valued at about £500 million. The award-winning architects of this exciting, vibrant building (for a short while the second tallest in the city) are part of the Sheppard Robson architectural practice, the fifth largest in the United Kingdom, with many highly experienced architects and cutting-edge young designers.

170

CROMWELL TOWER

Part of the Barbican complex in the City of London, the imposing Cromwell Tower rises to 404 feet (123 metres)

with forty-two floors. This impressive tower was given Grade II-listing in 2001. Its style is denoted as brutalist with an exterior that has a bush-hammered finish on a sharply ridged pattern of horizontals and verticals-its severity of line undoubtedly reflecting the harsh attitude of its 1600s Puritanical namesake. It is a residential skyscraper. offering one of the few places to make a home in an area dominated by offices and banks. This is the fourteenthtallest building in London-together with its partners in height, the almost identical Shakespeare Tower and Lauderdale Tower (also part of the Barbican Estate). The tower is named for Oliver Cromwell (1599-1658), the only non-royal ruler of Britain to be crowned as Lord Protector and who ruled England, Scotland, and Ireland from 1653. He played a major part in bringing King Charles I to his trial and subsequent execution in the wake of the English Civil War-in which Cromwell led the New Model Army, often called Roundheads after the shape of their helmets.

171

FROBISHER CRESCENT

This sweeping crescent links north and south Barbican and looks down on the Sculpture Court behind the arts centre. It houses arts centre offices and the City of London Business School—and serves as an entrance to the library. It is named after Sir Martin Frobisher (1535–94), the explorer of Canada's Frobisher Bay, who is buried in nearby St Giles (although St Andrew's in Plymouth claimed his heart and entrails).

172

THE CONSERVATORY

The Barbican's Conservatory is a high area surrounded by glass panels—hence the name—set on the top floor of the arts complex. Here tropical and semi-tropical flora and many other exotic plants flourish beside the pools, walkways, and fountains. This well-stocked conservatory is one of the largest greenhouses in London. In 1986, an Arid House was added to house cacti plus the largest *Carnegiea gigantea* in Europe—kindly donated by the mayor of Salt Lake City.

MUSEUM OF LONDON

Raised above street level by the Barbican, where busy Aldersgate meets London Wall, the museum's concrete 'drawbridge' offers a safe route over the traffic. Set on the site of a Roman fort, this is one of the largest, most comprehensive city museums in the world, with exhibits that trace London's story from 400,000 years ago through Roman settlement in A.D. 50 to today. Reconstructed street scenes and interiors discover a Roman room with mosaic pavement, the 'Great Fire Experience,' a Stuart interior. Newgate prison cells, Victorian and Edwardian restaurants and shops, and even a Selfridges Art Deco elevator.

OFFICES AND 'PLAISTERERS'

This vast glass expanses in this thirteen-storey curved 'ship-prow' office offer magnificent views over the city. The site includes the original wall that protected a Roman garrison nearly two thousand years ago, while its basement floor preserves the old Plaisterers Hall of the Worshipful Company of Plaisterers, whose first charter was granted by King Henry VII in 1501. Long before that, in 1189, the first Lord Mayor of London, Henry FitzAlwyn, made an order that all houses should be plastered and limewashed-endorsed by King John in 1212, who commanded that all shops on the Thames and London Bridge should be plastered—inside and out.

AWARD-WINNING OFFICES

This remarkable office complex is near to both contemporary skyscrapers and much older sites—such as the tower of Wren's St Alban's Church and the two ancient churchyards of St Mary's and St Olaves. There are three blocks. The numbers of storeys in these stepped blocks rise from ten, to fourteen, to eighteen-to remain in keeping with the height of the surrounding buildings. The gaps between the blocks are used for stairs, lifts, and services, thus keeping the main buildings free for occupation and retaining the maximum number of corner offices. Wide, triple-glazed, ultra-clear

windows mean that the external walls almost disappear; the stairs and the panoramic lifts have frameless glazing, too, making the most of the stunning views in all directions. Integrated, internal blinds are controlled by photo-cells and automatically adjust to suit the sunshine levels.

176

BUILT ON A ROMAN FORT

This stunning new building catches the eye because of its unusual shape, its various sections curving in at the top. It presents a pattern of stripes and textures, topped by an interesting overhanging roof format in a gentle rise with protruding edges. Ten floors of column-free office space occupy 10, 193 square metres (109, 717 square feet) and it stands 41 metres (135 feet) high on an island site in the city. It straddles the remains of a Roman fort and is set next to St John Zachary churchyard. This imaginative multi-storey steel framework embraces both the sunken garden and Roman archaeology. The accommodation is set around an open-sided, south-facing atrium to overlook the gardenextended with terraced planting beds that rise up the external face of the atrium.

SCHRODERS INVESTMENT BUILDING

This building was designed to serve as the new prestigious headquarters of Schroders Investment Management Limited. The building totals 20,438 square metres (220,000 square feet) and took less than nineteen months to complete. It uses few columns so as to maximise both daylight and space—and aims to provide a strong corporate image for the company as well as creating an attractive and functional working environment for the staff employed there.

ST LAWRENCE JEWRY

This church, by the medieval lewish area, was founded in 1136-over the tiered section of a Roman amphitheatreand dedicated to Saint Lawrence, who was roasted alive on a gridiron. The sumptuous building is one of Wren's most

expensive and was gutted in both the Great Fire and 1940s Blitz. Remarkably, a 1500s painting (showing St Lawrence's martyrdom) has survived. The decorated east front is based on St Paul's Cathedral, with rounded arches, and swags of flowers and fruit. Inside, goldleaf and chandeliers gleam in a vast white interior. Windows commemorate Sir Thomas More (who preached here) and Wren with his master-mason and master-carver.

179

GUILDHALL

Despite alterations over the centuries, the Guildhall retains its glorious medieval outlines. The first mayor was installed here in 1192. It was rebuilt in 1411 when Henry V granted the free passage of stone by boat and cart. The executors of mayor, Richard Whittington (of Dick Whittington folk tale fame), helped to pay for the paving and window glazing. The 1430 Gothic porch is still the entrance from Guildhall Yard. Here, in 1554, was held the trial of Lady Jane Grey. The large medieval crypt is the most extensive in London. Windows in the east crypt depict the Great Fire, Chaucer, Caxton, More, Wren, and Pepys. The west crypt has a superb vaulted ceiling.

180

ST MARY-LE-BOW

The church was called le Bow because of the bowed arches of stone in the eleventh-century crypt—where Norman columns can still be seen today. The glorious tower and spire soar to over 66 metres (217 feet)—set forward from the church and topped by a huge, golden, flying-dragon weather vane. The famous bells were first mentioned in 1091 when the roof blew off in a storm and later, as legend has it, for summoning Dick Whittington back to London town. The curfew was rung on Bow Bells during the Middle Ages, probably leading to the idea a true cockney must be born within hearing distance of these. The church had to be reconsecrated in the late 1200s after a series of incidents: one William Fitz Osbert escaped up the tower, after killing an archbishop's guard—he was smoked out, and hanged in chains at Smithfield. In 1271, the tower collapsed, killing

twenty people. In 1284, after a goldsmith was murdered here, sixteen men were hanged and one woman burned. In 1331, a wooden balcony collapsed during a joust to celebrate the birth of the Black Prince, hurling the Oueen and her ladies, to the ground-an event marked, after Wren rebuilt the church, by a memorial balcony, from which Oueen Anne watched the Lord Mayor's pageant in 1702. The church burned down in the Great Fire and was rebuilt. by Wren, who remodelled it on Rome's basilica of Maxentius. In 1818–20, the upper spire was rebuilt by George Gwilt. An elaborate doorway in a rusticated opening leads into the neat, white-and-gold interior, restored by Sir Arthur Blomfield in 1878–89. The church was severely damaged by 1941 bombs, and the beautiful steeple was taken down and stored away for almost twenty years. A plague on the exterior wall remembers John Milton, born in nearby Bread Street, while a statue outside celebrates locally born Captain John Smith (1580–1631), who became governor of Virginia.

181

NATIONAL WESTMINSTER BANK

The Westminster Bank first opened as the London and Westminster Bank in Throgmorton Street in 1834 and soon became a leading professional bank. Today, it has become a vast concern—an amalgam now of many clearing banks, including the National Provincial Bank of England, which was founded in 1833 by banking pioneer Thomas Japlin. The shorter name of Westminster Bank was adopted in 1923. Set on a challenging busy corner site, this very gracious building has numerous tall columns and fine sculpture work but is not overworked. Its arched entrance is set on the relatively broad corner façade.

182

EC2

NUMBER ONE POULTRY

This leading post-modern building was constructed where the offices of J & J Belcher once stood. The exciting new structure uses bold forms and strong colours, and is lavishly decorated with many forms and motifs. An office and retail development, it was designed to stand on a site owned by Peter Palumbo, a controversial property developer who had inherited part of the site from his father. The project had to overcome many obstacles and some thirty-five years would pass before the concept came to fruition. During its construction, a major archaeological dig by the Museum of London Archaeological Service excavated several significant finds. These included a wooden drain along the main Roman road that dates back to A.D. 47-at the time of the very foundation of Roman London (a town the Romans then called Londinium). It is interesting that such a striking new building stands where Roman London 'launched' the city. Set at a road junction, it maximizes this triangular position to dramatic effect with a tall 'prow' that revels in both cylindrical and angular shapes. A deep open courtyard below allows pedestrian access and also provides a way through to Bank Underground station. The final flourish at the top, above all the offices, is a roof-garden with surreal landscaping created by Arabella Lennox Boyd. There is also a fine restaurant here, Le Cog d'Argent, which is run by Terence Conran.

183

BANK OF ENGLAND

The Bank of England is the central bank of the United Kingdom. Often called 'The Old Lady of Threadneedle Street,' it has changed many times over its three hundred years of development to become an imposing edifice that spreads across four acres. The first bank opened in 1694 in the Mercers' Hall above the site of the ancient Roman temple of Mithras, appropriately the god of contracts. Later on it moved to the Grocers' Hall and finally, in 1732–34, into its present site. The stately colonnade on the northwest 'Tivoli' corner was based on the Temple of Vesta at Tivoli which Sir John Soane had sketched in 1779. The bank was founded by a Scotsman, William Paterson, in 1694 to act as the English government's banker. Its Royal Charter was granted in 1694. The first governor was one Sir John Houblon—who is depicted in the 1990 issue of the £50 note.

184

ROYAL BANK OF SCOTLAND

Founded in 1727, with its headquarters in Edinburgh, the

Royal Bank of Scotland acquired the English NatWest bank in 2000—in the biggest takeover in British banking history. This is now one of the largest banks in the world. This robust building is absolutely fitting for such a prestigious concern, with its sturdy columns, arched canopy over a rather daunting entrance, with numbers firmly placed each side of the door. The windows are set within brick arches, above intricate wrought-iron decoration. A lively imagination could perhaps relate the walls' decorative theme of circular motifs to counters or coins!

18

BRITANNIC HOUSE

Finsbury Circus was originally laid out in 1815–17 with handsome houses by William Montague, raised to the designs of George Dance the Younger, but long since demolished. In this setting with such an inspiring past, Britannic House was Lutyens's first large London building and is today an historic building with a Grade II–listing. Its seven-storey, classical façade makes a stately curve, with Corinthian attached columns and lovely arched windows. Its exciting renovation introduced a contemporary—and very impressive—semicircular atrium, allowing natural light to pour into the office areas.

86

THE PAVILION

This curves of this superb cylinder of gleaming glass are all the more dramatic because of its proximity to the straight high slabs of building all around it. The reflections make a pleasing play of light and shade. This building is rendered stunning by its very simplicity and sheer surface.

187

BISHOPSGATE INSTITUTE

The institute opened in 1894 to provide educational courses, the use of Bishopsgate Library—with its historical collections of London prints and drawings, and early labour movement documents—plus meeting rooms, and halls for examinations, conferences, and exhibitions. Designed by Charles Harrison Townsend, the institute is a most unusual building with its beige faience façade and lovely mix of Victorian Romanesque styling and Art Nouveau decoration. A generous round entrance arch is set between tall, narrow angular towers that rise to pinnacles—with a pretty, overhanging, steep roof squeezed in between them.

188

LIVERPOOL STREET STATION AND HOTEL

On the site of the old Bethlem Hospital (1200s-1600s) and countless streets, courts, and alleys, this was one of the last major stations to be built in London. It would serve as the metropolitan terminus for what would become the Great Eastern Railway, plus the place to catch local trains to the northeastern suburbs. It soon became one of the busiest stations, with more daily passengers than any other London terminus and some 123 million visitors each year. A daily express train connects with the ferry from Harwich to Hoek van Holland. Built in restrained Gothic redbrick, with its platforms well below ground level, it was named after the street on which it stands, in turn named to honour prime minister Lord Liverpool. In 1922, a large World War I memorial in the main booking hall was unveiled by Field Marshall Sir Henry Wilson-assassinated by the IRA on his return home that day. In May 1917, the station was the first London site hit by German Gotha bomber aircraft; 162 people died.

189

MANSION, MEETING HOUSE, AND HOMES

Jasper Fisher, goldsmith and clerk to the Court of Chancery, built an Elizabethan mansion here in the 1500s. Ever in debt, he was derided by his neighbours, who called the house Fisher's Folly. Eventually, he sold it to William Cavendish, the second Earl of Devonshire, who renamed it Devonshire House. What was once its large forecourt now forms Devonshire Square. Part of it was leased in 1666 to Quakers for a meeting-house. The minister, George Whitehead, used to take his night-cap to meetings in anticipation of raids and his being dragged off to prison. In 1675, Nicholas Barbon bought the house. It was demolished two years later; a new Quaker meeting-house was built and the square developed. A few 1600s houses still stand here, and there are lovely Georgian houses with multi-paned sash windows and steps leading up to elegant entrances.

90

STONE HOUSE

This is a very handsome 1920s addition to Bishopsgate. It stands on the site of a thirteenth-century stone building owned by Augustinian friars, and known in the locality as 'the stone house'—most buildings then were made of timber. The office block here today has inherited this title. It has a very generous, curved corner, ornate Art Nouveau–style metalwork above the double-storey plinth, and multiple rows of windows and sweeping cornices that serve to emphasise the building's flowing lines.

CITY OF LONDON CLUB

Once upon a medieval time, this was a very fashionable place to live. A well-known glasshouse made Venetianstyle glass from the early 1600s until the Great Fire. Today, the City of London is a traditional gentlemen's club, established for over 170 years in this Italianate building where the balustrades on the wall are echoed by those on its balcony fronts. The high-ceilinged ground and first-floor period rooms were restored in 1980, when a proposed development of a neighbouring National Westminster Bank threatened to absorb the club. This was thwarted and so gentlemen still meet here, maintaining this unique London practice in apt surroundings.

19

ROYAL EXCHANGE

The original Exchange was founded in 1565 by Sir Thomas Gresham, a rich merchant and advisor to Queen Elizabeth I. A meeting place for merchants and brokers, it became a focal point for merchants and financiers who made London the commercial centre of Europe. Samuel Pepys took refreshment in the courtyard here. This building was destroyed in the Great Fire; a second 1669 Exchange burned down in 1838. Today's building was opened by Queen Victoria in 1844, and faces Threadneedle Street (famous for opticians and makers of microscopes and telescopes). Roman lettering and sculpture decorate the large Corinthian portico; stout columns hide statues of Queen Elizabeth, Queen Victoria, and Charles II; a fine baroque spire graces the eastern end; and an immense glass ceiling covers the interior courtyard. The Exchange ceased to act as a centre of commerce in 1939, and now houses a luxurious shopping centre.

193

FC3

ST PETER UPON CORNHILL

This church was founded on the site of a very early site of worship-a Roman basilica raised in A.D. 179. By the Middle Ages, now set in a busy network of medieval alleys and courtyards, the church had a large library and a grammar school attached to it. Its post-Fire stuccoed exterior has a simple brick tower capped by a dome and obelisk. The façade is Palladian, with arched windows separated by pilasters, and two circular windows. Mendelssohn played the Father Smith organ here in 1840 and 1842. To the south is a raised graveyard described by Dickens in Our Mutual Friend. The adjacent terracotta building reveals a piece of architectural revenge. Because a Victorian rector at St Peter's had complained about a new office site encroaching onto church land by a few inches, the architects had to redesign the entire building. They added three angry devils-one spitting, one sticking up its fingers rudely, and one that resembles the protesting rector.

194

LEADENHALL MARKET

Here, on the site of a large Roman Basilica, there has been a poultry market since the 1300s when Leadenhall's mansion had a lead roof—hence the name. In the 1600s, Spanish ambassador Don Pedro de Ronquillo remarked to Charles II, 'There is more meat sold in your market than in all the Kingdom of Spain.' Both market and mansion burned down in the Great Fire and the market was rebuilt with three large courtyards—one primarily for beef, leather, and wool; the second for veal, mutton, lamb, poultry, and fish; and the third for herbs, fruit, and vegetables. Now, most wholesale trade operates from Smithfield, and Leadenhall has become a retail market with shops and stalls. The grandiose design is restored Victorian splendour—an ornate, iron roof structure with glazed arcades painted green, maroon, and cream, and cobbles everywhere. It was used as a backdrop for the Leaky Cauldron and Diagon Alley in the film Harry Potter and the Philosopher's Stone.

195

JAMAICA WINE HOUSE

This pub was the Turks Head tavern, until its merchant owner returned from overseas. loaded with coffee beans and with a Greek servant who knew how to prepare the brew. This Pasqua Rosée helped to found London's first coffeehouse-re-launched in the 1670s after Wren's post-Great Fire rebuild. Coffeehouses became a key element of Restoration London. The numerous ones in the Cornhill area catered for financiers, stockbrokers, and bankers, Because Rosée's was a centre for merchants in the West Indies trade, dealing with Jamaican rum and sugar, it was soon known as the Jamaica. Underwriters wrote their policies here but, as the century wore on, the focus shifted to entertainment and more alcoholic refreshment. In 1869, it was renamed the Jamaica Wine House and by 1892 had been bought by Shoreditch wine merchants E. J. Rose. Today the redbrick Jamaica Wine House still emanates its history: the bar is divided into little compartments by polished mahogany partitions. There is an oak bar with pine planking behind, superb oak-panelled walls, dark linoleum on the floor, and stout beams above. Fine coffee is still served, as well as beer and wine. A plague in the wall outside records its status as London's first coffeehouse.

196

A LUTYENS BANK

While Lutyens was creating this bank branch, he was also working on the vast Midland Bank headquarters which faces two streets. This bank, by contrast, was an infill, squeezed in between its neighbours—one of which has now been removed. Rather pretty towers rise above a

EC3

tidy seven-bay façade with pleasing rows of windows, supported on lofty arches that front the street.

197

LLOYD'S OF LONDON

This fascinating building (home to Lloyd's of London, the insurance institution) is based around a simple rectangle but reverses the conventions and—not unlike a medieval castle with its six vertical towers, albeit clad in stainless steel—keeps the lifts, staircases, electrical power conduits, and water pipes clinging to its exterior and so retains a dramatic twelve-storey atrium in the centre. The steel frame has a glass curtain wall and is 95 metres (312 feet) tall and looks especially dramatic when floodlit. This is one of the city's most celebrated and controversial modern buildings—set in the heart of the ancient quarter where Lloyd's began a coffeehouse in the 1600s.

198

CUNARD HOUSE

The London headquarters of Cunard was designed by Davis (Mewès had died in 1914). Arthur Joseph Davis had also designed the interiors of two Cunard liners, Franconia (1922) and Laconia (1923). The Cunard line—founded in 1840 by Samuel Cunard, of Nova Scotia, to carry the Royal Mail from Britain to North America—built the doomed Lusitania, Queen Elizabeth (1939), QE2 (1969) and Queen Mary 2 (2004). This large building arrived at a time when Edwardian baroque was being replaced by modernism and many major companies and financial institutions rebuilt or raised new headquarters in the city as architecture sought up-to-date ways to express their power. Today, this grand façade fronts many offices with several eateries at street level (including Caraveggio for Italian cuisine and a Caffè Nero coffee shop).

199

ST ANDREW UNDERSHAFT

The church gained its new name in the I400s, *undershaft* meaning 'under the maypole.' The maypole shaft used here for the spring festival was taller than the highest pinnacle on the tower. However, on Evil May Day, in 1517, a riot of apprentices led to three hundred arrests and one hanging. The shaft was stored under house eaves in Shaft Alley (also allied to the church's name) until, seen as a pagan symbol, it was chopped up and burnt. In 1520–32 the church was rebuilt in Gothic style and then restored in 1627. This was one of the rare medieval churches to survive the Great Fire (in part due to a vacant plot beside it) and the Blitz. It has stained glass and a font from the 1600s. Historian John Stow was buried here in 1605: every year, the Lord Mayor attends Stow's memorial service, placing a new quill pen into the hand of Stow's monument. He gives the old quill and a copy of Stow's book to the child who has penned the best essay in London.

200

SWISS RE BUILDING

The building's official name derives from its primary occupants, the Swiss Re re-insurers, but its rocket shape has lead to its more popular name, the Gherkin, and has also inspired the nickname of the 'Towering Innuendo.' With forty-one storeys that rise 180 meters (590 feet) high, this new landmark has some 745 dazzling glass panes clad over many thousands of tons of structural steel. Despite its overall curve, there is only one piece of actual curved glass on the building-the cap at the summit. Its restaurant at 165 metres (541 feet) is one of the highest in London. The design won the 2003 Emporis Skyscraper Award and the prestigious RIBA Stirling Prize for the best new building by a RIBA architect in 2004. It was voted as both the most admired new building in the world, in a 2005 survey of the world's largest firms of architects and, that same year, the Best New Building on the Planet in Building Design Magazine. The Gherkin has recently featured in television's Doctor Who and Woody Allen's film Match Point.

20

GREAT ST HELEN'S

On the site of a pagan temple, the first church here may have been built in the 300s by Emperor Constantine, when he was converted to Christianity, and was named for his mother, Helena. Today, St Helen's is the largest medieval London church to have survived both the Great Fire and World War II (but was subjected to IRA bomb damage in the 1990s). In the 1200s, a convent church arrived and now two naves stand side by side, the northern one then for nuns and the southern one for laity—separated by a screen. In 1385, the prioress was scolded (for keeping too many small dogs) and the nuns for kissing 'secular persons' and wearing showy veils. In 1538, the nunnery was surrendered to King Henry VIII. The interior remains largely 1400s. There are many monumental brasses from 1470 onwards, and Elizabethan and Jacobean tombs, including one for the Spencers. A memorial window marks Shakespeare's residence in the parish.

202

SPANISH AND PORTUGUESE SYNAGOGUE

This is London's oldest synagogue, built by Sephardic Jews in 1701. Its congregation have included members of the Disraeli family, and the birth of Benjamin Disraeli in 1804 is recorded in the register. Built by a Quaker master-builder, the synagogue was the first to be opened after Jews were allowed to return to England in 165. Queen Anne donated one of the main beams. The design is a plain rectangle with two tiers of windows, a flat ceiling, and three galleries. There are original Jewish furnishings and seven chandelier candlesticks from Amsterdam.

203

ST KATHERINE CREE

This was built in 1280 for the parishioners so that the 'canons be not disturbed by the presence of laity' at the priory. Its vaulted ceiling, decorated with city livery company arms, rises above Tuscan columns. The east rose window symbolises the toothed wheel on which St Katharine was martyred by Emperor Maximilius in 307. The chapel contains the tomb of Sir Nicholas Throckmorton, advisor to Elizabeth I. In the 1600s, Lord Mayor John Gayer endowed the Lion Sermon to be preached annually after his survival of a face-to-face confrontation with a lion. Purcell, Wesley, and Handel have played the 1686 organ here. 2

LLOYD'S REGISTER OF SHIPPING

Here are two stunning, glazed slabs. Rising up twelve and fourteen storeys respectively, they are connected to another six storeys of space set behind the original façades of Lloyd's listed headquarters building on Lloyds Avenue. A long-lost churchyard, buried within the city block, has been freed up again—as public space—and so now an ancient part of London makes a marked contrast with the transparent gleam of the service towers. Although this is a confined site, the mass of glass channels all the natural light into the area most effectively.

20

FENCHURCH STREET STATION

Opened in 1841, this was the first railway station in the city. Until 1849, when steam locomotives were used, trains had to be dragged from Blackwall to Minories by cables and then reach Fenchurch Street under their own momentum—leaving by gravity, encouraged by a little push from the platform staff. In 1854, this new station opened. The completion of a line to Willesden Junction brought the Victorian suburbs of Hackney, Highgate, and Kilburn within commuting distance of the city. Now a minor terminus of the Eastern Region, its four platforms serve over 28,000 passengers in the rush hour. The grey stock-brick facade has eleven, round-arched windows, a classic station clock. and a rounded gable roof. The arched bow of the trainshed roof continues over the brick offices at the front to form a pediment. Novelist Douglas Adams named his character Fenchurch (in The Hitchhikers Guide to the Galaxy) after the station-where he was conceived.

206

TRINITY HOUSE

This is the headquarters of the corporation that, since the first lighthouse was built in 1609, organises the nation's harbour pilots, buoys, and lighthouses. Its foundation stone was laid by William Pitt, then master of the corporation. The elegant rooms have a maritime flavour—with royal paintings, shipwrights' models, and the ship's bell from the Royal Yacht *Britannia*. Its lonic façade survived

EC3

World War II bombing. Trinity House reports directly to the sovereign.

207

WHITE TOWER, TOWER OF LONDON

The White Tower was begun by William the Conqueror, as a strong defence keep in Caen stone and Kentish ragstone. The walls are up to 4 metres (15 feet) thick. The lower floors now contain an incredible armour collection. The curtain walls, enclosing some 18 acres, were started under Henry III and completed under Edward I. The Tower guards the Crown Jewels and has been a palace, a royal menagerie (from 1235, when the Holy Roman Emperor gave Henry II three leopards), a prison, a mint, an observatory, and a place of execution. Its dungeons included the Little Ease, a dark cell too small for a prisoner to stand or lie down in. Soldiers' and servants' quarters were on the first floor, the banqueting hall, St John's Chapel, and nobles' bedrooms on the second, and royal bedrooms and the council chamber on the third. After the killing of the two young princes (Edward V and the Duke of York), the Garden Tower became known as the Bloody Tower. Tradition states that the State will fall should the resident ravens—which have nested here since the 1600s-ever leave.

208

CHRIST'S HOSPITAL OFFICES

This is a very pretty building with beautifully crafted brickwork and fine Dutch styling. From its regal door with the cross above to the dormer windows peeping out at the top, all is elegance and neat detail. Architect Reginald Blomfield was also a garden designer and author. He designed the Menin Gate Memorial in Ypres, Flanders, and the Carlton Club in Pall Mall (destroyed in World War II), and remodelled Regent Street in the 1920s.

209

ST DUNSTAN IN THE EAST

Named for a St Dunstan, a great Saxon Archbishop of

Canterbury, the first and very prosperous parish church was raised here during the late 1200s. The main body of the church survived the Great Fire but Wren rebuilt the damaged tower and steeple, in seventeenth-century Gothic style. The tower is surmounted by tall pinnacles, behind which flying buttresses support the lantern and spire, topped by a ball and vane. The effect is strikingly delicate but it resisted a fierce hurricane in 1703 that damaged many another city steeple. Today, only the four-stage tower remains after World War II bombing. The shell of the church still stands, trees and foliage growing out of its windows, and the Worshipful Company of Gardeners have now transformed the area into a garden.

0

WATERMEN'S HALL

The Watermen's Company was established by an Act of Parliament in 1555 and by 1585 Queen Elizabeth I had granted them a coat of arms. These oarsmen enabled Londoners to travel along the Thames but mainly served to help them to cross from one side to another—at a time when bridges were relatively few. They had to serve a seven-year apprenticeship to learn how to navigate the complex tides and water currents. The company's first hall (in Upper Thames Street, in the 1600s) was destroyed in the Great Fire and twice rebuilt before they moved their headquarters to St Mary-at-Hill in 1780. After World War II damage, this hall with its sturdy, stone Ionic front was repaired and improved in 1951 and 1961. All is curves and arches, with some decorative detailing and a central pediment.

11

PEEK HOUSE

This High Victorian façade incorporates very neatly positioned, decorated openings in a solid wall and delicate arches above the second-storey windows. An entrance to the church is through an open arch and small courtyard beyond. Sir Ernest George was one of the most successful later Victorian architects. He went into partnership with Thomas Vaughan in 1861, and later (with Harold Peto) formed one of the most successful practices of his day. He built many houses, including one for W. S. Gilbert in 1881–65, was responsible for the Royal College of Music in 1910, president of RIBA 1908 to 1910, made a knight in 1911, and elected to the Royal Academy in 1917.

212

C3

ST MARGARET PATTENS

The church entrance is flanked by an early 1800s house and shop but a 1067 inscription on the old stone porch indicates the church's longer history. It drew its name from a local industry: pattens (wooden soles worn to protect shoes from mud) were made here and sold in Rood Lane. Glass cabinets by the entry hold a few examples. After the Great Fire took its toll, Wren's rebuild included a 61-metre (200-foot) spiky spire. Inside are canopied pews from 1686—one carved with 'CW 1686' may have been Wren's—plus a beadle's pew, and a punishments bench with a devil's head where naughty folk had to sit during the service. An hourglass is set beside the pulpit for timing sermons. Relics include a baptismal register some 450 years old, and a 1543 silver communion cup.

213

SHOPS AND OFFICES

Eastcheap is on the site of a medieval meat market and, in 1831, a Roman road was discovered here. The stretch that used to run north past Gracechurch Street was demolished in 1829–31 when King William Street was built. The south side of the street was set back when the Metropolitan Railway was built in about 1875. This rather fine block has quite dramatic Gothic elements—more usually associated with churches. There are high gables, arches, and columns everywhere. Numbers 33–35 were described by Sir Nikolaus Pevsner as, 'one of the maddest displays in London of gabled Gothic brick.'

214

ADELAIDE HOUSE

This city office building adopted an exotic Egyptian style—so fashionable in the 1920s, following the discovery of Tutankhamun's tomb by Howard Carter in 1922. The building has huge curved cornices, striking vertical bays and four black marble Doric columns astride its wonderful, glittering entrance. Today, the building is the headquarters of solicitors Berwin Leighton Paisner.

21

FISHMONGERS HALL

The Fishmongers' Company, is one of the oldest livery companies, established in 1272. Their first company hall was raised in 1310; the next one burnt down in the Great Fire; and this replacement, designed by Edward Jarman, opened in 1671—but was demolished to make way for the new London Bridge in 1827. Inside are an embroidered fifteenth-century funeral pall, the dagger with which Lord Mayor Walworth (a fishmonger) killed Wat Tyler (leader of the Peasants' Revolt) at Smithfield in 1381, and a life-size wooden statue of the Lord Mayor, dagger in hand.

216

MANSION HOUSE

EC4

EC4

EC4

Built in Palladian style, this is the official residence of the Lord Mayor of London. It has three main storeys, a fine entrance façade with a six-column Corinthian portico, and many state rooms, including the long Egyptian Hall where the Lord Mayor holds banquets. The Lord Mayor's Police Court is the only Court of Justice in a private residence in England. Eleven holding cells include one for women (called the birdcage) where the women's suffrage campaigner, Emmeline Pankhurst, was once imprisoned. Mark Twain wrote about the building in *A Connecticut Yankee in King Arthur's Court.* Here, the Chancellor of the Exchequer makes an annual speech about the British economy.

21

EC4

BUSH LANE HOUSE

Here, in a delightful mix of practicality and design excellence, the tubular stainless steel on the building's exterior is filled with water as fire-protection, but also creates a most unusual diamond pattern. In 1995, a glazed atrium was added to the entrance lobby, by Malcolm Payne Design Group Limited. Roman remains have been found close by and it is believed that

FC4

FC4

FC4

Roman pavements once extended to Cannon Street and Bush Lane. Set behind an iron grille in the wall of offices near here is the London Stone—possibly over three thousand years old, and of Druid or Roman origin, that may indicate the mystical centre of London or Ancient Britain.

218

EC4

CANNON STREET STATION

This is where, from the 900s, the Hanseatic merchants had their mediaeval steelyards until 1598. Today, all that remains of the original station—built for the South Eastern Railway's City terminus—are the huge brick walls (that once carried an almost semicircular, single-span arch of glass and iron) and two magnificent redbrick towers at the mouth of the train shed. Prior to 1926, when electrification arrived here, most trains had to reverse in and out of Cannon Street to reach Charing Cross. During the 1960s, the station was revamped to include shops, office blocks, and a pedestrian walkway.

219

EC4

FC4

THAMES HOUSE

This rather splendid Edwardian baroque office block with its imposing entrance, sturdy wrought-iron balcony, and a mix of long, narrow, and round windows plus one bay window, have survived the post-war reconstruction of Upper Thames Street all around them. Now the building presents a stern frontage that challenges anyone threatening this stalwart survivor.

220

ST JAMES GARLICKHITHE

The first known record of the church was in a will dated around 1100; and Stow's Survey of London, in 1598, mentions garlic being landed and sold near here (*hythe* means 'jetty'). The church was rebuilt in 1326 and again after the Great Fire. Its delicate baroque spire, with ascending tiers, was added some thirty years later. Here, once again, Wren explores a central theme with an open central nave and the highest church roof in the city, second only to St Paul's Cathedral. Flooded with natural light, the church became known as 'Wren's Lantern.' There are sword rests with lions and unicorns, a pulpit with a wig stand, a magnificent organ, and a mummified body in the vestry. Several medieval Lord Mayors were buried here.

221

DISTINCTIVE OFFICES

This vast office building, set on an island site, looks like a great liner with its high curved 'prow,' raised 'forecastle,' and multiple windows. Glass canopies on both facades mark the entrances while glazed revolving doors lead to the reception area. There are granite floors and tall double-glazed windows around the entire perimeter, providing excellent natural light and the bonus of superb views over the city. The 6,898 metres (74,255 square feet) of offices have been refurbished several times and occupiers have included IASB (International Accounting Standards Board), Asahi Bank, Credit Lyonnais, Bank of New York. Goldman Sachs, the London Stock Exchange, the Royal Bank of Canada, and BT.

22

ALBERT BUILDINGS

Queen Victoria Street cut through from the Victoria Embankment to the Bank of England in 1867–71, at the same time as, down below, the District Line was being burrowed underneath. Many of the Victorian offices have now been replaced by modern blocks but this rather fine, French Gothic edifice still stands, its elegant splendour raised to glorify commerce and filling its triangular, corner wedge with arcades, arched windows, and pretty cornice decoration.

223

WILLIAMSON'S TAVERN

This tiny alley of Groveland's Court was the site of a new Lord Mayor's house, built over Roman ruins after the Great Fire. In 1739, the tavern was sold and converted into a hotel, but the mayors stayed here until 1753; one of the rooms in the pub is still called Mansion House lounge today. Originally at the mouth of the court, the wrought-iron gates include the initials of their donors, the royals William and Mary. Rebuilt in the 1930s, the tavern is believed to hold the oldest excise licence in the city, with a stone in the main bar, marking the centre point of the old City of London.

224

BRACKEN HOUSE

This was once the main office of the *Financial Times*, busy with furnaces, plate casting, and the setting of metal type. It was the first post-war London building to be listed and is now regarded as a classic twentieth-century milestone. Albert Richardson was awarded the Royal Gold Medal for Architecture in 1947, made president of the Royal Academy in 1954, and knighted in 1956. Now, renovations have seen the central hall replaced by a seven-storey circular atrium, offering lots more office space. All is steel and glittering glass, to maximise the effect of transparency. Four-storey, dark-red brick piers stand on a plinth of red sandstone, while a high, copper cornice is set back on tiny, glass- brick piers. An interesting feature is the glearning, Zodiac sundial calendar, which some claim features the face of Winston Churchill.

225

ST MARY SOMERSET

Only the 36-metre (120-foot) tower remains of this seventeenth-century church, the main part of which was demolished in 1871. Another church (St Mary, Hoxton) was built with the proceeds of the sale, and the single 1678 bell was transferred there. The tower has arched and round windows and is surmounted by pinnacles that look rather like tall, narrow chess pieces. Upper Thames Street is largely occupied by paper makers and dealers. Just south lies Queenhithe Dock, the site of the earliest fish-market in London.

226

ST BENET PAUL'S WHARF

Shakespeare lived nearby and, in *Twelfth Night*, a clown mentions this church. After the Great Fire, it was replaced by a Dutch country-style building in red and blue bricks, with a hipped roof and curved stone garlands above large windows. Its short tower has a small dome, lantern, and simple spire. Its square inside has a monument to Inigo Jones—buried in the old chancel. St Benet was the Parish church for the Doctor's Commons—a legal institution that could arrange hasty marriages—some 13,423 were solemnized from 1708 to 1731; Henry Fielding (author of *Tom Jones*) married his first wife's maid here in 1747. Parish records refer to a Welsh presence here, from about 1320. Queen Elizabeth I despatched the Welsh to the area and this is now a Welsh church, with services conducted in that language.

2

ST NICHOLAS COLE ABBEY

Wren's first post-Fire church, it cost £5,042, including a charge for 'Dinner for Dr Wren and other Company—£2 14s 0d' and 'Half a pint of canary for Dr Wren's coachmen—6d.' It was partly demolished in 1868, but the unusual tower was spared—with its elaborate balcony, railings, pinnacles, obe-lisks, and vases. After World War II damage, the church was restored to Wren's original design. Numerous fishmongers were buried here during the 1500s. The first celebration of mass after Queen Mary I's accession took place here, but the priest, accused of selling his wife to a butcher, was soon pelted with rotten eggs. A later patron was Puritan Colonel Hacker, who commanded the guard at the execution of Charles I. In the film *The Lavender Hill Mob*, the gold bullion robbery takes place just outside Cole Abbey.

28

COLLEGE OF ARMS

This is the home of the royal heralds, granted their first charter by Richard III in 1484. In medieval times, the heralds organised tournaments as well as the knights' arms on their shields and crests. Built by master bricklayers in artisan style, the building has a simple brick façade that surrounds three sides of a shallow open court, with two wings linked by magnificent black and gilded wrought-iron gates (from Goodrich Court in Hertfordshire). The College still examines and records pedigrees and grants family coats of arms, while the Earl Marshall (always the Duke of Norfolk) arranges state occasions such as coronations, funerals, and state openings of Parliament. Inside is a splendid wood-panelled entrance room with portraits.

229

TEMPLE BAR

EC4

The first Temple Bar was a turnpike. By 1293, a chain and wooden posts marked the boundary of Westminster; in time there was a wooden archway here, and a prison above. Elizabeth I passed through it en route to St Paul's to give thanks for the 1588 Armada defeat; since then, a ceremony has been performed here when the sovereign enters the city on state occasions. A new stone Temple Bar in 1672 had figures of Charles I, Charles II, James I, and Anne of Denmark, and a central arch for carriages. The boiled heads (or other remains) of traitors were displayed here. In 1806, the gate was covered in black velvet to mark Lord Nelson's funeral. The only main city gateway to survive, it was moved from the Fleet Street/Strand junction in 1878 to Paternoster Square in 2004—and is now crowned by a dragon.

230

CHAPTER HOUSE

EC4

EC4

The Chapter House was gutted in World War II and has since been restored. Today, it is a modest but neat sevenbay building, with brick quoins creating interesting patterning at the corners and on each side of the central three-bay section. Brass plates denote the occupants: St Paul's Cathedral Retail Ltd, St Paul's Cathedral Enterprises Ltd, and Friends of St Paul's Enterprises Ltd. This is where the secular aspects of St Paul's are controlled today. Remnants of the earlier, medieval chapter house cloister can be glimpsed in the gardens to the south side of the nave. This chapter house was octagonal, with an open, stone-flagged area, eight buttresses, and four central columns. Wren's site office was probably located in the partially rebuilt chapter house.

231

ST PAUL'S CATHEDRAL

On the site of a Roman temple, five cathedrals have risen here—one built by Saint Ethelbert, the first Christian king in England), one destroyed by Vikings in 961, and one burnt

(1087.) In the 1560s, the nave bustled with trade, debate, and fierce fights-while services were held in the choir. Later, Cromwell's army used the nave as a cavalry barracks. After the Great Fire, Wren's new cathedral had a spire over a domed crossing. The vast exterior dome is set above a cone of brick and an inner dome where frescoes depict St Paul's life. At one point during their creation, artist Sir James Thornhill stepped back to inspect his work-right to the edge of the platform. His assistant, afraid that a warning shout might make him fall, began to smear the painting. Thornhill leapt angrily towards him and so away from danger. Rising some 360 feet (110 metres), the elaborate dome is one of the highest in the world, supported by eight huge piers, above which is the galleried Whispering Gallery-famous for its acoustics; a whisper against the wall on one side can be heard on the opposite side. Higher still, are the Stone and Golden Galleries, from which there are superb views of the city. Wren checked the work every week, hoisted up to the lantern in a basket. It took thirty-five years, by which time he was seventy-nine years old. Every year, until his death (at ninety-one), he returned to sit under the dome. He was one of the first to be buried in the crypt (the largest in Europe); his inscription translates as, 'Reader, if you seek his monument, look about you.' Here, too, rest Wellington, next to his magnificent funeral carriage; Horatio Nelson; and artists Reynolds, Lawrence, and Turner. Holman Hunt's Light of the World in the south aisle is the artist's own copy. The flower-carved choir stalls are the work of Grinling Gibbons, as is the organ-played by Handel and Mendelssohn. The exquisite wrought-iron sanctuary gates of 1700 are by Jean Tijou. The west front of the cathedral, with its portico of twelve columns, is approached by a wide sweeping flight of steps. The huge bell. Great Tom, tolls the deaths and funerals of members of the royal family, bishops of London, St Paul's deans, and lord mayors of London still in office. Great Paul, the largest bell in England, weighs seventeen tonnes and is tolled each day at one p.m. St Paul's has been the setting for many ceremonial occasions including the 1965 funeral of Sir Winston Churchill and the wedding of Prince Charles and Lady Diana Spencer in 1981. The cathedral survived the fierce bombardment of World War II that totally devastated buildings all around. Vigilant volunteers bravely removed incendiary bombs and land mines but one bomb did explode inside, making some walls bulge outwards. Ringed by raging fires and falling masonry, lit red by the glow of fierce flames, the dome remained a symbol of British tenacity. A recent survey has shown St Paul's to be the best-loved building in England, a symbol of the city and the nation.

232

EC4

EC4

ST MARTIN WITHIN LUDGATE

According to Geoffrey of Monmouth (not always a reliable source), the church was founded by the Welsh hero, Cadwaller, in the seventh century. In the wake of the Great Fire, this building provided another opportunity for Wren to explore his centralised plans—as a cross within a square, with columns supporting barrel vaulting. A delicate slender lead steeple is set on a dome and octagonal stone tower. Some fine seventeenth-century woodwork survives inside, including the altarpiece, pulpit, and organ case.

233

CENTRAL CRIMINAL COURT

The first Old Bailey Sessions House was erected in 1539 beside Newgate Prison and was named after the street. The area has been the scene of many public floggings, pressings, burnings at the stake, and hangings. In 1868, mass public hangings outside the prison were stopped but prior to that, 'execution breakfasts' were served across the road at the Magpie and Stumps inn-and rooms could be hired out to view the scene. Built on the site of Newgate Prison, this grand Edwardian building, with oak-panelled courtrooms, is crowned by a dome above the entrance hall, and the famous statue of Justice-featured in many movies. By tradition, judges still sometimes carry posies of scented flowers, originally used to dispel the rank smells and gaol fever associated with the prisoners. Judge Jeffreys served here in the 1670s. Famous trials include those of Daniel Defoe (1703), Oscar Wilde (1895), Dr Crippen (1910), 'Brides-in-the-bath' murderer George Joseph Smith (1915), 'Lord Haw-Haw' William Joyce, (1945), J. R. Christie (1953), the Kray Twins (1969), 'Yorkshire Ripper' Peter Sutcliffe (1981), politician Jeffrey Archer (2001), and

lan Huntley (2003). A black-cloaked figure of a highwayman—hanged and buried in lime where the court now stands—haunts the site.

EC4

EC4

EC4

234

THE BLACK FRIAR

On the site of a 1200s Blackfriars Dominican monastery and the only Art Nouveau public house to survive in London—this wedge-shaped building is set close to the railway line at Blackfriars. It has an extravagant brick-and-tile exterior by Henry Poole, wrought-iron signs, and the statue of a laughing friar set above the main door. There are mosaics and carved figures can be seen everywhere, inside and out; the fun, ornate interior is busy with bright-coloured marble, bronze figures of jovial monks, mirrors, and brass glimmering all around, carved friezes, and wise sayings. Scenes in the 1987 movie, *Maurice*, were filmed here.

235

BLACKFRIARS HOUSE

Set just back just from the north bank of the River Thames on a historical site dating back to the time of Henry VIII, this finely proportioned steel-frame building has neat runs of windows, delicate cornices, and a simple, unassuming—but very pleasing—white faience frontage. It has now been converted into the Crowne Plaza hotel, with 203 bedrooms, an executive boardroom, three function conference suites, and with restaurants and bars as part of the complex.

236

PUNCH TAVERN

This opulently glazed pub has a tiled lobby, a large front bar with an ornate skylight, painted panels, huge mirrors, and glass panels etched with birds. In the 1880s, this was the recreational headquarters of *Punch* magazine staff and was renamed it its honour. At some time, the building was split between two owners, and a shop behind the pub has now been turned into a separate bar. A Punch theme dominates its décor—both the puppets and the famous magazine.

THE OLD BELL

This is said to stand on the site where Caxton's assistant, one Wynkyn de Worde from Alsace, set up the press he had inherited from his master: De Worde's official printing licence read: 'Emprynted at the sign of the Swan in Fietestrete.' This place has also been called Ten Bells, the Twelve Bells, the Golden Bell, and the Great Tom of Oxford. After the Great Fire, it was rebuilt to feed and house the reconstruction workers. In the Blitz, landlady Nellie Bear kept the Old Bell open, even when a German bomb half-demolished St Bride's. The ancient wooden floor undulates and customers might think they are drunk ahead of time.

238

EC4

EC4

GOLDMAN SACHS OFFICES

Here, Sir Owen Williams proves his reputation as an original and exciting architect. The exterior is a stunning sweep of shiny black Vitrolite and clear glass with curved corners. The top three floors are set back behind a cornice gantry so that daylight can penetrate through to the street below. The magnificent entrance hall has elaborate metal decoration and sculptures, and is an Art Deco extravaganza. Even the handrails are twisted chromium snakes. In 1989, the *Daily Express* moved to new offices across the Thames near Blackfriar's Bridge.

239

MORE GOLDMAN SACHS OFFICES

This huge building is an Art Deco delight from the jazz age. It has a splendid façade with lovely detailing, interesting patterns created by the recessed areas set between fine pillars and uprights, a delightful ornate clock with a bright blue face, and, originally, a grand entrance hall. In 1989, the *Daily Telegraph* moved the printing works and offices housed here to the Isle of Dogs, so this fine Fleet Street headquarters building became available for development. A huge extension designed by Kohn Pedersen Fox was built on the north side. The rear of the building has been rebuilt and the lovely front facade restored.

EC4

240

DR JOHNSON'S HOUSE

Doctor Johnson lived here from 1748–59, paying a rent of \pounds 30 a year as, with six copyists, he slaved for years to create his famous dictionary. He also published a twiceweekly periodical, *The Rambler*. His wife, Tetty, died here in 1752, after taking an overdose of opium. After great efforts to restore the building, much has been preserved, including a fine staircase and American pine panelling—brought back as ballast in ships trading with the colonies. Visitors today can see the dictionary itself, many portraits of Johnson and his friends, an alleged piece of the great Wall of China collected by Johnson, a chair from the Old Cock Tavern, and Johnson's silver teaspoons and sugar tongs. The curator's house next door is the smallest in the city.

241

TEMPLE CHURCH

This temple (so called because it was a Knights Templar church) encompasses eight hundred years of history. It is the only circular Norman church in London and is one of the earliest in true Gothic style. Its round nave was inspired by the church of the Holy Sepulchre or the Dome of the Rock in Jerusalem. Here are life-size stone effigies of nine knights (including William Marshal, Earl of Pembroke, who mediated between King John and the Barons in 1215), Purbeck marble, high lancet windows, and grotesque carved stone heads. In one gruesome cell. Walter-le-Bacheler, Grand Perceptor of Ireland, was left to starve to death after disobeying the Master of the Order. Later the Temple was leased to the Temple lawyers. In the mid-1600s, Samuel Pepys bought copies of the latest songs from a music shop in the west porch. The building was renovated in the 1800s, but still resonates with the events of centuries past. Temple ghosts include Sir Henry Hawkins, a distinguished barrister. Dressed in wig and gown, he glides silently through the Temple's cloisters with a bulging file of paperwork tucked under his arm.

242

INNER TEMPLE LIBRARY

This is one of the oldest law libraries in the country—in

BUILDING DESCRIPTIONS 579

EC4

EC4

FC4

continuous use since the early 1500s. Bombing in 1941 destroyed the building but, although about 45,000 volumes were lost, the most valuable manuscripts and early printed books that already been removed to a safer place. The library had already been destroyed in the Great Fire of 1666; and was blown up again in 1679. Its treasures include fifteenth-century illuminated manuscripts; the Petyt Manuscripts, bequeathed in 1707 by William Petyt, Keeper of the Records in the Tower of London and Treasurer of the Inner Temple: Edward VI's Devise for the Succession (written in his own handwriting when he was just sixteen, in an attempt to exclude his half-sisters Mary and Elizabeth from the succession in favour of his cousin, Lady Jane Grey); and a letter signed by Lady Jane Grey as Queen. Today, the library is used by barristers, judges, and students, and has over 70,000 volumes of English law.

243

EC4

EC4

KING'S BENCH WALK

Some seventeenth-century chambers remain here—some still with the iron rings to which barristers once tied their horses. The King's Bench Office (where the chief clerk or master of the Court of King's Bench worked) has been sited in the Inner Temple since 1621. The original buildings burned down in the Great Fire, and so King's Bench Walk was rebuilt—only to be destroyed again in another fire just eleven years later. Numbers 1–11 on the east side are particularly fine. Several buildings were destroyed in the Blitz and had to be reconstructed, but the doorway of number 1 was rescued intact. There are three lovely brick doorways at numbers 3, 4, and 5.

244

FOUNTAIN COURT

As Boswell put it in 1763, this is 'a pleasant academical retreat.' It remains peaceful in this L-shaped court, whose original fountain (built in 1680, restored in 1919) still splashes merrily. The fountain appears in Dickens's *Martin Chuzzlewit* as a meeting place for Ruth Pinch and John Westlock; and Godfrey Turner wrote: And—when others fled from town to lake and moor and mountain—I have laid my troubles beside

the Temple Fountain, Charles Lamb described sitting by the fountain with his friends during the late 1700s; poet William Blake lived at number 3 from 1821 until his death 1827.

EC4

245 MIDDLE TEMPLE HALL

Lying on the south side of Fountain Court is Middle Temple Hall, opened in 1570 by Elizabeth I. The original, brilliant redbrick was encased in stone in 1757, but the interior remains much as it was when the Virgin Queen danced here. There are suits of armour and coats of arms on the walls that date from 1597. A large open fireplace stood in the centre of the hall, which would once have been covered with rushes. Here were staged lavish banquets. masques, and plays-including the first known performance of Shakespeare's Twelfth Night, performed for the Queen in 1602. It has a superb oak double hammer-beam roof, a rich, wooden screen, and tables made from a tree felled in Windsor Great Park (presented by Elizabeth I) and from the timbers of Drake's Golden Hind. The hall escaped the Great Fire-partly because other buildings were demolished in its path and partly because the wind changed course, while twentieth-century wartime bombing destroyed just a small part of the eastern end. In 1894, workmen discovered a box, hidden in a wall recess, containing a man's skeleton, perhaps some two hundred years old.

ΕI

TOWER BRIDGE

This stunning Victorian Gothic-style bridge with its pinnacles and decorative wrought iron is a world-famous London icon. An upper level originally allowed pedestrians to cross the river but closed to the public in 1910 because of the large number of suicides. The massive steel-framed towers house stairs and the lifting machinery (originally steam driven, now electric) that raises the two halves of the lower level to allow for the passage of tall ships. There was a near catastrophe in 1951 when a bus found itself at the point of no return as the bridge opened. The driver accelerated and cleared the gap safely. After a major renovation of Tower Bridge in 1982, the walkways were glassed in and opened as a tourist attraction. Two years later, a museum opened on the south side of the bridge. The old steam engines can still be seen in the pump rooms.

247

ΕI

ALMS HOUSES, TRINITY HOSPITAL

These pretty little houses are laid out in two rows that face each other with trees and grass between them and a neat little chapel at the end of the avenue. They were originally built for '28 decayed masters and Commanders of Ships or ye widows of such.' They have survived the threat of demolition in 1896, 1941 bombing, and more recent modernisation by the London County Council.

248

SILKWEAVING HOUSES

This part of Stepney has houses from the 1700s where weavers created damask and silk brocade, and needed good light in which to work at the looms—so there are generous high windows. The street would have been busy with merchants, dyers, retailers and master weavers—as well as those beavering away inside—with twelve to fifteen thousand looms in action when the industry was at its peak, and a workforce of thirty thousand. Huguenot weavers liked singing birds, and ornamental cages hung at the windows. It is hard to envisage such heavy industry today among these houses with tall chimneys and sash windows, behind scant pavements.

ALBERT GARDENS

This is a well preserved and very attractive small square that linked the docks to the city. Here neat four-storey Victorian terraced houses occupy what is now a relatively quiet and exclusive area. It is set quite close to the docks where all was hustle and bustle a few years back; Commercial Road, originally built to service the East and West India Docks, is still a busy thoroughfare.

250

ST GEORGE IN THE EAST

This is one of the fifty churches of Queen Anne in an area once inhabited by wealthy merchants, until the arrival of the docks and the railway—when it became a slum. During the 1860 'anti-Popery' riots, disorderly congregations shouted, lit matches and firecrackers, threw orange peel and nut shells, and shot peas at the rector—until the police arrived to restore order. The church was bombed in the Blitz, but the 'pepper-pot' towers survived and a new interior was constructed within the Romanesque walls. The original cemetery, St George's Gardens, has been maintained as a public park since mid- Victorian times.

251

WHITECHAPEL ART GALLERY

This gallery, established by the local vicar of St Jude's and his wife to bring art to the people of the East End, opened to the public in 1901. The building has a distinctive façade, with galleries over two floors. In 1985's major rebuilding, the gallery re-opened with an upper gallery, a restaurant, and extra exhibition space. Its impressive massive doorway has a fine semicircular arch (in its sturdiness rather like a Norman arch), Arts and Crafts foliage decoration, square corner towers and a high row of simple windows. Its first exhibition attracted 206,000 local people. Important artists whose works have been shown here include Picasso (1938), Jackson Pollock (1950s), David Hockney (with his first-ever show, in 1970), and Lucian Freud (1993).

THE ROYAL MINT

In 1798, a man named Turnbull managed to rob the Royal Mint of the princely sum of 2,804 guineas by holding the staff at gunpoint. Whether or not this promoted a rethink is uncertain but the mint moved to Mansell Street from the Tower of London in the following decade—in 1809. The stone building has a long neo-classical façade and portico, a scallop-edged pediment, and two lodges. In 1986–89, the manufacture of coins was transferred to South Wales, and the buildings were renovated as offices.

25

THE TEN BELLS

This old pub has ornate Victorian tile work on the walls depicting the days when this area was countryside—and is full of old battered sofas, low tables, and candles. It is infamous for its connections with Jack the Ripper. Two of his victims were seen here close to the times of their murders, and all five lived close by. Mary Kelly was said to have plied her trade outside the pub; her body was discovered in Millers Court off Dorset Street, on the opposite side of the road from the Ten Bells. The pub also has several hauntings to add to its allure, including an old man dressed in Victorian clothes, possibly a former landlord named George Roberts who was murdered with an axe in a cinema.

254

CHRIST CHURCH

This is a marvellous example of Nicholas Hawksmoor's inspiring work. This church originally welcomed the Huguenot refugees who had fled Europe and were working with the silk weavers living hereabouts—over half of the eighteenth-century gravestones remember French 'occupants.' The sumptuous interior has a high, coffered ceiling and a gallery. Struck by lightning in 1841, the building suffered drastic changes, but remains a masterpiece, with a strong portico of four Tuscan columns and a lovely tower with an octagonal spire that dominates the surrounding area. This looks particularly splendid when floodlit at night, piercing the dark sky above the Commercial Street ware-

houses. The crypt has been used as a refuge and home for recovering alcoholics since 1965.

255

PROSPECT OF WHITBY

This timber-framed inn, associated with pirates and smugglers, may be London's oldest, with beams and pillars made from a ship's mast. There are bare stone flags, a long pewter counter on barrels, and riverside bars. In the early 1700s, a sailor drinking here sold a new plant he had discovered on his travels to a local market gardener—the first fuchsia to reach Europe. In 1777, the inn's name changed when the ship *Prospect* (registered at Whitby) moored here. Customers have included Judge Jeffreys; Dickens; artists Doré, Whistler, and Turner; Pepys, and actors Paul Newman, Glenn Ford, and Rod Steiger. Sir Hugh Willoughby sailed from near here in 1553 on his attempt to find the northeast passage to China. A replica hangman's noose swings over the river, as a reminder of former gruesome hangings hereabouts.

256

BOUNDARY STREET ESTATE

One of the first large housing schemes, this late Victorian and early Edwardian estate forms a complex of streets around Arnold Circus and replaced an infamous slum near Shoreditch Parish Church. The redbrick five-storey tenements have high gables with bands of yellow brick highlighting the façades. Interesting building details include projecting bays that are almost like turrets. Over five and a half thousand people (some two hundred per acre) were given new homes with shops, a surgery and a school provided as part of the estate scheme.

257

KEELING HOUSE

A Modernist architect, Lasdun was influenced by Le Corbusier's concept of 'streets in the air' as well as Cubist painting; classical influences are also evident—such as the work of Hawksmoor. He worked for a while with Lubetkin before setting up his own practice, and ultimately was responsible for the South Bank's National Theatre. These blocks of stacked maisonettes are separated by wide bands of concrete and arranged around a central staircase and lift shaft. Lubetkin hoped that the shared landing would encourage sociability. Two six-storey blocks of maisonettes in dark brick are part of the same scheme. Now a Grade II–listed building, Keeling House has been saved from the threat of demolition and transformed into luxury loft-style apartments.

258

FL

MODEL DWELLINGS

Until 1840, this area was the site of a large farm and watercress beds. Baroness Burdett-Coutts, granddaughter of banker Thomas Coutts, donated millions to charities and was the first woman to become a baroness through her own achievements. She spearheaded the Metropolitan Association for Improving the Dwellings of the Industrial Classes, set up in 1852. Her favourite architect was Darbishire (see also Holly Village, page 308). These flats are set in a flow of four- and five-storey blocks with open staircases. Access is via short galleries. They were part of an ambitious plan that included Columbia Market, an imposing Gothic building, sadly demolished in 1958. By the 1980s, the flats still had no heating and cold water only; some retained gas lighting. Many houses here were boarded up and the entire area was due to be cleared, but a local association prevented this and now most of the properties have been restored.

259

GARNER STREET HOUSE

FAT stands for 'Fashion, Architecture and Taste'— a design group that revels in breaking the rules. This unconventional building incorporates a cut-out shape like a child's drawing of a house with its little chimney and wavy garden hedge. This is set in front of another cut-out—an office-block façade like a miniature skyscraper that bends around the side where the cut-outs turn into high Dutch gables—all in sky blue clapboard. Inside, an office, apartment, and family house wrap around each other and are just as full of surprises.

F2

E2

F2

MUSEUM OF CHILDHOOD

Profits from the Great Exhibition of 1851 were used to buy land in South Kensington, where Prince Albert hoped to create museums, societies and educational institutions. This highly decorative redbrick building has a frieze of terracotta and inlaid panels, semi-circular windows, mosaic and cast-iron galleries. Inside (where the marble mosaic tiles were made by women prisoners in Woking jail) are over six thousand exhibits—toys, books, games, costumes, nursery items, art, furniture, and doll's houses, many items dating from the 1500s.

261

GEFFRYE MUSEUM ALMSHOUSES

Named after its benefactor, Sir Robert Geffrye, this museum explores the changing styles of English domestic interiors through a series of middle-class living rooms-from 1600 to the present day. Here, 1600s oak furniture and panelling, refined Georgian splendour, a Victorian parlour, a 1930s flat, a contemporary 1950s room, and a late-1900s converted warehouse can be compared. The museum is housed in fourteen two-storey Ironmongers Company almshouses set on three sides of a huge courtyard. From the gated entrance a formal avenue of lime trees leads to a chapel in the centre. The almshouses were converted into a museum in 1910–14, when floors, stairs, and many party walls were removed to create galleries that display collections of furniture, textiles, and paintings. Outside, a series of period gardens includes an award-winning walled herb garden.

262

TIDE MILL DISTILLERY

The Domesday Book refers to eight mills here, and there were still three in medieval times. Set in a complex pattern of water channels, possibly created by order of King Alfred the Great, the mills have ground gunpowder, as well as flour for the city's bread, and distilled gin. The House Mill of 1776 and the Clock Mill of 1817 are the only surviving tide mills in the Greater London area and the largest in England. Tide mills are far rarer than wind or water mills. The House Mill has a Grade I listing and stretches across four internal mill races and two waterways. The Tide Mill Distillery has a lovely cupola. Here, grain was brought by barge or cart, lifted by the sack hoist, and stored on the top floor. Today, the mills have been restored as a working museum. Nearby, on an island in the river, are Three Mills Studios with sixteen film stages. This is where *Lock*, *Stock and Two Smoking Barrels* was filmed, as well as scenes for television's *London's Burning* and *Bad Girls*.

263

E2

ALBION SQUARE

With railway expansion and improved roads in the latter half of the 1800s, there was a rush to raise new properties in many of the outer boroughs, including Hackney. Especially popular was the urban villa. The larger of these versatile and often rather grand houses were often occupied by more than one family. This early Victorian railed square surrounds a garden with a lovely (now restored) water fountain. Designated a conservation area in 1975, the square includes elegant Italianate villas and a number of Grade II–listed buildings. The house shown here has neat brickwork, and lovely arched first-floor windows and entrance porch.

264

E4

24 CHURCH CRESCENT

This interesting house, one of four, has an overhanging hipped roof—not unlike many Alpine buildings. There are extensive expanses of white rendering and its many unusual features include the second-floor loggia, a high circular window, and glass and timber panel strips. Creating a sharp contrast to these modern examples of public housing, is nearby St John of Jerusalem Church (1845–48) and a plaque marking the fact that, in 1669, Henry Monger left money for almshouses here and annuities for six poor men over sixty.

E8

E9

FINANCIAL TIMES PRINTING WORKS

This long block was built to house the new *Financial Times* presses when these were moved from their old home in Fleet Street. It incorporates office and services at its two aluminium-clad extremes with staircase towers. The enormous printing presses and plate-making machines are housed in the centre section. Fin-like steel columns and braces support the roof and glazing—a veritable wall of frameless toughened glass.

266

E14

E14

F14

F14

PUMPING STATION This monumental building presents a mix of ancient histori-

cal inspirations with its Greek-style pediment and stout Egyptian-style columns. The building has no windows and strict security boudaries for its interior is full of machinery and computers; if these were vandalised, parts of London could be flooded. The control room is surrounded by concrete that could withstand the collapse of the structure during an earthquake or explosion. The lowest walls are built in hard engineering bricks—in red, yellow, and dark blue.

267

CASCADES

CZWG was launched by four young architects who began working together in the 1960s while still at the Architectural Association School. In particular, Piers Gough became well known for his post-modern buildings. Here the Cascades Apartment Tower (the first private high-rise housing development in Docklands) on the Isle of Dogs riverbank includes 171 apartments with cantilevered balconies on twenty floors, a suspended swimming pool, fitness centre, sauna, and floodlit tennis courts. Designed to look like a berthed ocean liner, it has spectacular views over the river.

268

ST ANNE'S

This Baroque church has a broad-based Gothic-style tower, the second highest in Britain, topped only by Big Ben (raised by the same builders). Its tower was a landmark for ships using the East End docks and boasts the highest church clock in London. When it was consecrated, then set in open fields, the bishop partook of 'a little hot wine and took a bit of ye sweetmeats and then ye clergy and ye laity scrambled for ye rest for they left not a bitt.' Shaped like a Greek cross, the church has Corinthian columns and an elongated nave. The ceiling forms a great flat circle, edged by Corinthian moulding.

269

25 CANADA SQUARE

25 Canada Square, along with 33 Canada Square, make up the Citigroup Centre—a forty-five-floor office complex. This gleaming skyscraper is 200 metres (656 feet) high, occupies 170,000 square metres (1.8 million square feet), and is home to the Citigroup companies, as their European headquarters. This impressive building has entrances on two streets and underground floors that lead to the Canada Place shops plus the underground station. The two Citigroup buildings seized their rank as the second tallest buildings in the United Kingdom as they rose above Docklands—nicknamed Oliver I and Oliver 2 by local employees.

270

HOUSING 'COMPASS POINT'

Viewed from the river, the terraces of Mariners' Mews town houses with sharply pointed 'serrated' or curved gables—have an Old Amsterdam flavour. There are long windows, curved bays, and no chimneys. The compex also includes landscaped terraces of three- and four-bedroom villas, four-storey apartment towers, and a riverside walk. Some French film makers who rented a property here aroused some local curiosity by leaving a coffin (just a prop) in their garden while filming *Cement Garden*.

271

REUTERS

Reuters is a news agency and financial service founded in London in 1851 by German immigrant Paul Julius Reuter.

E14

E14

E14

He began by using carrier pigeons but then cables and telegraph transmission made sending stock market quotations far more efficient. Today, Reuters employs some 15,300 staff in nearly ninety countries. This very large building is set beside the Thames, with services and computers occupying its lower levels, and offices rising above—faced with interchangeable glass and opaque panels. From here news—as text, graphics, images, or video—can be sent to media oranisations all around the world.

272

E14

ONE CANADA SQUARE

At 244 metres (88 feet) high, One Canada Square is Britain's tallest building and Europe's second tallest—visible as far away as the hopfields of Kent and Hampstead Heath. A giant obelisk, with a pyramidal top, and stainless steel cladding, it make an impressive sight as it rises above docklands and the flat, marshy landscape, its bright, red warning light flashing at its pinnacle. The building is designed to sway as much as 35 centimetres (14 inches) in strong wind, and its fifty floors are served by a lift that can rise to the top in forty seconds. Seven thousand people work here, including employees of the *Independent*, *Daily Telegraph*, and *Daily Mirror* newspapers.

273

STRATFORD REGIONAL STATION

Since the first trains chugged into the station here in 1839, Stratford, has been an important railway centre: The Docklands Light Railway opened a century later in August 1987. This new regional station is a great steel and glass building with sweeping lines, a glazed concourse, and a roof with curved, cantilevered girder ribs covered by a double skin—to draw warm air out of the building. There is a magnificent lofty hall (with a vast clock), a sheer glass façade, and an upper-level walkway. All the staircases are wide and there is a general feeling of spaciousness. 274

ABBEY MILLS PUMPING STATION

At a time when sewage poured into streams and the Thames often overflowed into the streets, London was rife with such diseases as cholera. Joseph Bazalgette came to the rescue. His pioneering sewage system saved the city from any repetitions of the Great Stink of 1858-when a massive overflow caused thousands to flee the city. Some I32 kilometres (82 miles) of new sewers were built, many hidden below new Thames embankments. North London's waste was routed to Abbey Mills Pumping Station. Sometimes referred to as the 'Cathedral of Sewage,' its exterior is a sturdy but splendid mixture of Victorian, Byzantine, and Gothic styles, with a mansard roof and ornate dome. It had two, high ornate chimneys but these were demolished during World War II—to avoid their serving as a landmark for German bombers. Inside, eight huge coal-fired beam engines (replaced by electric motors in 1933) were housed in a grand machine hall.

27

UNIVERSITY OF EAST LONDON

Set alongside the Royal Albert Dock, and facing London City Airport across the water, this campus was built in just eighteen months. The aim was, ultimately, to provide accommodation for seven thousand students. Built as a group of cylinders with dips and curves and 'pancake' roofs, the surfaces are pierced with windows making neat rows of little squares, and round ventilation 'buttons,' rather like the patterns a child creates with folded paper and scissors—a very satisfying effect. Blue, yellow, and green has been used liberally for the surfaces. The complex includes a Learning Resource Centre, an auditorium, academic departments, shops, and cafés. It was opened by the mayor of London on his first day in office.

276

WILLIAM MORRIS GALLERY

From 1847 to 1856, the young William Morris (designer, craftsman, author, and socialist) lived in this large, double-

15

E16

E17

fronted, three-storey Georgian house at a time when this area was a comfortable Victorian suburb. The former Water House, set in its own extensive grounds, has a portico and entrance that is flanked by two circular bays and multiple sash windows. Between the ground floor and the first storey, and below the roof, the building's lovely curves are emphasized by decorative horizontal panels. It is now a gallery (opened by Prime Minister Clement Attlee in 1950), and houses an extensive collection of furniture, fabrics, wallpapers, stained glass, painted tiles, books, drawings, and sketches produced by Morris and Company.

GEORGIAN HOUSES

These houses—with beautiful façades, fine brickwork, and pretty balconies—once overlooked the New River created by Sir Hugh Myddleton. This pioneer of London's water supplies brought an artificial stream to Islington from Hertfordshire springs in I613. A garden now follows the culverted course. This is the setting for the huge church of St John the Evangelist (1843). Douglas Adams, who wrote *The Hitchhiker's Guide to the Galaxy*, lived in the terrace during the 1980s.

278

NI

NI

NI

NI

DUTCH-STYLE HOUSES

The houses in this gem of a square present a mixture of Tudor, Dutch, and Jacobean styles. The district was developed in the 1830s and '40s, its prized centrepiece the ornate neo-Jacobean villas here. It is Georgian in layout but there are Tudor-style details such as oriel windows and mullions, and high Dutch-style roofs. Here the gable has beautiful curves and swirls, and the bay windows and decorative white window surrounds stand out from the gentle texture of the brickwork.

279

FIVE-BAY HOUSE

The only original house that exists in this square today, the three storeys of this neatly symmetrical, five-bay frontage are set behind multiple railings. It has painted keystones above the sash windows of the first two storeys and there are five smaller windows above. The manor of Hoxton was recorded in the *Domesday Book* as being worth 45 shillings and was held by the bishop of London until the I300s. It became a fashionable 'overspill' area during the I500s.

280

BUSINESS DESIGN CENTRE

This, the former Royal Agricultural Hall, is a huge, splendid hall set back from Islington High Street, behind a giant entrance arch and vast, glass façade that creates lovely sweeping curves. The column-free venue provides vast exhibition and product-launch space, flexible conference facilities, and rooms for banquets for up to two thousand guests. It has a huge exhibition floor, a high, barrel-vaulted ceiling, and masses of natural light. It was converted into the Business Design Centre in 1986. Once upon a time, in the 1870s, it was used for walking races on two tracks—one requiring seven laps, and one needing eight laps to the mile.

281

HOLY TRINITY

Set in the centre of an Islington square at a time of Gothic revival, this church, like the architect's later Houses of Parliament, explores neo-Gothic forms and was modelled on King's College Chapel, Cambridge. It could hold over 2,009 parishioners. This view shows the east end with its tall window and pinnacles.

282

THORNHILL SQUARE

This, the largest square in Islington, was laid out from 1848. The adjacent streets and St Andrew's church were completed by 1854. It forms an ellipse with Thornhill Crescent. Once available only to residents, the gardens were donated to the public by Captain Thornhill in 1946. With Georgian embellishments, such as lintels over the doors and arches above the windows, the houses face the lovely square—the setting for Hugh Grant's home in the movie *Four Weddings and a Funeral.*

283

ST MARY'S CHURCH

During the Reformation, statues were taken from the church and smashed on Islington Green. Later, under Queen Mary, forty locals who refused to attend Mass, were burned at the stake. Curates here have included David Sheppard, the cricketer George Carey (later the Archbishop of Canterbury) and John Wesley's brother. Wesley preached here ten times in 1739, before both brothers were thrown out by the churchwardens. The lovely steeple is the sole survivor of the Blitz.

141

NI

NI

N6

N6

N6

284

PEABODY TRUST HOUSING

American philanthropist George Peabody rose from poverty to riches and endowed many building schemes to house the poor—some rather sombre. This block has deeply recessed windows, a sturdy arch and canopy over the front door, and an Italianate style (soon adopted by other local buildings). Four blocks surround an open square. Islington was an overnight stop for cattle on their way to Smithfield market so many pavements are raised high above the cattle run's mire.

285

NI

NI

N6

NI

GEORGIAN HOUSES

Islington grew from an Anglo-Saxon settlement through Roman and then medieval development. This was an area of good dairy farms, known for its pure water springs. Queen Elizabeth I is said to have visited Sir Walter Raleigh in Upper Street (at the westward end of Cross Street). Charles Wesley and Daniel Defoe were educated here. Authors George Orwell and Joe Orton, artist Walter Sickert, and the notorious gangster Kray twins have all been part of the Islington scene. These neat late-eighteenthcentury Georgian houses are set behind railings, close to the slope of the street and with scant frontage between the houses and the pavement.

286

TUDOR-STYLE HOUSES

Here, the use of Tudor styling breaks away from the Georgian tradition of London's streets, and the houses in this lovely square have fine pointed gables. There are decorative lintels above the tall windows, and the Tudor-shaped doors are set below appropriate quatrefoil decoration. The houses were designed by Richard Cromwell Carpenter (known then as a church architect) in 1835–43 for the Draper's Company—which eventually sold the buildings in 1954.

287

THE GROVE

This remarkably well-preserved group of houses are set

around a small green that still conveys a village atmosphere. There are broad sash windows, fine Doric porches and, as shown here, ornate iron gates. Poet Samuel Taylor Coleridge lived at number 3 in 1816. Later residents in the Grove have included Sir Yehudi Menuhin, Robert Donat, author J. B. Priestley, plus Sting, and Annie Lennox of the Eurythmics, whose homes here sold for over £5 million and £6 million, respectively.

288

STEEL-FRAMED HOUSE

This three-storey steel-framed house was designed by the architect and author as his own home. John Winter worked and travelled in the United States during the 1950s and '60s and returned enthused about the new approaches he discovered there, including the use of Corten steel. Structural steelwork was exposed and so able to rust gently and to give the building interest and a feeling of age that contrasts well with its 1960 ultra-modern lines. Its use in this house is the only domestic example in London. Meanwhile, vast sheets of clear glass create a light interior and many interesting reflections.

289

HOLLY VILLAGE

Swains Lane separates the two parts of Highgate Cemetery. Here, the campaigner and benefactor of the East End poor, Baroness Burdett-Coutts, was responsible for this group of eight rustic Gothic-style dwellings for her servants. They are set around a village green within a private courtyard behind the highly ornate entrance gate. Everywhere, there is a huge indulgence in flamboyant detail. Highgate still has a nineteenth-century atmosphere and remains much as it was when Dickens first came here in 1832; he returned many times and used it as a setting for David Copperfield's residence. Dickens's wife and one of his daughters, Dora, are buried in Highgate's West Cemetery.

290

HIGHGATE CEMETERY

The imposing entrance to this 37-acre cemetery celebrates

BUILDING DESCRIPTIONS 589

death as only the Victorians could, a solemn gateway to 51,000 tombs, vaults, graves, mausoleums, and catacombs for 167,000, including Karl Marx, George Eliot, John Galsworthy, Charles Cruft (who founded the famous dog show), and prize fighter Tom Sayers, whose chief mourner was his dog. Egyptian Avenue, the Circle of Lebanon, and winding paths are dug into hillsides. Geary also designed gin palaces.

291

17-21, 23, AND 42 HIGH STREET

Highgate's hilltop position has been the setting for rich, elegant homes for over four hundred years, and here are many excellent eighteenth-century houses. Typically, these neat brickwork houses are set behind railings, have slim front doors below pediments, and are approached by a short flight of steps. There are sliding sash windows with small panes, and basements provide extra space below the ground floors.

292

CATACOMBS AND VAULTS

The cemetery was launched when space for burials in London became critical in the early 1800s. By 1975, many of the buildings were dilapidated and the gardens had run wild with brambles. In 1981, the freehold of both parts of the cemetery was acquired, and the Friends of Highgate were able to conserve and restore both structures and landscaping. The buildings are both eerie and beautiful, and include tombs, monuments, catacombs, and family vaults. Chemist Michael Faraday and novelist George Eliot are buried here.

293

CHOLMELEY LODGE

The Highgate hills rise to the height of St Paul's Cathedral. Built on the site of the Mermaid Inn and an earlier Cholmeley Lodge, this sweep of forty-eight flats is near the entrance to Cholmeley Park. On its curving front, redbrick bands alternate with flowing balconies and pretty small-paned windows—the central ones in bays. The nearby free grammar school was founded in 1562 by Sir Roger Cholmeley, a knight who procured its two charters from Queen Elizabeth I.

294

LONDON METROPOLITAN UNIVERSITY

N7

N7

A small plaza leads to the entrance where three intersecting blocks clad in stainless steel are set at interesting angles to create a dramatic impact as the triangular shapes seem to rise from the ground—the whole effect augmented by the diamond patterns on the surfaces. Even the doorways and windows are irregular and create sharp slashes in the metal façade. Meanwhile, the embossed stainless-steel surface panels reflect the sky and busy world around them to create an ever-changing pattern. The building, built on the north campus on the Holloway Road, cost less than £3 million but is now regarded as one of the most exciting new developments in London. The portfolio of architect Daniel Libeskind includes the Jewish Museum in Berlin and his acclaimed proposal for the redevelopment of the World Trade Center site in New York.

295

N6

N6

PENTONVILLE PRISON

This model prison (based on the plan of the Eastern Penitentiary in Philadelphia) has five brick wings with cells in three storeys, radiating out from a central control block-all set behind a massive, forbidding portico and wall. Today, it holds 1, 177 convicts. Back in the 1800s, many male convicts were taught a trade here, prior to their being transported. Some worked on the crank, a hard-labour machine, others at picking coir (tarred rope) and weaving. To relieve mental problems, the amount of exercise in the yards was increased and areas of brick walking were introduced. Prison numbers rose as capital punishment for many crimes ended and transportation was reduced. One hundred and twenty men, including Dr Crippen, were hanged at Pentonville between 1902 and 1961, and this is still the place to learn the skills of execution-a one-week course teaches how to calculate and set the drop. Today, there is a pre-release hostel where suitable prisoners are able to live and work outside during the day as their sentence reaches its close. Despite one and a half centuries of history and refurbishment, the prison layout remains little altered.

ST MATTHIAS

William Butterfield (1814–1900) was a pioneer of the High Victorian phase of Gothic revival and one of the first to experiment with the use of colour in construction. This old church, damaged in World War II and since restored, is a fine early example of Butterfield's work in elemental Gothic style. Set in a leafy churchyard, it has tall, steep gables—and is now a centre for dance and martial arts. From the time of the Quakers and Dissenters, Stoke Newington has been home to radicals and to several who have opposed authoritarian traditions. Now the area is home instead to a lively mix of authors, merchant bankers, actors, academics, and many immigrant communities.

297

N16

N16

WATERWORKS PUMPING STATION

It is said that this imposing castle-style edifice—with its turrets, towers, crenellations, chimneys, and buttresses could pump one million gallons of water a day. The course of the New River now finishes at Stoke Newington. Until the reign of Elizabeth I, most Londoners drew water from open water-courses (often contaminated by sewage) or it was carried up from the river in barrels by water-bearers. In 1608, James I agreed to fund the New River Company (in return for half the profits). In 1709, the Upper Pond was constructed. William Chadwell Mylne, engineer to the 1811 New River Company, was involved in many water-supply and canal projects—and is buried in St Paul's Cathedral.

298

ST MARY

The growing population of the parish in the nineteenth century led to the building of a new Gothic Revival church in the 1850s on the site of the old rectory. Its architect was also the designer of the Albert Memorial, the Foreign Office in Whitehall, and St Pancras Station frontage. A tall spire was added to this church in 1890. Fifty years later, the building suffered extensive World War II damage in 1940 when the roof was bombed and much had to be repaired. By 1998, this was the first London church to be fully floodlit.

N16

299

OLD ST MARY

The history of Old St Mary goes back nearly one thousand years, for a chapel existed on this site at the time of the Norman Conquest. Unfortunately, the church records were held in St Paul's, and so were destroyed in the Great Fire in 1666, but the church definitely had a rector by 1313. The nave is late medieval; the vestry, west tower, and south aisle date from 1560. Sir Charles Barry added the north aisle in 1824, and the timber spire dates from 1829—when he also installed gas lighting. Tudor brickwork is still evident on the south side, with a date plaque of 1563. Barry (who, with Pugin, famously built the House of Commons) managed to enlarge the church while still retaining its medieval village atmosphere. In the churchyard rest anti-slavery campaigner James Stephen (great-grandfather of author Virginia Woolf), and Alderman William Picket (the Lord Mayor of London in 1789).

300

CLISSOLD HOUSE

Grade II-listed Clissold Mansion was built in the 1790s for an Irish Ouaker and banker (whose bank later became part of Lloyds Bank). In 1811, ownership passed to the Crawshaw family (who made a fortune from iron making in South Wales). It became Clissold Place when one of the daughters married Reverend Augustus Clissold. This liaison had been opposed by her father, who heightened the garden wall to prevent their seeing each other and threatened to shoot the go-between who carried their love letters. Renamed Clissold Park in 1889, it opened as a public park under the Metropolitan Board of Works. This neo-classical house has a one-storey colonnade of fluted Greek Doric columns approached by a ramped courtyard. The threestorey brick villa, with its tall windows, diamond-patterned railings, and many-potted chimneys, overlooks a crescentshaped lake, originally part of the New River.

301

WHITE HART LANE ESTATE

White Hart Lane is most famous as the home of the Tottenham Hotspur Football Club that moved here in 1899.

N16

N17

In somewhat earlier times, 'Totenham' appears in the *Domesday Book* and soon became a rural village. The estate here was a vast undertaking at the turn of the century, when some 7I hectares (177 acres) were developed by the London County Council with the intent to create a garden city that met current ideals. Here, the inventive detailing of porch and brickwork, plus the projecting central bay, relieve the flat street frontage and, with the tidy small-paned windows, manage to achieve the romantic cottage look, albeit in suburbia.

302

LAUDERDALE HOUSE

Placed among the rolling acres of Waterlow Park, the relatively simple, late Georgian exterior of this house hides a much older Tudor manor—but only the masonry and one southeast room have survived from the 1500s. First built (and named) for a rich city merchant, the Earl of Lauder-dale, this is said to have been the home of Charles II's most famous mistress, Nell Gwynn, and their baby son. Inside are a 1600s staircase and a lovely entrance hall with Corinthian columns. The park inspired poet Andrew Marvell to write 'The Garden' and later, poet Samuel Taylor Coleridge came to stroll and contemplate the sweeping views across the city. Today, restored Tudor gardens occupy the site of what was, at one stage, a private pleasure garden.

303

ROW OF HOUSES

These buildings were an early project for the leading 1960s and '70s architect who went on to create the renowned housing at Alexandra Road (see page 400). His buildings all exhibit his strong ideas about social structuring and the need to interrelate all the elements into a pleasing architectural and urban composition. This neat row of houses have very wellplanned interiors with interesting use of different levels as well as epitomising new 1960s architecture at the domestic level.

N19

N19

NWI

304

NWI

ST PANCRAS STATION, HOTEL, AND OFFICES

This splendid building, the terminus of the Midland Railway. is one of the engineering wonders of the Victorian Age. It has a vast 74-metre (243-foot) single span. The glass and iron train shed is 213 metres (689 feet) long with 55-ton ribs. and curves up to rise 30 metres (100 feet) above the rails at its apex. Its skeletal transparency is a masterpiece. An extension is being added to allow Eurostar trains to use the station as a terminus for the Channel Tunnel Rail Link and the station will be serve a shuttle service to the 2012 Olympic Games. The hotel used 60 million bricks and 9,000 tons of ironwork, and boasts polished granite and limestone columns, a beautiful, long curving dining room, a majestic staircase, and London's first smoking room for ladies. It was converted into offices (St Pancras Chambers) in 1935. In the mid-nineties, the exterior was restored at a cost of around $\neq 10$ million.

305

NWI

ST MARY THE VIRGIN

This Commissioners church was designed by Henry W. & William Inwood in what is called 'Carpenter's Gothic' style. Its centre tower was built in London stock brick and rises above a symmetrical west front and bright blue doors that open into a rich warm interior. This church, so close to Euston Station, has been called the 'Cabbies Church' and has also welcomed many Pearly Kings and Queens. It was a focal point of the slum clearance movement here, lead by Friar Basil Jellicoe.

306

NWI

MARYLEBONE STATION

This Victorian station is one of the smallest of the railway terminals in London, and the newest, apart from Waterloo International. It has an elegant glass and iron structure that spans the street to connect it with the Great Central Hotel. When the station was opened in 1899, it was the terminus of the Great Central Railway's newly extended London main line. It features in the British version of the board game Monopoly, and several scenes in the 1964 Beatles movie, *A Hard Day's Night*, were filmed here. In the late 1980s, the station was greatly improved with a multimillion-pound facelift.

307

SUSSEX PLACE

Sussex Place is the most unconventional terrace here with curved wings. Twenty-six houses have polygonal bow windows, octagonal domes, pointed cupolas along the roofline, and fifty-six Corinthian columns decorating the façade. This terrace is named after Augustus, the Duke of Sussex (George IV's younger brother). The view of the lake from the terrace is superb. During the 1960s, the terrace was rebuilt behind the original façade to serve as the premises for the London Graduate School of Business Studies, and the Royal College of Obstetricians and Gynaecologists is based at number 27.

308

BUILT ON A CRICKET GROUND

These houses rose on the site of Thomas Lord's first cricket ground, here from 1787 to 1811, and the square was named after the Duke of Dorset, who was an early patron of the game. Here, the well-preserved, late-Georgian houses retain individual features. On the eastern side are some fine castiron verandas, a feature that arrived in the wake of the British colonial experience, when many Eastern influences impacted on domestic architecture. The houses on the north side are more or less original. Number 1 was the Free French Headquarters in World War II, and a plaque remembers the brave men and women who set off from here to occupied France. Number 28 was home to George Grossmith, an actor and the co-author of *The Diary of a Nobody*.

309

ST JOHN'S WOOD CHAPEL

Thomas Hardwick (1752–1829) was an eminent architect and the son of a master mason. Thomas's son Philip and grandson Philip Charles both held the post of surveyor

NWI

to St Bartholomew's Hospital. Thomas Hardwick studied architecture under Sir William Chambers, and helped with the construction of Somerset House. He explored buildings in Paris, Lyon, and Rome, and this influenced his own neo-classical style. This church has a splendid lonic portico. Inside, Tuscan columns support glazed galleries, while lonic columns rise to the gentle curve of the ceiling. Hardwick, mainly a church architect, was also clerk of works at Hampton Court for King George III—and worked at Kew Palace and gardens. He advised J. M. W. Turner (one of his pupils) to concentrate on painting rather than architecture.

310

NWI

NWI

WESTMINSTER COUNCIL HOUSE, MARYLEBONE TOWN HALL

These classical Edwardian structures in Portland stone are both fine examples of public buildings. The town hall was built some twenty-five years after the Westminster Council House and now, a reflection of the changing roles of such places, has four complexes used for marriages: the Blue Marriage Room, the Yellow Marriage Room, the Purple Marriage Room, and the Reception Room. From the intricate detailing on the tower of the older building to the smoother lines of the newer one, the refining of the architect's style and the general direction of architecture is clearly demonstrated.

311

HANOVER TERRACE AND LODGE

This terrace was named after George III's other kingdom, Hanover. Twenty tall mansions have a continuous roofed gallery along the ground floor, with three decorated pediments. Mystery writer Wilkie Collins (1824–89) lived here and entertained artists and writers, including Charles Dickens. Today, number 10 is the office of the provost of University College. In 1827, Hanover Lodge was designed for Colonel Sir Robert Arbuthnot, a hero of the Napoleonic campaigns, and serves as an entrance to Regent's Park. The house is octagonal with a tall central chimney and steep pitched roof. From 1832-45, Admiral Thomas Cochrane resided here. Known as the Sea Wolf, this courageous and audacious Royal Navy commander used to harass enemy shipping in the Mediterranean.

LONDON CENTRAL MOSQUE

In 1944, King George VI gave several acres of land and a Victorian mansion to Britain's Muslims as a centre for worship and study. This huge mosque has a golden-copper dome and an elegant, tall, white minaret—the balcony of which provides a panoramic view of the courtyard and gardens, Regent's Park, and the lovely Nash terraces. Inside, there is a glorious chandelier, traditional Islamic blue mosaic patterns, and a great expanse of carpet in the huge hall, which can accommodate almost two thousand worshippers. A separate porch gives entrance to female worshippers, and a balcony for them overlooks the main hall. The cultural centre here has a library and reading room with a collection of books in all languages, including every book in English on Islam.

313

RUDOLPH STEINER HOUSE

Rudolf Steiner (1861–1925) was an Austrian philosopher, literary scholar, architect, playwright, educator, and social thinker. He founded schools with new approaches to education, biodynamic agriculture, anthroposophical medicine, and new artistic approaches. Here, the Expressionist architecture sought to reflect its namesake by exploring Steiner's preference for curves over right angles. There are interesting double entrance doors.

314

DORSET HOUSE

Situated next to the Marylebone Station, this wonderful example of Art Deco style consists of ten-storey interlocking blocks of apartments, with commercial establishments at its base. The living space ranges from one- to three-bedroom apartments, the size of their terraces and balconies proportional to the scale of the home. There is some pleasing vertical detailing on the brick walls, bay windows

NWI

NWI

NWI

NWI

with French doors, curved corner decorative mouldings, and metal balustrades. The top stories are stepped back.

315

ROYAL ACADEMY OF MUSIC

When the first academy opened—in a house in Tenterden Street, Hanover Square—there were only twenty-one very young pupils, one being Charles Dickens's sister, Fanny. Today, this exalted academy for advanced musical training offers excellent amenities, including a wonderful concert hall, teaching rooms, recital hall, and library. Pupils have included Sir Arthur Sullivan, Sir Henry Wood, Sir John Barbirolli, and Simon Rattle. It is now a constituent college of the University of London.

316

NWI

ST KATHARINE'S HOSPITAL

Founded in 1148 by Queen Matilda of England (wife of King Stephen), St Katharine's Hospital was started as a charitable body to treat thirteen poor people. It sat on the banks of the Thames near the Tower of London until 1825, when St Katharine's Dock was built and the hospital was relocated to the Regent's Park. In 1826, Ambrose Poynter designed a Tudor Gothic stone-and-brick chapel and a school for children of impoverished families—built adjacent to the hospital. This chapel was granted to her fellow Danes by Queen Alexandra in World War I. The 1600s wooden figures of Moses and John the Baptist were brought here from the old Danish church at Limehouse. Outside there is a copy of the rune stone erected in Jelling by Harald Bluetooth, the first Christian king of Denmark, in the year 980.

317

KENT HOUSE

NWI

Incorporating many of the socialist ideals of early modern architecture, Kent House consists of two buildings (one a storey higher than the other) with white stuccoed walls, metal window frames, and cantilevered balconies that protrude like metal-caged theatre boxes. Its name is blazoned clearly on the front in large letters.

318

ALL SAINTS, CAMDEN TOWN

Originally known as Camden Chapel, All Saints is one of three chapels designed by William Inwood and his son, Henry William Inwood. The yellow stone building is now a Greek Orthodox place of worship that welcomes many Greek Cypriots. There is evidence of Henry's enthusiasm for Greek architecture, in the semicircular portico with Ionic columns and decorative Greek details, while the porch with a lantern is clearly a British feature.

319

CUMBERLAND TERRACE

This is a most magnificent structure, the longest and most elaborate terrace here, situated on the eastern side of Regent's Park. It is named after the Duke of Cumberland (King George IV's younger brother). Three main blocks are linked together with ornamental crescents and elegant arches; their grandeur is theatrical. The pediment of the central block is graced with statues, designed by George Bubb, including Britannia—with the arts, sciences, and trades that marked the achievements of her empire.

320

WORKING MEN'S COLLEGE

This rather austere Edwardian building has arched and circular windows with 'Founded in 1854' clearly stated high up on the wall. It was one of the first British adult educational institutes and it moved here some five decades after its inception. It was begun by a small group of professionals; teachers and students were treated as equal members of a community, and the focus was on humanitarian studies and the furtherance of Christian brotherhood and social justice. Renowned teachers have included Tom Hughes (author of *Tom Brown's Schooldays*), Charles Kingsley (of *The Water Babies* fame), and artists Ruskin, Rossetti, and Burne-Jones.

32

STUDIO APARTMENT

This multi-storey group of studios has a rendered exterior,

painted white, and comprises a mixture of double-height studios and single-storey apartments. There is a lovely roof garden on top and much of the living accommodation looks out over another garden to the rear, with views beyond of the rise of Highgate ridge. Highgate Wood was once part of the ancient Forest of Middlesex and was declared 'an open space forever' by the Lord Mayor of London in 1886. The Cliff Road elevation is a painted concrete frame with glass bricks; and metal louvered doors can cleverly convert the inside space into a balcony.

322

NWI

OLD ST PANCRAS CHURCH

This is one of the oldest Christian places of worship in Europe, the first church built here as long ago as ad 3I3 or 3I4. A Saxon altar found here dates from about 600, and the chancel was rebuilt in about 1350. Fragments from the 1200s remain in the Norman doorways but the Grade II–listed building is now largely Victorian. Joseph Grimaldi, a clown, was married here in 1801 and, in 1814, poet Percy Bysshe Shelley and Mary Godwin declared their love for each other over her mother's grave. An attempt to create a railway tunnel in 1866 that would have disturbed the churchyard caused a huge public outcry, and the matter was discussed in the House of Commons. Today, the sombre Soane Mausoleum is Grade I–listed. Other people buried here include composer Johann Christian Bach, author John Flaxman, and many refugees from the French Revolution.

323

UNIVERSITY COLLEGE HOSPITAL

The University College Hospital first began as a dispensary in 1828 and was converted into a 130-bed hospital in 1834. In 1844, Joseph Lister (later Lord Lister) was a student here. In due course, he would become famous for his introduction of antiseptic surgery. In 1846, Robert Liston performed the first major operation (a leg amputation) under ether in Europe. Another renowned medic here was Sir William Gowers, a neurologist whose text book on the nervous system is still revered. Sir John Blundell Maple donated £200,000 towards a major rebuilding programme in 1897 and the number of beds increased to three hundred. The rather eccentric red terracotta building, with turrets and spires, is seven storeys high and occupies an X-shape, set diagonally across its square site.

324

ST PANCRAS CHURCH

This is a fine example of Greek revival architecture. Built in brick and faced with white Portland stone, it has a pretty octagonal bell tower that rises above a spacious lonic portico. Two pavilions (that serve as vestries and also guard the entrance to the burial vaults) are supported by regal, draped caryatids made of terracotta—based on the caryatids of Erechtheum.

325

THE BRITISH LIBRARY

This vast library comprises the British Museum Library, the National Central Library, and the National Lending Library for Science and Technology. I50 million items include 10 million books and a copy of every new British publication—in 625 kilometres (388 miles) of shelves. twelve kilometres (over 7 miles) are needed every year to hold 3 million new items—pamphlets, manuscripts, maps, charts, music scores, Egyptian papyri; government papers, newspapers, prints, drawings, patents, and 8 million postage stamps. Sixteen thousand people use them each day. A glass tower contains the King's Library, with 65,000 books, manuscripts, and maps collected by King George III.

326

NWI

WYLDES FARM

NW3

NWI

Part of a tract of land donated by Henry VIII to Eton College, this I600s farmhouse is now the central section of a larger building. Famous former owners have included the painter John Linnell, who made it his home from 1792–1882, during which time the poet William Blake made many visits. Over the years, other guests have included artists George Morland and John Constable, and also writer Charles Dickens—who stayed here while mourning the death of his cherished sister-in-law, Mary Hogarth. The renowned architect and planner of Hampstead Garden Suburb, Sir Raymond Unwin, also lived at Wyldes while he was working on that prestigious undertaking, and it was he who oversaw the conversion of the lovely large barn into a home.

NW3

JACK STRAWS CASTLE

This coaching inn was named after a leader of the Peasants' Revolt, lack Straw, one of Wat Tyler's lieutenants. He is supposed to have taken refuge here, building an encampment from which he planned to march on London: but he was captured and hanged. The pub's patrons have included authors Wilkie Collins, William Thackeray, and Charles Dickens. Today, it takes the form of a timber-frame mock castle with castellations-all pre-fabricated and assembled on site. The fittings are original, however, and the pub has lovely views.

328

ANNESLEY LODGE

Among all of Voysey's works in London, many consider this to be his best. It was built for his father in the suburbs of London. The L-shaped Art Nouveau house maximises the corner plot, its garden and front lawn neatly enclosed by two long wings. A path leads between these to the front door set centrally at the junction. Voysey's signature style is evident in the long, unbroken red tiled roof (buttressed at the corners), the tall chimney, white pebbledash walls, and the pretty heart motif on the front door.

BURGH HOUSE

Originally occupied by the Sewells, this grand property is now named after a vicar, the Reverend Allatson Burgh, who bought it in 1822. A fine Queen Anne mansion, it has been a militia headquarters and offices' mess-and home to a physician (who added the present wrought-iron gates which bear his initials), a professional upholsterer, a stained-glass designer and his twelve children, a miniature portrait specialist, and, in the 1930s, the daughter of Rudyard Kipling.

It was bought by Hampstead Borough Council in 1946 and then Camden Council and, finally, run by a trust who sought to rescue it from demolition. A local museum and exhibition centre were established, and today is licensed for civil marriages—held in its panelled music room.

330

GEORGIAN HOUSES

There are many Georgian houses in this vicinity, including good examples in Lower Terrace, Mount Vernon, Holly Walk, Holly Place, Hollyberry Lane, Benham's Place, and Prospect Place. Mount Vernon takes its name from General Charles Vernon who brought property hereabouts in 1785. This older, traditional part of Hampstead has many criss-crossing streets and alleys. Famous residents include the painter John Constable, who lived at 2 Lower Terrace. This is Holly Cottage, which seems rather tall for its name.

THE OLD BULL AND BUSH

The Old Bull and Bush pub is among the oldest vestiges of the hamlet of North End (where the 1776 home of Pitt the Elder can also be found). The bull of the pub's name derives from the fact that it was once also a farmhouse, and the bush, from the famous yew trees—supposedly planted by William Hogarth, who may have lived here once. Always popular with artists and writers, including with William Blake, it was made famous by Florrie Forde's song 'Down at the Old Bull and Bush.' In its current role as a contemporary bar and restaurant, its interiors do not really reflect the building's long history.

HAMPSTEAD TOWERS

Now an Italian convent, Hampstead Towers was built in 1875 by Shaw, for himself. Many features such as the tall chimneys and porthole windows are characteristic of his architecture and of the Oueen Anne style. A decade later, he extended the house at the rear and, subsequently, other owners have made a few minor changes. Half of the house is higher than

NW3

NW3

EAST HEATH ROAD

the other side; the main staircase divides the sections. The difference in elevation is also marked by one side being brick-faced and the other being stuccoed. Various types of windows make an interesting pattern on the exterior, and two long oriel windows stand out on the street side. The interior retains much of the original panelling.

333

NW3

East Heath Road borders the southeast of Hampstead Heath. The lodge consists of two houses that share a large, south-facing platform and are marked by a blue plaque in recognition of distinguished resident, composer Sir Arthur Bliss. Built in brick with an arched entrance around the door, the building has a gently curving front bay and large shutters flank the other windows. Katherine Mansfield and her husband, John Middleton Murray, lived nearby—at number 17, a large grey house they called the Elephant.

334

NW3

PRETTY GEORGIAN HOUSES

Hampstead is a treasure trove of eighteenth-century Georgian houses, and this is a very neat row with delicate wrought-iron rails and balustrades—and brick, arched patterns curving around the doors. At the end of Flask Walk is the Flask Inn, where the Kit-Kat Club met (founded in 1705 by Whig politicians and writers). In nearby Well Walk, the Great Room and Pump Room were renowned for their healing waters, concerts, and dances. It was demolished in 1822 and another spa rose here, patronized by Dr Johnson. Writers John Masefield, D. H. Lawrence, and J. B. Priestley lived nearby.

335

HOUSE WITH GLASS BRICKS

This unusual house is set in a concrete frame and has multiple panels of glass brick, set on an exposed concrete frame. There are interesting levels, and cantilevered floors and overhanging elements. The window frames were painted red. This was a house that Housden built for himself on a site that slopes down to the heath. His architecture was greatly influenced by the Dutch architect Van Eyck.

336

BOLTON HOUSE

Long gardens front a group of fine Georgian houses that includes Volta House, Bolton House, Windmill Hill House, and Enfield House. This brown brick structure here is laced with redbrick, and beautiful carved brackets support the doors. Painter George Romney (1734–1802) lived in Holly Bush Hill.

33

FENTON HOUSE

Although the house was built in 1693, the building's name originates from a merchant, Philip Fenton, who bought it in 1793. The National Trust was gifted this property in 1952 by Lady Binning, along with her remarkable porcelain collection, furniture, and paintings (including works by Constable and Brueghel the Elder). Today, there is also a display of early musical instruments bequeathed by Major George Henry Benton Fletcher—including a 1612 harpsichord played by Handel. There are wrought-iron gates on the south side, and an entrance in Hampstead Grove.

338

CENTRE HEIGHTS

One of the early experiments in mixed commercial and residential use blocks, Centre Heights is all concrete and glass increasingly popular building materials in the early 1960s. It was influenced by Le Corbusier and the Italian Rationalists of the time. There is an interesting stair tower, shops on the ground floor, and five floors of flats and maisonettes set above all this.

33

ABSTRACT HOUSING

This series of nine terraced houses form a simple, long, low run. (There is a similar, even longer stretch, in Mansfield Road to the north). Here, in Oak Village (to the south of Mansfield Road), the run is linked by a continuous storey at attic level. Though externally the houses assume a simple abstract form as they flow from one to another, internally there are quite complex split levels.

340

ALL HALLOWS

The foundation stone of this (the last church designed by James Brooks) was laid by Queen Mary's mother in 1892. It was consecrated in 1901, the year of the architect's death. This vast building has no spire, but the massive buttresses supporting the aisle structure create a sense of enormity (somewhat diminished by the emergence of brick houses around it). Inside, the aisles and the monumental nave are of the same height.

341

THE VISAGE

Here, I3I up-market apartments, duplexes, and penthouses—in various sizes and configurations—have been arranged over eleven floors, with sweeping views over Primrose Hill and Regent's Park. The building is stepped up from north to south, with the south façade 'inversely raked,' so that each floor overhangs the one below it. As well as state-of-the-art facilities, the amenities on offer include theatre-ticket booking, dining reservations, a twenty-four-hour concierge service, and even butler service—at a price; these rather exclusive apartments cost over £2 million each.

342

PUBLIC LIBRARY AND SWIMMING POOL

This was part of a much larger civic centre plan that was never fulfilled when Hampstead came under Camden borough; the library and swimming pool were the only buildings to be completed in 1964—and are now regarded as a landmark in British Modernist architecture. Sir Basil Spence's library houses the central facility of the public library service; an admirable restoration effort has sensitively adapted this classic library and it now implements modern hi-tech requirements. Meanwhile, the swimming pool is being replaced by a new leisure centre. The exterior has protective pre-cast concrete fins that act as sun protection.

343

ST STEPHEN

Having been declared redundant in 1977, this building then lay dilapidated for twenty-five years before being rescued. It is one of London's most striking nineteenth-century churches, now Grade I listed, with a huge, ornate tower and capped roof. A new crypt has been built, and the nave now serves as a community hall and classrooms for Hampstead Hill School.

344

HOUSING COMPLEX

This small crescent of eleven large four-storey houses is set behind a walled yard. The immaculate brickwork is arranged in very pleasing stripes with various arrangements of windows in squares and strips. The end dwellings are like a turret with double-height studio bedrooms and an attached curved bay.

345

ST AUGUSTINE, KILBURN

St Augustine is a fine example of Victorian church architecture and is one of the largest churches in London, its crowning glory the soaring spire that reaches 77 meters (254 feet) in height. The church is in redbrick with many pinnacles and a huge round window. Its fine vaulted interior was the work of Pearson, the renowned Gothic architect. Sir Giles Gilbert Scott designed the altar in the Lady Chapel.

346

NW3

NW

KINGSWOOD AVENUE

Thirty-acre Queen's Park was established on land bought from All Souls College, Oxford, with money left in the will

BUILDING DESCRIPTIONS 599

of one William Ward. It had superb trees and a lovely castiron bandstand. The Victorian housing development here (that gave its name to the famous football club) provided two thousand homes for sixteen thousand residents. It was built by the Artisans' Labourers' and General Development Company. The early residents were mainly the families of railwaymen, policemen, artisans, and clerks. These are fine houses, with generous bays, white brick surrounds to the windows, and many elegant Gothic details.

347

NORTHGATE MANSION

St John's Wood has courtly origins. Granted by William the Conqueror to a lady called Eideva, the area belonged later to the Knights Templar and then the Knights of St John of Jerusalem in 1312, who gave the district its present name. Prince Albert Road first appears in the tax records in the 1820s and was called Albert Road until 1938, when it was renamed after the Prince Consort. Northgate is a large Edwardian redbrick mansion that occupies an entire whole block. It is highly ornate, with decorative balconies, lovely gables and turrets, and a superb view across Regent's Park.

348

NW8

NW8

NATWEST MEDIA CENTRE

This centre of this dramatic curving, aluminium, state-of-art media centre was actually prefabricated by boat builders (Pendennis Shipyard) and the different sections were then welded together on site. Set high above the cricket ground, it offers a brilliant view for radio and television sports journalists. As well as a tiered seating area, the egg-shaped structure includes a restaurant and hospitality rooms. The cost of construction was about £5 million. Stirling Prize judges described the Media Centre as 'A breath of architectural fresh air... a wacky solution to a singular problem.'

349

NW8

HOUSE AND STUDIO

This rather splendid Grade II-listed building was home to two famous artists—first Jacques Joseph Tissot, a.k.a.

James Tissot (1836–1902), the French painter who depicted social life in Victorian Times. Next, Sir Lawrence Alma-Tadema (1836–1912)—a Dutch-born English classicist painter—spent several years, and a large part of the fortune his paintings had earned him, refurbishing the place. After two or three years' prodigious labour, he had created a magnificent, triple-height silver-domed studio with a vaulted ceiling and apse, an atrium with a fountain, and further artist's studios. He also added many Greco-Egyptian embellishments. After damage inflicted during World War II, the house was converted into eleven apartments, but has recently been restored as a single residence.

NW10

NWII

350

ACAD CENTRE

The ACAD (ambulatory care and diagnostic) centre at Central Middlesex Hospital (once the Willesden Workhouse) is designed for the diagnosis and treatment of patients who do not require a hospital bed. There is a spacious reception area and a two-storey treatment wing, with x-ray facilities and operating theatres. The consulting and treatment rooms are arranged around open landscaped courts. Stonework, brickwork, aluminium cladding, timber panelling, and glass blockwork have all been used. An internal double-height street, has bridged walkways, and oodles of top light.

351

SHOPS AND FLATS

Set on land originally given to Eton College by Henry VI, Hampstead Garden Suburb was founded in 1907 as a model of community life. Henrietta Barnett, a cosmetics heiress turned social worker, spearheaded the project, hoping to provide homes for the needy at the same time as saving Hampstead Heath from the fast-encroaching tube lines and march of terraced houses. On the edge of the estate, these two impressive redbrick blocks have a rather Germanic appearance, with their steeply pitched roofs, towers, and dormer windows.

NWII

WATERLOO COURT

This multiple housing scheme was built to contain fifty flats for single working women. A timber-covered approach leads to a two-storey court with white-painted brickwork. There are sweeping arcades with fine semi-circular arches all around, and the simple but delicious central pavilion has a neat bellcote. Baillie Scott revelled in the whimsical and here the smooth, round-arched cloisters, deep roofs, and heavy timbers are a delight, with a theatrical, almost fairy-tale appeal.

353

NWII

NWII

ELEGANT SYMMETRY

The west side of Erskine Hill was designed by Lutyens in splendid 'Wrenaissance' style. The properties are built in grey brick with dormers and multiple white-painted window frames. Here number 9 rather resembles a country rectory—made formal for town with its straight lines and tall chimneys.

354

COTTAGE-STYLE HOUSES

Here, the pebble-dashed cottage-style properties have steeple pitched roofs, and dormers—and are full of interesting and unexpected angles. Baillie designed numbers 6–10 Meadway as well as this property. All are rather romantic. Here there are flowing roofs, 'doll's-house' windows, and high 'Hansel and Gretel' gables.

WESTMINSTER ABBEY

Westminster Abbey can be found just to the west of the Houses of Parliament. Reaching the grand scale of a cathedral, this has been the traditional venue for coronations. royal weddings, and many funerals of English monarchs. Monks were living and working here from A.D. 785; the scant remains of a Norman monastery now house the Abbey Museum. Edward the Confessor built a new church in 1065, and William the Conqueror was crowned here on Christmas Day 1066. In the 1240s, King Henry III decided to rebuild the abbey in its current Gothic style. The exterior was constructed from soft Reigate stone and has been refaced several times. Master mason Henry Yevele demolished the nave and constructed a replacement in keeping with the earlier style. Until 1375, the abbey had a Gothic eastern end and a Norman nave. In 1400, Geoffrey Chaucer was buried here, and since then the remains of many authors have been laid to rest in Poets' Corner, including Sheridan, Browning, Tennyson, and Ben Jonsonburied upright, at his own command, to conserve space. Actor Laurence Olivier is also buried here. Today, in the centre of the nave, the Grave of the Unknown Warrior is a sombre reminder of those lost at war.

356

PICKERING PLACE

Pickering Place is one of the smallest public squares in Great Britain. It is found through a narrow oak-paneled passageway that threads between two shops in St James's Street. The paved court is surrounded by four brick houses and is lit at night by original gas lamps. The houses were built by William Pickering, whose mother-in-law owned a grocer's shop on the site of number 3 James's Street. Along the passageway into the square is a door into the original shop. During the seventeenth century, the cul-desac was a common venue for dueling contests. Indeed, it is thought that the last duel in Great Britain may have been fought here.

/ |

357

ROYAL AUTOMOBILE CLUB

This building is an opulent Edwardian celebration of the motorcar by Mewès. It has a large Portland stone façade and a high entrance hall that leads on to luxurious club rooms, all in Louis XVI style. The basement houses squash courts, Turkish baths, a solarium, and a luxurious marble swimming pool with Moorish pillars faced in fish-scale mosaic. Spies Burgess and Maclean had lunch in the club before fleeing the country. A few years ago, one of the staff was actually murdered here—moreover, by someone who was not a member! An old gentleman spent every day in the library pretending to read: 'I have come here to die', he explained. 'I have had a busy life and I want to end it in peace.' He did so here.

3

CARLTON HOUSE TERRACE

In Carlton House Terrace, blocks of Grade I–listed, white stucco-faced houses overlook St James's Park. They were constructed on the site of Carlton House, George V's residence before Buckingham Palace was built. All is in Roman classical style with short Doric columns on cast-iron platforms and a grand sweeping façades of taller Corinthian columns. Although now occupied mainly by businesses or organisations, over the years the houses have been home to several prime ministers—including Lord Palmerston (number 5, 1840–46), Earl Grey (number 13, 1851–57), and William Gladstone (number 11, 1857–75).

359

ADMIRALTY ARCH

Built in Portland stone, this giant Corinthian triple archway marks the first point of the royal route from Buckingham Palace to St Paul's Cathedral. The Grade I–listed building has three deep arches with splendid wrought-iron gates, the one in the centre opened only for ceremonial occasions. The triumphal arch incorporates offices and living quarters for senior navy officials, has served as a hostel for London's homeless, and is home to the Prime Minister's Strategy Unit. Since 2000, it has been used by the Cabinet

SWI

Office. Commissioned by King Edward VII in memory of his mother, Queen Victoria, its Latin inscription translates as: In the tenth year of King Edward VII, to Queen Victoria, from most grateful citizens, 1910.

360

THE ATHENEUM CLUB

Its name deriving from the goddess Athena, this Neoclassical gentlemen's club stands on Pall Mall, at the corner of Waterloo Place, and is noted for its fine Doric portico. Founded in 1823, it soon became a gathering place for clergymen, bishops, politicians, scientists and writers –with an impressive membership that has included Charles Dickens, Rudyard Kipling, Wellesley the first Duke of Wellington, Sir Walter Scott, Cecil Rhodes, Charles Darwin, Lord Palmerston and Winston Churchill. For some reason its clock has two figure sevens and no figure eight. The Clubhouse became one of the first buildings to be lit by gas – and then, in 1886, by electricity.

361

NORMAN SHAW BUILDING

Part of the old Whitehall Palace was originally lodgings for Scottish kings. In 1829, when Sir Robert Peel created the new Metropolitan police force, Great Scotland Yard became their headquarters. This imposing red-and-white brick Victorian Gothic fortress has round towers inspired by Scottish castles and is 'a very constabulary kind of castle.' The granite facing was probably quarried by convicts on Dartmoor. Its original telephone number was the famous Whitehall 1212. The police moved out in 1967 but the name, New Scotland Yard, went with them. It was bombed by the Fenians in 1883, when a wall exploded. In 1888, a woman's torso was discovered in the cellar.

362

INSTITUTE OF DIRECTORS

The Institute of Directors building rose on the site of the demolished Carlton House. Indeed, the interior incorporates the original staircase, a magnificent design, presented

to the club by George IV. John Nash built the United Service Club building in 1827, but fifteen years later Burton remodelled the exterior to look more like the Athenaeum he had raised opposite at number 116. This Victorian Italianate exterior has a Roman Doric porch, cornice with balustrade, frieze, and fluted Corinthian columns on the upper portico. Burton incorporated nineteen lanterns around the exterior; they are still fully functional.

363

TRAVELLER'S CLUB

The Traveller's Club, founded in 1819, is the oldest of the Pall Mall gentlemen clubs. It was established as a reunion venue for gentlemen who had travelled abroad—at least five hundred miles in a straight line from London. It is built in the style of an Italian Renaissance palace (the Palazzo Pandolfino in Florence) around a central court. There have been two suicides on the premises. On both occasions a member shot himself in the billiards room. After the second death, the chairman, Colonel Baring, commented, 'I'll take damn good care he never gets into any other club I have anything to do with.'

364

PICCADILLY ARCADE

This was an extension to Burlington Arcade. It runs under a building between Piccadilly and Jermyn Street, and is lined with twenty-eight bow-fronted shops. The upper floors were designed as offices and chambers and, in 1915, part of the upper accommodation became the Felix Hotel. The Portland stone Piccadilly front is a lively mix of columns, pilasters, cornice, frieze, and neat iron-railed balcony. Irena Sedlecka's life-size statue of Beau Brummell, the nineteenth-century English dandy, stands at the Jermyn Street entrance.

365

SWI

HIGHLY ORNATE OFFICES

St James's Street arrived after Henry VIII acquired St James's Hospital and built St James's Palace here. It was an area renowned for its coffee and chocolate houses and clubs. Shaw, the architect of these ornate offices, was extremely influential in the last decades of the nineteenth century, best known for his country houses and commercial buildings. This elaborate castle-like structure is a great example of his brick and gabled style—copied widely by others. He revelled in half timber and hanging tiles, projecting gables, and tall chimneys.

366

BROOKS'S CLUB

SWI

Brook's was a social rather than political gentlemen's club. In 1778, it moved to number 60 St James's Street, a residence under the management of wine merchant and money-lender William Brooks. Although it was the main social centre for the Whigs, it also acquired a reputation for heavy gambling. The frontage to the building is constructed from white brick, with three floors, tall Corinthian pilasters, and a cornice that spans the central four columns. Inside, are a glass domed ceiling and a stone staircase. In an upstairs room are the busts of Charles Fox and William Pitt, who were members.

367

SW

MIDDLESEX GUILDHALL

Built on the site of a notorious slum, Parliament Square provided an open aspect for the 1870 Houses of Parliament. In 1926, it had Britain's first official roundabout and traffic lights. Behind Abraham Lincoln's statue, this medieval-style, Gothic hall has leering gargoyles and a 1600s doorway, a remnant of Tothill Fields Prison. Here was the Sanctuary Tower, where the oppressed sought refuge; Edward V was born here after his mother found sanctuary. The Grade II–listed building now houses Middlesex Crown Court, with seven courtrooms, some used during World War II by the Allies maritime courts. in 2008, it will accommodate the House of Lords Supreme Court.

368

ADMIRALTY SCREEN AND ADMIRALTY HOUSE

The Admiralty Screen was Robert Adam's first assignment, constructed in front of the courtyard of Admiralty. Its Roman Doric design features a central arch with seahorse decoration and flanking pavilions with sculptured pediments. Admiralty House can be found to the south of Admiralty, and was built by Cockerell as a residence for the First Lord of the Admiralty—a role it played until 1964. It has also been the home of Members of Parliament, including Sir Winston Churchill. It is a three-storey building in yellow brick. The front façade has three bays, and to the rear, five bays face Horse Guards Parade.

369

DOVER HOUSE

Although Dover House is essentially the work of two architects, it is still possible to see the influence of both within the building. The main block and two-storey wing running into Whitehall were built in Paine's distinctive Romanesque style, while the façades show the mark of Holland's Greek-inspired work. At the front of the building is a rusticated wall and Greek portico with Ionic columns. The impressive entrance hall and rotunda is also Holland's. Dover House suffered bomb damage during World War II and was restored in 1955. It was the London headquarters of the Scottish Office until 1999. Architect James Paine is depicted in a portrait in the entrance hall waiting room.

370

OLD TREASURY BUILDING (AND CHURCHILL MUSEUM)

This outer façade is typical early Victorian, with stone rustication and a small portico of lonic columns. Inside there are impressive entrance halls and fragments of Henry VIII's Whitehall Palace, including tennis courts and a fireplace. Sir John Soane's addition proved too small and it was replaced by Sir Charles Barry's design. World War Il bombs inflicted serious damage, and what we see now is mostly the work of the most recent architect. The building is presently mostly occupied by the Cabinet Office. Here are the rooms from which Churchill directed Britain's war effort during the darkest days of World War II, often catching brief snatches of sleep here too, in the rooms below ground. The Churchill Museum opened in 2005 to mark the fortieth anniversary of his death.

371

SWI

SWI

THE HORSE GUARDS

A small guardhouse was built here in 1649 on the site of Henry VIII's tiltyard (a tournament ground). By the 1660s, a larger building had been constructed for both horse guards and foot guards. The current building was completed in the 1750s by John Vardy after the death of its designer William Kent, and is of Palladian design; it was originally the main entrance to Buckingham Palace. Its picturesque arches surround Venetian or pedimented windows. At the rear, away from the road, is the parade ground. Here, the Changing of the Guard ceremony happens daily in summer, and the Trooping of the Colour once a year. This custom of the latter dates back to Charles II's reign, when the colours of a regiment were used as a rallying point in battle: To ensure that every soldier would recognise the colours of his own regiment at a glance, they were trooped in front of the men every day.

372

HENRY VII'S CHAPEL, WESTMINSTER ABBEY

The Henry VII Lady Chapel can be found at the far eastern end of Westminster Abbey. Its architect was also a statesman—and one of the Henry VII's closest advisors. The chapel is an impressive presentation of Perpendicular architecture and one of the first buildings in Britain to be influenced by Renaissance design. Its best feature is the fanvaulted roof with fine carved pendants. Statues of ninetyfive saints surround the walls, and the large windows flood the interior with light. Henry VII originally planned to build the chapel as a shrine for his half uncle, King Henry VI miracles were recorded as happening at Henry VI's tomb in Windsor, so Henry VII wanted to have him canonised. This never transpired however, and Henry VII was himself buried in the chapel in 1509.

73

ST JAMES'S PALACE

Built by Henry VIII on the former site of a leper hospital, from 1698, this became one of the principal homes of England's kings and queens. Charles I spent his last night here. The building was mostly destroyed by fire in 1809. Whilst it was being rebuilt, George III chose to live at Buckingham House, now known as Buckingham Palace, which Queen Victoria made her royal home in 1837. This palace was constructed in a Tudor style, using redbrick, and designed around four interior courtyards. It is mostly the work of Christopher Wren, apart from the gatehouse and its octagonal turrets—part of the original building, and now includes the Prince of Wales's London residence.

374

SCHOMBERG HOUSE

This Grade II-listed building was designed for the German Duke of Schomberg. The central section of its brown brick, red-trimmed façade juts out slightly and each end has tower-like projections. Home to portrait painter Thomas Gainsborough, the War Office, and a high-class brothel and gambling den, in 1771 it was the Temple of Health and Hymen. Here, infertile couples hoping to conceive slept in the Magnetic Celestial Bed—sometimes entertained by the 'Goddess of Health,' a young girl in a diaphanous robe; this was the future Lady Hamilton, and Horatio Nelson's lover. The 'Dr' Graham who ran this concern was eventually confined in a lunatic asylum!

375

THE NAVAL AND MILITARY CLUB

The original building here was owned by the tenth Earl of Kent, Anthony Grey. In fact, his descendants owned the land until 1908. The house burned down in 1725; rebuilt, it has remained relatively unchanged since then. The impres-

SWI

sive Palladian frontage is five windows wide and three storeys high, with a deep band of brickwork above the first floor windows. This was once the home of Nancy Astor; Waldorf Astor, the second Lord Astor, lived here from 1912–42. Since 1999, the building has been house to the Naval and Military Club—founded in 1862 and one of the oldest clubs in London. The Libyan embassy in St James's Square was the site of the 1984 siege.

376

QUEEN'S CHAPEL

This was first designed for the Infanta of Spain who was due to marry Charles I, but was finally built for Queen Henrietta Maria and refurbished for Catherine of Braganza, wife of Charles II. Inspired by Italian styles, it has stucco walls, Portland stone quoins, and a simple pediment. Inside is a coffered ceiling and England's first Venetian window, at the eastern end of the chapel. This is one of the two main Chapel Royals in England—the other one is also in St James's Palace. Chapel Royal originally referred to a body of priests and singers who served the sovereign, but it is now associated with a number of chapels used by monarchs over the centuries.

377

HOUSES OF PARLIAMENT

The Palace of Westminster began life in 1042 as a royal residence for King Edward the Confessor. The present Houses of Parliament were built after a devastating fire in 1834. Sir Charles Barry was largely responsible for the neo-Gothic design of the exterior, and Augustus Pugin for its ornamentation and the interior. Following damage by bombing during World War II, the House of Commons was rebuilt and some of Pugin's decorative features were simplified. There are a thousand rooms, eleven courtyards, eight bars, and six restaurants. It is dominated by the famous clock tower, completed in 1858 and commonly called Big Ben—but actually this is the name of the bell. The Victoria Tower was finished in 1860, the year of Barry's death (attributable in part to exhaustion after this huge undertaking); his son supervised the final stages. Pugin died

in Bedlam (Bethlehem Hospital, for the care of the insane) in 1852, just one the year after the official opening of the Houses of Parliament. The cellars are still searched by the Yeomen of the Guard before each State Opening of Parliament, after Guy Fawkes and his fellow conspirators plotted to blow up King James I and his ministers on 'Remember, remember the fifth of November' in 1605.

SWI

SWI

378

SWI

THEATRE ROYAL

The theatre's front façade boasts nine decorated windows above an impressive portico of Corinthian columns. In 1873, it was the venue for the first scheduled matinee show. During its \pm 1.3 million refit in 1994, some 1,200 books of twenty-four-carat English gold leaf were used. Much of the stage machinery used today is original. Oscar Wilde's A Woman of No Importance (1893) and An Ideal Husband (1895) were first produced here. Buckstone, a friend of Charles Dickens's and manager of the Haymarket from 1853–79, still haunts the auditorium and dressing rooms, keeping an eye on his beloved theatre.

379

SWI

WESTMINSTER CATHEDRAL, ARCHBISH-OP'S HOUSE, AND CLERGY HOUSE

Presided over by the Archbishop of Westminster, this is the headquarters of Britain's Catholic Church. Marshland was reclaimed by the Benedictine monks of Westminster Abbey and used as a market site. Here was held St Mary's Fair, and later a prison occupied part of the site. The Roman Catholic cathedral that stands here now is in Byzantine and Romanesque styles, inspired by Bentley's visits to Europe and Constantinople, and is built in redbrick with contrasting bands of Portland stone. There are several domes, over a hundred different marbles, mosaic cladding, plus Eric Gill's Stations of the Cross on the nave's main piers. The eight columns of dark green marble in the widest nave in England were hewn from the quarry that, back in the 500s, had provided the marble for St Sophia, in Istanbul. Pope John Paul II celebrated mass here in 1982.

WI

HOUSE ON AN HISTORIC SITE

This lovely Portland stone house in Palladian style was designed by John Vardy, the Clerk of the Works at Whitehall and St James. He was associated with architects such as William Kent and Inigo Jones, and also designed furniture he worked on pieces for Lord Spencer at Spencer House, for example. This was once the site of the palace of Edward the Confessor and, later, Chaucer lived in a house on the north side. Old Palace Yard now serves as a car park used by Members of Parliament. In 1606, however, this was the site on which Guy Fawkes and his fellow plotters were hung, drawn, and quartered. Explorer Sir Walter Raleigh was also executed here in 1618.

381

SWI

NEAT GEORGIAN STREETS

The houses in both these streets were constructed in brown brick, with neat redbrick decoration around the windows and arches. They are two of the most complete examples of early Georgian streets in London. Both were developed in 1722, and are extremely popular as elegant places to live for Members of Parliament. Cowley Street was constructed in recognition of the actor Barton Booth, who attended the local Westminster School and is buried in Cowley, just outside London. At number 2 Lord North Street is the Institute of Economic Affairs.

382

SWI

THE HORSE AND GROOM

Surrounded by narrow, cobbled Groom Place, and some of Belgravia's great houses, this former mews cottages once housed the grooms who gave the street its name. It is still a tiny, one-room, wood-panelled pub. It opened in 1864, to take advantage of the Beer Act that allowed householders to sell beer on payment of two guineas a year to the justices. During the 1960s, one regular here was Beatles manager Brian Epstein—and it is rumoured that a good deal of mescaline and LSD was indulged in here, too, as well as beer. Dedicated Beatles fans still make pilgrimages to the pub.

383

FROM HORSES TO HOUSES

These two surviving stretches of Nash's 1820s development show a Greek influence, and have elegant stuccoed façades and pretty ironwork balconies. In Suffolk Street, number 1 dates from 1906 and was designed in Parisian style by Sir Reginald Blomfield. Nash was responsible for number 7—a Roman Doric design, with an arched ground floor and portico. Numbers 18 and 19 stand at the back of the Theatre Royal. Suffolk Place takes its name from the Earl of Suffolk who had stables on the site in the early seventeenth century.

384

SWI

SWI

PORTCULLIS HOUSE NEW PARLIAMEN-TARY BUILDING

This splendid building is named after the chained portcullis that symbolises the Houses of Parliament on letters and documents. Six floors of offices for members of parliament and staff are arranged around an atrium, with shops at ground floor level and an underground station below. The corners hang from the roof on massive steel beams. It has lovely sandstone and bronze window frames, and a steeply pitched roof-its tall, narrow ventilation ducts resembling Victorian chimney stacks. A thick slab of concrete separates the building from the station, possibly to defend against bomb attacks. There is a post office, an 'e-library,' conference suites, and committee rooms-named Betty Boothroyd, Harold Macmillan, Margaret Thatcher, Clement Attlee, and Harold Wilson, A formal restaurant is called the Adjournment, an informal cafeteria is the Debate, and a snack shop, the Despatch Box.

385

SWI

ST MARGARET'S WESTMINSTER

Standing between Westminster Abbey and the Houses of Parliament, this has been the parish church for the House of Commons since 1614. In late perpendicular Gothic style, and encased in Portland stone, it still retains many ancient features. Founded in the 1100s to serve the lay people of the monastery, it ran in conjunction with Westminster Abbey for centuries. In the 1600s, its was the local Puritans' choice of place to worship and there have been parliamentary services here ever since. The richly coloured Flemish glass of the east window dates from 1509, and marks the betrothal of Catherine of Aragon to Prince Arthur, Henry VIII's brother. Other windows remember William Caxton—Britain's first printer, buried here in 1491, Sir Walter Raleigh, buried here in 1618 after his execution, and poet John Milton (1608–74), who was both buried here—and married, as were Samuel Pepys (1655) and Winston Churchill (1908).

386

RICHMOND TERRACE

This is now all government offices, primarily the Department of Health but, back in the 1820s, it was an understated brick terrace, built on the site of Richmond House. One of the houses here was home to the explorer H. M. Stanley (who died in 1904 at number 2), and the philanthropist Quentin Hogg lived at number 6 from 1873–77 and at number 4 from 1877–81. In the 1960s, the terrace was threatened with demolition; it survived, but the interiors had to be rebuilt in the 1980s. The neo-Perpendicular entrance, which can be seen from Whitehall, was added towards the end of the 1980s.

387

CHANNEL 4 TELEVISION HEADQUARTERS

A RIBA award–winner, this dramatic building uses lots of glass and steel, with curved pillars and two wings set each side of a convex corner entrance area. Two more wings enclose a central courtyard garden. There is plenty of the glass, pewter grey aluminium, and exposed structural steelwork that are the hallmark of Richard Rogers's brave designs, but this was a (relatively) budget-conscious exercise, with a £35 million cost limit. The entrance is approached by a bridge over what seems, at first glance, to be a glass pool but which, in fact, is the roof of a studio set underground. Inside, a concave atrium leads through to a staff restaurant with the lush, landscaped courtyard beyond.

388

BUCKINGHAM PALACE

Buckingham Palace has been the official residence of the monarch since 1837, when Oueen Victoria moved here. Built in 1715, it started life as a country house, and, although George III bought it in 1762, it stayed in its original role until 1820, when Nash was commissioned to transform the building-one can still see evidence of his French neo-classical work in the rear facade that faces the garden. Nash was dropped from the project in 1830, and Edward Blore succeeded him, building over the frontage that faces the Mall. Oueen Victoria's ballroom was once the biggest room in London, measuring 37 by 18 metres (122 by 60 feet). By 1913, the soft French stone of the palace frontage was deteriorating, and so Sir Aston Webb designed what we see now in Portland stone. The current palace comprises more than six hundred rooms. The forecourt, where the Changing of the Guard takes place, was constructed in 1911

389

SWI

SWI

SWI

BANQUETING HOUSE

This was originally planned as part of a new Palace of Whitehall and was the first purely Renaissance building in London. The façade visible from the street is faced in Portland stone and lined by two floors of columns, lonic at ground level and Corinthian above. The lower of the two floors was used for the king's less formal parties. The upper was a more lavish room for masques and banguets. The roof is almost flat and framed by a balustrade. The superb ceiling painting in the gallery was executed by Rubens as a commission for King Charles I. Years later, in 1649, the same king was executed on a high scaffold set in front of the building. Although the event drew massive crowds, it was a controversial execution. The head executioner refused to wield the ax and his assistant could not be found. Eventually a hooded individual, whose identity was never revealed, executed the sovereign.

LANCASTER HOUSE

Lancaster House was originally built for the Frederick Duke of York, the second son of King George III. It has been renamed many times, mutating from York House to Stafford House when it was bought by the Second Marquess of Stafford; and finally to Lancaster House, in 1912, when it came into the hands of Lancastrian soap-maker Sir William Lever. The Bath stone façades have three Corinthian porticoes. Sir Robert Smirke was originally commissioned to build the house, but the duke's brother, George IV, disliked the plans and Benjamin Wyatt replaced him. However, Wyatt died before the building was finished, and so Smirke and Sir Charles Barry returned to complete the work.

391

QUEEN ELIZABETH II CONFERENCE CENTRE

Built in white concrete and lead, this seven-storey, purposebuilt venue encompasses conference rooms, accommodation for the press, and offices. An in-house team of audiovisual specialists assist with the staging of events. There are also caterers, a built-in wireless network, webcasting, online conference facilities, and all the latest technology to make a conference run smoothly. Up to a thousand delegates can be accommodated, with the Churchill Auditorium having the capacity to seat seven hundred-but many consider that a new London conference centre, able to cope with much greater numbers, is now sorely needed.

392

NOEL COWARD HOUSE

Probably built on the site of Tothill Fort, this estate was an early attempt to break away from high-rise flats in highdensity housing projects. The huge development aimed to house two thousand people, and to provide shops, surgeries, a community hall, pubs, and a library. It was not completed until the late 1970s and was made a conservation area in 1990, with certain elements listed Grade II. The relatively low-rise, redbrick buildings have cantilevered balconies and interesting roof angles. Outside are Mediterranean gardens, classic mixed borders, an exotic tender plant area, a sensory garden with a bubble fountain, and a secret wildlife garden.

CHEQUERBOARD HOUSING

These large five- and six-storey modernist blocks of flats were built first as artisans' apartments. Their large U-shape wraps around a paved courtyard. A dazzling chequered effect is created by alternating windows with silver-toned brick and white Portland cement panels. The balustrades of the galleries are faced in Portland cement with brick piers. Decorated classical pavilions between the blocks house shops. A freestanding, one-storey pavilion at the south end of each courtyard serves as an entrance gatehouse, while cast-iron fences and gates give a view of the courtyard beyond.

MILLBANK TOWER

This visible landmark in the skyline has thirty-two storeys set upon a podium and rising 118 metres (387 feet) high. It marks the bend of the river between Vauxhall and Lambeth. Before the 1997 General Election, the Labour Party took over two floors for its general election campaign centre, but the £1 million per annum rent forced them out soon afterwards! The United Nations and the Central Statistical Office (predecessor of the Office for National Statistics) have also had offices here.

395

ST JOHN

St John was built at the same time as the square under the Fifty New Churches Act of 1711. The aim of this act was to halt Nonconformism in the Church of England. The church is Baroque in style and boasts four towers crowned with pineapples. On the north and south sides are pediments and porticos to the entrances, and steps up to impressive Tuscan columns. In the east and west walls are large Venetian windows. The building has been damaged over the years. It

was burned down in 1742, struck by lightning in 1773, and hit by a wartime bomb in 1941. The church is now used widely as a concert hall because of its good acoustics.

396

TATE BRITAIN

This gallery stands on the site of a vast prison. Sir Henry Tate, the sugar magnate, after whom it is now named, helped to fund the building and contributed his art collection. There have been six additions; the central cupola arrived in 1937. Art dealer Sir Jospeh Duveen paid for a wing to house the Turner Collection (thousands of watercolours and oil paintings). Later, his son paid for a further extension for modern foreign works and helped to build the long sculpture gallery in 1937. In 1979, the gallery absorbed the old military hospital opposite. Then a major reorganisation saw the shift of contemporary art to the converted power station at Bankside. Tate Britain explores work from the 1500s onwards, including pieces by Hogarth, Gainsborough, Constable, the Pre-Raphaelites, Stubbs, Blake, Turner, Moore, Epstein, and Hockney.

397

CLERGY HOUSE

The site of the cathedral and adjoining Clergy House and Archbishop's House was once all marshland—known as Bulinga Fen. The land was reclaimed by the Benedictine monks who built Westminster Abbey, and in the Middle Ages it was used as the site for a market and an annual fair. Following the Reformation, there was a maze here, plus a pleasure garden and a ring for bull-baiting, but much of it was still waste ground until the seventeenth century. Then, a part of the land was sold by Westminster Abbey and a prison was built here—later demolished and replaced by an even bigger prison in 1834. The site was acquired by the Catholic Church in 1884.

398

PANTECHNICON

The word pantechnicon was coined in English when a busy

shop opened up on this site in 1830. The word derives from the Greek, meaning 'pertaining to all the arts or crafts.' The vehicles that moved the furniture to and from the shop were called pantechnicon vans, and the term 'pantech truck' or 'pantech van' is still used in Australia. The shop in Motcomb Street did not last for long, however. The building was turned into a furniture warehouse, and, even though it was constructed to be fireproof, burnt down in 1874—to be resurrected as the current building with its large Doric façade. Today, tailor-made clothing is sold here.

39

REGENCY HOUSES

Grosvenor Crescent connects beautiful Belgrave Square with Hyde Park Corner. Here are lovely sweeping curves of elegant terraced housing, those on the north side designed by Seth Smith. On the south side are individual houses created by Thomas Cubitt, and at the Hyde Park end is the Lanesborough Hotel. No I Grosvenor Crescent is a superb house—a Grade II–listed Regency masterpiece, meticulously restored, with ornate panelling and plasterwork, and a magnificent central staircase. Previous residents in the area have included Britain's war minister, Sidney Herbert, and Florence Nightingale, whom he sent out to the Crimea.

400

SWI

ROYAL COURT THEATRE

In 1870 a Dissenters' chapel here was converted into a small theatre. The first major successes were the dramas of Sir Arthur W. Pinero, in the 1890s—and then the works of George Bernard Shaw. The theatre closed in 1932 for twenty years (except for a brief spell as a cinema). It was bombed in 1940, rebuilt in 1952, and then the English Stage Company took it over in 1956. Many radical productions followed—such as *Look Back in Anger, Chips with Everything*, and *The Entertainer*. In 1980, a rehearsal room became the 80-seater Theatre Up-stairs. Today, this is a leading force in world theatre, producing new, innovative plays, and described by the New York Times as 'the most important theatre in Europe.'

GREEK REVIVAL FLATS

Now residential flats, the former Literary Institute is in Greek Doric style, with its stuccoed frontage, columns, and portico looking like a veritable miniature temple set between taller buildings. Indeed, its designer, J. P. Gandy-Deering, was one of the few architects to promote Greek Revival style within this Mayfair estate area. In the sixteenth and seventeenth centuries, the manor of Ebury (from which the name Ebury Street derives) was leased by the monarchy to servants or favourites. The composer Wolfgang Amadeus Mozart wrote his *First Symphony* at nearby 180 Ebury Street.

402

ROYAL MEWS

The Royal Mews (mews means 'stabling with living quarters') is home to the royal horses, plus carriages such as the Gold State Coach, and cars—eight state limousines, five Rolls-Royces (with no number plates), and three Daimlers. The first royal to travel in a motorcar was Edward VII, when he was still heir-apparent. A giant entrance archway is flanked by Roman columns and overlooked by a clock tower. The Riding House inside was built in the 1760s, sixty years earlier than the mews itself. It was decorated at the beginning of the nineteenth century with the acanthus frieze and a pediment, *Hercules Capturing the Thracian Horses.*

403

SWI

MARY SHELLEY'S HOUSE

This long slender square has many elegant houses with cobbled mews set behind them. Novelist, biographer, and poet Mary Shelley (1797-1851) lived here from 1846–51 at number 24. Mary had her first poem published at the age of ten. When she was sixteen, she ran away to France and Switzerland with the poet Percy Shelley; they were married in 1816. It was Lord Byron who set Mary the challenge to write a good ghost story when she was eighteen. Mary was aged twenty-one when her story *Frankenstein; or The Modern Prometheus* was published.

HARRODS

404

In 1834, Henry Charles Harrod was a wholesale tea merchant. This famous store developed from a small Knightsbridge grocer's shop he bought in 1849. In 1883. the store burned down, but the current Mr Harrod still managed to dispatch all his Christmas orders. By 1889, the new store was bought for £120,000. When the first escalator in London was installed in 1898, an assistant stood had sal-volatile and brandy ready for nervous customers. It is now the largest store in Europe, covering 1.8 hectares (4.5 acres), with 5.5 hectares (13.5 acres) of floors and some five thousand staff. The superb food halls have mosaic friezes and tiles depicting hunting scenes. Its ornate, red, terracotta-tiled exterior looks spectacular when illuminated at Christmas with 11,500 lights. Today, 'Everything for Everyone Everywhere' Harrods is rated the third most popular London attraction for overseas visitors and, at peak times, has up to 300,000 customers each day. The lifts travel 50,000 miles a year. The present owner is Egyptian tycoon Mohamed Al-Fayed, who bought the store in 1985 for £615 million.

40

ST PAUL'S CHURCH

St Paul's parish was founded in 1843 as the first developments were being made in Belgravia, which is part of the Grosvenor Estate. A beautiful Grade II–listed Victorian building, the church was built from brick in perpendicular style. An impressive entrance has been created at the base of the castellated western tower. The church is split into three galleries, supported by cast-iron columns, with the exposed woodwork of the roof construction an attractive feature.

406

HOLY TRINITY

Poet Laureate Sir John Betjeman once described this church as the 'Cathedral of the Arts and Crafts Movement.' It has beautiful decoration in Italian and Gothic styles, stained glass by Morris and Company (including the work of Edward Burne-Jones), altar rails, a grille, and railings outside

S/V/

by Henry Wilson, woodwork by Harry Bates—and other contributions by Bainbridge Reynolds, Nelson Dawson, and F. Pomeroy. The use of different Italian marbles shows a Ruskin influence. The architect believed that a church should be 'wrought and painted over with everything that has life and beauty—in frank and fearless naturalism.'

407

SWI

CHURCH OF ST PETER Set in a residential garden square in London's exclusive Belgravia district, the Church of St Peter stands at the northeast corner here and on the corner of Hobart Place. Designed in classical Greek Revival style, it boasts an impressive six-columned Ionic portico and a clock tower. Inside, the chancel was added and the nave enlarged between 1872 and 1875. Despite being gutted by fire in the 1980s, the chuch thrives today—as does its associated school.

408

SWI

SWI

LANESBOROUGH HOTEL

Lanesborough House was built on the site in 1719 by James Lane, Second Viscount Lanesborough. A three-storey plain brick building, at that time on the edge of countryside, it was taken over by St. George's Hospital in the 1730s. A rustic cottage close by was occupied by Huggitt, the cowkeeper, who supplied the hospital with milk. By the 1820s, there was demand for more accommodation, and a new structure was designed by William Wilkins—influenced by classical eighteenth-century architecture. The façade looking over Hyde Park Corner is Greek stuccoed, with a central porch of square columns and two side wings. The top floor is a later addition. Henry Gray, who penned the famous *Anatomy* (1858), worked here. The hospital left here in 1980, moving to Tooting in South London, and the building was redeveloped into the Lanesborough Hotel.

409

MANDARIN ORIENTAL HYDE PARK

This extravagant exterior resembles Harrods, with grand turreted redbrick and stone. Two huge, bronze Oriental

dogs guard the entrance and mark its present Far Eastern ownership. Inside, everything is opulence and marble. This is a good spot from which to watch the royal horses riding off to change the guard at Buckingham Palace. Queen Elizabeth and Princess Margaret learned to dance in the ballroom, Prince Philip brought his children here for tea, and Queen Mary often visited. Queen Victoria, however, objected to its being referred to as a gentlemen's residence on her royal land, and insisted on the Hyde Park gate being locked—now opened only with royal permission when royalty or heads of state arrive. Its restaurant—frequented by celebrities such as Madonna, and where Baroness Thatcher held her eightieth birthday party—is entered via a crystal-like corridor lined with glass shelves and over five thousand bottles of wine.

410

SWI

APSLEY HOUSE AND WELLINGTON MUSEUM

Sitting on the southeast corner of Hyde Park, Apsley House was originally built by Robert Adam for Baron Apsley. However, its most famous resident moved into the property fifty years later—Sir Arthur Wellesley, the First Duke of Wellington. It was at this time, in the 1820s, that the property took on its neo-classical look. Benjamin and Philip Wyatt enlarged the original brick building with Bath stone facing, an extension to the western side, and a Corinthian portico. It was known as Number One London the first property inside London's western tollgate. The 'Iron Duke' is best known for his 1815 battle victory against Napoleon Bonaparte at Waterloo, although he served as a politician as well as a soldier. The building opened as the Wellington Museum in 1952.

411

GROSVENOR HOTEL

One of the best examples of Victorian London architecture, this is also one of the first examples of 'Second Empire' style and is the only remaining building from the opening of the first Brighton line station in 1861. The first five storeys are cut from brick and Bath stone. It is crowned with two further storeys, inserted into a dormered roof with French pavilions at either end. Medallion portraits include images of Queen Victoria and her husband Prince Albert, set between the arched windows. The hotel was refurbished, as part of a larger reconstruction of the station—and a further annexe opened in 1907.

412

ST BARNABUS: SCHOOL AND HOUSE

The small Gothic, Anglo-Catholic church in Kentish ragstone was designed by Thomas Cundy and was the first London church to incorporate the ideas of the Oxford Movement, thus playing its part in the build-up to the anti-papal riots of 1850. Butterfield's rather fine clergy house and school has pointed windows, turrets, and tall chimneys. There seem to be sharp triangles and angles, quoins, and different textures everywhere.

413

DOLPHIN SQUARE

SWI

This large, redbrick, neo-Georgian building comprises 1,236 flats arranged around a central garden (with tennis courts, squash courts, and a Modern-style restaurant). There is a swimming pool and the grounds cover over seven acres (3 hectares). This is close to the centre of Westminster, and many of the apartments are owned by Members of Parliament. When it was built, it was the largest residential block in Europe and, during World War II, became the headquarters of de Gaulle's Free French Army.

414

SWI

ST JAMES-THE-LESS PARISH HALL AND SCHOOL

This superb Victorian Gothic complex incorporates a church, hall, and infant school. Its pretty, detached tower with sharp pinnacles marks the Vauxhall Bridge Road entrance and is surrounded by railings decorated with iron arum lilies. It was built when the area was very poor, and *The Illustrated London News* described it as 'a lily among weeds.' All the buildings are in redbrick, with black brick detailing. It has generous granite columns inside and three

wide bays decorated with black brick, and red and yellow wall tiles. G. F. Watts was responsible for the mural fresco placed above the chancel arch.

415

PIMLICO SCHOOL

This four-storey comprehensive school is a shining example of 1960s new concepts for schools. It has a long internal 'street' and a dramatic glazed exterior with many interesting angles. The building won a RIBA award in 1972. Sir Hubert Bennett has created many school and college buildings and other large-scale projects.

416

CHELSEA BARRACKS

This long neat red-and-white-chequered structure has been home to the Queens Guard, the ceremonial troops of the Household Division, for some forty years or so. It has served as offices and quarters for 1,284 people, and its parade ground bustled with activity. Now the army and all their trucks have moved to Woolwich. The five-hectare (fourteen-and-a-half-acre) site is up for sale in 2007/2008 by the Ministry of Defence, with a price tag of £150–£250 million.

417

VICTORIA STATION

Victoria Station was built in two parts. The western side opened in 1862, comprising six platforms, ten tracks, and the vast Grosvenor Hotel. Another nine-track, woodenfronted building operated next door. Both were occupied by different companies, and, although there was a partial rebuild at the beginning of the 1900s, it was only in 1924 that both buildings united. To the east, J. Fowler's building houses platforms one to eight. It is made up of two vaulted iron-and-glass structures, plus a segmental arched roof. The frontage is of Edwardian design with baroque elements. For the 1910 funeral of King Edward VII, an emperor and empress, seven kings, more than twenty princes, and five archdukes arrived at this station. Between 1914 and 18, the station witnessed the mass transport of troops to France.

418

NATIONAL AUDIT OFFICE

This stone building strove to represent airlines and a flying theme with a sharp 'nose' at the peak of the tall tower and its two wide, outstretched wings. It has a dominant clock at the top and a splendid sculpture of a pair of winged figures, by E. R. Broadbent, set above the entrance. The building was used by both BOAC and British Airways but now houses the National Audit Office.

419

THE LAWRENCE HALL (THE ROYAL HORTICULTURAL SOCIETY)

This hall was renamed the Lawrence Hall in the 1990s. Regular exhibitions and flower shows are held here—in a building that was designed in the most modern style of its time. A stone on the corner marks the architects and their RIBA (Royal Institute of British Architects) award, acknowledging the first use of curved reinforced concrete in England in its interior. Stepped-back glazing is set between these parabolic concrete arches. The society was founded in 1804 by a group of enthusiastic gardeners and botanists, brought together by John Wedgwood (eldest son of the famous potter); Prince Albert was their president in 1858.

420

SW2

PULLMAN COURT

The manufacturing base of the nineteenth century and the industrial revolution left a legacy of poor housing in overcrowded, polluted cities—a balance which many twentiethcentury architects sought to redress. As the Modern Movement developed, reinforced concrete and steel were explored as mediums in their own right. In this very lively, early Modern English design, the aim was to make a light building with clean lines. Three- and seven-storey blocks of flats are set around a green with mature trees. This was a pioneering design, and one that proved highly successful. Gibberd believed that, by using flat roofs as terraces for gardens, it was possible to maximise the amount of open space available to residents; large communal parks would replace small, individual gardens. Here the structure is of reinforced concrete throughout. Exterior walls have a thick cork lining for thermal insulation.

421

BRIXTON TOWN HALL

This Edwardian Baroque inspired design has a very tall tower (with a pretty four-sided clock and pinnacles) rising high above its corner site. The building was created by two talented young architects, Septimus Warwick and Herbert Hall, who submitted their winning design in the shape of an A. It was opened by the Prince (later George V) and Princess of Wales in 1908. In 1935–38, an assembly hall was added and the building was raised by one storey.

422

AUTHORS, DOCTOR, AND MISER

The road derives its name from the Cheyne family—lords of the manor of Chelsea from 1660–1712 when this was a quiet riverside village. Many houses have fine gardens, walls, and gates, with decorated gateposts and ironwork. Numbers 3–6 have early Georgian features from about 1717. Painter William Dyce lived here and also novelist George Eliot (then Mrs. Cross) from 1819–80. Number 5 was occupied by miser, John Camden Nield, who left his fortune to Queen Victoria. Number 6, built by Sir John Danvers in about 1718, was home to a Dr Domincetti from 1765–82; he introduced medicated baths and treated thousands of patients here.

423

LONDON ORATORY

This was the first large new Roman Catholic Church to be built in London after the Reformation, its architect and design chosen through a competition. The building is vast. It has a fine concrete dome and vaulted side chapels. There are Rex Whistler paintings of Sir Thomas More and John Fisher, and many mosaics, and wood and stone carvings. The glorious St Winifred's Chapel has a magnificent high altar and Italian altarpiece inlaid with precious stones, and marble statues of the apostles from Siena cathedral. In 1892, the funeral of Cardinal Manning was held here. Chevalliaud's marble statue of Cardinal Newman was erected outside in 1896.

424

SW3

ARTS AND CRAFTS HOUSES

Only two houses remain of the eight that Arts and Crafts enthusiast Charles Robert Ashbee designed for Cheyne Walk. Number 39 was built as a speculative venture. Number 38, however, set behind street railings of black ironwork with ornamental gold balls, incorporated a studio for artist C. L. Christran. This was set in the top two storeys, behind the gabled façade with a pretty porthole window with an octagonal pattern. The lower floors have tall, narrow windows.

425

QUEEN'S HOUSE

Numbers 15–16 are wonderful early Georgian houses. The largest in the terrace is Queen's (or Tudor) House and this is well preserved, with ornate ironwork at the entrance court. The initials on the beautiful iron gate are those of Richard Chapman, the builder. There is a large 1800s bay window in the centre bay. A. C. Swinburne and George Meredith lived here, as did the founder member of the Pre-Raphaelite Brotherhood, Dante Gabriel Rossetti who kept a small zoo, including many noisy peacocks (since then leases for this building exclude the keeping of these birds). The house became a meeting place for poets and artists from 1871–81.

426

ROYAL HOSPITAL

This was founded as a home for army veterans by Charles II, and James II. Built around three courtyards, it is still home to some four hundred ex-servicemen, the Chelsea Pensioners, and hosts the annual Chelsea Flower Show in the gardens. Inspired by Louis XIV's Hôtel des Invalides, the courts are open to face the river. Apart from minor alterations and the addition of stables, the building is largely unchanged. Tall, arched windows in the brick façades denote the most important rooms within—a central saloon, flanked by a gaunt hall and a grand chapel. In 1852, the Duke of Wellington lay in state here; two people died in the crush to file past his coffin.

427

HOUSES BY THE RIVER

Here, seeming to rise in layers from the river, can be found some three centuries of the finest domestic eighteenthcentury architecture. Over the centuries, the houses were separated from the river by a shared garden frontage and a pavement planted with plane trees. Here were the homes of many famous artists, politicians, and other notables. Numbers 7–12 are lovely 1880s houses, with number 9 especially noteworthy. Number 10 was once the home of David Lloyd George from 1924–25 and, later, of Archbishop Lord Davison.

428

GOTHIC HOUSE

This pink Gothic extravaganza has a plethora of statues, balconies, and decorative wrought ironwork. There are chimneys in 'barley-sugar twist' style, a weather vane, an animal's head carved over the arched entrance—while a large oval decoration dominates the one surface that is otherwise featureless. Number 48, nearby, was Charles Rennie Mackintosh's studio house during the final years of his life, and a brickwork cottage (now number 51) is said to have been (but probably wasn't) a hunting lodge of King Henry VIII.

429

MICHELIN BUILDING

This vivacious, white faience building was the Michelin's first permanent British headquarters. It is an exhilarating

SW3

mix of Art Nouveau and Art Deco designs with tyres as a major decoration feature. Motorists used to have tyres speedily changed in fitting bays at the front of the building. A series of tile panels, on the ground floor and inside, explore motoring history and early racing cars. In the 1980s, the illuminated corner turrets (designed as a tyre stack) were restored, more office floors were added, and the Conran shop arrived (plus a new restaurant and bar) named Bibendum, after the Michelin man. Inside, a brilliant mosaic depicts Bibendum raising a glass of nuts and bolts. Etchings of the streets of Paris on some of the first-floor windows reflect the Michelin mapping role.

430

1930S HOUSE

The southern section of this street was once called Church Lane and its northern length was called the Road to the Cross Tree. Number 66 is 1930s architecture par excellence, designed by two leaders of modern functional architecture. After World War I, Gropius was made director of the Weimar School of Art, reorganizing it as the Bauhaus. Driven from Germany by the Nazi regime, he practised in London with Maxwell Fry and then went to America, where he headed the school of architecture at Harvard until 1952. Maxwell Fry was a Modernist architect in prewar Britain who also pioneered the Modernist movement in the Third World.

431

SW3

SWAN HOUSE

This stunning, original, graceful house on the Chelsea Embankment is considered by some to be the finest Queen Anne-revival domestic building in London. A pair of swans is depicted at the entrance. It has three gorgeous oriel windows at first-floor level and three, tall, narrow, oriel ones, alternating with slender windows, on the second floor. Above are smaller, matching windows and three dormers. Everything is beautifully proportioned. Richard Norman Shaw was one of the most influential British architects from the 1870s to the 1900s and became a member of the Royal Academy in 1877.

432

STUDIO HOUSE

This studio house is in an Anglo-Dutch style and was designed for Mortimer Menpes—an artist and etcher who was a friend of Whistler's. It has wonderful double-height oriel windows and a Japanese-style interior with carved panelling made in Japan by over seventy craftsmen, under the supervision of Menpes. Doors, windows, carved friezes, and ceiling panels were packed in two hundred cases and shipped to London. Some of the lovely wooden panels resemble Japanese temples and the decor for each room was based upon a different flower.

433

KING'S HEAD AND EIGHT BELLS

Dwarfed by Carlyle Mansions (where lived writers Henry James, T. S. Eliot, and Ian Fleming) this comfortable early Victorian pub used to be on the riverfront with its own landing, called Feather Stairs—until the embankment and busy main road arrived. Artist J. M. W. Turner discovered the pub and introduced it to fellow artists Whistler and Augustus John (who was having an affair with Ian Fleming's mother). Welsh author and poet Dylan Thomas also visited often. There are some lovely pieces of Victorian glasswork.

434

MODERNIST HOUSE

In this street, the oldest thoroughfare in Chelsea, Gropius and Mendelsohn introduced continental modernism to London, and number 64 is a very good example of 1930s architecture. In the 1920s, Erich Mendelsohn was one of the most prolific modern architects in Europe. He arrived in Britain in 1933, escaping Nazi Germany as Adolf Hitler became chancellor. His partner here was architect and interior designer (and a former ballroom dancer) Serge Chermayeff; he had come from Caucasia to study in the United Kingdom when he was twelve years old, changing his name from Sergei Ivanovitch Issakovitch. Later, in 1968, the stuccoed surfaces of these buildings would be refaced by Crosby Fletcher Forbes.

SW7

ROYAL ALBERT HALL

The Royal Albert Hall of Arts and Sciences is dedicated to Oueen Victoria's beloved consort. Prince Albert, who originally set about raising a cultural centre in Kensington with profits from the Great Exhibition. (The 50-acre site also houses the Imperial College of Science, Technology and Medicine, the Royal College of Art, the Victoria and Albert Museum, the Science Museum, the Natural History Museum, the Royal College of Music, and the Royal Geographical Society). With its vast elliptical dome of glass and iron, the Albert Hall is one of the best Victorian buildings in London, and opened in 1871 as the then-widowed Queen Victoria wept with emotion. A magnificent frieze encircles a building which has witnessed the first performance of Longfellow's Hiawatha (with music by black composer Samuel Coleridge-Taylor, who conducted it there in 1900), Wagner conducting six concerts, the first-ever gramophone concert, and Oueen Elizabeth II's Coronation Ball. It is home to the largest pipe organ in the United Kingdom—and to the famous Sir Henry Wood's Promenade Concerts, held here since 1941.

436

HENRY COLE BUILDING

This building is named after the first enthusiastic director of the Victoria and Albert Museum, Sir Henry Cole. It now serves as an extra wing to the museum and houses a new archive, but was formerly occupied by the School of Naval Architects, the Science School, and the Imperial College of Science. The exterior is richly decorated with terracotta panels with an Italianate arcade (loggia) running above its seven splendid central bays. Inside, in the Manuscripts Study Room, original documents can be explored with the guidance of experts (a main point of focus is architecture) and an education room is available for projects, workshops, and seminars.

437

SW

1930s APARTMENTS

This was a famous, ultra-modern, functionalist block of flats.

Its two topmost floors are set back to form an attic. Below, striped banding and the criss-crossed lines of metal window frames flow across the rendered façade. The building's cantilevered balconies and waffle slabs are typical of the 1930s modern look. Architect George Adie (1901–89) began by designing barracks and dormitories for soldiers during World War II. From this unpaid work, he went on to run a renowned Mayfair practice. An accomplished and innovative architect, he sought the new, while retaining a keen sense of living history and the traditions of architecture.

438

439

IMPERIAL INSTITUTE

The tall elegant Collcutt Tower (now called the Queen's Tower), with its dome and balustrades, arches, and striped façade, is the sole remaining feature of a building erected after the 1886 Colonial Exhibition. Eighty-five metres (280 feet) high, it was saved to become a freestanding edifice in 1968. All around it, new Imperial Institute buildings sprang up during the 1960s, so that now it is surrounded by this redevelopment growth yet remains a dominant and very pleasing feature.

SW

ALBERT COURT

Albert Court follows the sweep of the Albert Hall and is a large and imposing seven-storey apartment building. It is built in brick with many ornate features—multiple pillars, tiered loggias, corner turrets, balustrades, and a veritable march of tall Victorian chimneys. Leading through to the Albert Hall area, an unusual 'internal street'—with light wells that illuminate its passage—is resplendent with huge fireplaces, minstrel galleries, post boxes, and even grandfather clocks. This is Victoriana at its most lavish 'wedding-cake' best.

440

THE SCIENCE MUSEUM

The London Science Museum has over ten thousand science, technology, and medicine exhibits, its earliest pieces drawn from the Royal Society of Arts and the Great Exhibition of 1857. More recently, work began on the museum's new Wellcome Wing in 1997. Once through the museum's somewhat austere entrance, visitors can see Whittle's first jet propulsion engine, Stephenson's Rocket, Arkwright's spinning machine, Edison's original phonograph, Babbage's 'difference engine,' and Crick's original DNA model. An impressive library holds many ancient manuscripts and books. All this is housed within an imposing structure, with its exterior modelled on an Edwardian office building and the interior on a department store. A roof-lit central well within is home to a display of large engines, and there are open galleries at the sides. This building is a fine example of Victorian Romanesque architecture.

441

ST AUGUSTINE

A curate, Richard Chope, raised an iron shed in his garden as a place to worship in Anglo-Catholic tradition in 1865. Ultimately, a parish was established four years later and was to be served by a new church, St Augustine. At first, the site had to be accessed from the back and so the church is set at an odd angle. The nave and aisles were built in 1871, and the sanctuary and chancel in 1876. Architect William Butterfield was obsessed with colour and every part of the simple interior was brightly decorated, but a 1928 whitewash covered much of his work. After a good deal of fund-raising, helped by the patronage of John Betjeman (later poet laureate), a 1980 restoration removed most of the whitewash to reveal Butterfield's favourite mix of multicoloured brick mosaics and diaper-patterns, coloured marble, and glazed tile murals.

442

ROYAL SCHOOL OF MINES

The Royal School of Mines was founded over 150 years ago and today comprises the departments of Earth Science and Materials at Imperial College. Its origins lie in a 1851 establishment in Jermyn Street—a geology museum with minerals, maps, and mining equipment collected by Sir Henry de la Beche—director of the Geological Survey of Great Britain, who gave students the chance to study mineralogy and metallurgy. In 1863, it became the Royal School of Mines. Architect Webb was responsible for this early 1900s building, as well as the Victoria and Albert Museum and Imperial College. The school and the Bessemer Laboratory were completed by 1913, and the Goldsmith's Extension by 1915. Built of hard light stone, it has an impressive vast central entrance flanked by sculptures. Famous geologist Thomas Huxley is a notable past student.

443

VICTORIA AND ALBERT MUSEUM

This museum was part of Prince Albert's scheme to improve technical and art education, and was initially called the South Kensington Museum (renamed in 1899). Its first façade—with cast and corrugated iron resembling steam boilers lying side by side—was soon irreverently christened 'Brompton Boilers.' Francis Fowke's new 1869 buildings served as the main entrance until the opening of the Aston Webb façade in 1909. The museum acquired the collection of the East India Company's India Museum in 1880. During World War II, the V&A suffered a bomb blast but most of the works of art had been evacuated. Meanwhile, it served as a school for evacuees from Gibraltar and as a canteen for the Royal Air Force. Today, it exhibits paintings, ceramics, textiles, tapestries, furniture, costumes, jewellery, and other fascinating objets d'art from around the world.

444

THE NATURAL HISTORY MUSEUM

Built to house the British Museum's growing collection of natural history specimens, this vast and impressive building has an amazing cathedral-like frontage with sculptures of plants and animals decorating its ornate façade. An iron and steel frame is set behind multiple arches and columns. Beyond the enormous arched entrance, a sweeping staircase leads to the upper galleries. There are four acres of exhibits in all, including the famous Blue Whale and the Diplodocus skeleton on view in the fine Central Hall—a gallery decorated with carved fauna details and a richly painted ceiling. Phase One of the Darwin Centre (see below) is now open, housing 22 million zoological specimens.

DARWIN CENTRE

This incredible research centre and museum holds some 22 million zoological specimens gathered over the last two centuries and preserved in alcohol; some were brought from Australia by Captain Cook in 1768. The building serves as a store for these precious specimens, laboratories for over a hundred researchers and scientists, offices, and a museum that offers fourteen guided tours a day. Visitors can see the scientists at work from the connecting walkways along the side of the central atrium. This award-winning innovative building is climate controlled and starkly utilitarian—but very impressive.

446

DUTCH-STYLE HOUSE

Queen's Gate was built on land bought in 1855 by the Royal Commissioners for Prince Albert's Great Exhibition, and they originally named the street Albert Road. This house was built for a rich young stockbroker and connoisseur, J. P. Heseltine—and its style launched other Dutch-inspired houses in Kensington. It is reminiscent of many Renaissance townhouses in Holland, with its tall narrow frontage; high, curved, and stepped gable end; and redbrick frontage with terracotta decorative panels. Nearby are many splendid family homes in Italianate style—and embassies.

447

TANAKA BUSINESS SCHOOL

This new business school is part of a project to undertake a radical reconstruction of the college's main entrance. Some of the postgraduate accommodation is contained within a refurbished 1920s block, but this new stainlesssteel and gleaming glass façade makes a dramatic new statement on Exhibition Road. Behind the sheer glass are vast high areas, stairwells, and facilities that include a multipurpose forum area, interactive lecture theatres, study zones, and places where the students can relax and eat. This new building is yet another strand of the schemes set in motion by Prince Albert back in the 1850s.

4

ROYAL COLLEGE OF ORGANISTS

This very pretty building was part of the scheme launched by Prince Albert to sponsor places of education with some of the £186,000 profits from his Great Exhibition at Crystal Palace. Cream, maroon, and pale blue sgraffiti by F. W. Moody decorate a very ornate three-bay building. Considering that the college is now dedicated to organ playing, it seems odd that its frieze of musicians contains no organist, but the building began as the National Training School of Music and was not confined to organists until 1904. Sir Arthur Sullivan, of Gilbert and Sullivan fame, was its first principal.

449

MONTEVETRO

This impressive block of over one hundred apartments was constructed as a conscious attempt to reverse the trend of population loss in central London, by persuading people that even the most densely urban areas could be pleasant places to set up home. The block was built on the site of an old flour mill, and enjoys impressive views along the Thames to Battersea Bridge; each apartment has one floor-to-ceiling wall of glass overlooking the river. The luxurious (and enormous) penthouse apartments not only have glass walls on two sides, but also feature projecting rooms with glass floors. Overall it is a triumph of modern design.

450

ARDING AND HOBBS

This building replaced an 1885 department store that was destroyed in a devastating fire of 1909. It was completed in the Edwardian Baroque style that dominated the public buildings and larger commercial structures of the time. The key feature is the cupola that tops the curved corner frontage on to Lavender Hill and St John's Road. This has been the most noticeable landmark in Clapham since it was built, and is now enhanced after dark by floodlighting. The overall effect is to dwarf the nearby commercial shops completed in more modest scale and style during Victorian times—which was no doubt the intention.

BUILDING DESCRIPTIONS 619

HOUSING, ALTON WEST ESTATE

Here, on 40 hectares (100 acres) near Richmond Park, this major 1950s project by the London County Council managed to retain the rolling Georgian landscape. Some 1,850 dwellings were raised, together with schools, shops, a library, and homes for the elderly. There are eleven-storey maisonettes, rows of three- and-four storey maisonettes, and twelvestorey point blocks—all built and clad in concrete, in a style reminiscent of Le Corbusier's Unite d'Habitation in Marseille, France. Generally, they lack interesting detailing or geometrical order, but perhaps the panoramic views of Richmond Park and southwest London compensate for this.

452

ROEHAMPTON HOUSE

During the late 1200s, a village grew up around a farm with many rooks—which led to the name Roehampton. In time, this area became a popular place for the very wealthy to raise vast country villas. The Earl of Portland, treasurer to Charles I, built Grove House in 1630. The area became an even more favoured residential suburb after Putney Bridge opened in 1729. This Grade I listed building was Thomas Archer's first London work, built as a country house for Thomas Cary. It has a grandiose entrance with pillars, a fine deep-red brick façade, balustrades, and multi-paned windows. During World War I, soldiers were billeted here and it was converted into Queen Mary's Hospital—mainly to provide maimed soldiers with artificial limbs and to help retrain them in various trades.

453

620

PARKSTEAD HOUSE

Set in 14 acres, this is a simply splendid example of a Palladian house, with an lonic portico and majestic domed ceilings and archways. This Grade I building was raised for the Second Earl of Bessborough, to entertain his friends and house his collection of antique sculpture. Since 2005, it has served as a venue for conferences, weddings, and other events. Sir William Chambers was also the architect of Somerset House and the Pagoda at Kew Gardens.

15 454

DIXCOT

Streatham and Tooting were originally Anglo-Saxon settlements: Streatham means 'dwellings by the street' and Tooting means 'the dwelling of the sons of Totas.' They developed from villages to suburbs through the I600s and I700s, when merchants and other wealthy folk set up their country homes here. Several large mansions and elegant villas were built in the area as the population of Tooting slowly expanded. These pretty buildings have pointed gable ends, interesting strips of leaded windows, and odd interesting angles everywhere.

SEL

SEL

455

TATE MODERN

The Bankside Power Station closed its doors to power production in 1981, and was left unoccupied for almost a decade and a half. During the mid to late 1990s, it was transformed into the Tate Gallery's centre for contemporary and international art, and it is now one of London's most popular attractions. A great deal of the building's former robust character has been maintained. The entrance leads into what was once an immense turbine hall, which housed the electricity generators of the old power station; it is seven storeys tall, with vast areas of floor space. Today, it is generally used for specially commissioned largescale projects. Elsewhere, exhibits of international modern art from 1900 to the present day include works by Dali, Picasso, Matisse, Moore, Rothko, and Warhol.

456

IMPERIAL WAR MUSEUM

The Imperial War Museum building was once the site of the Bethlehem Royal Hospital, the world's oldest hospital for the insane. The term bedlam derived from the name of this dire place, where visitors once paid to view the crazed inmates chained in gallery cells. Sidney Smirke, brother of Sir Robert Smirke, added the Ionic portico and dome in 1838, but, despite the now-grand exterior, it was still grim inside. Architect Augustus Pugin was a patient here in 1852. In 1936, the building mutated into a war museum, and a 1989 renovation included the addition of a top-lit exhibition hall with a diagonally latticed, barrel-vault roof. This is a light steel structure, but original, heavy masonry walls remain. Exhibits here include everything from tanks and aircraft to ration books.

457

QUEEN ELIZABETH HALL

Queen Elizabeth Hall is an example of 1960s Brutalism, and the passion then for multi-level constructions. The services and stairs are set around the exterior, leaving an uncluttered central core. The windows are almost invisible as they are set behind the line of the walls and roof. The venue was

opened by the Queen in 1967 and, with seating for just over a thousand, it is used mainly for small orchestral concerts,

SEI

SEL

SEL

a thousand, it is used mainly for small orchestral concerts, chamber music, poetry readings, conferences, and film performances. The more intimate Purcell Room seats 372; soloists and chamber groups usually perform there. At ground and subterranean level, the concrete ramps have become hugely popular with local skateboarders!

458

LAMBETH PALACE

Lambeth Palace has been the official London residence of the archbishops of Canterbury since 1200. Located on the south bank of the Thames, the land here was low and sodden—known then as Lambeth Marsh. The palace comprises medieval, Tudor, and Jacobean buildings, and it would originally have been approached by river. Wat Tyler's rebels over-ran the palace in 1381, burning books, and smashing furniture and wine casks. The vaulted crypt under the chapel is thirteenth century, and Lollard's Tower dates from 1440. At the Tudor gatehouse (1486–1501), the Lambeth Dole was handed out three times a week to the poor until 1842. The palace was used as a prison during the British Civil War.

459

SOUTHWARK CATHEDRAL

Southwark Cathedral, the earliest Gothic church in London, with many French-inspired details, developed from a priory—and then the Church of St Saviour and St Mary Overie. The current construction is the fourth holy building to have been built on this site; it became a cathedral in 1905. It is thought that the first building was constructed as early as the beginning of the seventh century. Traces of the third construction, the early twelfth-century Norman Priory church, still survive. In Elizabethan times, part of the church was leased as a bakery and even used as pigsties. A large nineteenth-century stained-glass window is dedicated to William Shakespeare. It depicts scenes from some of his plays; a nearby statue shows the writer holding a quill. John Harvard, the founder of Harvard University, was born in Southwark in 1607, and baptised in St Saviour's.

GUY'S HOSPITAL

Guy's Hospital was founded in 1721 by religious publisher. MP, and sheriff of the City Sir Thomas Guy, who had made a 'killing' with South Sea stock. Set behind iron gates and railings, the ground floor of the frontage is rusticated and spanned by arched windows. Above three central arches, are columns crowned by a pediment—lupp's Palladian addition of 1774. Behind the frontage are eighteenth-century courts and chapel. Famous 'Guy's' include Richard Bright (who pinpointed Bright's disease), Thomas Addison (Addison's disease), Thomas Hodgkin (Hodgkin's disease), plus poet John Keats, who was a student here. Guy's became the first hospital in London to appoint a dental surgeon, and it has been famous for dentistry ever since. The thirtyfour-storey Guy's Tower was added in 1974. This makes the building one of the tallest in London, and the highest hospital anywhere-at 143 metres (469 feet).

461

SEI

SEL

MARKET PORTER

There has been a pub here since 1638. This building is in Olde English Tudor style, with small-paned lead windows and lots of beams, panels, old partitions, a carved barback, stained glass, and open fires. The pub still has a market licence to serve the market porters, and is open for breakfast drinks. Its owner co-founded Bishop's Brewery. The pub was transformed into the 'Third Hand Book Emporium' in the film *Harry Potter and the Prisoner of Azkaban*, situated next to 'The Leaky Cauldron.'

462

CENTRAL BUILDINGS AND THE HOP EXCHANGE

The Hop and Malt Exchange was a centre for hop growers, merchants, and dealers. Cast-iron hops entwine the front, and carvings depict hop gatherers pulling, picking, and packing the crop into wicker baskets or carts; many Londoners spent summer days hop picking in Kent's fields. Inside, this highly ornamental building has a spectacular atrium, dramatic high ceilings, and three floors of ornate galleries and balustrades. A 1920 fire destroyed the ornamental glass roof that allowed buyers to inspect the hops in daylight. The building has been restored—as offices and a venue for hire.

46

FORMER COUNTY HALL

This riverside spot has long been a busy place and excavations to the site here revealed the remains of a Roman boat. The building's progress was interrupted by World War I, and County Hall was not finally opened by King George V until 1922. It was not until 1933 that the northern riverside façade was constructed, and it was 1963 by the time the whole block was completed. The size is impressive—a span of over 233 metres (765 feet)—with a colonnaded crescent and end pavilions. It is built in Edwardian Renaissance style—faced with Portland stone, but with a granite base. There are several internal courtyards. Today, County Hall is the site of Dalí Universe and the London Aquarium, as well as two hotels, plus several restaurants and apartments.

464

RIVERSIDE HOUSES

Here are a few surviving fragments of the 1700s. Provost's Lodgings, numbers 50 and 52, were gutted in World War II but then restored. The houses from 49 to 52 remained as homes, even during the recent development of the Globe Theatre. The busy Thames riverside was crammed with ale houses. The Anchor, on the corner, has existed here for over eight hundred years, but has been rebuilt several times. A plaque on number 49 claims that Wren lived here while designing St Paul's across the river (this may not be true). Samuel Pepys had watched the Great Fire of London across the river from here—seeking refuge in 'a little alehouse on bankside...and there watched the fire grow.'

465

ST THOMAS'S HOSPITAL

This ancient institution was probably part of a priory. In

SEI

SEL

SET

the early 1400s, Lord Mayor Richard Whittington made 'a new chamber with eight beds for young women who had done amiss, in trust of a good amendment.' By 1566, the first physician received £13 6s 8d a year; in 1583, the cook earned an extra £1 per year as a gravedigger. The hospital moved here in the 1860s—built in the Italianate style approved by Florence Nightingale, who established the Nightingale Training School of Nursing and revolutionised the role of nurses, replacing degenerate (and often inebriated) slovens with caring hygienic professionals. After World War II, a new east wing was built; a north wing arrived in the 1960s.

466

WAREHOUSES

Today, Shad Thames is partly cobbled, and is flanked by many converted brick warehouses with original brickwork, winches, and Victorian signage. Now there are restaurants, shops, and offices at ground level, and domestic flats above. In Victorian times, this vast warehouse complex stored tea, coffee, and spices. High above the pavement, raised walkways criss-cross the path between the Butlers Wharf and Cardamom buildings. These would have been used to roll barrels between the warehouses. In *Oliver Twist*, Charles Dickens set Bill Sykes's den at the eastern end of Shad Thames. This area has been a film location for *Oliver!* (1968), *The Elephant Man* (1980), *The French Lieutenant's Woman* (1981), *A Fish Called Wanda* (1988), and *Mad Dogs and Englishmen* (1995).

467

HORSELYDOWN SQUARE

With its Mediterranean colours of bright ochres and reds, Horselydown Square makes a cheerful contrast to its neighbours, the Shad Thames warehouses. The buildings set around the square are a mixture of domestic flats, offices, and shops set into alcoves. The five- and seven-storey buildings are a combination of brick, metal, and glass, with interesting windows, balconies, bays, and circular towers that almost look like lighthouses.

468

THE NEW GLOBE

This exciting project seized the world's imagination as Shakespeare's Globe Theatre rose again beside the Thames. Today's reconstruction of the playhouse (designed first in 1599) is very close to the original site-now partly covered by a listed Georgian building in Anchor Terrace: a coloured brick semicircle marks its exact location. Here, Shakespeare acted and wrote many of his greatest plays. In 1613, the theatre burnt down when a spark from cannon set the roof alight during a performance of Henry VIII. The Globe was rebuilt in 1614, closed by the Puritans in 1642, and demolished two years later. Other buildings, including a brewery, followed-but, eventually, the site was deserted. This New Globe was inspired by actor-director Sam Wanamaker and raised on the Bankside after over twenty years of determined effort. The complex includes a pub, visitors' centre, and exhibition hall. The New Globe has the first thatched roof permitted in London since the Great Fire, made of Norfolk reed (well fire-proofed!), on a timber frame of green oak. The open air arena (called the pit or yard) has a raised stage surrounded by three tiers of roofed galleries.

469

COURAGE BREWERY

Originally built in 1787, the Courage Brewery operated for some two centuries, with nearby Anchor Terrace built for senior brewery employees in the 1830s. The brewery presents a massive bulk to the river, with its tall chimney, galleries, and a domed tower that all lend it great height and presence. Between 1985 and 1987, the brewery and adjacent boiler-house were converted into apartments.

470

WATERLOO INTERNATIONAL TERMINAL

The original mainline Waterloo Station opened in 1848, named after the Battle of Waterloo in which Napoleon was defeated near Brussels. This station was also the terminus for London's daily funeral express to Brookwood Cemetery and transported many a coffin at 2/6d a single

LONDON SOUTHEAST (SE)

trip. The station was torn down at the turn of the last century and rebuilt. With Eurostar's Channel Tunnel services to France and Belgium, Waterloo International was linked to the mainline terminus in the 1990s, at a cost of £130 million. Its design, with a 400-metre (1,312-foot) glass canopy with bowstring arches, won several awards-but now the Eurostar service is moving to St Pancras in 2007. The station is linked to the South Bank by an elevated walkway.

471

ROYAL NATIONAL THEATRE

The idea for a Royal National Theatre had been debated for two centuries and, at last, this purpose-built theatre arrived on the South Bank. The idea to build a theatrical complex here was conceived by Sir Laurence Olivier in 1963, but it took a further thirteen years for Lasdun and Partners' designs to be realised. The first-ever production starred Peter O'Toole in *Hamlet*, directed by Sir Laurence. The building has three performance venues: the Olivier, the Lyttleton, and the Cottesloe. The building was updated in 1998, with the addition of a new entrance from the river Thames side and a paved square known as Theatre Square.

472

DESIGN MUSEUM

Inspired by 1930s buildings, this was an imaginative renovation and transformation of a 1950s warehouse, with 'cool' stuccoed surfaces painted sparkling white. Its calm spacious interior has galleries on the top two floors, and a neat exhibition display system. Exhibits include cars, tableware, telephones, radios and televisions, washing machines, office equipment, and furniture—arranged by theme. Temporary shows are sometimes held in the Collection Gallery. The top floor focuses on contemporary design, with everything from Nike trainers to an Aston Martin V12 Vanquish. The Blueprint Café enjoys extensive balconies, overlooking the Thames and Tower Bridge. The building was described by fashion designer Paul Smith as 'the natural home for everyone who has ever enjoyed or appreciated design.'

473

MORDEN COLLEGE

This began as an almshouse founded by philanthropist Sir John Morden, a merchant who faced potential poverty when his ships were believed to be lost. In 1695, when the vessels had finally arrived safely, he built these homes, as a thanks offering—for 'poor Merchants. . . and such as have lost their Estates by accidents, dangers and perils of the seas or by any other accidents ways of means in their honest endeavours to get their living by means of Merchandising.' He is buried here, and there are statues of him and his wife in a double arch in a pediment above the west door. The building has a lovely colonnaded courtyard and is home to elderly people.

474

SEL

SEL

VANBRUGH CASTLE

An author of Restoration comedies, Sir John Vanbrugh was also an architect, renowned for his design of Castle Howard and Blenheim Palace. In 1716, he was appointed surveyor to Greenwich Hospital as Wren's successor, and built this edifice—England's first mock medieval castle, overlooking the Royal Hospital. It has Gothic-inspired narrow windows and turrets and false roofs, and was called 'the Bastille' by Vanbrugh—who had been imprisoned in the Bastille in 1692 on suspicion of being a spy. Only the centrepiece has survived redevelopment in the 1890s and 1900s. The Blackheath Preservation Trust purchased the site in 1976 and set about restoring the castle and converting it into four dwellings.

475

ST GILES CHURCH

In February 1841, the parish church of Camberwell was destroyed by fire. A competition to find an architect for a new church was won by the Scott & Moffatt practice. This replacement church, raised with the £14,500 insurance money, was consecrated in November 1844. Its central tower has a broach spire some 64 metres (210 feet) high; this has recently undergone a complete rebuild due to major structural defects. The large Kentish ragstone church

SE3

SE5

SE9

is in Gothic style, but with some continental details; and its imposing porch has many decorative features. The church is now Grade II listed. An early 1300s church once stood on this site, and just a few remnants of this have been placed in the south wall of the present chancel.

476

SE7

SE9

CHARLTON HOUSE

This is the only complete Jacobean house in Greater London. It was built as a retirement gift for Adam Newton, a tutor to James I's son—now a community centre and library. The redbrick building has white stone quoins and dressings, and forms an H shape. An orangery and summerhouse here are probably the work of Inigo Jones. The north wing was damaged in World War II and rebuilt, but much else survived intact, including original ceilings, fireplaces, the carved main staircase, wood panelling, and stables. The ceilings have been restored using the original mouldings. The oldest mulberry tree in England may be the one planted here by James I in 1608.

477

TUDOR HOUSE

Eltham developed along the old road from London to Maidstone. Its name may mean 'Homestead or river meadow frequented by swans' or, more likely, 'a man named Elta.' Later Tudor royalty preferred the riverside palace of Greenwich, but Sir John Shaw, supporter of Charles II's Restoration, built himself an elegant mansion here. Eltham Lodge. Famous locals include Bob Hope and Lee Ryan (born here), Frankie Howerd and Boy George (brought up here), and the daughter of Sir Thomas More, Margaret, and her husband, William Roper, who lived nearby at the Tudor Barn. Edith Nesbit (whose books include The Phoenix and the Carpet and The Railway Children) lived at Well Hall House. This particular building is a superb slice of Tudor architecture with its sturdy timberwork striping the gable end, dormers, superb leaded windows, and overhanging upper storeys.

478

ELTHAM PALACE

In the 1000s, Odo, Bishop of Bayeux owned Eltham manor, but it was a royal palace from 1311-presented to the future Edward II; he extended it for Oueen Isabella. who spent much time here. It was ever a convenient spot for monarchs travelling to and from their French territories. Later improvements and the building of a stone bridge over the moat were supervised by Geoffrey Chaucer, then clerk of works. Here, Henry IV was married by proxy to Joan of Navarre in 1402. The moat bridge and the great hall (built in the late fifteenth century) have survived. The hall boasts the third largest hammer-beam roof in England. constructed about 1479 by Edward IV. A new chapel was built in the reign of Henry VIII, who often called by. When Parliament seized it, after the execution of Charles I, the palace was used as a farm. It was soon reported to be 'much out of repair,' and by the 1660s, was in ruins-with the Great Hall used as a barn. It was not rescued until the 1930s, when the medieval palace was restored and a new house rose here, too, with a splendid Art Deco interior and a glass dome. At the entrance to the palace, in Court Yard, is Chaundrye Close, once home to Cardinal Wolsey.

479

CUTTY SARK

Here, in a delightful row of elegant houses from the late 1700s and early 1800s, is this Grade II–listed tavern with a large bow window. There has been an inn here for nearly five hundred years. The present building (renamed after the famous tea clipper in dry dock at Greenwich), dates back to at least the early nineteenth century, but may well be much older. The ground floor bar is dominated by an enormous staircase, and there are nooks and crannies everywhere, stone and bare board floors, black oak beams, Victorian glass, ship timbers, brass lamps, and lanterns. The chairs are made out of barrels to reflect this nautical flavour. Outside, a riverside terrace is set beyond a narrow cobbled way.

BUILDING DESCRIPTIONS

625

SE10

ROYAL NAVAL COLLEGE

The King Charles Block was planned as a palace; the hospital arrived later, on the instructions of Queen Mary of Orange, who was concerned about the plight of wounded sailors. This magnificent retreat incorporated the Queen's House and King Charles Block into a grand symmetrical sweep. The buildings mirror each other, and create an 'avenue' leading to the river. The hospital closed to pensioners in 1869; the buildings were occupied by the Royal Naval College from 1873 until 1998—and have appeared in *The Madness of King George, Four Weddings and a Funeral, The Mummy Returns* and *Lara Croft: Tomb Raider.*

481

ADMIRAL HARDY

This tavern exterior remains more or less original with its formal stone frontage and narrow, deep sash windows. Inside is a stone floor, wooden panelled walls, a cast-iron fireplace, suitably nautical oil paintings, and tall lamps made from oars. The pub adjoins the covered market and at one time incorporated a grocery store, fishmongers, and a delicatessen. The tavern was named after the Hardy from whom Nelson received his dying kiss at Trafalgar. Captain Hardy served with Nelson in Egypt, Naples, Sicily, Copenhagen, Toulon, and the West Indies. He became the first sea lord of the admiralty but spent the last years of his life as governor of Greenwich Hospital.

482

CHAPEL

Wren's original chapel was gutted in 1779, when a fire spread from a tailor's shop below. Its restoration incorporated elaborate Baroque and Rococo styling with delicate plasterwork decorations and pastel colours. Two pairs of vast Corinthian columns flank Benjamin West's vast painting of St Paul's shipwreck near Malta. Decorative panels on the pulpit also depict St Paul, and there are excellent paintings by Italian artist Biagio Rebecca. A fine bust depicts Admiral Sir Thomas Hardy (of 'Kiss me, Hardy' fame), who commanded the Victory at Trafalgar. The huge organ, set in a gallery with fluted, marble lonic columns, was made by famous organ-builder Samuel Green. Above the entrance, rises a great domed tower with eight bays and three tiers of windows.

483

SE10

SE10

SE10

A PARK LODGE

Kennington Common was a site of public executions until 1800, and witnessed many a grisly hanging. More cheerfully, this has ever been a place for great cricket matches, long before the Oval cricket ground arrived. Later, when John Wesley spoke here in 1739, he addressed a crowd of some 30,000. In 1852, the common was enclosed after the unruly Chartists had gathered here in 1848. Charlie Chaplin grew up locally and is possibly met his first girlfriend in the park. This building eventually became the lodge for Kennington Park; it looks like a single entity but in fact was designed to comprise four small Tudor-style homes—two on each storey. The building was first seen at the 1851 Great Exhibition, as an example of Reformist housing. Then, with its multi-coloured brickwork, elegant gables, and central balcony, it was rebuilt here.

484

DEPTFORD TOWN HALL

The architects for this Grade II–listed town hall, one of Deptford's most renowned buildings, were chosen through a competition. Their work was instrumental in the classical revival and founding of Edwardian Baroque. This magnificent, sevenbay stone façade has many nautical features, including statues of admirals and a clock tower with a sailing-ship weathervane. A sea battle is depicted in the tympanum and, inside, behind this jolly façade, are marble columns, more sculptures, and a domed lantern. The building was given a much-needed facelift after Goldsmiths College acquired it in 2000.

485

ST MARY ROTHERHITHE

The first church here, served by Catholic priests from Bermondsey Abbey, became a Puritan church. In 1714, parishioners and local craftsmen rebuilt it 'which stand-

SEII

SE14

SE16

SE18

SE18

ing very low and near the banks of the Thames, is often overflowed, whereby the foundation . . . is rotted and in great danger of falling.' Some medieval stone blocks remain. The piers are ship masts, encased in plaster. The Bishop's Chair is of timber salvaged from a battle of Trafalgar gun ship. A plaque commemorates Prince Lee Boo, son of a cannibal chief, who rescued shipwrecked sailors in 1783 and was brought to visit Rotherhithe.

486

NELSON HOUSE

Nelson Dock is the only dry dock left in London. This very pleasing five-bay house with its beautiful wrought-iron gates and an elegant, white central section was the original dock owner's home—and a very rare example of the style used for merchant ship owners during the 1700s. It is now part of a Hilton Hotel complex that incorporates the original wharf buildings here. Nearby is La Dame de Serk, a full-size replica of a three-masted French barque that now houses a bistro called Traders.

487

ST PETER THE APOSTLE

St Peter's has no tower and its chancel was added later. Pugin was the son of a French architect who came to England to escape the French Revolution. He designed both Anglican and Catholic churches here and abroad. His father had taught him to draw Gothic remains and, from fifteen years old, he was designing Gothic-style furniture for Windsor Castle. Later, he worked with Sir Charles Barry to complete the plans for the Houses of Parliament. Pugin produced a 'mediæval court' at the Great Exhibition of 1851 but died suddenly after a mental collapse. Queen Victoria granted his widow a pension of £100 a year. He was the father of Victorian architect E. W. Pugin.

488

ROYAL ARSENAL

Woolwich is an historic riverside site linked to both dockyard and weaponry since Henry VIII raised the first arsenal in 1512. In 1671, the Crown bought an old mansion (Tower Place), to use as an ordnance storage depot, and soon ammunition, fuses, and gunpowder were made here, too. This brick entrance is magnificent, with robust piers, lions set on pedestals, and a high central semicircular arch. In I7I6—after an accident at the city's Moorfield foundry caused seventeen deaths—the government built its own foundry at Woolwich, designed by Sir John Vanbrugh. It is still much as it was then but today is home to a fascinating museum on firepower and artillery.

489

SE16

SE18

SE18

SEVERNDROOG CASTLE

In the I500s, Shooters Hill was a beacon hill for signal bonfires. Here, rising above the trees of Castlewood, this triangular Gothic tower is an attractive folly with castellated hexagonal turrets and lancet windows. It was raised by Sir William James's widow (whose house was in the valley below) to celebrate her courageous seafaring husband's 1755 capture of its namesake, a pirate fortress in India. Ironically, a pirate radio station attempted to put its antenna on the roof of this Grade II–listed building. The castle rises I9 metres (63 feet) high but needs repair and, in 2004, was featured in the BBC Restoration series.

49(

ROYAL ARTILLERY BARRACKS

Woolwich has been the home of the Royal Artillery since 1716 but the Master General of the Ordnance has equipped British campaigns from here since 1671. In 1805, the Royal Carriage Factory, Royal Laboratory, and Royal Foundry were amalgamated into the Royal Arsenal. Its splendid façade is the longest (323 metres, or 1,060 feet) continuous single piece of architecture in London. It has a white triumphal arch in the centre, with the three-storey brick barracks linked by elegant white colonnades. Today the Queen is Captain-General of the Royal Artillery. Woolwich has a few other claims to fame. General Gordon of Khartoum was born at 29 Woolwich Common and educated at the Royal Military Academy, diarist Samuel Pepys lodged in Woolwich during 1665 to escape the plague, and the United Kingdom's first ever McDonald's arrived here in 1974.

BUILDING DESCRIPTIONS 627

WOOLWICH GARRISON

The former Royal Military Academy was launched in 1741 to instruct 'raw and inexperienced' recruits and, some sixty years later, this building was raised next to Woolwich Common—to replace the original school within the Arsenal. A brown and yellow brick façade in Gothic Revival style, it overlooks the parade ground with its centrepiece and domed corner turrets based on the Tower of London. The end pavilions are a later addition. It is still possible to see soldiers from the nearby Royal Artillery Barracks training on Woolwich Common. The Woolwich garrison is now home to a thousand infantry soldiers who are mainly engaged in ceremonial duties.

492

DULWICH MUSEUM, MAUSOLEUM AND PICTURE GALLERY

England's oldest public art gallery was built for Dulwich College in simple classical lines. Unfussy and elegant, it houses a collection of paintings originally intended for the king of Poland but left to Sir Francis Bourgeois, whose bequest funded the college. Here are almshouses and, at the heart of the Gallery, a small mausoleum—possibly based on an Alexandrian catacomb—where the founders still lie. The buildings were renovated in 1953 after the mausoleum had suffered a direct bomb hit in 1944. The art gallery houses a collection of masterpieces by Canaletto, Gainsborough, Poussin, Rembrandt, Rubens, and Watteau.

493

POND COTTAGES

Here in prosperous Dulwich is a fascinating mix of twentieth-century suburbia, Victorian houses, clusters of cottages, and fine Georgian buildings. In the traditional village centre is the world-famous Dulwich Picture Gallery— England's oldest. Near the Mill Pond, by Dulwich College playing fields, are these delightfully rural, weatherboard and brick Pond Cottages, where the miller and tile-kiln workers once lived. Further down the road, a working toll-gate is the only one still in operation in London. Charles I came here to hunt stags but it was not always so peaceful. Two

SE18

SE21

SE21

highway robberies occurred within an hour in 1800, and the common was often the site of a bloody duel.

494

HORNIMAN MUSEUM

Designed by an Arts and Crafts architect, this museum has a massive clock tower. Its top-lit galleries house the collection of F. J. Horniman—a prosperous tea trader in the late 1800s—and include musical instruments and curios such as an orang-utan's foot and Arabian shoes with flaps to scare off scorpions! The collection began in his home but, by 1898, Horniman had commissioned this museum. The exterior is in smooth stone with relief ornament and a large mosaic façade, Humanity in the House of Circumstance by Robert Anning Bell. The exterior is free style; interiors are simple and functional, but the Victorian atmosphere pervades. A lecture hall and library were added in 1910. There are sixteen acres of gardens and an aquarium.

495

SE26

SF23

SIX PILLARS

As a student, Lubetkin had witnessed the Bolshevik revolution in Russia. He said that this was a defining moment and that architecture was another kind of politics: it should change people's lives. Lubetkin found others to join his radical practice, Tecton, aiming to bring Modernism to Britain. Grade II–listed Six Pillars was built for the headmaster of Dulwich preparatory school. An understated blend of concrete and London-stock brick, it has a high roof terrace and, of course, six pillars. At the back, large windows run the length of the rooms; in the ground-floor drawing room, a huge window-wall spans half the length of the house. There are multi-level roof terraces, a promenade balcony, and a wall of glass blocks with a 'cockpit' study set high above. The emphasis is on space and light.

DA6

DA18

496

TW9

PALM HOUSE

Prince Frederick, the son of George II and Queen Caroline, leased the Kew estate in the 1730s-and it was after his death in 1751 that his widow began the first true botanic garden here. Sir Joseph Banks was the first director of the royal gardens from 1772. He had sailed with Captain James Cook, on the HMS Endeavour (naming Botany Bay, Australia, in 1770) and collected many exotic plants. In due course, these were housed in Botany Bay House (1788-1856); 1841 is generally regarded as the foundation of the Royal Botanic Gardens when Sir William Hooker founded the museum, library, and herbarium. In 1848, the Palm House was added. This Grade I-listed building, a glass and iron palace for plants, is one of the world's finest surviving nineteenth-century glasshouses, and was the largest in the world when it opened. It was created specifically to house the collection of exotic palms and its structure was based on shipbuilding techniques, the design like an upturned hull. In 1984, it was emptied to be rebuilt and restored. Undoubtedly this helped it to survive the severe gales in 1987. It reopened in 1988, and today its toughened safety glass is held by sixteen kilometres (ten miles) of stainless-steel glazing bars.

497

ORANGERY

This elegant Grade I–listed structure has high ceilings, sweeping archways, and vast impressive windows. It was built for Princess Augusta in 1761 and filled with citrus trees. In 1863, it became a museum, but was restored in 1959 to once again hold citrus plants, before mutating into a gift shop and tea-room by the 1980s. The armorial bearings of Prince Frederick and Princess Augusta on the front are a reminder of its royal associations. In 2002, it reopened as a fine restaurant and entertainment venue—and now has a new outdoor terrace in York and Portland stone.

498

PAGODA

In the mid-1700s, chinoiserie was highly popular in English

garden design. This ten-storey octagonal structure is nearly 50 metres (163 feet) high and was the tallest reconstruction of a Chinese building in Europe at that time. It tapers, with each floor slightly smaller than the one below, and has neat red-painted fencing around each tier. The roofs were covered with varnished iron plates, and originally had eighty carved wooden dragons on the corners—gilded with real gold—but these fiery fellows have not been replaced in recent restorations. Two hundred and fifty-three steps lead to the top and spectacular views across the gardens to London, with the London Eye, the new Wembley Stadium, and Canary Wharf visible—both here and as a 360-degree panorama online. Below, Pagoda Vista is lined with paired broad-leaved trees and evergreen plantings, including a superb juniper collection.

499

RED HOUSE

Commissioned by William Morris in 1859, this Gothic building in warm redbrick has a steep, medieval-style, overhanging redtiled roof, both long and circular porthole windows, and a toadstool-style structure beside the arched entrance. Its interior retains many pieces of furniture designed by Morris and Webb, as well as wall paintings and stained glass by Rossetti and Burne-Jones. This has been a family home for a century and a half and epitomises countryside escapism.

500

TW9

MODERN ART GLASS LIMITED

This spectacular building is particularly apt for a company dealing with glass and served as a prototype for some of Norman Fosters's later glass edifices. The warehouse exterior is in blue stove-enamelled corrugated steel sheet taken over the top of a neat steel framework. With reflections pooling into its glass façade, the frontage almost disappears into images of sky and chasing clouds.

INDEX

ABBEY MILLS, 291, 577 ABSTRACT HOUSING, 360, 587 ACAD CENTRE, 371, 588 ADAM STREET, 7, 135, 551 ADELAIDE HOUSE, 229, 567 ADMIRAL HARDY, 506,610 ADMIRALTY ARCH, 382, 590 ADMIRALTY SCREEN AND ADMIRALTY HOUSE, 391, 591 ALBERT BUILDINGS, 237, 568 ALBERT COURT, 462, 603 ALBERT GARDENS, 266, 573 ALBION SQUARE, 280, 575 ALL HALLOWS, 361, 587 ALL SAINTS, MARGARET STREET, 24, 530 ALL SAINTS, CAMDEN TOWN, 339, 584 ALL SOULS, 26, 530 ALMS HOUSES, TRINITY HOSPITAL, 264, 573 ANDREW UNDERSHAFT, 214, 564 ANNESLEY LODGE, 349, 585 APARTMENTS, 1930'S, 460, 603 APSLEY HOUSE AND WELLINGTON MUSEUM, 433, 598 ARDING AND HOBBS, 473, 605 ARK, THE, 83, 542 ARMOURY HOUSE, 178, 558 ARTS AND CRAFTS HOUSES, 447, 600 ATHENAEUM, THE, 383, 590 AUTHORS, DOCTOR, AND MISER, 445, 600 AWARD-WINNING OFFICES, 190, 560

BANK OF ENGLAND, 198, 561 BANOUETING HOUSE, 412, 595 BEDFORD PARK, 76, 540 BENETTON 85 542 BISHOP OF ELY'S HOUSE, THE, 51, 535 **BISHOPSGATE INSTITUTE, 202, 562** BLACK FRIAR, THE, 249, 571 BLACKFRIARS HOUSE, 250, 571 BLEEDING HEART TAVERN, 167, 556 BOLTON HOUSE, 357, 586 BOUNDARY STREET ESTATE, 273, 574 BOURNE ESTATE, 162, 556 BOW-FRONTED SHOPS, 101, 544 BRACKEN HOUSE, 239, 568 BRITANNIC HOUSE, 200, 562 BRITISH LIBRARY, THE, 346, 585 BRITISH MUSEUM, 113, 546 BRITISH TELECOM TOWER, THE, 32, 531 BRIXTON TOWN HALL, 444, 600 **BROADCASTING HOUSE, 27, 530** BROOK'S CLUB, 389, 591 BUCKINGHAM PALACE, 411, 595 BUILT ON A CRICKET GROUND, 329, 582 BUILT ON A ROMAN FORT, 191, 560 BURGH HOUSE, 350, 585 BURLINGTON ARCADE, 45, 534 BURLINGTON HOUSE, 47, 534 BUSH LANE HOUSE, 232, 567 BUSINESS DESIGN CENTRE, 299, 578

CANADA HOUSE, 121, 548 CANADA SQUARE, 25, 286, 576 CANNON STREET STATION, 233, 567 CARLTON HOUSE TERRACE, 381, 590

CASCADES, 284, 576 CATACOMBS AND VAULTS, 311, 580 CENTRAL BUILDINGS AND THE HOP EXCHANGE, 487, 607 CENTRAL CRIMINAL COURT, 248, 570 CENTRAL SCHOOL OF ARTS AND CRAFTS 115 547 CENTRAL YMCA, 110, 546 CENTRE HEIGHTS, 359, 587 CENTRE POINT, 117, 547 CHANNEL 4 TELEVISION HEADOUARTERS 410 595 CHAPEL, GREENWICH HOSPITAL, 507, 610 CHAPEL, LINCOLN'S INN, 149, 553 CHAPEL OF THE OPEN BOOK, 182, 559 CHAPTER HOUSE, 245, 569 CHARING CROSS STATION, 130, 549 CHARING CROSS STATION HOTEL, 128, 549 CHARLTON HOUSE, 501, 609 CHELSEA BARRACKS, 439, 599 CHEQUERBOARD HOUSING, 416, 596 CHESHIRE CHEESE, 144, 553 CHINA HOUSE, 43, 534 CHISWICK HOUSE, 75, 540 CHISWICK MALL, 73, 539 CHISWICK PARK, 77, 540 CHOLMELEY LODGE, 312, 580 CHRIST CHURCH, COMMERCIAL STREET, 271, 574 CHRIST CHURCH, NEWGATE STREET, 173, 557 CHRIST'S HOSPITAL OFFICES, 223, 566 CHURCH CRESCENT, 24, 281, 575 CHURCH OF ST PETER, 430, 598 CHURCHILL ARMS, THE, 88, 542 'CIRCULAR SQUARE', A, 109, 545 CITY BARGE, THE, 79, 541 CITY OF LONDON CLUB, 206, 563 **CITY POINT, 184, 559**

CITY UNIVERSITY COLLEGE, 161, 556 CLACHAN, THE, 38, 533 CLERGY HOUSE, 420, 596 CLISSOLD HOUSE, 319, 581 COLLEGE OF ARMS, 243, 569 COLVILLE PLACE, 34, 532 CONGRESS HOUSE, III, 546 CONNAUGHT HOTEL, 53, 536 CONSERVATORY, THE, 187, 559 COTTAGE-STYLE HOUSES, 375, 589 COURAGE BREWERY, 494, 608 COUTTS BANK 134, 550 COVENT GARDEN PIAZZA, 131, 550 CROMWELL TOWER, 185, 559 CUMBERLAND TERRACE, 340, 584 CUNARD HOUSE, 213, 564 CUTTY SARK, 504, 610

DARWIN CENTRE, 468, 604 DEBENHAM HOUSE, 95, 543 DEPTFORD TOWN HALL, 509, 611 DESIGN MUSEUM, 497, 608 DETACHED ILLUSION, A. 71, 539 DICKENS MUSEUM, 106, 545 DISTINCTIVE OFFICES, 236, 568 DIXCOT, 477, 605 DOLPHIN SQUARE, 436, 599 DORCHESTER HOTEL, 61, 537 DORSET HOUSE, 335, 583 DOVER HOUSE, 392, 591 DR. JOHNSON'S HOUSE, 255, 571 DUDLEY HOUSE, 57, 536 DULWICH MUSEUM, MAUSOLEUM, AND PICTURE GALLERY, 517, 612

DUTCH-STYLE HOUSE, 469, 604 DUTCH-STYLE HOUSES 297, 578

EAST HEATH ROAD, 354, 586 EDWARD VII GALLERIES, 107, 545 ELEGANT HOUSES, 17, 528 ELEGANT SQUARE, AN, 31, 531 ELEGANT SYMMETRY, 374, 589 ELTHAM PALACE, 503, 609

FENCHURCH STREET STATION, 220, 565 FENTON HOUSE, 358, 587 FINSBURY SQUARE, 181, 558 FINSBURY TOWN HALL, 159, 555 FISHMONGERS HALL, 230, 567 FIVE-BAY HOUSE, 298, 578 FORMER COUNTY HALL, 488, 607 FORMER PUBLIC RECORD OFFICE, 152, 554 FOUNTAIN COURT, 259, 572 FREEMASON'S HALL, 155, 555 FROBISHER CRESCENT, 186, 559

GARNER STREET HOUSE, 276, 575 GATEHOUSE, 148, 553 GEFFRYE MUSEUM ALMSHOUSES, 278, 575 GEORGE, THE, 145, 553 GEORGIAN HOUSES, 33-35 CROSS STREET, 304, 579 GEORGIAN HOUSES, DUNCAN TERRACE, 296, 578 GEORGIAN HOUSES, NEAR HAMPSTEAD UNDERGROUND STATION, 351, 586 GEORGIAN HOUSES, PRETTY, 355, 586 GOLDMAN SACHS OFFICES, 253, 571 GOLDMAN SACHS OFFICES, MORE, 254, 571 GOTHIC HOUSE, 451, 601 GRAND 1700'S STREET, A, 28, 530 GRANGE LANGHAM COURT HOTEL, 25, 530 GREAT ST. HELEN'S, 216, 565 GREEK REVIVAL FLATS, 424, 597 GREYHOUND, THE, 86, 542 GROSVENOR CHAPEL, 59, 537 GROSVENOR HOTEL, 434, 599 GROSVENOR HOUSE HOTEL, 56, 536 GROVE, THE, 306, 579 GUILDHALL, 194, 560 GUY'S HOSPITAL, 485, 606

HAMMERSMITH SURGERY, 82, 541 HAMPSTEAD TOWERS, 353, 586 HANDEL'S HOUSE, 20, 529 HANOVER TERRACE AND LODGE, 332, 583 HARRODS, 427, 597 HEAL AND SON LIMITED, 33, 532 HENRY VII'S CHAPEL, WESTMINISTER ABBEY, 395, 592 HENRY COLE BUILDING, 459, 602 HIGH STREET 17-21, 23, AND 42, 310, 579 HIGHGATE CEMETERY, 309, 579 HIGHLY ORNATE OFFICES, 388, 591 HILTON LONDON METROPOLE, 65, 538 HOGARTH'S HOUSE, 74, 540 HOLLAND HOUSE, 94, 543 HOLLY VILLAGE, 308, 579 HOLY SEPULCHRE WITHOUT NEWGATE, 172, 557 HOLY TRINITY, CLOUDESLEY SOUARE, 300, 578 HOLY TRINITY, KINGSWAY, 153, 554 HOLY TRINITY, SLOANE STREET, 429, 598 HOME TO THE BEATLES, 15, 528 HOMES FOR 'PERSONS OF QUALITY', 55, 536 HOOVER BUILDING, 81, 541

HORNIMAN MUSEUM, 519, 612 HORSE AND GROOM, THE, 405, 594 HORSE GUARDS, THE, 394, 592 HORSELYDOWN SQUARE, 492, 608 HORSES TO HOUSES, FROM, 406, 594 HOUSE, 1930'S, 453, 601 HOUSE AND STUDIO, 370, 588 HOUSE OF TRIANGLES, A, 164, 556 HOUSE ON AN HISTORIC SITE, 403, 593 HOUSE WITH GLASS BRICKS, 356, 586 HOUSES AND FLATS, 91, 543 HOUSES BY THE RIVER, 450, 601 HOUSES OF PARLIAMENT, 400, 593 HOUSES WITH ORNATE TILING 52 535 HOUSING, ALTON WEST ESTATE 474, 605 HOUSING "COMPASS POINT", 287, 576 HOUSING COMPLEX, 365, 587

INCOMPLETE CIRCUS, THE, 13, 528 IMPERIAL INSTITUTE, 461, 603 IMPERIAL WAR MUSEUM, 481, 606 INNER TEMPLE LIBRARY, 257, 572 INNS OF COURT, 116, 547 INSTITUTE OF DIRECTORS, 385, 590 INSTITUTE OF EDUCATION, 103, 544

JACK STRAWS CASTLE, 348, 585 JAMAICA WINE HOUSE, 210, 564 JAMES SMITH AND SONS, 114, 546

KEELING HOUSE, 274, 574 KENSINGTON PALACE 90, 543 KENSINGTON PALACE ORANGERY, 89, 542 KENT HOUSE, 338, 583 KENZO, 21, 529 KING'S BENCH WALK, 258, 572 KING'S COLLEGE, 143 , 552 KING'S HEAD AND EIGHT BELLS, 456, 602 KINGSWOOD AVENUE, 367, 588

LADBROKE ESTATE, 92, 543 LAMB AND FLAG, 123, 548 LAMBETH PALACE, 483, 606 LANCASTER HOUSE, 413, 595 LANESBOROUGH HOTEL, 531, 598 LANSDOWNE HOUSE, 93, 543 LAUDERDALE HOUSE, 321, 581 LAWRENCE HALL (THE ROYAL HORTICULTURAL SOCIETY) THE. 442,600 LAW SOCIETY LIBRARY, 147, 553 LEADENHALL MARKET, 209, 563 LE MERIDIEN, 44, 534 LIBERTY'S, 37, 532 LINCOLN'S INN NEW HALL, 150, 554 LINDSEY HOUSE, 156, 555 LIVERPOOL STREET STATION AND HOTEL, 203, 562 LLOYD'S OF LONDON, 212, 564 LLOYD'S REGISTER OF SHIPPING, THE, 219, 565 LONDON CENTRAL MOSOUE, 333, 583 LONDON METROPOLITAN UNIVERSITY, 313, 580 LONDON ORATORY, 446, 600 LONDON'S LARGEST SOUARE, 104, 545 LUTYENS BANK, A, 211, 564

MAISONETTES, 1960'S, 69, 539 MANDARIN ORIENTAL HYDE PARK, 432, 598 MANSION HOUSE, 231, 567 MANSION, MEETING HOUSE, AND HOMES, 204, 562 MARBLE ARCH 12, 528

MARKET PORTER, 486, 607 MARYLEBONE STATION, 327, 582 MARY SHELLEY'S HOUSE, 426, 597 MARY WARD HOUSE, 102, 544 METROPOLE, THE, 129, 549 MICHELIN BUILDING, 452, 601 MIDDLESEX GUILDHALL, 390, 591 MIDDLE TEMPLE HALL, 260, 572 MILLBANK TOWER, 417, 596 MODEL DWELLINGS, 275, 574 MODERN ART GLASS LIMITED, 527, 613 MODERNIST HOUSE, NEWTON ROAD, 68, 538 MODERNIST HOUSE, OLD CHURCH STREET, 457, 602 MONTEVETRO, 472, 605 MORDEN COLLEGE, 498, 609 MUSEUM OF CHILDHOOD, 277, 575 MUSEUM OF LONDON, 188, 559

NATIONAL AUDIT OFFICE, 441, 600 NATIONAL GALLERY, 124, 548 NATIONAL PORTRAIT GALLERY, 125, 548 NATIONAL WESTMINSTER BANK, 196, 561 NATURAL HISTORY MUSEUM, THE, 467, 604 NAVAL AND MILITARY CLUB, THE, 398, 592 NATWEST BANK, 42, 533 NATWEST BANK, 42, 533 NATWEST MEDIA CENTRE, 369, 588 NEAT GEORGIAN STREETS, 404, 594 NELSON HOUSE, 511, 611 NEW GLOBE, THE, 493, 608 NOEL COWARD HOUSE, 415, 595 NORMAN SHAW BUILDING, 384, 590 NORTHGATE MANSION, 368, 588 NUMBER ONE POULTRY, 197, 561 OLD BELL, THE, 252, 571 OLD BULL AND BUSH, THE, 352, 586 OLD HALL, 151, 554. OLD ST. MARY, 318, 581 OLD ST. PANCRAS CHURCH, 343, 584 OLD TREASURY BUILDING (AND CHURCHILL MUSEUM), 393, 592 OFFICES AND 'PLAISTERERS', 189, 560 OFFICES, SHOPS AND SKATING RINK, 183, 559 OLYMPIA EXHIBITION HALL, 96, 544 ONE ALDWYCH, 141, 552 ONE CANADA SQUARE, 289, 577 ORANGERY, 524, 613 ORION HOUSE, 120, 547

PADDINGTON STATION, 67, 538 PAGODA, 525, 613 PALACE THEATRE, 139, 551 PALLADIA HUDSON HOUSE, 133, 550 PALM HOUSE, 523, 613 PANTECHNICON, 421, 596 PARK CRESCENT, 29, 531 PARK LANE, 45, 60, 537 PARK LODGE, A, 508, 610 PARKSTEAD HOUSE, 476, 605 PAVILION, THE, 201, 562 PEABODY TRUST HOUSING, 303, 578 PEEK HOUSE, 226, 566 PEMBROKE STUDIOS, 84, 542 PENTONVILLE PRISON, 314, 580 PICCADILLY ARCADE, 387, 591 PICKERING PLACE 379, 589 PIMLICO SCHOOL, 438, 599 PITSHANGER MANOR MUSEUM, 80, 541 POND COTTAGES, 518, 612 PORTCULLIS HOUSE NEW PARLIAMENTARY BUILDING, 407, 594 PROSPECT OF WHITBY, 272, 574 PRUDENTIAL INSURANCE, 166, 556 PUBLIC LIBRARY AND SWIMMING POOL, 363, 587 PULLMAN COURT, 443, 600 PUMPING STATION, 283, 576 PUNCH TAVERN, 251, 571

QUEEN ELIZABETH II CONFERENCE CENTRE, 414, 595 QUEEN ELIZABETH HALL, 482, 606 QUEEN'S CHAPEL, 399, 593 QUEEN'S HOUSE, 448, 601

RED HOUSE, 526, 613 REGENCY HOUSES, 422, 597 REUTERS, 288, 576 RICHMOND TERRACE, 409, 594 RITZ HOTEL, THE, 50, 535 RIVERSIDE HOUSES, BANKSIDE, 489, 607 **RIVERSIDE HOUSES, CHISWICK, 78, 541** ROEHAMPTON HOUSE, 475, 605 ROW OF HOUSES, 322, 581 ROYAL ACADEMY OF ARTS, THE, 46, 534 ROYAL ACADEMY OF MUSIC, 336, 583 ROYAL ALBERT HALL, 458, 602 ROYAL ARCADE, THE, 49, 535 ROYAL ARSENAL, 513, 611 ROYAL ARTILLERY BARRACKS, 515, 611 ROYAL AUTOMOBILE CLUB, 380, 589 ROYAL BANK OF SCOTLAND, 199, 562 ROYAL COLLEGE OF ORGANISTS, 471, 604 ROYAL COURT THEATRE, 423, 597 ROYAL COURTS OF JUSTICE, 146, 553

ROYAL EXCHANGE, 207, 563 ROYAL HOMES, 58, 536 ROYAL HOSPITAL, 449, 601 ROYAL INSTITUTE OF BRITISH ARCHITECTS, 30, 531 ROYAL MEWS, 425, 597 ROYAL MINT, THE, 269, 573 ROYAL NATIONAL THEATRE, 496, 608 ROYAL NAVAL COLLEGE, 505, 610 ROYAL OPERA HOUSE, THE, 132, 550 ROYAL SCHOOL OF MINES, 465, 603 RUDOLPH STEINER HOUSE, 334, 583 RUSSELL HOTEL, THE, 105, 545 RUSTICATED GRANDEUR, 41, 533

SADLER'S WELL THEATRE, 160, 555 SALISBURY, THE, 122, 548 SAVOY HOTEL, 138, 551 SCHOMBERG HOUSE, 397, 592 SCHRODERS INVESTMENT BUILDING, 192, 560 SCIENCE MUSEUM, THE, 463, 603 SELFRIDGES, 18, 529 SENATE HOUSE, 108, 545 SEVERNDROOG CASTLE, 514, 611 SHELL-MEX HOUSE, 136, 551 SHEPHERD MARKET, 62, 537 SHOPS AND FLATS, 372, 588 SHOPS AND OFFICES, 228, 567 SILKWEAVING HOUSES, 265, 573 SIR IOHN SOANE'S MUSEUM, 154, 554 SIX PILLARS, 520, 612 SLIM HOUSE, 176, 558 SMITHFIELD MARKET, 170, 557 SOHO THEATRE, 36, 532 SOMERSET HOUSE, 140, 552

ST. MARY-LE-BOW, 195, 561 SOUTH AFRICA HOUSE, 127, 549 ST. MARY-LE-STRAND, 142, 552 SOUTHWARK CATHEDRAL, 484, 606 ST. MARY ROTHERHITHE, 510, 611 SPANISH AND PORTUGUESE SYNAGOGUE, 217, 565 ST. ANNE'S, 285, 576 ST. MARY SOMERSET, 240, 568 ST MARY THE VIRGIN 326, 582 ST. AUGUSTINE, 464, 603 ST. MARY'S, 14, 52 ST. AUGUSTINE, KILBURN, 366, 587 ST. MARY'S CHURCH, 302, 578 ST. BARNABUS: SCHOOL AND HOUSE, 435, 599 ST. MATTHIAS, 315, 580 ST. BARTHOLOMEW THE GREAT, 174, 557 ST. BARTHOLOMEW'S HOSPITAL, 171, 557 ST NICHOLAS COLE ABBEY 242 569 ST. BENET PAUL'S WHARF, 241, 569 ST. PANCRAS CHURCH, 345, 585 ST. PANCRAS STATION, HOTEL, AND OFFICES, 325, 582 ST. DUNSTAN IN THE EAST, 224, 566 ST. PATRICK'S CHURCH, 35, 532 ST. ETHELREDA, 168, 556 ST. GEORGE, 112, 546 ST. PAUL'S CATHEDRAL, 246, 570 ST. GEORGE IN THE EAST, 267, 573 ST. PAUL'S CHURCH, 428, 598 ST. GEORGE'S, 23, 530 ST. PETER THE APOSTLE, 512, 611 ST. GILES CHURCH, 500, 609 ST. PETER UPON CORNHILL, 208, 563 ST. GILES-IN-THE-FIELDS, 118, 547 ST. PETER'S. 22, 529 ST. JAMES GARLICKHITHE, 235, 568 ST. STEPHEN, 364, 587 ST. IAMES'S PALACE, 396, 592 ST. THOMAS'S HOSPITAL, 490, 607 ST. JAMES-THE-LESS PARISH HALL AND SCHOOL, 437, 599 STATESMEN AND BOOKS, 63, 538 ST. JOHN, SMITH SQUARE, 418, 596 STEEL-FRAMED HOUSE, 307, 579 ST. IOHN, ST. IOHN'S SOUARE, 163, 556 **STONE HOUSE, 205, 563** ST. JOHN'S WOOD CHAPEL, 330, 582 STRATFORD HOUSE, 19, 529 ST. KATHARINE'S HOSPITAL, 337, 583 STRATFORD REGIONAL STATION, 290, 577 ST. KATHERINE CREE, 218, 565 STUDIO APARTMENT, 342, 584 STUDIO HOUSE, 455, 602 ST. LAWRENCE JEWRY, 193, 560 ST. LUKE, 180, 558 SUSSEX PLACE, 328, 582 ST. MARGARET PATTENS, 227, 567 SWAN, THE, 70, 539 ST. MARGARET'S, WESTMINISTER, 408, 594 SWAN HOUSE, 454, 602 SWISS RE BUILDING, 215, 564 ST. MARTIN-IN-THE-FIELDS, 126, 549 ST. MARTIN WITHIN LUDGATE, 247, 570 TANAKA BUSINESS SCHOOL, 470, 604 ST. MARY, PADDINGTON GREEN, 64, 538 TATE BRITAIN, 419, 596 ST. MARY, STOKE NEWINGTON CHURCH STREET, 317, 581 ST. MARY ABBOTS, 87, 542 TATE MODERN, 480, 606

TEMPLE BAR, 244, 569 TEMPLE CHURCH, 256, 572 TEN BELLS, THE, 270, 574 THAMES HOUSE, 234, 568 THEATRE ROYAL, DRURY LANE, 137, 551 THEATRE ROYAL, HAYMARKET, 401, 593 THORNHILL SQUARE, 301, 578 TIDE MILL DISTILLERY, 279, 575 TIMBER HOUSE, 175, 557 TIMES PRINTING WORKS, 282, 576 TOWER BRIDGE, 263, 573 TOWER HOUSE, 97, 544 TRAVELLER'S CLUB, 386, 590 TRINITY HOUSE, 221, 566 TUDOR HOUSE, 502, 609 TUDOR-STYLE HOUSE, 54, 536 TUDOR-STYLE HOUSES, 305, 579 **TYBURNIA**, 66, 538

UNIVERSITY CHURCH OF CHRIST THE KING, 100, 544 UNIVERSITY COLLEGE HOSPITAL, 344, 584 UNIVERSITY OF EAST LONDON, 292, 577

VANBRUGH CASTLE, 499, 609 VICTORIA AND ALBERT MUSEUM, 466, 604 VICTORIA STATION, 440, 599 VIRGIN MEGASTORE, 40, 533

VISAGE, THE, 362, 587 WALLACE COLLECTION, THE, 16, 528 WAREHOUSES, NEAL STREET, 119, 547 WAREHOUSES, SHAD THAMES, 491, 607 WATERLOO COURT, 373, 588 WATERLOO INTERNATIONAL TERMINAL, 495, 608 WATERMEN'S HALL, 225, 566 WATERSTONE'S, 48, 534 WATERWORKS PUMPING STATION, 316, 580 WESLEY'S CHAPEL (AND HOUSE), 179, 558 WESTMINSTER ABBEY, 378, 589 WESTMINSTER CATHEDRAL, ARCHBISHOP'S HOUSE, AND CLERGY HOUSE, 402, 593 WESTMINSTER COUNCIL HOUSE, MARYLEBONE TOWN HALL. 331, 583 WESTMORLAND HOUSE, 39, 533 WHITBREAD'S BREWERY, 177, 558 WHITECHAPEL ART GALLERY, 268, 573 WHITE HART LANE ESTATE, 320, 581 WHITELEYS, 72, 539 WHITE TOWER, TOWER OF LONDON, 222, 566 WILLIAM MORRIS GALLERY, 293, 577 WILLIAMSON'S TAVERN, 238, 568 WOOLWICH GARRISON, 516, 612 WORKING MEN'S COLLEGE, 341, 584 WREN HOUSE, 165, 556 WYLDES FARM, 347, 585

YE OLDE MITRE, 169, 557